THE PRINCE WHO
WOULD BE KING

SARAH FRASER

The Prince Who Would Be King

THE LIFE AND DEATH OF HENRY STUART

WILLIAM COLLINS

William Collins
An imprint of HarperCollins*Publishers*
1 London Bridge Street
London SE1 9GF
WilliamCollinsBooks.com

First published in Great Britain by William Collins in 2017

18 19 20 LSCC 10 9 8 7 6 5 4 3 2 1

Copyright © Sarah Fraser 2017

Sarah Fraser asserts the moral right to be
identified as the author of this work

Maps by Martin Brown

A catalogue record for this book is
available from the British Library

ISBN 978-0-00-754808-8

Printed and bound in the United States of America
by LSC Communications

Find out more about HarperCollins and the environment at
www.harpercollins.co.uk/green

For my sons, Sandy and Calum

CONTENTS

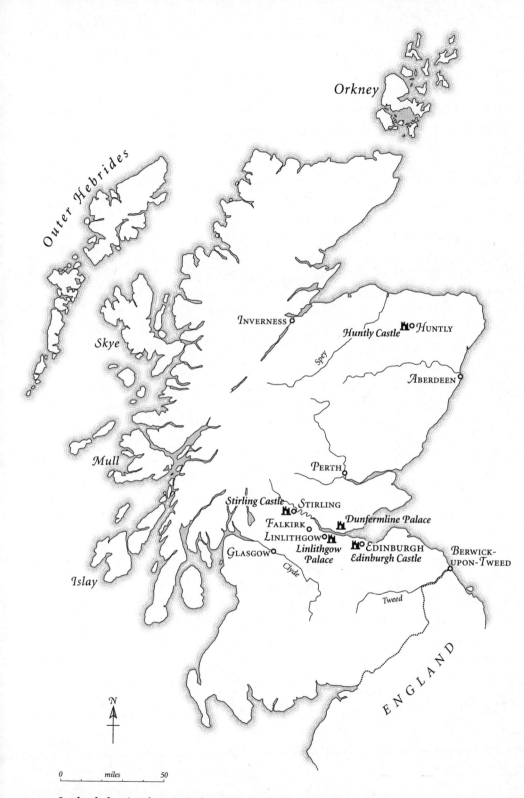

Scotland, showing the principal royal Stuart residences in Henry's first ten years.

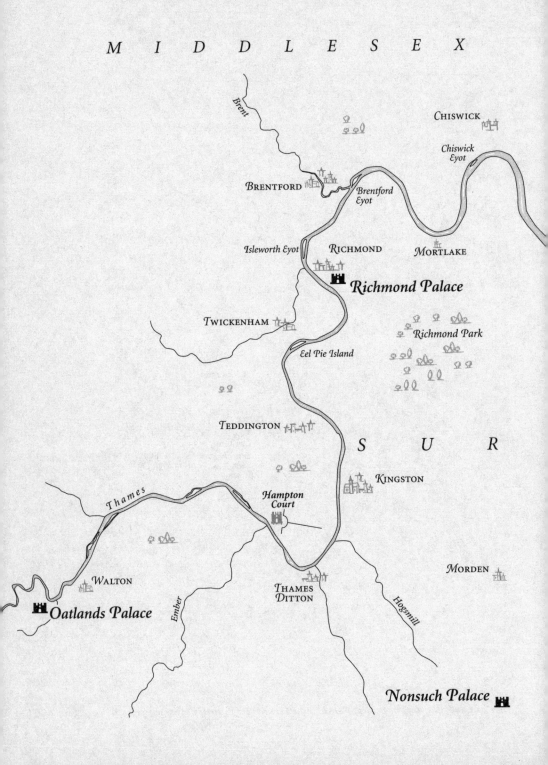

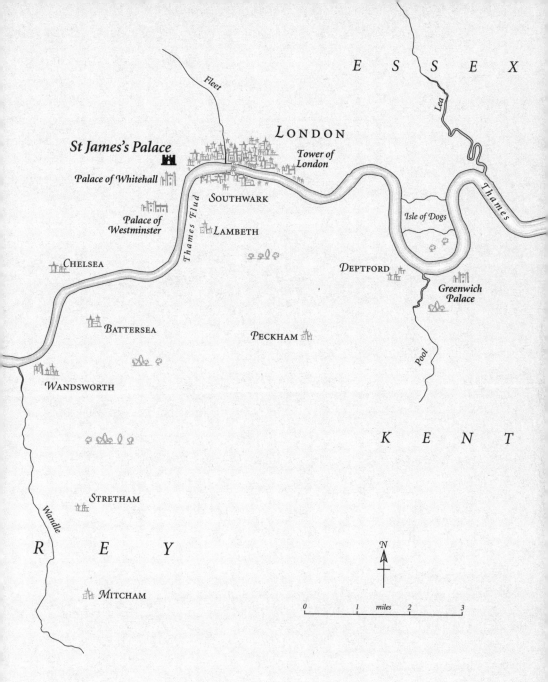

E S S E X

Fleet

Lea

L O N D O N

St James's Palace

Tower of
London

Thames

Palace of Whitehall

SOUTHWARK

Thames Flud

Palace of
Westminster

LAMBETH

Isle of Dogs

CHELSEA

DEPTFORD

Greenwich
Palace

BATTERSEA

PECKHAM

Pool

WANDSWORTH

K E N T

Wandle

STRETHAM

R E Y

N

MITCHAM

0 1 miles 2 3

*The Thames between Oatlands to the west and Greenwich to the east,
including Henry's principal homes.*

The House of Stuart

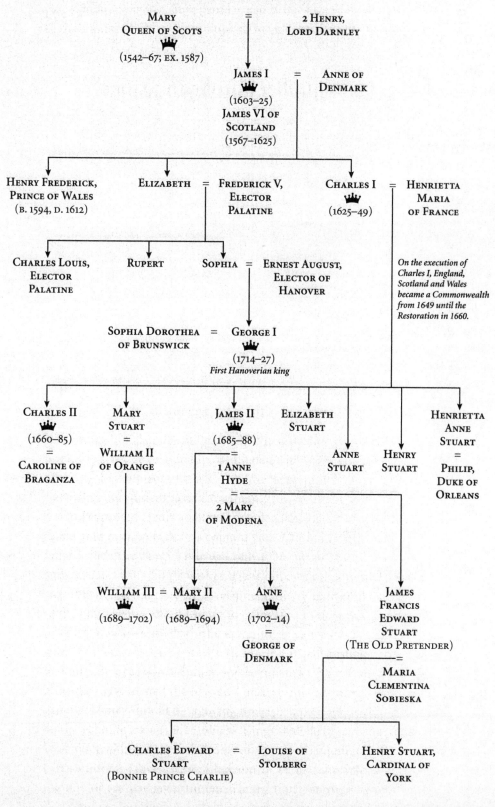

MARY QUEEN OF SCOTS ♛ (1542–67; EX. 1587) = 2 HENRY, LORD DARNLEY

JAMES I ♛ (1603–25) JAMES VI OF SCOTLAND (1567–1625) = ANNE OF DENMARK

HENRY FREDERICK, PRINCE OF WALES (B. 1594, D. 1612)

ELIZABETH = FREDERICK V, ELECTOR PALATINE

CHARLES I ♛ (1625–49) = HENRIETTA MARIA OF FRANCE

On the execution of Charles I, England, Scotland and Wales became a Commonwealth from 1649 until the Restoration in 1660.

CHARLES LOUIS, ELECTOR PALATINE

RUPERT

SOPHIA = ERNEST AUGUST, ELECTOR OF HANOVER

SOPHIA DOROTHEA OF BRUNSWICK = GEORGE I ♛ (1714–27) *First Hanoverian king*

CHARLES II ♛ (1660–85) = CAROLINE OF BRAGANZA

MARY STUART = WILLIAM II OF ORANGE

JAMES II ♛ (1685–88) = 1 ANNE HYDE = 2 MARY OF MODENA

ELIZABETH STUART

ANNE STUART

HENRY STUART

HENRIETTA ANNE STUART = PHILIP, DUKE OF ORLEANS

WILLIAM III ♛ (1689–1702) = MARY II ♛ (1689–1694)

ANNE ♛ (1702–14) = GEORGE OF DENMARK

JAMES FRANCIS EDWARD STUART (THE OLD PRETENDER) = MARIA CLEMENTINA SOBIESKA

CHARLES EDWARD STUART (BONNIE PRINCE CHARLIE) = LOUISE OF STOLBERG

HENRY STUART, CARDINAL OF YORK

CONVENTIONS AND STYLE

Spelling and punctuation, unstable in this period, are modernised to assist comprehension, and to prevent interruption of the narrative by lexical curiosities that might catch the eye and distract from the narrative flow. Even James VI and I revised his *Basilikon Doron* for publication to ease readability.

Contractions are expanded (thus mistie becomes Majesty). The spelling of proper names has been standardised. For example, Henry also spelled his name 'Henrie', but I have opted here for Henry. Individuals born with several titles, or those who changed name on receipt of them, can be a particular problem for the biographer writing for a non-specialist audience. Cecil was not the monolith 'Salisbury' when James VI negotiated in treasonable secrecy with Secretary Robert Cecil to inherit Elizabeth's thrones. I note *in media res* when an important change has taken place and from then on, I use the new name. With regard to place names, 'Great Britain' as a term for the multiple Stuart territories is a bit of an anachronism, but I use it as it is so apposite. Place names are modernised and standardised (thus Finchingbrooke becomes Hinchingbrooke).

For dates, the year begins on 1 January not 25 March (as it did on this side of the Channel).

British currency was in pounds, shillings and pence: £ *s. d.* One English pound was worth £12 Scots. To understand what a particular amount would represent today you can add two zeros to the figure, to get a rough approximation.

Effigy

'How much music you can still make with what remains'
– ITZHAK PERLMAN

In the conservation room at Westminster Abbey lies the wreck of a life-sized wooden manikin, stretched out on a white table. This is what remains of Henry Frederick Stuart, Prince of Wales.

Recalling a cast of the nameless dead at Pompeii, the figure's mute appeal touched me. Its ruined state tells of Henry's importance, but also what happened to his legacy. After Henry died, visitors ransacked this likeness for relics – someone even stole his head. His effigy was unique in 1612. Up until then, they were made to honour monarchs and their consorts, not their offspring.

Who was Henry Stuart, to earn this effigy, and the state funeral that went with it – itself unprecedented in England, in scale and magnificence?

This book sets out to recreate Henry, an important but almost forgotten piece of history's puzzle. Restoring Henry in his time and place reveals paths running through his court, from Elizabeth I to the Civil War, to a Puritan republic, and the British Empire in America; but also, to the transformation of the navy into a force achieving global domination of the high seas, and the breaking down and recreation of Britain's armed forces into a world-class fighting machine.

Henry re-founded the Royal Library, amassing the biggest private collection in England. He began to create a royal art collection of

European breadth – paintings, coins, jewellery and gem stones, sculpture, both new and antique, on a scale no royal had attempted before. These went on to become world-class collections under his brother, Charles I, and form the backbone of the British Library and the Queen's Royal Collection today. Henry began the grandest renovations of royal palaces in his father King James VI and I's reign, and mounted operatic, highly politicised masques. His court maintained a dozen artists, musicians, writers and composers. Ben Jonson, Michael Drayton, George Chapman and Inigo Jones all created work for him. He responded with enthusiasm to the vogue for scientific research, putting time, money and men into buying state-of-the-art scientific instruments – telescopes and automata that tried to model the heavens. He financed 'projects' – business schemes – to try and extract silver from lead, and make furnaces more fuel efficient.

Henry and his circle's curiosity and ambition reflected the era's desire to sail through the barriers of the known world. He persuaded his father the king to let him begin a full-scale review and modernisation of Britain's naval and military capacity. He was raised in the ancient culture of chivalry, but welcomed active servicemen from the front line of Europe's religious wars. Henry's court was where the latest developments in the art of warfare were received and developed. He became patron of the Northwest Passage Company, established to find a sea route across the top of America and open up the lucrative oriental trade to British merchants. He and his court were important promoters of the project to realise the decades-long dream of planting the British race permanently in American soil. Whatever we think of colonialisation now, such men transformed the world.

As a man and prince, Henry saw himself to be European as much as British, using as one of his mottoes the expansionist '*Fas est aliorum quaerere regna*', 'It is right to ask for the kingdoms of others'. At his death aged eighteen, he was preparing to go and stake his claim to be the next leader of Protestant Christendom in the struggle to resist a resurgent militant Catholicism. He was a devout, Puritan-minded Protestant. In the arena of politics, there is a case for seeing Henry's

court as a significant waystation between the abortive aristocratic uprising in 1601 – when the 2nd Earl of Essex sought to force Queen Elizabeth to name James VI of Scotland as her heir in Parliament – and the regicides who shivered in the Palace of Westminster's Painted Chamber, ready to sign the death warrant of Henry's little brother, Charles I, in January 1649. By the time of Henry's death, you could see the prince and his court positioning themselves at the front line of so much that came to define Britain in its heyday.

I am aware that when I say, Henry did this, and Henry did that, one question arises at once. Who *was* Henry?

Henry was a son, brother, friend, master, patron. 'Henry' was the crown prince. The inverted commas around his name allude to the medieval idea of the king's two bodies – ordinary man and the monarchy, the Crown. The natural man decayed and died. The Crown merely suffered a demise and passed to the next bearer. Crown Prince Henry possessed a physical body and a body politic. He was a boy and the crowns united: the first Prince of Wales born to inherit the united kingdoms of Britain.

His legacy stretched beyond his death to the conflagration coming in 1618. The Thirty Years' War would be the longest, bloodiest conflict in European history until the First World War in 1914. It tore Europe apart, and Henry had been determined to drag England towards involvement in it. What did that imply about his character?

He was only nine when he came to England. For nearly a decade in Scotland and nearly a decade in England some of the most influential men, and women, of the Jacobean age wanted to shape the character of the future king and his monarchy. Who he responded to, and to whom he did not, suggests what kind of king he would have made.

His effigy remains as a symbol of his dual nature. As his teenage body rotted in its coffin, his icon was supposed to live for ever. The eager ravages the effigy suffered reflect how well Henry had grown into his public role. By 1612, his court was recognised as an important power bloc at home and abroad. For me, he is the greatest Prince of Wales we ever had.

A recent straw poll shows how far Henry has dropped out of the national memory. In 2012 the National Portrait Gallery in London staged an exhibition devoted to him. It introduced what one reviewer after another called this 'forgotten prince' to a wider audience. The faceless anonymity of his effigy now symbolises his disappearance. Many people do not realise his brother Charles was never born to be king – nor how bright a star Henry rose to be in the Jacobean and European firmament. This biography is driven by a passionate desire to change that.

As I set out on my researches, Westminster Abbey began work to create new galleries to house its unique collection of effigies, including what remains of Henry's. This book is my contribution to the restoration of Henry, Prince of Wales – from forlorn worm-eaten object in a backroom, to an iconic, colourful character standing tall in his time and place, on the stage of British history.

PART ONE

Scotland

1594–1603

ONE

Birth, Parents, Crisis

'A SON OF GOODLY HABILITY AND EXPECTATION'

Dawn, Tuesday, 19 February 1594. The herald left his fire, shivered up the stone steps and strode out onto the walls of Stirling Castle to announce the great news. For four years Scotland had waited for a child, a male heir, to secure the throne. At last the king 'was blessed with a son of goodly hability and expectation'. Prince Henry Frederick Stuart's birth gave 'great comfort and matter of joy to the whole people'. The entire day cannonades ricocheted across the country. Scots of all ranks danced in the light of huge bonfires, as 'if the people had been daft for mirth'.

The proud father, James VI, despatched messengers to his fellow princes of Christendom, the first sent galloping south to London. Henry was James's gift to his childless cousin, the ageing, putative virgin queen, Elizabeth Tudor of England. The gift he expected in return was nothing less than her thrones and dominions. A prince had been born to embody the kingdoms united for the first time in history. *If* Elizabeth would name James VI of Scotland and the future King Henry IX her heirs, the boy could secure England's as well as Scotland's future.

* * *

3

Throughout the celebrations, Henry's mother, Anne of Denmark,* had remained lodged in the birthing chamber at Stirling Castle.

Landing at Leith four years earlier, fifteen-year-old Anne had made a sensational entrance: pale-skinned, reddish blonde hair, notably attractive, she rode through Edinburgh, her new husband at her side showing off his queen. Behind them the king's oldest friends, the Mars of Stirling Castle, followed stony-faced. From the side of the highway, a flock of black-clad ministers of the Scottish Calvinist kirk eyed the daughter of Denmark – her 'peach and parrot-coloured damask' dress, her 'fishboned skirts lined with wreaths of pillows round the hips'; their gaze travelling across her liveried servants, horses and silver coach – and shuddered.

In England these hard-liners – or 'purer' Protestants, as they saw themselves – were derided as 'Puritans'. They called themselves the godly. Soon enough, Christian duty would compel them to open their pursed lips to censure Queen Anne and her circle for their erratic attendance at interminable sermons on sin and corruption. God made them denounce the young queen's 'lack of devotion to the Word and Sacraments', and love of 'waking and balling' – staying up late to dance and gamble. She filled her evenings with music and elaborate court entertainments. One radical Calvinist griped that all royals were 'the devil's bairns', so what could you expect? (James responded by exiling him.) The idea of Anne as utterly frivolous would prove remarkably enduring.

Anne knew herself more than equal to them. Her brother, Christian IV, ruled Denmark – the Jutland Peninsula and the islands around it. His influence extended over Norway and east across what is modern-day Sweden, Gotland and the Baltic island of Bornholm. He also ruled Iceland and Greenland. To the south, Denmark controlled the German duchies of Schleswig and Holstein. Holstein lay within the borders of the Habsburg-dominated Holy Roman Empire of the

* She called herself 'Anna' in Scotland, but was Queen Anne in England. James's name for her was 'Annie' (sometimes 'my own Annie'). To avoid confusion, I will refer to her as Anne.

German Nation. So, one branch of the house of Oldenburg, Anne's family, were also imperial princes, owing allegiance to the Catholic Holy Roman Emperor in Vienna. This involved the Danes in German and imperial affairs. Off the north coast of Scotland itself, Denmark owned the Orkneys and the Faroe Islands.

Anne grew up a royal princess of one of the largest Protestant political entities in Europe. Her grandfather, Christian III, converted Denmark to Lutheranism in 1536, but Denmark declined to adopt the 'purer' form of Protestantism – the Calvinism that Scotland came to profess under John Knox. Anne's former suitor, Prince Maurice of Nassau, withdrew his offer on hearing that she would not convert to Calvinism in order to marry him.

Denmark's location gave it control of the sea lanes connecting the Atlantic to the Baltic. The tolls it charged shipping to pass through the Danish Sound and trade with the Hanseatic ports, made its monarchy wealthy. When Christian IV finished modernising it, Denmark boasted 'the largest and most efficient naval force in northern Europe'. His new nephew, Prince Henry, would grow up to cherish an equal passion for his navy.

The Danes spent as befitted Renaissance Protestant princes. Their riches and power financed cultural activity that put them at the forefront of the Renaissance. Christian's huge architectural projects changed the face of Copenhagen, making it one of the loveliest cities in Europe. Anne and Christian's mother, Sophie of Mecklenburg, maintained Tycho Brahe, the first astronomer in Europe to win international fame. Scholars flocked from across the Continent to meet him. Visitors to Brahe's island home included James VI when he came to collect Anne, his betrothed, in October 1589. James passed with amazement and delight through rooms full of books, maps and spheres to help man uncover the laws of nature by which God moved the heavens. Laboratories bubbled and steamed with alchemical scientific experiments. Brahe set on his own printing press his groundbreaking book on astronomy, the foundation text for Kepler and Galileo.

Buildings and gardens, statuary and art works, developments in all branches of science, new political theory and historical awareness,

were all part of that international lingua franca of the Renaissance. It was a language Anne grew up speaking as a native and passed on to all her children. Anne of Denmark was, in every way, a brilliant match for James VI of Scotland. A princess raised in this milieu; a woman who was bilingual in Danish and German; who had enough French to be able to write and converse with her new husband (who had no German); who then quickly learned Scots to a high level of idiomatic ease; who enjoyed and patronised a broad range of cultural activity, was unlikely to be the empty-headed fool of hard-line Calvinist censure.

In addition, the Scottish court soon discovered their queen possessed a strong will. Shortly after she arrived in Scotland in 1690, Anne dismissed James's most important female attendant from her service, sixty-five-year-old Lady Annabella Murray, Dowager Countess of Mar. The king's love and respect for 'Lady Minnie' ran deep. The Mars were hereditary keepers of Stirling Castle and, by tradition, the guardians of Scottish monarchs. King James had been fostered out to them when he was an infant and Lady Minnie was the only mother he knew. The king grew up with her son, Master John Erskine, whom he nicknamed Jocky o' Sclaittis (Slates), in fond recollection of schooldays spent together.

Anne, though, discovered Lady Minnie gossiping with her friend, the wife of the Scottish chancellor: the devout old dowager regretted too loud that James had not married the more suitable Catherine, sister of French Huguenot leader, Henri of Navarre. Out both women went. In their place Queen Anne brought in her Danish friends and lively young Scots women, including the Ruthven sisters, Beatrix and Barbara, and Henrietta Stuart, Countess of Huntly. Henrietta was the Catholic wife of a Catholic earl – pure gall for the godly who believed the queen's court was being peopled with the weak and the wicked: Lutherans and papists.

Four years later, in February 1594, Anne understood very clearly the huge political and dynastic significance of her son's arrival. From the birthing chamber, a lady-in-waiting carried the baby to its royal

nursery within the Prince's Tower. They swaddled him and he latched onto the dugs of Margaret Mastertoun, his mistress nurse. When he gurned, Mistress Mastertoun handed Henry to one of his four rockers.

Good medical practice prescribed swaddling to keep Henry's limbs straight, prevent rickets, and ensure strong growth. A few months later, liberated from the torment of swaddling bands, Henry started to stretch and move, but not crawl. Crawling suggested a prince too close to his animal nature, with its connotation of original and other sins. God condemned the serpent to crawl on his belly and eat dust all his days – not the crown prince. As soon as the infant could hold himself upright, Henry's nursery maids strapped him into a wheeled and velvet-lined baby walker.

To keep him alive, four medical practitioners attended in rotation: Dr Martin, Gilbert Primrose the surgeon, Dr Gilbert Moncrieff, and Alexander Barclay, Henry's apothecary. Infant mortality in the under twos ran at up to fifty per cent, giving a royal mother good reason to stay close and supervise. Queen Anne meant to preside over her son's nursery, to oversee his infant japes and woes. By birth and upbringing a political animal, Anne also wanted to instil in Henry her religious, political and cultural values, not an enemy's; and enemies, in the queen's view, lived too close to her boy.

Anne had been horrified when James commanded her to leave her own palace and go to the Mar stronghold at Stirling to give birth. As soon as it was clear that the baby would live, the king followed Scottish royal custom. Within forty-eight hours of his safe delivery, Prince Henry was fostered out to the Earl of Mar and that 'venerable and noble matron' Lady Minnie. The king formally contracted Mar not to deliver the prince 'out of your hands except [if] I command you with my own mouth, and being in such company as I myself shall like best of.'

'In case God call me at any time,' James said, 'that neither for the Queen nor Estates [Parliament's] pleasure ye deliver him till he be eighteen years of age and that he command you himself.' Henry would live out his entire infancy, childhood and youth at Stirling Castle.

Anne would have to accept she would never govern Henry's household. Her son would be raised by the high-born women of the Mar faction – the ladies Morton, Dunhope, Clackmannan, Abercairney, and the widow of Justice Clerk Cambuskynneth – and his male officers, James Ogilvie, Marshall and David Lennox, who served and ate at the ladies' table. Over the years the boy's intimacy with these families would build up his royal 'affinity'. As king he would then have a powerful magnate group at his side, his most loyal supporters. None were the queen's supporters.

Barely a fortnight after Henry's birth, events appeared to vindicate James's decision to isolate his son. On 5 March the Catholic earls of Bothwell, Huntly, Angus and Errol gathered in a plot to kidnap the boy. Once they had him, Huntly's wife, Henrietta, a favourite of the queen, would reunite mother and son.

After uncovering the plan, James ordered the earls to be placed under house arrest. But in answer they came 'against his Majesty at Holyroodhouse'. Elizabeth I instructed her cousin to put his 'lewd Lords … to the horn as traitors' – outlaw and hunt them down. James refused. High-handed, the English queen overrode him and sent a direct warning to the earls 'in no case to seek the young Prince'. If the child was killed, the inheritance of England and Scotland, Ireland and Wales would be thrown into chaos, leaving the realm vulnerable to foreign claimants.

The General Assembly of the Scottish Presbyterian Church added to the complaints against James. Why did the king not simply crush those magnates seeking 'the ruin of the state by foreign forces'? – meaning Spain and the pope. They warned of trouble arising from our 'intestine troubles' – the subversive activities of Bothwell, Huntly and their crew, but also Queen Anne. The French special envoy described the queen, in the wake of the removal of her son, as 'deeply engaged in all civil factions … in Scotland in relation to the Catholics'.

Within weeks of Henry's birth, the Scottish court split between allegiance to the king and the Mar clan, and allegiance to the queen and her faction. As much as it was an event to be celebrated, Henry's

birth threatened King James's hard-won domestic peace. If the earls seized Henry, they could force the king to give Catholics more power in the government of Scotland and divide the nation between Presbyterian followers of the king and papist followers of the queen. It seemed as though history might repeat itself, as James was only too aware.

James's memories of his own childhood determined that his son must stay at Stirling. In 1566, David Riccio, secretary to Mary, Queen of Scots, was stabbed to death in her presence – or as James put it, 'while I was in my mother's belly'. The king said that the in utero trauma scarred him with a 'fearful nature'. James's father, Lord Darnley, was suspected of conspiring with Protestant nobles, including lords Ruthven, Morton and Lindsay, in the killing; and Darnley himself was found strangled to death when James was just a few months old. Mary, Queen of Scots, then married the probable murderer of her son's father.

James was kidnapped by a group of Protestant lords and taken to Stirling Castle, where he was crowned, aged thirteen months. He never saw his mother again. Scotland divided into two factions: the king's men behind the infant James VI, the queen's behind Mary, Queen of Scots. From this bitter civil war, the king's men emerged triumphant. James's mother, the focus of the unrest, was arrested and imprisoned. She escaped to England and was put back under lock and key by her cousin, Elizabeth, on whose mercy she threw herself. James remained with the Mars at Stirling, as civil unrest rumbled on. During one outbreak of fighting, the five-year-old king saw his beloved paternal grandfather carried past him, stabbed and dying, the old man's blood streaming across Stirling Castle's flagstones.

In 1587, James learnt that his mother had been beheaded on Elizabeth I's orders. Seizing power in Scotland the moment he could, the highly intelligent and capable young king dedicated the first years of his reign to melding the factions and turbulent powers of his country into a workable whole. By the age of seventeen he had gained full control of his government.

Yet he still lived in constant fear of attack. Threats remained from within the king's inner circle. In August 1582, the Earl of Mar had been involved in the Ruthven Raid against his former charge. Mar and his allies held James captive in an attempt to force the king to oust certain favourites, particularly the king's French cousin Esmé Stuart. James was widely believed to be in love with Stuart, whom he had created 1st Duke of Lennox, and openly hugged and kissed him in public. Lennox was a Catholic – anathema to the devout Calvinist Mars. He converted to Protestantism but that did not convince the Scottish Calvinist elite. The Ruthven raiders ensured Lennox was exiled to France, where he died the following year. James was heartbroken.

The king and queen's failure to have children for the first four years of their marriage had only heightened the speculation that James could not fulfil his duty to his country, to secure it through an heir. Anne reminded her husband that he was now entrusting their son to a faction that had held the king to ransom. James countered that some of the queen's closest confidants had been at the heart of recent plots against him. In August 1600, when Henry was four, one resulted in the king's near assassination. The king had the ringleaders, the Earl of Gowrie and his brother, executed and demanded that Anne 'thrust out of the house' her ladies-in-waiting, Gowrie's sisters Beatrix and Barbara Ruthven.

Scotland's unruly magnates were not merely power hungry. The political threats during Henry's early childhood reflected the often violent religious conflicts dividing Europe in the wake of the Protestant Reformation. Religiously motivated wars and uprisings broke out continually throughout Christendom; assassinations and kidnappings were a common feature of those divisions. In 1585, the Calvinist ruler of the Dutch free states, William the Silent, was murdered by a Catholic fanatic. In France, the Protestant Henri of Navarre had just converted to Catholicism in order to unite France, win the throne, and try to bring to an end the religious wars and repeated attempts to assassinate him. In England, Elizabeth I's

spymaster, the late Walsingham, had regularly intercepted foreign plots against the queen.

For all these reasons, of custom and of threats to the monarchy and heir, James was adamant. Henry stayed at Stirling.

Launching a European Prince

On the issue of the prince's christening his warring parents were as one. Henry was not the name of a Scottish king. England, though, had lived under eight Henrys to date. The last was James VI's great-great-uncle, Henry VIII, father of Elizabeth. James's father was also a Henry – Henry Stuart, Lord Darnley. Anne's father was Frederick II. The boy would be christened Henry Frederick Stuart.

The king sent for his Royal Master of Works, William Schaw, to demolish the chapel royal at Stirling Castle and replace it with a new one worthy of Scotland's first major Protestant royal christening. Schaw came up with a 'scale model of Solomon's temple', and a little Renaissance gem. The interior reflected modern Renaissance Protestant thought and very likely the cultural dowry Anne had passed to the king. When James went to Denmark to bring Anne home, he witnessed an ebullience, sophistication and diversity of cultural and scientific activity he had never before experienced. He enjoyed Denmark and the company of his new Danish in-laws so much that he stayed for months longer than he needed to. This chapel royal seemed designed to reflect that happy period of his life.

The king asked Elizabeth I to stand godmother to Henry, bringing English queen and Scottish prince together in a quasi-parental relationship. James asked Henri IV of France to become Prince Henry's godfather. For weeks no answer came – until Elizabeth heard that Henri IV had refused to send a representative. Elizabeth was only too aware of the politics of this gesture. Elizabeth originally intended to refuse to send a proxy. Now, she accepted James's

invitation. As a Protestant, Henri, the Huguenot King of Navarre, had been Elizabeth's most powerful ally against the papal-backed Habsburg rulers of Spain and their cousins, the Holy Roman emperors. When Henri converted to Catholicism to unite France in July 1593, Elizabeth, still locked into war with Spain, felt bitterly betrayed. Henri was crowned king of all France the following February, the same month Henry was born, leaving Protestant England to face a newly united Catholic France twenty miles across the Channel. In the summer of 1594, therefore, Elizabeth wrote to Queen Anne, expressing '[our] *extreme* pleasure ... [in] the birth of the young Prince[and] ... the honourable invitation to assist at the baptism. We send the Earl of Sussex as our representative.'

The English queen's acceptance irritated Henri IV, as it was meant to. France disliked any sign of an enlarged multiple British monarchy forming across the Channel, already recently strengthened by Anne's Danish connections. After all, the family tree of a ruling dynasty was a European political network. Anne's sister, Hedwig, was married to the Elector of Saxony, one of the seven men who elected the Holy Roman Emperor. The Saxons were cousins of the free Dutch leader, Anne's former suitor, Maurice of Nassau.

By July, Anne's German relatives from Brunswick and Mecklenburg were beginning to arrive for the christening. Henry's mother knitted her son into the top echelon of Protestant Europe's rulers, while his father's French blood connected him to major Catholic rulers. The Venetian ambassador reported to the Senate that 'the Ambassadors of France, England, the States of Holland, and some German Princes ... meet in Scotland at the baptism of the king's son. The occasion is considered important on account of the understanding which may then be reached' on how to humble the resurgent Catholic powers of Spain, the Holy Roman Empire and the papacy. Fear of a coalition of Habsburg interests drove the abiding contemporary narrative of fear of predatory militant popery.

No less than three representatives arrived from the independent Dutch states for the christening, with twelve gentlemen and a train of thirty servants, reflecting the importance of the event. Embroiled in a

prolonged war to free themselves from Spanish control, the Protestant Dutch came 'to renew the ancient friendship between' Scotland 'and their own country, and to persuade' King James to 'enter into a general alliance against Spain'. They also brought gifts. Henry was given a 'fair cupboard of plate' (silver) and the promise of a hugely generous annuity of 500 crowns a year for the rest of his life.

As the event's political stature grew, empty coffers forced James and Anne to address the tiresome issue of how to fund the grand baptism. The king turned to the Edinburgh money men, 'to cause provision for wine and beer in great for the furnishing and entertaining' of their guests. Thomas Foulis, goldsmith, lent the king £14,598 (Scots). James promised to repay it by November the following year. The royal couple already had a reputation for profligacy and Foulis beseeched his majesty for a more tangible guarantee than his sacred word. The king pawned 'two drinking-pieces of gold, weighing in at fifteen pounds and five ounces of gold'. If he defaulted, then Thomas Acheson, master 'cunyeor' (coiner) was to 'strike down and cunyie' the cups into five-pound pieces of gold at the Cunzie House, the counting house, or royal mint. Foulis would take what he was owed and 'the superplus, if any be, to make forthcome and deliver to his Majesty's self'.

Others loaned and received their gold cup as security. A one-off parliamentary levy brought in £100,000 Scots, for 'the incoming of the strangers to this honourable time of the baptism of the Prince, his Highness dearest son'. At the end of August and weeks overdue, Elizabeth's proxy godparent, the Earl of Sussex, arrived, acting as if nothing could happen in Scotland until England appeared.

On the morning of 30 August 1594 the guests took their places in the chapel royal. At the east end stood the king's chair of state, empty on a platform, cloth of gold spread all round it. Stuffed and gilded chairs received the fundaments of a series of leading foreign dignitaries, who took up their places beneath red velvet canopies adorned with the arms of each of their countries. The arms of England hung over a chair to the right of the throne, Denmark's hung over the one to the

left, and the arms of Scotland dominated the centre. Anne sat to one side with her ladies and friends.

The new pulpit dazzled with cloth of gold and yellow velvet. The black-clad Calvinist clergy sitting at a table below felt a little queasy. Their eyes found no relief from the idolatrous frippery, as they glanced from alabaster bas-reliefs to classical Greek friezes, and a huge fresco of the king in his pomp behind the altar. Calvinists insisted on the separate jurisdictions of God and state. James VI apparently did not. Rather the opposite.

Waiting to conduct the service were David Cunningham, the Bishop of Aberdeen, David Lindsay, Minister of Leith; Patrick Galloway, a minister in the royal household and moderator of the General Assembly; Andrew Melville, who had recently criticised the queen for her lack of piety, and John Duncanson. A hundred younkers guarded the chapel door.

A fanfare sounded announcing the king, who sent for his son. The Earl of Sussex walked in carrying the infant Henry beneath the prince's red velvet canopy of state, just like the canopies that hung over saints in religious parades in towns throughout Catholic Europe. The godly ministers bridled. Such ceremonial flummery had been banished from Christian worship in the Protestant revolution, but here the canopy hinted at the shifting iconography of the sacred, from church and saints to monarchy, as if the king replaced God as an object of worship and his power was as sacred as it was secular. For them, authority rested in the Bible alone, the Word of God. It was unassailable by a mere mortal, even a king.

The chapel fell silent as Galloway climbed the pulpit and preached from Genesis 21:1 – where Isaac is born to Abraham and Sarah in their very old age. The boy was the child of barren loins. James was twenty-eight and Anne nineteen, so this could hardly mean them. Was it a dig at the other 'parent', Henry's barren godmother Elizabeth? At the end of Genesis chapter 21, the Lord makes his solemn league and covenant with Abraham, identifying his descendants as the chosen people. All would have understood the allusion: biblical language and symbolism saturated these reformed Christian lives.

Henry was Isaac, the one in whom the chosen Stuart race was called to greatness.

At the font, the ministers blessed Henry, wishing on him heroic energy and courage, strength to conquer monsters, raise the people of God, lead his nation, and to go into battle against hell's legions (Rome and Spain), to complete the glorious revolution and found the New Jerusalem of the Protestant Promised Land. In years to come in England, apocalyptic Puritan preachers would seek out Henry. Here is where they found purchase, in this groove carved into him from birth, stirred in along with the luxury.

Finally, to the sound of trumpets, Lord Lyon, King at Arms, proclaimed: 'Henry Frederick, Frederick Henry'.

Everyone now processed out of the chapel and into the sun, laughing and talking. From high windows, servants threw handfuls of gold coins down on the people of Stirling, waiting outside the castle walls. The christening party crossed to the great hall. Henry was placed at the highest table, while guests filled the benches below – relaxing, swapping observations and stories, planning how to report this event to their masters in the courts of Europe.

Another blast of trumpets interrupted their chatter. The doors swung open and a chariot laden with delicacies, bearing the goddesses of Liberality and Fecundity, rolled in. At first, Anne had hoped the king's pet lion would pull the chariot, until her servants expressed doubts about how the lion would react to the hubbub, and who would be eating whom if he went berserk because 'the lights and torches … commoved his tameness'. In the end they settled on Anne's favourite Moor. They strapped the man into the lion's harness. He leaned in and pulled.

The goddess of Fecundity held forth bushels of corn, to represent 'broodiness' and abundance. Her motto alluded 'to the King's and Queen's majesties – that their generations may grow into thousands'. The Stuarts flaunted the symbolism of the fertile holy family, infuriating for the spinster queen in the south. Liberality, meanwhile, held two crowns in her right hand and two sceptres in her left with the motto: 'Having me as the follower, thou shalt receive more than thou

shalt give'. More treason to Elizabeth's ears. Unable to take an official role in government, Anne applied her skill in the political use of revels. A 'sensuous and spectacle-loving lady', she sat back, well pleased with her show.

Anne's chariot retreated and a ship over twenty feet long was hauled in. Neptune stood at the prow and 'marine people' hung from the sides, their bodies decorated with the sea's riches – pearls, corals, shells and metals 'very rare and excellent'. The ship boasted thirty-six brass cannon and was gaily decorated with red masts and ropes of red silk, pulleys of gold, and silver anchors. On her foresail a painting of a huge compass billowed, pointing to the North Star. Europe could set its course by James and Henry.

Sugars, sculpted and painted to resemble seafood, lay in heaps on the decks – 'herrings, whitings, flukes, oysters, buckies, lampets, partans, lobsters, crabs, spout-fish, clams'. Sea maidens distributed the feast among the guests. From the galleries at the end of the room, the hautbois began a tune, joined by the viols, recorders, flutes, and then scores of choral voices all in deafening counterpoint to each other, singing in praise of king, queen and the prince of glorious expectation, Henry Frederick Stuart. As the music reached a crescendo, each of the thirty-six cannon unleashed a volley. The walls of the great hall thundered and echoed. The infant must have leapt from his skin.

From Stirling to St James's Palace in London, Prince Henry would learn a humanist truism: the encounter with the ancients in whatever form you find them – in coin or word or image, in plays, masques, and pictures – will endow you with their qualities of rationality, eloquence, glory, wealth, virtue, and political wisdom. Europeans communicated through these symbolic languages. James and Anne used this language on Henry's christening day to demonstrate the sophistication and merit of the dynasty sitting in wait for the death of Elizabeth Tudor.

Next morning the celebrations continued, as guests made their way in groups into Edinburgh. Others headed for the port of Leith and their ships. Ambassadors penned their accounts and examined the quality of the gifts of gold chains King James sent for their masters. Meanwhile a poem, '*Principis Scoti-Britannorum Natalia*' ('On the

Birth of the Scoto-Britannic Prince'), by Andrew Melville, one of Scotland's leading Presbyterian churchmen, reminded them of the true significance of Henry's birth for Christendom:

> Those who were divided by the Tweed …
> The rule of Scoto-Britannic sovereignty now joins together,
> United in law and within a Scoto-Britannic commonwealth,
> And a Prince born of a Scoto-Britannic king
> Calls them into a single Scoto-Britannic people.
> To what great heights will Scoto-Britannic glory now rise
> With no limits set by space and time?

By the time Elizabeth of England heard the word 'Scoto-Britannic' in this context for the fifth time in five lines, she was incandescent with rage. Chief minister, Robert Cecil, penned a letter on her behalf, pointing out that it verged on treason to say that James VI was 'king of all Britain in possession'. James responded laconically that, 'being descended as he was' from Henry VIII's sister Margaret Tudor, 'he could not but make claim to the crown of England after the decease of her Majesty'. He was Elizabeth's closest blood male heir.

James connived in having the poem broadcast as widely as possible and authorised the Royal Printer, Robert Waldegrave, to publish it. It enjoyed wide circulation in Protestant circles across Europe and was reprinted several times in Amsterdam.

Once Henry heads the united 'Scoto-Britannic people', the poem thundered on, he will lead them into the cosmic conflict against the combined forces of papacy and Spain to 'triumph over anointed Geryon'. In Roman mythology, Geryon is the triple-headed monster guarding the cattle in the Underworld. And here Geryon meant Spain. Melville addressed the infant:

> Your foot tramples the triple diadem of the Roman Cerberus,
> Dinning out of Hell sounds with thunders terrible
> From the Capitoline Hill.

The pope was 'the Roman Cerberus', the attack dog guarding the gates of hell. Cerberus belonged to Geryon (Spain), who fattened him with titbits of Spanish New World wealth. Melville combined classical motifs and an Old Testament prophetic tone so beloved of godly radicals, alert for signs their God willed them to complete the religious revolution.

Lurid propaganda perhaps, yet fear of popery drenched Protestant Europe. 'It crossed all social boundaries; as a solvent of political loyalties it had no rivals.' The destabilising range and power of that fear was heightened by the biggest problem facing Protestant Europe right now – the revival of militant Catholicism.

Hitting back, Melville promoted Henry as Christendom's saviour. Born in obscurity in Scotland, he would lead the Protestants of a united Europe against the sprawling gold- and silver-engorged powers of Habsburg Spain, the Holy Roman Empire and the papacy in a battle for the soul of the 'nation of Europe'.

'The holy zeal of Christians ... in their struggle against the anti-Christ' had found their future leader.

The Fight for Henry

'TWO MIGHTY FACTIONS'

It was pleasing for James to envisage the European scale of Henry's destiny, but he and his advisers knew it might come to nothing if the king could not ensure order and tranquillity at home – where, the English ambassador Bowes told Robert Cecil, 'the question of the Queen and her son', is 'a breach working mightily'.

Some even saw Henry's wet nurse as playing a sinister part in the drama. Everyone knew a child imbibed the nurse's character with her milk. When a messenger told Anne that Margaret Mastertoun had 'become dry through sickness', she feared the worst. But the drama soon passed. Whatever illness the wet nurse had, Henry had caught it, 'but is now well again. The King coming, the Nurse prayed pardon.' Her milk, however, had gone. 'The old nurse being of the Countess of Mar's choice,' Bowes explained, 'some seek to impute this fault to Mar.' If abundant breast milk equalled loyalty, the withdrawal of it implied treason. The Mars found another woman to tend to Henry, but 'the young Prince cried for want of' his old nurse and refused to feed. Recovering but unsettled, he preferred to go hungry and risked weakening himself further.

Anne asked that 'the keeping of the Prince' be moved to Edinburgh Castle, where she might personally oversee his care and prevent his nursery woes escalating into real danger. But Edinburgh, the seat of government, religion, and plots, was felt to be a more

dangerous place for the prince. James refused to hand over Henry's care to her.

The queen's initial misery at being deprived of her son now settled into a pulsing anger. 'Two mighty factions' formed: the king's support-ers – including Mar, his kinsman Thomas Erskine and Sir James Elphinstone – warning that Anne, Queen of Scots, schemed with the discontented Catholic '[Earl] Bothwell and that crew, for the corona-tion of the Prince and the departure of the King'. Sir John Maitland, the Scottish chancellor, spearheaded support for the queen. 'What the end will be, God knows,' sighed Robert Aston, an English agent.

The king tried to get the leaders of the factions, Mar and Maitland, to reconcile before the court but found that courtiers continued to put light 'to the coal' of the strife, standing back to 'let others blow at it'. This 'is the condition of this estate … Everyone shooting at others without respect to King or Commonweal, or the safety of the young Prince', commented Aston.

From Whitehall, Robert Cecil pondered the implications for England if King James and his obdurate consort ascended the English throne. James's apparent disinclination to suppress dissent and put his 'Lords … to the horn' left a question mark against his suitability as successor. Yet the Scottish king had settled Scotland as his forebears had failed to do. The child was a healthy male and, despite the unpro-pitious circumstances, there were whispers at court that he might soon have a sibling: 'by all appearances [the queen] … is with child, yet she denies it', agent Aston reported to Ambassador Bowes.

Hostilities quickly resumed though, with James informing Anne that in pressing for the removal of the prince, her supporters 'sought nothing but the cutting of his [the king's] throat'. Worse, he said, her plots were not only 'a danger to his person', but 'treason'. Anne collapsed under the strain. If she had been pregnant, she was not any more.

Anxiety for the health of his 'dearest bedfellow' drove James to see Anne at Linlithgow palace, set away from 'the tumults of Edinburgh'. Here, James entertained 'the Queen very lovingly … to draw her off' her obsession. She received him well and was reported to be 'all love

and obedience'. But at supper, thinking she had her husband 'in a good humour', she declared that 'it was "opened" in Scotland, England and Denmark that she had sought to have the keeping of the young Prince and that therefore it touched her honour and her credit' as mother of the heir and queen, not to be slighted. James insisted that 'he regarded her honour and the safety of the Prince as much as she, and would, if he saw cause, yield to her'. On both sides, love was intimate and strategic. James spoke for them all when he told Henry later: 'a King is as one set on a stage'.

The fight to be reunited with her son drew out a relentless streak in Henry's unhappy mother. The result, an audible rending of the fabric of the Stuarts' domestic life, was terrible to witness. By July 1595, Anne seemed to be 'somewhat crazed' in her grief. She obsessed over the right 'cause' to make the king 'yield to her'. She asked him to 'convene his nobles for their advice therein ... But he has utterly refused her motion and continues his promises to Mar. So this matter is "marvellous secret"', intelligencer George Nicolson observed with some sarcasm.

The feud turned violent when the queen's supporters clashed with the king's men under the walls of Stirling Castle, and Mar's baillie, a man named Forrester, was slaughtered. 'I fear it will very suddenly burst into bloody factions,' Nicolson judged, 'for all sides are busy packing up all small feuds for their advantage.' The kirk ordained a day of fasting 'for the amendment of the present danger' caused by this rupture. James, meanwhile, pleaded with the queen to abandon her campaign. 'My Heart,' he wrote, 'I am sorry you should be persuaded to move me to that which will be the destruction of me and my blood.'

One of the queen's ladies-in-waiting carried the stories to Denmark. Anne's mother, Queen Sophie, unmoved by her daughter's distress, advised that she should 'obey the King in all things'.

In London, Cecil was told 'there is nothing but lurking hatred disguised with cunning dissimulation between the King and the Queen'. Elizabeth I let off an exasperated rebuke to her cousin, rueing 'to see him so evidently a spectacle of a seduced king, abusing counsel,

and guiding awry his kingdom'. Her brother prince – her heir, perhaps – had let his popish lords lay out their demands, 'turning their treason's bills to artificer's reckonings – one billet lacking only', she fumed, and that is, 'an item … so much for the cord whose office they best merited'. James did not immediately follow advice on executions from his mother's killer, no matter how wittily expressed – though he did love wit.

A rapprochement occurred between king and queen towards the end of the year, and by early 1596 Denmark's daughter was pregnant again. Princess Elizabeth, named in honour of Elizabeth I, was born at Falkland Palace, Fife, in August 1596. She too was quickly fostered out to the king's allies and Henry saw nothing of his new sister. Nor would he see his baby brother, Charles, born four years later. Nor Princess Margaret, born 1598, but dead by March 1600.

Prince Henry's first portrait dates from this time. It shows a king in miniature. About eighteen months old, in his high chair, dressed in jewel-encrusted, padded white-satin robes, with a coronet on his head, he holds a rattle as if it were a tiny sceptre. The reddish blond down on his head is baby hair. His skin is white as the moon. He resembles his mother.

Nursery to Schoolroom

'THE KING'S GIFT'

By 1599 James had shooed 'the skirts' out of Prince Henry's lodgings and ordered diverse men of 'good sort to attend upon his person' instead. It was time to prepare the boy to be king.

James produced a hands-on guide to kingcraft for this purpose. You must 'study to know well [your] own craft ... which is to rule [your] people', he told his five-year-old son. The king had been writing and thinking about this for a long time. His *Basilikon Doron* ('The King's Gift') came out that year in a tiny print-run of seven. Copies of 'His Majesty's instructions to his dearest son, Henry the Prince' went to a privileged few: Prince Henry, the queen, Mar, and the man James appointed to be Henry's tutor, Adam Newton.

Self-help guides in preparation to rule were an established genre. The most famous, still in use at this time, was Erasmus's *Institutio Principis Christiani* ('The Education of a Christian Prince', 1516). James VI's book possessed a special allure, though, being written by a ruling personal monarch with vast experience of the subject.

He divided *Basilikon Doron* into 'three books: the first instructing the prince on his duty towards God; the second in his duty when he should be king; and the third informing him how to behave himself in indifferent things, which were neither right nor wrong, but according as they were rightly or wrong used'. James's writing voice enlivened the content. He could be intimate, colloquial, shrewd and

humorous, but also deeply learned. When it came to publishing the book for a wider readership, in England in 1603, James revised it, allowing his subjects to see how the wise philosopher-king was nurturing the student prince for them.

God expected Henry to have a detailed knowledge of scripture, his father told him, in order to 'contain your Church in their calling'. In James's view, the clergy's role was only to be custodians of his church, subservient to the king's wishes. Henry must not let ministers over-step this mark, interfere in government, or try to limit the authority of the king. Henry should strive to cultivate a middle path in matters of faith: 'Beware with both the extremities; as well as ye repress the vain Puritan, so [also] not to suffer proud Papall Bishops.' The king had already experienced memorable run-ins with certain Calvinist ministers who treated the heavenly and worldly realms as distinct. In general, Henry should be 'a loving nourish-father' to his church, said James, echoing Isaiah 49:23, where 'Kings shall be thy nursing fathers'.

A poet, philosopher and one of the most intelligent rulers in Christendom, James wanted his son to be as scholarly as him. In matters of secular government, Henry must 'study well your own laws', and recommended as further reading Xenophon and Caesar on statecraft. Henry's tutors agreed, but had their own preferred exem-plars; in time they would expose the prince to them, to the king's displeasure.

James encouraged Henry to study mathematics, which would allow him to fulfil the prime function of monarchy: the management of national security and foreign policy – or, when and how to make war. For this, maths would improve his mastery of 'the art military, in situ-ations of Camps, ordering of battles, making fortifications, and the placing of batteries'. A good commander could calculate the range and elevation for firing artillery and placing of infantry, and understand engineering issues such as where to mine walls for maximum destruction.

Although *Basilikon Doron* was a practical manual on kingcraft, James touched on the theory of monarchy, as expanded upon in his recent long essay: *The True Lawe of Free Monarchies*. The king nuanced

the Calvinist theory of predestination when he told Henry there was nothing you could do to earn the right to rule; God's will destined Henry to be king. Kings preceded the creation of all councils, including parliaments and church. Thus, on every count the king's power was pre-eminent.

This was the voice of a personal and absolute monarch speaking: one in whom supreme power rested, without any necessity to work through parliaments or councils. King Henry IX will be a type of 'little god', said James, adapting Psalm 82:6: 'I have said, ye are gods', there to exercise imperial power. Nonetheless he must earn his subjects' respect – as 'the highest bench is the sliddriest to sit upon'.

Lofty and earthy, this was a classic Jamesian image of kingship, congruent with his *True Lawe of Free Monarchies* (subtitled *The reciprock and mutuall dutie betwixt a free King, and his natural Subiectes*), in which James made an apology for the theory of the divine right of kings and absolutism, the monarch's 'imperium'. Since they were quasi-divine beings, said James, kings could not be punished by subjects if they were weak or wicked.

In the last resort, a monarch was 'free' to do as he liked. Only God could tip monarchs off the 'sliddriest' bench into the abyss if they failed to rule well. A king's duty was more onus than honour. His first duty was to be a good ruler. If Henry kept that in mind, he would avoid the loathing of God and men.

Tutors and Mentors

'STUDY TO RULE'

To shape this 'little god', James and Mar appointed the humanist scholar Adam Newton, an Edinburgh baker's son, as principal tutor. Newton had been the only commoner to receive *Basilikon Doron* in 1599. Henry now sat in the schoolroom in the Prince's Tower at Stirling, where his father and Mar had sat twenty-five years before, when they had been nurtured by a luminary of the Calvinist renaissance, the aged, godly and abusive George Buchanan. Buchanan might well have thrashed James senseless for proposing the unassailability of absolute monarchy.

Buchanan's own political writings legitimised not merely resistance, but prescribed overthrow, even tyrannicide, for ungodly monarchs. Extreme Calvinism and the idea of a contractual, not absolute, monarchy often went hand in hand. James thought Buchanan was a 'vain Puritan', violently overstepping his calling, and he had feared him. The beatings the boy-king suffered were on occasions frenzied. Once James left the schoolroom and took control of government, he banished Buchanan and burned his books.

As well as tutoring the king, Buchanan had mentored the godly Melville, author of Prince Henry's baptism poem. Henry's newly appointed tutor, Adam Newton, had in turn been mentored by Melville. Newton was as demanding as the king's tutors had been, but kind. Henry's servants remembered that 'next his parents, he was

always most loving to his schoolmaster ... notwithstanding that ... Newton did always prefer his own duty and his Highness well-doing before the pleasing of his fancies'.

After receiving his degree, Newton had travelled to France to hear Huguenot philosophers debate the politics of rightful resistance to a king. The philosophy of contractual monarchy argued that a monarch must rule by the consent of the people, for the benefit of the whole commonwealth. If not, he should be resisted, perhaps removed. In exchange for good governance, the people submitted to his rule, and gave their loyalty, even to death. Honouring this implicit 'contract' sanctioned the ruler's supreme power over their subjects and safe-guarded their liberties. Newton went to teach this political vision at the prestigious St Maixent college in Poitou, north of La Rochelle. He believed in monarchy as a system of rule, but in a contractual not imperial version. Yet he served a king whose theories on the nature of monarchy allowed no resistance to the will of the 'little god' monarch, no matter how bad he was.

Henry's guardian, the Earl of Mar, appeared to embrace some of Buchanan and Newton's political vision. In one council meeting, Mar censured fellow nobles for saying they would 'leave all to the King's pleasure'. 'It was not well that they should not freely give their advice as Councillors,' said Mar, 'which the King well allowed of.' Although James VI welcomed advice and debate, he never felt bound by any of it. The godly Mar envisaged king and well-born advisers ruling together in council, through the legislature, for the good of the realm as a whole. It was hard to imagine Newton or Mar working to shape a future Henry IX who believed his councillors should 'leave all to the King's pleasure'.

From these first days in the schoolroom, Prince Henry was exposed to at least two potentially incompatible sets of ideas about who he was, what he should believe, his attitude to monarchy and how he should act.

* * *

Newton was not left alone to educate Henry. Walter Quin, an Irish poet, was sent for to assist him. Quin came with the blessing not only of King James of Scotland but also of the Earl of Essex over four hundred miles away in London. Robert Devereux, the 2nd Earl of Essex, was Elizabeth I's principal favourite, a significant power in the country and a military commander in Ireland. In his poems praising James VI, Walter Quin urged the king to let a man of great Renaissance virtue guide him onto the English throne. He surely had Essex in mind.

Essex meanwhile courted James and tried to persuade Elizabeth of the need to settle the succession in favour of the Scottish king and his progeny. However, Elizabeth would not listen to his counsel, to the earl's fury. Essex firmly believed strong councillors secured an absolute monarch. These councillors must criticise when they saw their sovereign acting in error, against the good of the whole commonwealth.

As well as tutors of all kinds, Henry needed body servants. Mar brought in his first cousin, David Murray of Gorthly, as First Gentleman of the Bedchamber. Murray's high forehead and thick red hair and beard framed small bright eyes, giving him the look of an alert, friendly squirrel. A full-lipped mouth twitched upwards in a smile, all set in a long, rectangular face. A Renaissance soldier-poet, Murray was also a godly Calvinist, like most of the Mar clan. As overseer of the prince's bodily needs, Murray slept on a truckle bed in Henry's chamber. No man saw more of the boy.

James sent David Foulis to work with Murray and take charge of Henry's wardrobe. Foulis had first come to James's court as a pageboy. Later, he would be entrusted with taking the king's communications to Elizabeth. Now, as 'an ancient friend' of the Essexians, he acted as go-between in the secret correspondence between James and Essex. His role allowed him easy access to intelligence on the prince and his household, which he then sold on to the English earl and his camp.

In the letters, Essex's codename was 'Plato' and the king 'Tacitus'. James might have wondered why he was Tacitus. The Roman historian was a source of great fascination for the Essexians and Henry

Savile, who tutored Essex's son, was a renowned translator of his writings. Rediscovered in the Renaissance, Tacitus's works analysed the virtues of Rome under the Republic, where power resided in a strong council of elected individuals representing the flower of the whole community, under an elected leader. In comparison, Tacitus had reservations about the imperial era in Rome under the rule of the Caesars: absolute rule by non-elected emperors, 'free' to be unaccountable for their actions, if they wanted. Referring to James VI as 'Tacitus' suggested the Essex group dreamt that Stuart rule would inaugurate a Tacitus-influenced English political system: strong council with virtuous rule, and the security of a hereditary monarchy.

Mar facilitated and encouraged regular communication between Prince Henry's schoolroom and Essex House, the Earl of Essex's power base near Westminster. In this arrangement Mar boasted of his own importance as guardian of the heir and future King of Scotland and England. Essex confided to Mar that his faction's support for the Scottish king might possibly lead to arms, forcing Queen Elizabeth to name James as her successor in Parliament. The imprimatur of parliamentary legal consent mattered to Essex's group. For them, only a strong buffer of constitutional safeguards, legitimised in Parliament, guaranteed the Crown's authority. Issues such as the succession must then, Essex House concluded, include parliamentary participation. Although, Essex believed MPs had to be guided by Parliament's steering group, the Privy Council, staffed mainly by politically and militarily active aristocrats.

The Cecil faction, Essex's rivals for Elizabeth I's favour, also wanted to serve a monarch exercising absolute or 'imperial' powers, but contained by the due process of law and counsel by virtuous men of honour. The chivalric soldier in Essex would go further, fatefully, than any of the Cecil group in an attempt to bring this to fruition. For now, Essex suggested Mar come to London for private discussions.

This, then, was the complex, multifaceted and intensely ideological environment in which Henry began his formal education at the age of four: writing the alphabet; reading classical masters of Latin

grammar; studying the elements of rhetoric; learning French, and a bold italic hand to express himself in. If James thought his own character had been adversely affected by the brutality and instability of his childhood, then perhaps Henry's more temperate personality – described as showing 'sparks of piety, majesty, gravity … using a mild and gentle behaviour to all, chiefly to strangers' – reflected the kinder setting in which the boy was being raised. He shared his classroom with some of Mar's seven boys, and the earl's five daughters lived close by. Henry grew up with plenty of other children, but not his siblings.

Henry's handwriting was seen as reflecting the quality of the king in training, and the esteem he felt for the recipient. A scrawled letter, half illegible in a childish hand, found to be full of spelling mistakes when it could be deciphered at all, insulted the person and country receiving it. Henry sat in the Prince's Tower and practised italic script over and over. Cicero said you could not think well if you did not have a solid grounding in morally edifying texts, and good handwriting. So Henry filled his notebooks with lines of *rrrrrs* and *ssssses*. He perfected phrases before they went into the final copy of a letter. Typical child, he covered pages of his exercise books with his signature, practising his joyful twirls and flourishes –, *Henricus*, *Henricus*, *Henry*, *Henry* – for illustrious addressees.

By the age of six, he was initiating exchanges with foreign states and rulers. The first official letter he wrote in 1600 was to the Dutch States General and Maurice of Nassau, commander of the Protestant Dutch troops in their rebellion against Catholic Spain. In it he thanked them for their good opinion of him in his tender years. Henry promised these 'first fruits of his hand' showed 'his interest in serving them … hereafter in better offices'. The Dutch were already paying the 500 crown annuity promised at his baptism, though it went straight to the king's coffers. Henry would repay their faith in him, by coming to serve in the field, and learn the military arts from Maurice himself.

The king appointed a court favourite Sir Richard Preston to school the prince in the military arts. Preston had fought for the Dutch with the Earl of Leicester and Leicester's brother, the late Sir Philip Sidney,

both English heroes of international Calvinism. Many of Prince Henry's household, and the Essexians in London, shared a belief that Scottish Calvinism and the Church of England were parts of a greater body: the united European community of Protestants. With a touch of knights on a quest about them, such individuals felt honour-bound to defend any fellow Protestant state threatened by a Catholic power. Subsequently Preston, 'a gentleman of great accomplishments in mind and body', became a follower of Essex.

As Preston trained Henry, it was quickly observed how well the young prince 'began to apply himself to, and to take pleasure in, active and manly exercises, learning to ride, sing, dance, leap, shoot with the bow and gun, toss the pike, &c., being instructed in the use of arms'. Preston tutored Henry in the honour code of 'Protestant martial Virtue' he espoused. By May 1599, Preston occupied a '"Praetorian" role', as 'captain over all the officers in the King's Household'.

Veterans of Europe's religious wars, men such as Preston, recounted poems and stories, and introduced the prince to the latest innovations on the modern battlefield. Henry learned, while tales of siege trenches, training and army camp life replayed in his and his followers' imaginations. Soon 'no music being so pleasant in his ears as the sounding of trumpet and the beating of drum, the roaring of the cannon, no sight so acceptable, as that of pieces, pistols, or any sort of Armour', he wanted to be practising his martial skills all the time. The young prince attacked a plate of strawberries, holding up his two spoons. 'The one I use as a rapier', he chattered, 'and the other as a dagger.' Looking on, the men around him proudly shared these anecdotes: signs their education was taking root.

Henry also grew up with a keen sense of the threats to his father's kingdom. He saw the bodies of rebels rotting on gibbets as he trotted in and out of Stirling Castle. He knew how some of 'the great ones' in Scotland plotted to seize him and take him away. Sitting on his pony with his friends, watching the king and Mar hunt stags, someone asked Henry if he loved to hunt animals as much as his father.

'Yes', said Henry, 'but I love another kind of hunting better.'

'What manner of hunting?' they asked.

'Hunting of thieves and rebels with brave men and horses,' and adding: 'such thieves as I take shall be hanged, the great ones higher than the rest.'

By the age of seven, Henry was seeking to improve his essays by imitating classical masters, composing epistles in Latin in different styles. In the first instance Adam Newton, a master of style, would compose them and Henry transcribe them. But as he grew, Henry began to pick out anything that caught his eye. Newton gave him Cicero's *De Officiis*. Henry annotated it, heavily, underlining unusual words and phrases and copying them out to help him remember. He numbered the stages of a Ciceronian argument so he could learn how to debate. He marked up phrases he liked – often those where Cicero advocated active participation in public life.

Henry took care when writing to address both his parents. In one letter he thanked them for various gifts, enquired after their health and assured them of his own excellent and busy life. He also sent his father some verses.

In reply the king chastised him: 'Ye have rather written than dyted it' (copied not composed it). As a father, James was easy and loving. As kingmaker, he was harder to please. 'I confess I long to receive a letter from you that may be wholly yours,' James continued, listening for that golden tone – son to father, as well as Prince Henry to the King's Majesty. 'Nothing will be impossible for you if you will only remember two rules,' he told him. 'Trust a little more to your own strength and away with childish bashfulness', and 'my oft repeated rule unto you, whatever ye are about, *hoc age*', do not hang back – 'Strike!'

Written exchanges between father and son could swing easily between the private and public, between the occult and the rational, even; between loving encouragement and the drawing of a moral lesson from every little thing. Henry told his father he thought a witch on trial for malefice was a fake, and that they should do something about it. James thanked his son for the 'discovery of yon little counterfeit wench', and further counselled: 'You have often heard me say

that most miracles nowadays prove but illusions, and ye may see by this how wary judges should be in trusting accusations without an exact trial ... God bless you, my son, your loving father, James R[ex].'

Forced into the background of Henry's life, by the turn of the century Anne of Denmark had converted to Catholicism, having most likely been introduced to the Roman religion by her close confidante, Henrietta, Countess of Huntly, the daughter of the Duke of Lennox. Anne kept up her campaign to get guardianship of her son and told Pope Clement that she would raise her children as Catholics – though how she would do that when they were firmly ensconced in three different Protestant households was hard to see. She inferred James VI might grant Catholics toleration from Protestant vows of obedience if he were to ascend the English throne. The king's own pronouncements on the subject made many Catholics believe it also. The pope wrote to James offering a large sum in exchange for having Henry in Rome and educated in the Vatican. James refused.

As queen consort, Anne explained, she had to attend 'the rites of heretics' with the king and asked the pope's absolution for doing so. She did not like it, but knew she must acquiesce, due 'to the hostile times which we have to endure'. The queen's 'court Catholicism' was a form of religious dissimulation widely practised in both England and Scotland at every level of society. Most crypto-Catholics were loyal to the Protestant crowns, including many of Queen Anne's supporters.

Anne's conversion and secret correspondence with Pope Clement did little to advance the cause of domestic harmony between Henry's parents. 'The King and Queen are in very evil ménage,' a Scottish noble reported to Cecil, 'and now she makes to take upon her more dealing than hitherto she hath done. At public table she said to him that he was advised to imprison her, but willed him to beware what he "mintit" at.' When James responded that she must be mad to believe such a thing, Anne replied he should find that she 'was neither mad nor beside herself if he "mintit" at that he intended'.

By early 1603 the English saw how 'new troubles arise daily in Scotland, but the worst of all is the domestic dangers and heart

breaking that the King finds in his own house'. What discords, they wondered, would king and queen bring to London if James VI succeeded to the English throne?

England was about to suffer discords of her own. Troubled by 'choler and grief', Elizabeth was in steep decline. Two years earlier, in February 1601, the Earl of Essex had risen against the queen to force her to name James as her successor in Parliament. The coup failed and he was executed. Since then Elizabeth had aged rapidly. Her Privy Council was now dominated by men more concerned to caretake than develop England's influence in Europe as Christendom's principal Protestant state.

Some of Queen Elizabeth's militant Protestant servants saw the coming of the Calvinist Stuarts as a chance to change this. And perhaps soon.

For, on 24 March 1603, at Richmond Palace, Elizabeth I died, departing this life 'mildly, like a lamb'.

PART TWO

England

1603–10

The Stuarts Inaugurate the New Age

The Privy Council locked the gates of Richmond Palace, closed the ports and moved to Whitehall. Grief over the queen's death was tempered by memories of Essex's uprising and weariness of the Armada war in which the country was locked. The status quo needed to change. It seemed that, at the last minute, on her deathbed, even Elizabeth had acknowledged it and named James her heir. When asked by her Privy Council if she agreed that the Scottish cousin should succeed her, she was seen to move her arm to her head, which Cecil took as a sign of assent. Public mourning mixed with fear and anticipation as news of the queen's death spread across London.

Elizabeth's councillors wondered what English Catholics, maybe thirty per cent of the population, were planning. And, what would James VI do if he met the anticipated resistance. He might invade, backed by his powerful Danish in-laws?

The council organised to get the new dynasty – king, queen, heir, the rest of the royal children – under English protection and control. Robert Cecil proclaimed King James of England from the gates of Whitehall barely seven hours after Elizabeth's death. As the news spread, Thomas Cecil, Lord President of the North, reassured his half-brother: 'the contentment of the people is unspeakable, seeing all things proceed so quietly, whereas they expected in the interim their houses should have been spoiled and sacked'.

Nine days after Elizabeth died, King James VI of Scotland and I of England and Wales, and Ireland, and Queen Anne, attended a service of thanksgiving at St Giles Cathedral in Edinburgh – no mourning

here. James addressed his people, promising to return every three years. The following Tuesday, the king kissed his wife in front of the crowds jammed into the high street, and left. The three royal children were safe in nurseries dotted between Edinburgh and Stirling. Two others – Margaret, and Robert (who died in 1602) – had not survived infancy. The queen was pregnant again, for the sixth time.

The king wrote to Henry, apologising for not coming to tell his son in person of their great good fortune, 'but time is so precious'. James could not relax until he had the crown of England on his head. 'Let not this news make you proud or insolent,' he warned his boy, 'for a King's son and heir were you before, and no more are you yet … Be therefore merry, but not insolent,' he said. 'Keep a greatness, but *sine fasti*,' without giving yourself airs and graces. 'Be resolute, but not wilful.' He recommended the prince keep the *Basilikon Doron* by him, and signed off, 'Your loving father, James R'.

It was intended that princes Henry and Charles and Princess Elizabeth would remain in Scotland for the rest of their childhoods. At a stroke, nine-year-old Henry faced a future without either of his fathers – James and Mar. An Anglophile familiar with the English court, the earl had to accompany the king, who had never been to England (let alone Wales or Ireland).

Henry turned to his mother at once, writing: 'I will lose that great benefit I had by' my father's 'frequent visitation'. So, 'I most humbly request your Majesty to supply that lack by *your* presence, which I have the more just cause to crave that I have wanted it so long', before adding forlornly, 'to my great grief and displeasure'. The boy had never seen enough of her. However, Anne had been ordered to leave Scotland and join the king in London as soon as she was packed.

Henry hoped 'your Majesty by sight may have, as I hope, the greater matter to love me and I, likewise, may be encouraged to go forward … and to honour your Majesty with all due reverence …'. Couched in the usual language for a prince addressing the queen, nevertheless his words are full of longing. He spoke of love, not merely honour and reverence.

He did not need to ask twice. From the battlements of Stirling, the Mar clan watched as Anne approached – attended by a trail of armed nobles, soldiers and servants. It looked to some like the long dreaded coup to seize the prince. But the queen's 'request' that her son be brought out to greet her 'prevailed not. The Lady Mar and ... the Lord of Keir gave a flat denial and would not suffer the Prince to go out.' Old Lady Minnie told the queen that if Henry 'went with her, the Catholics would certainly abduct him, in order to have a hostage in their hands when they rose in revolt'. This was a barb, as the queen was Catholic. Anne demanded they admit her, then. The Mars regretted it, but they could not refuse entry to the queen's grace, especially in her condition.

Once inside the castle, Anne entered the royal palace, took possession of her lodgings, just below the Prince's Tower, and announced she would not be leaving without her son. Horrified at the turn of events, members of the Scottish Privy Council raced to Stirling to convene in the castle, resolve the crisis, and work out how to shift her.

On 10 May, a letter from Montrose, Lord Chancellor of Scotland, interrupted the king's delirious progress south. 'Her Majesty's present estate and condition I refer to the bearer's report,' he started. Pregnant and implacable as she was, Montrose said if they could just get 'Her Grace out of Scotland' it might defuse 'all fear of hazard, and danger of inconvenience'.

Back at Stirling, waiting guidance from the king, the privy councillors handled the possible 'inconvenience' of a kidnapping and 'revolt' as best they could. Lord Fyvie was given the unenviable task of persuading Anne to depart for England. Lord President of the Court of Session, Fyvie was the highest placed civil judge in Scotland. He was also a Catholic sympathiser, guardian of Prince Charles, and served Anne as baillie and justiciary of the regality of Dunfermline, one of Anne's possessions. Tall, with a fine figure, slim eagle nose and sensitive countenance, if anyone could expect a good reception from the queen, surely it was Fyvie.

He dragged his feet as he walked across the inner courtyard and entered the queen's presence chamber. As soon as he opened his

mouth on the subject, Anne was seized by a fury fit and started to 'beat at her belly' in distress.

Fyvie, aghast to 'be with her Majesty ... at the very worst', saw her fall. Bleeding 'from the womb', the queen's ladies crowded round and led her away. The brain has no sense of time. Perhaps it was a kind of aftershock, dropping her back into the horror of nine years ago, giving birth to Henry here, only to lose him.

'At such a time', in the history of the fledgling Britain, 'such an accident, to such a person, what could he [Fyvie] do or say?' the Scottish council asked James. Fyvie quaked in his boots. What if she died? Someone would have to be held to account. The councillors now changed tack, going all out to appease Anne, allowing Henry free movement through the castle to visit his mother.

The atmosphere thickened with hostility. 'Her Majesty's passions could' only be 'moderated or mitigated ... by seconding, following and obeying all her directions', though of course these were 'subject and depended wholly upon your sacred Majesty's answers and resolutions as oracles', they told the king. The councillors requested urgent, clear and credible orders.

Anne's fury had erupted, Demeter-like in its scorching power. She now showed every possible manifestation of her scorn, of being denied motherhood and the guardianship of her children for almost a decade. Her passion emptied her out, and stunned all around. She miscarried the baby, a boy.

'Physic and medicine require greater place with her Majesty at present', than lectures on realpolitik, Fyvie carefully advised his king. The queen's demeanour spoke much louder than any words. For days she lay motionless and silent. She could so easily haemorrhage or contract a puerperal infection, and that would be that. John Spottiswoode, her almoner, rode south to tell the king to prepare for the worst. Prince Henry, meanwhile, feared he was about to lose his mother, having just lost both father figures. The king sent Mar, of all people, home to deal with the crisis.

Eventually the queen began to recover. The castle hummed with 'controversy and a jar anent this question of the Prince's delivery' once

again, as it had following Henry's birth. There 'rests greater hatred and malice' than ever between the Mars and the queen's party. The risk is, the Lord Chancellor told James, that 'if it be not prevented' it will 'make a greater stir in this country'. In England, so far, all the talk had been of peace and happiness, of the chance to 'begin a new world', said the Earl of Montrose.

But at home, Stirling had become a microcosm of all the dangers James had tried to shield Henry from – and a potential trigger point for revolution. On the eve of the union of the thrones, with the king out of the way, the queen's faction might try to kidnap Henry, crown him and declare an independent Scotland, with the Danish Queen of Scots acting as regent.

James could not comfortably make his formal entry into London with a consort so angry and estranged it nearly killed her, and lost him his children. Half the appeal of the Stuarts was a promise of stability and continuity, taking the country away from succession battles and the threat of civil war from rival claimants. Prince Henry was vital to that promise. Two other children lived, but the boy, Charles, was a weedy child.

Anne stood firm, however. 'The Queen's Majesty is not minded to depart unless the prince go with her, and will no ways rest content that the Earl of Mar should accompany her,' Montrose told the king, suggesting James relieve Mar of his duty. James appealed to his wife: 'God is my witness that I ever preferred you to all my bairns, much more than to any subject', including Mar. Then he spoiled it by lecturing her not to open her ears to every 'flattering sycophant', and ended by praising Mar as 'an honest and wise servant for his true and faithful service to me'. He wanted Anne's trust, but seemed to have lost it.

The queen must join him immediately and thank 'God for the peaceful possession … of England, which, next to God, might be ascribed to the Earl of Mar', he commanded. Someone should have advised the king to omit the last phrase. Anne responded that 'she would rather never see England than to be in any sort beholden to

him [Mar] for the same'. She was staying put, in the same country as her children, and would deny Mar access to her.

After years of politicking, Anne had the upper hand, and played it, using Henry to provoke the first crisis of the new dynasty.

English ministers looked on in dismay. The king bowed to the inevitable. He ordered the Scottish Privy Council to discharge the Mars, thanking them for their years of good service. 'Our cousin, the Duke of Lennox' is coming to sort it all out, he told them. This was Ludovic, son of the late Esmé Stuart. The queen trusted young Lennox. He was the brother of her favourite, Henrietta Stuart, Countess of Huntly.

A few days later, the Earl of Mar escorted Henry across the courtyard to the Privy Council sitting in the great hall where he gave the prince into 'the charge of other Lords appointed to wait on him on his journey to England'. As the child approached Lennox, his mother and the lords of the council, he suddenly stopped, ran back and 'embracing the said Earl, burst forth in tears'.

After she miscarried, Anne kept the foetus and placed it in a tiny coffin. This now travelled with the royal party on its slow progress south. The queen 'brought with her the body of the male child of which she had been delivered in Scotland', the French ambassador explained to King Henri IV, 'because endeavours had been used to persuade the public that his death was only feigned'. Malicious tongues whispered that she was never pregnant – just psychotically manipulative.

James begged her to cheer up. 'Leave off these womanly apprehensions, for I thank God I carry that love and respect unto you which by the law of God and Nature I ought to do to my wife and mother of my children … As for your dole weeds' – the black mourning clothes she put on for her dead baby boy – 'wearing it is utterly impertinent at this time', he told her. He wanted to show the English that the Stuarts came in great splendour to spread peace and harmony, and preside over a new dawn for the nations of Britain. Instead, his queen flaunted what she saw as the consequences of their enmity. Anne's gesture was as dramatic as it was self-dramatising. Miscarriages were traumatic, then

as now, no matter how frequently they occurred. In a spectacle-loving age, living on the royal stage, extravagant personal gestures cohabited with the most rigid etiquette.

By 23 May, just over two weeks after she had stormed into Stirling, the queen rode with Henry into Edinburgh. Having been delayed by a cold, six-year-old Elizabeth now joined them from Linlithgow. The two bewildered, excited children were together for the first time. In each other's company they found a refuge amid all the changes. Soon, Henry 'loved her … so dearly that he desired to see her always by him'.

In Edinburgh, huge crowds gathered agog with curiosity to see their crown prince and Elizabeth. Cannon saluted them from the city's castle. Anne ordered a new carriage from George Hendry, coachmakers. Now she had what she wanted, she cast off her black dole weeds, preferring a new dress of figured taffeta, with a velvet-trimmed white satin mantle for travelling. She dressed Henry in a royal purple satin doublet and breeches and Elizabeth in Spanish red taffeta. Even the queen's clown was fitted with a new coat.

'Many English ladies in coaches, and some riding on fair horse', appeared in the Scottish capital, like a flock of exotic birds blown off course. Led by Lucy Russell, Countess of Bedford, and the beautiful Penelope Rich, sister of the late Earl of Essex, these were young women from the fringes of Queen Elizabeth's court. Fashionable, intelligent, witty, highly cultured, and about the same age as the queen, Anne took several of the Countess of Bedford's circle into her service immediately. She appointed Lucy to the bedchamber, the only Englishwoman to be brought so close at present.

The French ambassador observed the queen's nature 'was quite the reverse of' the king's. He liked to be private. 'She was naturally bold and enterprising; she loved pomp and grandeur, tumult and intrigue.' Henry rode beside his mother and Elizabeth, saluting the crowds with care from a fine French horse presented to him by Lennox. The infant Charles would join them in England when he was considered strong enough. Queen Anne was doing the English Privy Council's job for them, giving them what some of them had been bargaining for in the last years of Elizabeth's reign – the whole Stuart royal family.

Just over the border, at Berwick-upon-Tweed, the elderly ladies of Queen Elizabeth's privy chamber waited for their new mistress. Ever keen on continuity in order to demonstrate the legitimacy of his rule, James had simply reappointed them. With them they carried piles of the old queen's dresses for Anne, and caskets of her jewels. Their grip tightened at the sight of Lucy Bedford and Lady Rich close at the new queen's side. Anne listened as the venerable old ladies offered to dress her in her predecessor's hand-me-downs, pin her jewels on her bosom and resume their old positions of privilege and intimacy at court. The queen thanked them, took the gifts, and sent her husband's appointees away.

The royal party reached Althorp house in Northamptonshire on Saturday 25 June, where Ben Jonson had created a masque for the house's wealthy owner, Sir Robert Spencer, and his esteemed guests.

Through the summer's evening light, a willowy line of fairies and a satyr led 'Queen Mab' through the park and woods around Althorp, leaping and dancing towards the royal party.

'Your father gives you here to the service of this Prince,' the Satyr announced to thirteen-year-old Master Spencer, playing a huntsman. Prince Henry crossed from the audience into the masque to accept him. The two boys then rode off, to hunt together inside the magical world of the masque, though the two deer they killed were real enough. It was a world away from the fortified world of Stirling, protected from the public gaze.

The following day, Ben Jonson sent them all off with a blessing, addressing Henry as his:

dear Lord, on whom my covetous eye,
Doth feed itself, but cannot satisfy,
O shoot up fast in spirit as in years;
That when upon her head proud Europe wears
Her stateliest [at]tire, you may appear thereon
The richest gem, without a paragon.
Shine bright and fixed as the Arctic star …

Jonson foresaw Henry risen to his full height – Henry IX, the guiding North Star of Protestant Christendom, hanging in icy isolation. That day, 'when slow time hath made you fit for war', look across the narrow sea, 'and think where you may but lead us forth' on that day when 'swords/Shall speak our actions better than our words'.

English glee bubbled over – a prince called Henry and a princess called Elizabeth. The age was both new and old.

A Home for Henry and Elizabeth

OATLANDS

The family reunited with the king at Easton Neston, sixty-five miles north of London. By the time the Stuarts reached Windsor Castle at the end of June, their train numbered over five thousand, a scale unseen for decades. Lady Anne Clifford, aged thirteen, and her mother, the Countess of Cumberland, killed three horses in their dash to reach the royal family and get a toehold near them. There 'was some squaring at first between our English and Scottish Lords, for lodging and other such petty quarrels; but all is passed over in peace'. All the Stuarts had to do to repay this fervid reception, was satisfy the expectations of everyone in England who mattered.

At Windsor, James created a host of Garter Knights, the highest order of chivalry, to celebrate his accession. One of the first was Henry Wriothesley, Earl of Southampton, freed from the Tower where he had been imprisoned since 1601 for rising with his friend, the late Earl of Essex. For all the talk of continuity, this really was a new age – mixing English, Scots, European family and elites, and rehabilitating the disgraced Essexians.

Prince Henry kneeled with Lennox, the earls of Mar and Pembroke, a proxy for James's brother-in-law the King of Denmark, and the German Duke of Württemberg. When the prince stood up again, the Garter insignia – a gold-enamelled Protestant St George, thrusting the sword of truth down the maw of the Catholic hellfire-breathing

dragon – rested on his breast. Princess Elizabeth and Anne Clifford watched from behind a screen. Lady Anne overheard 'the earls of Nottingham and Northampton highly commended [Henry] ... for diverse his quick witty answers, Princely carriage, and reverend performing his obeisance at the altar'. The earls' flattery was normal court discourse, but it showed the ease with which Henry was able to play his public role at such a young age. Six weeks after leaving Stirling, Prince Henry had walked onto a stage of oppressive magnificence – and one he could never leave.

The Stuarts' increasingly grand and numerous progress towards the capital stalled at Windsor. Plague had broken out in London once more, forcing the king and queen to abandon plans for a great coronation. They slipped to Westminster to be crowned on 25 July, where their new subjects were forbidden from approaching them, and then rode away as fast as they could. The court and council followed in their wake, setting up temporary government wherever the king chose to stop.

James was obliged to establish a royal household for the prince and princess in a hurry. He was advised to choose Oatlands palace in Surrey, some ten miles upriver from Hampton Court, though in an alien kingdom he cannot have had any real idea where it was.

With the king unable to settle and establish his own court, Henry immediately took on some of his father's public duties. At Oatlands he met with the Venetian Secretary, to receive the Republic's congratulations on James I's succession. 'He is ceremonious beyond his years,' Scaramelli wrote of the prince.

When the Secretary asked him how he filled his days in England, Henry opened up. 'Through an interpreter he gave me a long discourse on his exercises, dancing, tennis, the chase' – in lengthy, excited detail. 'He then conducted me ... to visit the Princess. I found her surrounded by her Court under a canopy. They both said they meant to learn Italian.'

Italian delegate and British royals charmed each other. King James's tutor, Buchanan, had extolled the Venetian constitution, recommending it as a model to his followers. Buchanan's student, Melville, would

have passed the approval to his student, Adam Newton, who passed it to Prince Henry. Yet, Venice was a republic, and Henry the son and heir of a man proclaiming vocally and in print, the divine right of kings and absolute monarchy.

The plague outbreak was the worst for a generation. Travellers carried it from London out into the countryside. The Lord Chamberlain and the Lord High Steward moved the royal couple on, and on – with the Privy Council and the law courts still following behind.

Soon Oatlands fell victim to anxiety over the plague, forcing Henry and his train to follow his father's court. Elizabeth was moved to new guardians, the Haringtons, parents of Lucy, Countess of Bedford, at Coombe Abbey in Northamptonshire. 'I most kindly salute you,' Elizabeth wrote to Henry when she was settled, 'desiring to hear of your health, from whom, though I am now removed far away, none shall ever be nearer in affection than, your most loving sister, Elizabeth.' Henry replied with a gift, a verbal message, but also 'these few lines ... I beseech you to accept, as witnesses of my tender dutiful affection ... and that by our absence shall [not] be diminished but rather with our years shall be increased ... I rest, your loving brother, Henrie'. The formal register of all royal communication masked, but could not prevent, a sense of the deep mutual affection coming through the rhetoric.

Elizabeth thanked him by return. I shall keep these 'delightful memorials of your brotherly love in which assuredly (whatsoever else may fail) I will endeavour to equal you, esteeming that time happiest when I enjoyed your company ... As nature has made us nearest in our love together, so accident might not separate us from living together.' She always hoped they would live together again.

By December 1603 the number of plague cases each week was falling. On the 23rd, Robert Cecil wrote from Hampton Court, 'where now the King, with the Queen and the Prince are safely arrived, thank God'.

James had confirmed Cecil in his position as Secretary of State, and raised him to the peerage as Baron Essendon. The king sought to

balance Cecil's power by bringing in two Howards, the earls of Northampton and Suffolk respectively. James was soon calling the three men his 'trinity of knaves'. The two Howards benefited by the serendipity of being that object beloved by James, 'an ancient pearl' of the nobility, as well as having been consistently pro-Stuart before 1603. Northampton was renowned as a man of 'subtle and fine wit, of good proportion, excellent in outward courtship, famous for secret insinuation and fortuning flatteries, and by reason of these qualities, became a fit man for the condition of these times'. He shared James's eye for good-looking young men, and was a pedant and flatterer. A Catholic, his support for the Stuarts originated with James's mother, Mary, Queen of Scots' claim to the throne. Northampton reverenced the monarchy as divinely appointed, though how he managed to assume high office without swearing the Oath of Allegiance to James and abjuring the pope, was another matter. He must have fudged it somehow. The man wore many masks, and probably played with conviction the role of each one he donned. After years of disappointment, his moment now came with the accession of the Stuarts. Both courtier and councillor, Northampton pursued his own fortune, and government reform. Men like Northampton typified the kind of expert opinion a new ruler could use.

The court settled to enjoy their first British Christmas. Henry threw himself into it. At one moment during the dancing of 'galliards and corantos ... the young prince was tossed from hand to hand like a tennis ball'. The first dynastic marriage of the new era was celebrated – between Philip Herbert, brother of the Earl of Pembroke, and Lady Susan Vere, daughter of the Earl of Oxford. Henry and his Danish uncle, the Duke of Holstein, 'led the bride to church ... The marriage dinner was kept in the Great Chamber, where the Prince, the Duke of Holstein and the great Lords and Ladies accompanied the bride.' Henry sat next to her at the wedding feast, chatting amiably.

In addition, 'we are to feast seven Ambassadors: Spain, France, Poland, Florence, and Savoy, besides masques, and much more', Cecil told a friend, already exhausted by the stamina required to socialise and network at night, and work by day. The names were geopolitical.

Some had been in England for months, waiting for the king to return and settle. Cecil longed for Christmas to end so he could get on with the business of government: 'I protest I am not thoroughly reconciled, nor will not be till we meet at Parliament.' Whoever was absent on that day, Cecil said, 'I will protest they do it purposely because they would say, "No" to the Union.'

The plague had delayed the real work of beginning to understand the new sovereign. Having united the crowns, the king now sought the full union of England and Scotland.

The court had its first chance to see who King James really was when he summoned the moderate Calvinists of the English Church, the Puritan Calvinists, and the Roman Catholics to a conference at Hampton Court on 14 January 1604. There they would thrash out the shape of the Jacobean Church.

The Catholics arrived feeling sure the king would lift the penalties against the public profession and practice of their faith. As far as they understood it, James, through the late Earl of Essex, had agreed to remove anti-Catholic legislation, in exchange for Catholic support for James's candidacy for the throne.

The Puritans arrived feeling even more confident. They anticipated the Calvinist king of a properly reformed Presbyterian Scotland would purify the Elizabethan Church of its papist residues. For them, salvation came only through predestination: God's will. It could not be earned by attending church ceremonies and rituals of piety, or doing good deeds, as the idolatrous papists and moderates sitting opposite them believed. You got to heaven through faith alone, and constantly proving your faith in God's goodness by your pious way of life. They knew the Church of England had stalled part way along the path to the international Protestantism of Calvin. God's appointment of James of Scotland to the English throne was a sign that He knew it as well. James came to perfect the Reformation.

Henry entered the royal presence chamber and sat by his father, the lords of the Privy Council looking on. The king told the conference he did not come 'to make innovations' in religion 'but to

conform'. There was 'one religion' as 'by the law maintained', said James. This law required conformity to the Book of Common Prayer. Elizabeth's was a national church, generally Calvinist in doctrine but closer to Catholicism in church structure and the rules governing ceremony and forms of worship. The moderates were pleased. Henry knew his father was being consistent with the advice of *Basilikon Doron*, that the monarch should rule an inclusive church from the middle ground.

The godly Puritans heard, with horror, the king inform them that the English Church only needed upgrading, not further reformation. Investment in education and proper salaries for preachers would produce an intelligent, high-quality clergy. James insisted on retaining ceremonial conformity in the church. He wanted to hear no more extempore preaching odysseys from Puritan clergymen, less open-ended examinations of the Bible with speculative exegesis on its meanings – and no interfering in politics from the pulpit. No theorising would be tolerated about a contract theory of monarchy, or the rightful resistance to a failing monarch; or the explorations of the idea of separate realms and jurisdictions of church and state that had bedevilled his relations with the Scottish kirk.

Worse for the Puritans, James told them that the Roman Catholic Church was still 'our Mother Church'. Everyone had to grow up and leave 'mother' at some point; James believed Catholics were imma-ture. Prone rather to delusion than sedition, they had believed too many of the fairy tales the Mother Church told them in order to keep them obedient.

James foresaw the established church and English Catholics on shared ground 'in the midst' of a 'general Christian union' to match the new union of crowns. A lot of this was hard for even the predom-inantly moderate Puritan clergy to swallow. It was the king's vision of the harmony all Christendom might aspire to, if they just followed his lead. Catholics need only renounce the error of maintaining the pope's supremacy to the king. Given this, James saw no need to lift the penal-ties against them. The Catholic representatives left bitterly disap-pointed, feeling used and deceived.

As for the Puritans, the king denied they were a church; they were merely 'novelists ... a private sect lurking within the bowels of the nation'. Recalling the radical Scottish clergy, they were too arrogant 'to suffer any superiority' to their own authority, he said. Therefore, they could not 'be suffered in any well-governed Commonwealth'. The hard-line Calvinists departed in furious frustration.

Puritans and Catholics should have read *Basilikon Doron*. It was now widely available after all. James believed the church needed containing not empowering.

If a Calvinist king could not meet Puritan needs, and their queen was a crypto-Catholic, the Puritans would have to look elsewhere. Given the godly character of Henry's senior servants, men such as his tutor Adam Newton and the soldier-poet David Murray, some radical clergy began to orientate towards a prince still young enough to be moulded in their own image of him.

The Stuarts Enter London

'WE ARE ALL PLAYERS'

Eleven months after Elizabeth I's death, the Stuarts had not even made their official entry into London. As the plague petered out, the day was fixed for the Ides of March, to be followed by the state opening of the first Parliament.

Fields and wooded parks divided the two Londons – the cities of London and Westminster. The City of London resounded with the clatters and bangs of hundreds of 'mechanicians ... carpenters, joyners, carvers and other Artificers sweating at their chisels', energy levels kept up by a 'suck [on] the honey dew of Peace'. On 15 March the royal family emerged from the Tower, their palace in the City. Ben Jonson and Thomas Dekker created the pageant, and Dekker's company of actors was now Henry's: the Prince's Men. To celebrate, Dekker was collaborating with Middleton on a play for their ten-year-old master – *The Honest Whore*. Jonson, burly, with a square bruiser's head, dismissed Dekker as 'a dresser of plays about town', but they put aside professional rivalries to produce a politicised vision of the new united kingdoms of Britain as an earthly paradise.

The royal procession left the Tower around midday. Henry rode in front of his father, men on foot and mounted nobles in between them, accompanied by the prince's friends and leading household officers. The prince gazed about, 'smiling, as overjoyed, to the people's eternal comfort'. This was just how the late queen Elizabeth had comported

herself among her people in the capital. Henry now turned and 'saluted them with many a bend'. They shouted and cheered 'fair Prince' Henry to the skies, riding 'in glory ... as in the abridgement of some famous story'. To them, he was his father and forebears in miniature. In Henry, the poet Michael Drayton identified 'every rare virtue of each king/Since Norman William's happy conquering'.

A five-hour parade lay ahead of them. The king sat on his favourite white filly under a canopy of silk and cloth of gold, 'glittering, as late washed in a golden rain'. Horses and men seemed made of gold. Courtiers great and small, household officers of all ranks, filed into place.

Shakespeare and his fellow actors, now the King's Men, had received four yards of scarlet cloth to make up their livery for this day. They began to march. As the King's Men they were also grooms of the chamber in ordinary. At court functions, they came in as ushers. The court resembled a huge three-decker ship, rocking, unsinkable. Courtiers clambered up, fell overboard, conspired against others, flattered and bantered and vied for favour. Hide-bound by ritual to honour each other to their faces, they hid, spied, informed, gave and broke their word just out of sight. It was rich, brutal and elegant. Shakespeare and his friends waited and watched. What a trove of royal material – a cacophony of information to feed into plays about kings, the nature of monarchy and empires.

From the Tower to Temple Bar (gate), labourers had gravelled the muddy, filth-strewn streets, and railed them to separate the crowds from the nobility. Along the road, the City's Worshipful Companies waited in their liveries with their 'streamers, ensigns and bannerets' blowing. The conduits of Cornhill, Cheap and Fleet Street ran with claret. 'Diverse music' flowed from every arch, heightening the party atmosphere and making the wine 'run faster and more merrily down into some bodies' bellies'.

The Stuarts processed along Cheapside, lined with the gold-workers' shops and jewellery merchants they would soon patronise. Near Fleet Street they passed the Mitre and Mermaid taverns. Close to the Inns of Court, these taverns attracted many of the artists, thinkers,

radical lawyers, MPs and clerics who would soon be drawn to Henry's circle, to eat and talk about their employers, their work, and plans for their country's future, when their hopeful young master was called to the thrones.

Between the Tower and Westminster, the pageant passed under seven arches in all, some over seventy feet high. From the top of the second arch, Genius addressed Queen Anne, praising her birth and virtues, and 'that fair shoot … your eldest joy, and top of all your store', Henry. After solitary Gloriana, the English revelled in the myth of a royal family. After the Virgin Queen, pure and alone, came marriage, earth, offspring, fecundity and growth, security of succession. Richard Martin MP welcomed the king on behalf of Members of Parliament and lawyers. He praised the 'fair inheritance from the loins of *our* ancient kings … your princely offspring', deliberately tracing the Stuart descent from the Tudors.

When Henry reached the sixth arch by the conduit on Fleet Street, it looked like 'some enchanted castle guarded by ten thousand harmless spirits'. It was a 'tower of pleasure'. In the middle a huge globe rotated slowly, 'filled with all the degrees and states that are in the land'. Astraea – one of the traditional symbols of Elizabeth I – sat on top, her garment thickly strewed with stars, a crown of stars on her head, a silver veil covering her eyes.

Near Astraea stood Envy, eating the heads off adders. Her 'rank teeth the glittering poisons chew' and swallowed, as blessings descended on Henry and his family. The City celebrated 'the attractive wonder of man's majesty' after a loved but barren woman's majesty: 'Our globe is drawn in a right line again/And now appear new faces and new men.'

Yet, the presence of Envy and her sisters showed that the Stuarts had enemies. They had inherited Elizabeth's wars, religious divisions and potential assassins, along with her thrones. The previous year, while the Stuarts rode from here to there, outrunning the plague, two Catholic conspiracies – the Main and Bye plots – had been unearthed, resulting in the first religiously and dynastically motivated executions and imprisonments of the new era. Sir Walter Ralegh had become

entangled in one. He was sentenced to death, but sent to the Tower until James made up his mind whether to kill or free him.

In a private letter, Father Tesimond, a disenchanted Catholic priest, gloomily concluded it was Prince Henry, Princess Elizabeth and Prince Charles, the king's 'numerous progeny', that really guaranteed this Protestant succession. Tesimond's colleague, Father Garnet, a prominent English Jesuit, concurred. The king secured the present, 'but the son that follows him' was more important in the long run. Over the hill at thirty-eight – an average male life expectancy in 1600 – James might die any moment. However, James's heir was in place and being educated for the job. The peaceful transition to the new dynasty made clear to the discontented: the cause of other claimants was a dead issue.

The final arch at Temple Bar marked the meeting point of the City and Westminster. Here the City of London handed the royals over to the court and politicians. Beneath the arch the god 'Janus' hung the arms of the new kingdom: a life-sized lion and unicorn rampant, made of brass, gold and silver gilding.* The dedication read: to '*Janus Quadrifrons*', word-play perhaps for James needing four faces (and eight eyes), each one to watch over one of the countries he ruled. This extraordinary union had come about peacefully, after centuries of conflict between the English and Scots. At Whitehall, James's government had started to work on ending the war with Ireland, and the king and Cecil were negotiating to bring the Armada war to a close.

Towards the end of the day, the court retired to Whitehall to feast and celebrate the new British monarchy. Up the road in the City, the people fell to looting the allegorical world. They hauled down the arches as if it were a revolution, and carried off the chipped, gaudy paintwork, to raise fires and mend houses.

The Stuarts had at last taken possession of Elizabeth's palaces and hunting lodges, furniture, books, gems, tapestries and jewels. James also inherited her policies and her factions in court, church and state – all competing for power and favour. He reappointed many of

* The arms hang today in the Guildhall.

Elizabeth's ministers and lower-ranking officers. He inherited expectations as well as wealth and status. But Henry was new. He had to be settled in a manner suitable for a role hardly anyone remembered – that of crown prince. The last had been Edward VI, born in 1537.* Cecil now set to work, consulting old household books from Henry VIII's time, to find the protocols for creating the crown prince's household.

* Nottingham was born in 1536, his cousin Northampton in 1540; Edward VI inherited in 1547, so even men like these remembered nothing useful of Edward's time as Prince of Wales.

Henry's Anglo-Scottish Family

NONSUCH

James set up his son's first permanent English home at Nonsuch Palace in Surrey. Built by Henry VIII for his son, the future Edward VI, Henry VIII demanded it rival the greatest French Renaissance palaces: there would be *none such* anywhere in the world. Six hundred and ninety-five carved stucco-duro panels decorated the facades and inner court of the palace. They extended over 850 feet long, rising from sixteen to nearly sixty feet high in places. Gods and goddesses lolled and chased each other across the walls. Soldiers in classical uniforms battled for their lives, frozen for ever in their moment of triumph or death.

The panels overlooking the gardens featured depictions from Ovid's *Metamorphoses*. Stucco-duro polished easily to a high marble-like sheen: Nonsuch dazzled in sunlight. Other scenes illustrated to the heir the duties of a Christian prince. One panel showed Henry VIII and Edward seated among gods and mythical heroes. Divinities watched over them, blessing the Tudor dynasty. All in all, it was the 'single greatest work of artistic propaganda ever created in England'. James instinctively knew it was the right setting in which to nurture the first ever Prince of Wales of the united kingdoms. The king had given Nonsuch to the queen, as one of her royal palaces.

Topping the massed bulk of the octagonal towers at each corner of the southern facade, enormous white stone lions bore Prince

Henry's standard in their paws. Mouths frozen in a snarl, their fierce eyes followed Henry and his friends as they hunted, practised feats of arms on foot and horseback, readying themselves to defend, attack, defeat, rule. The boys chased each other through gardens laid out by the keeper of Nonsuch, Lord Lumley, around fountains where water squirted out of the goddess Diana's nipples, and past tall marble obelisks with black onyx falcons perched on top. Amongst all the treasures, Lumley's most prized possessions were his books. He had built up the greatest private library in England and now offered an unparalleled collection of teaching materials to Henry's circle.

The king confirmed Adam Newton in his post as Henry's principal tutor, and Walter Quin to assist. Newton prevailed on the prince to ask the king to give the vacant, lucrative post of the deanery of Durham to him. (Newton was establishing himself at court by marrying into the Puckerings, an important Elizabethan political family.) Henry did so, writing to his father, the prince said, not because I think 'your Majesty is unmindful of the promise he made at Hampton Court' that the Dean's position would go to Newton in due time, but because I want to 'show the desire I have to do good to my master'. Henry's bookish father wanted his son to esteem his tutor. Henry's letter jogged his father's memory. Newton got the post of Dean of Durham.

In his domestic sphere, David Foulis retained his place as cofferer in charge of Henry's wardrobe. David Murray became the prince's Gentleman of the Purse, and remained in the bedchamber as Groom of the Stool. The affectionate, constant presence of men such as Newton, Foulis and Murray helped give Henry's new life in England stability. His parents came and went, but these men abided continuously, and seemed to love and honour each other.

They bickered like a family too. Newton and Murray 'did give [the prince] liberty of jesting pleasantly with' them, initiating banter. Playing shuffleboard, Newton saw Henry swapping his coins to see if a different one gave him an edge. He told Henry he 'did ill to change them so oft'. Taking a coin in hand, he told Henry to watch. Newton

would 'play well enough without changing'. He shoved his penny – and lost.

'Well thrown master,' Henry crowed.

Newton pushed himself back from the table. He 'would not strive with a Prince at shuffleboard', he said.

'You Gown men,' Henry countered, 'should be best at such exercises, being not meet for those that are more stirring' – such as archery, or artillery practice, or preparing to lead men into war.

'Yes,' Newton said, 'I am. Fit for whipping of boys.'

'You need not vaunt of that which a ploughman ... can do better than you,' Henry laughed.

'Yet can I do more,' Newton eyed him. 'I can govern foolish children.'

Henry looked up 'smiling', and acknowledged that a man 'had need be a wise man that would do that'.

The king and Privy Council extended Henry's 'Scottish family' to reflect the prince's enlarged British identity. James appointed an Englishman, Sir Thomas Chaloner, to replace the Earl of Mar and run Henry's household. Determined to maintain her connection with Henry, the queen gave Nonsuch and all her private estates over to Chaloner's management. As governor, after the king and council, Chaloner had the last word on who came and went and lived at Nonsuch. Before 1603, Cecil had trusted him to carry Elizabeth's pension to James in Scotland, and Cecil's own secret correspondence about the succession. Awarding Chaloner this high office, the king expressed his confidence in him, rewarding Sir Thomas for those long, perilous journeys.

Chaloner had grown up with Cecil at the intellectual, godly college set up by Cecil's father, the great statesman Lord Burghley. Cecil knew what a great house should look like, and how it should run. Chaloner shared the contemporary obsession with alchemy and chemistry; he maintained a good friendship with the magus John Dee, and corresponded with the Dutch inventor, Cornelius Drebbel, encouraging him to come to England and have Henry patronise him. Chaloner's scientific endeavours would lead to the discovery of alum on his estate

in Yorkshire. He obtained a licence to exploit the mineral, which was widely used in shaving, to treat sores and halitosis, to make glues, and in the purification of water.

Chaloner married Elizabeth, daughter of the late William Fleetwood, Queen Elizabeth's Recorder of London. Chaloner's father-in-law had been a Puritan-inclined MP. A committed royalist, Fleetwood nevertheless upheld the place of Parliament against Crown encroachments on its powers, citing Magna Carta to prove his case. Like his Fleetwood in-laws, Chaloner inclined to a more godly Protestantism than James would have liked. He understood the chance fortune had just handed the Chaloners, to build up a base among those jockeying for a place around the heir. He persuaded the king and Cecil to appoint his brother-in-law, Thomas Fleetwood, into Henry's service as the prince's solicitor. He encouraged Henry's cofferer, David Foulis to marry Cordelia, another Fleetwood daughter.

Before he entered royal service, Chaloner had fought in France under Leicester, the 'Captain-General of the Puritans'. He had tutored Leicester's illegitimate son, Robert Dudley, and worked as an agent in France and Italy for the 2nd Earl of Essex. Chaloner brought all this experience to his new job.

Something about the prince's first British entourage recalled the heyday of Elizabethan Protestant internationalism in the 1580s and '90s, under Leicester, Sidney and Essex, with the group's 'militarised ideal of active citizenship ... which emphasised the rewards of honour through virtuous service' to the monarch and commonwealth. It seemed that Henry would soon be drinking in the heady brew of an honour cult of old blood, ceremony and magnificence, blended with humanism, Puritan-leaning religious and political values, and a pronounced martial bent. This was always likely given the character of Henry's Scottish household, and the Scots who had accompanied him to England.

Time would tell. In the first instance though, Nonsuch was a boys' home. The prince needed a clutch of new friends to grow up with, the best advancing him to help him rule in God's good time. On his way

south from Scotland, James had embraced Robert Devereux, son of the executed Essex, greeting him as 'the eternal companion of our son', and restoring the Essex title to him. The young earl had carried James's sword during the official entry to London and was now sent to live with Henry. The king confirmed Cecil's son, William Cecil's, place here. Newton's new young brother-in-law, Thomas Puckering, also gained admission.

Two of Chaloner's five boys, William and Edward, stayed. Two other Chaloners, Thomas and James, came and went continually, joining in the hunts, martial exercises, the equestrian training and dancing. Lord Treasurer Dorset's grandson, Thomas Glenham, came with Dorset's nephew, Edward Sackville, arriving shortly after. Thomas Wenman appeared with his luggage trunks and tutor (Wenman's uncle, Sir George Fermor, a veteran of Cádiz 1596, had hosted the king a few months earlier at Easton Neston). The aristocratic and the more favoured boys were educated with Henry. Others became retainers, halfway between servant and friend.

Queen Anne managed to insert into the prince's household the relatives of her favourite ladies-in-waiting, Lucy Bedford and Penelope Rich. Lady Rich was the 3rd Earl of Essex's aunt. Lucy Bedford's brother, John Harington, son of Princess Elizabeth's guardians, was sent to Henry. Against the king's wishes, the queen appointed the nephew and heir of the late Earl of Leicester, Sir Robert Sidney, to be her Lord High Chamberlain and Surveyor General. Robert Sidney's late brother was the poet and Puritan soldier, Sir Philip Sidney. Robert Sidney's son came to live with Henry. Sidney and young Essex were cousins by marriage. (The 2nd Earl of Essex had married Philip Sidney's widow.) Though Henry's new family contained many different surnames, a dense mesh of blood, religion, and politics connected them beneath the skin.

Through these boys, Anne acquired a constant stream of news and contact with her son when she desired it. Since Henry's household communicated continually with the king, Anne could also tap into the real heart of power: her husband's court at Whitehall. Henry went 'often to visit' his mother, to 'show his humble and loving duty towards

Her Majesty'. Sometimes the queen might be busy and not admit him: he would wait 'a long time, in vain', before returning disappointed to his palace.

At other times, mother and son spent weeks at a time in each other's company. In the summer of 1605, Anne and Henry stopped at Oxford on a summer progress in order to meet with the king and enrol Henry at Magdalen College. Anne and Henry watched plays and listened to music together. At the university Henry attended debates on a bewildering range of subjects, including: 'Whether saints and angels know the thoughts of the heart'; and the political problem of 'Whether a stranger and enemy, being detained in a hostile port by adverse winds, contrary to what had been before stipulated in a truce, may be justly killed by the inhabitants of that place'. Students and academics debated 'Whether gold can be made by art?' – touching on the alchemical question. Another day, the psychologically curious issue of 'whether the imagination can produce real effects' was discussed in its relationship to mind over matter, fantasies, and questions about the real power of magic, charms, spells, and dreams.

In the early days of Henry's new life in England, a painting appeared that captured its general ambience. It is a hunting picture. Henry stands centre canvas, a friend kneels by him, with the prince caught in the act of drawing his sword from his scabbard. A stag lies by Henry's feet, neck exposed for the crisis of the kill. The artist, Robert Peake, made two versions. It was the first ever painting to give a glimpse of a royal in action. In one version, John Harington looks up at Henry. In the other, it is young Essex. The king was devoted to the hunt, so he would have liked the ostensible subject. Yet, the boys' clothes are the green-and-white livery colours of the Tudors, not the red-and-white of the Stuarts. In the centre of the painting, Henry's St George Garter badge dangles at his chest, capturing the prince as a Protestant knight, prepared to kill for his cause. By contrast, his father's portraits showed a regal, peaceful sovereign. James never liked to be immortalised in arms.

Many of Henry's new friends arrived with their own private tutors. Dr Gurrey accompanied Essex; James Cleland, Scotsman and friend

of Adam Newton, taught John Harington; Mr Bird tutored young Sidney, until Sidney stabbed his tutor, and both had to leave – the boy's father apologising profusely to the king and queen. Thomas Wenman's tutor was the poet William Basse. Huguenot immigrant, friend of Ben Jonson and Francis Beaumont, Basse collaborated with Shakespeare. They came across each other during their attendance on prince and king, as well as in the greater world outside palace walls.

In the schoolroom, Chaloner employed Peter Bales to give Henry a neat hand. Bales taught Henry for nearly two years before he dared petition Cecil for remuneration. A former Essexian, his unpaid service worked his passage back into favour. The Earl of Rutland introduced Robert Dallington as another unpaid tutor, who might be given a wage if he made himself useful for long enough. A brilliant scholar, Dallington had been imprisoned by Elizabeth I, along with Rutland and Bales, in 1601 when they rose with Essex. These floating tutors, along with various senior aristocrats, would be able to educate Henry's whole person about his role and his history.

From the other side of the religious divide, the crypto-Catholic Howards, led by the earls of Suffolk and Northampton, generated a connection to Nonsuch through boys like Rowland Cotton, now admitted to serve Henry. Rowland's father, Sir Robert Cotton, MP and the most eminent antiquary in England, was Northampton's friend and client.

The other high-placed Howard, Lord High Admiral Nottingham, had no children to place around Henry. Instead he commissioned a model ship, twenty-five feet long, as a gift. He told shipwright Phineas Pett to sail it up to Limehouse and anchor it 'right against the King's lodgings'. After lunch on Thursday, 22 March 1604, Nottingham led Henry and his friends on board. Pett ordered the little ship to weigh anchor, 'under both topsails and foresail', and they sailed downriver as far as St Paul's Wharf.

It was love at first sight. The speed and power of a ship moving under him, and the freedom out on the water, thrilled Henry. He took a great silver bowl of wine in his hands, named his first ship the *Disdain* (how fighting men and ships reacted to danger) and drank to

her. All his young friends drank after him. Then Henry walked over to the side of the vessel, leaned out and poured the rest of the wine into the Thames as a libation, tossing the bowl in after it.

Northampton lavished flattery on Henry, as he did the king. The prince was a Renaissance prodigy, he said, matching 'Mercury with Diana ... study with exercise'.

TEN

Henry's Day

'THE EDUCATION OF A CHRISTIAN PRINCE'

At Nonsuch, Adam Newton and his team of tutors continued the curriculum begun at Stirling, scholars and schoolboys sitting below Holbein's portrait of *Erasmus Writing*. Henry's Latin grammar book contained the Creed, the Ten Commandments, the Lord's Prayer, and Erasmus's *Christiani hominis institutum* ('A Christian man's practice'). Anthologies of the masters of grammar and rhetoric included Plautus, Cicero, Sallust, Horace, Demosthenes, Seneca, Virgil, and Tacitus. By the age of ten, Henry could tell his father he had been reading 'Terence's *Hecyra*, the third book of Phaedrus' *Fables* and two books of the selected Epistles of Cicero'. Unlike James, Henry did not seem to have read Greek texts in the original, but in Latin translations. Since every royal male had to be articulate and literate in Latin, it was an easier way to tackle Greek writers.

Henry thanked his mother in French for a copy of Guy de Faur's *Quatrains*, poems on how to wield power and do so morally. Based on a Latin original, Henry's poet, Sylvester, translated them from French into English. Henry translated them back into Latin, saying they 'deserved to be imprinted in the minds of men'. Perfectly pitched for the black-and-white morality of a ten-year-old mind, the poems clearly impressed him. A 'good part' of them, he told the king, was 'most powerfully written for the education of princes'. Maybe no scholar, he was no dunce.

Henry, however, never showed his father's great and deep love of learning. One of James's tutors, Peter Young, said James at about this age cleansed his thoughts first thing in the morning, by asking God's blessing on his studies. Then, before anything to eat and drink, he read the Bible in Greek, or Isocrates, and learned Greek grammar. After breakfast he turned to Latin: Livy, Justin, Cicero, or Scottish histories. After dinner, he practised compositions. The remainder of the afternoon he gave over to arithmetic, cosmography (which included geography and astronomy), dialectics and rhetoric. In adolescence, the king knew by heart much of the Bible and reams of classical verse. As James I he was one of the few contemporary writers of European renown, thanks to books such as *Basilikon Doron*, recognised as a major contribution to the hot European debate over the nature and root of sovereignty.

At Nonsuch, after morning prayers, Henry studied for only about two hours at his desk, before leading his friends outdoors. He passed as much of the day as he could 'hawking, hunting, running at the ring, leaping, riding of great horses, dancing, fencing, tossing of the pike, etc. In all which he did so far excel as was fitting for so great a Prince … he would many times tire all his followers before he himself would be weary'. The Venetian ambassador thought the prince attended to his books 'chiefly under his father's spur, not of his own desire'. One day, Henry and his friends used up so many cannon balls and gunpowder they were told to stop. That practical part of his education the prince would have worked at ceaselessly, but the household could not afford it.

If Henry and his father did not share academic interests, outside the schoolroom they attended sermons, discussing them afterwards, shared official duties and hunted together. 'Since he was but two years old,' the prince 'knew and respected the King his father above all others … Yea, his affection to his Majesty did grow with his age,' wrote one of the king's court. When James fell from his horse, Henry was said to have thrown himself off his pony and rushed to him in distress.

Visiting Henry in Lumley's fabulous library, James asked his son what was his favourite verse, from any book he was studying?

Unhesitating, Henry took the *Aeneid*, found his page, read the Latin, and then translated: 'We had a king, Aeneas called, a juster was there none/In virtue, or in feats of war, or arms, could match him one.' Aeneas was one of the legendary founders of Rome. Had James come to found a new Rome in London? Henry complimented his father with qualities the boy deemed attractive – piety, justice, martial excellence, civic responsibility and valour in arms to build the new Rome.

Adam Newton, curious to know how Henry felt and saw the world, asked him to choose a sentence he really liked out of the hundreds the tutor gathered as teaching materials. Henry flipped through until he found Silius Italicus: 'Renown is a furtherer of an honest mind'. Elsewhere translated as 'Glory is the torch of the upright mind', Henry adopted it as one of his mottoes. It could not be more different from the king's: 'Blessed are the peacemakers'.

'Thou doest thy father's forces lead,/and art the hand, while he is the head,' David Murray's poet friend, Sir William Alexander, concluded after seeing Henry. You shall 'shine in valour as the morning star'. It filled old soldiers like Alexander with joy 'to see thee young, yet manage so thine arms'. Whatever Northampton might have claimed about the prince matching 'study with exercise', others saw that Henry acted as if he honed his virtue more by feats of arms than philosophy.

Although he did 'have Minerva's mind' as well as 'Bellona's hands', Henry more often honoured the goddess of war than intellect.

Henry's expanded role in public life required his household to remove to London every so often, leading James to give over St James's Palace to his son. The king ordered new stables and barns to be built for Henry's official Westminster residence. No official residence was available for Prince Charles when he arrived in the summer of 1604, and Henry gave up his lodgings at Whitehall for his delicate young brother, though Charles often came to stay with Henry for long periods. The king did his best to give his children what he had missed: a secure family life.

'Sweet, sweet brother, I thank you for your letter ... I will send my pistols by Mr Newton,' Charles told Henry when they were apart. 'I

will give anything that I have to you: both my horse, and my books, and my pieces, and my cross bows, or anything that you would have. Good brother, love me, and I shall ever love and serve you, Your loving brother to be commanded, York.' He seemed to adore his brother. Their tone swung from formality – when Charles was 'York' – to the emotional declaration: 'I will give anything I have to you', only, 'Good brother, love me'. Henry must have loved both his siblings to elicit this kind of response.

The king encouraged his sons to practise dancing, 'though they whistle and sing to each other for music' when they could not get hold of a musician. The children sometimes fooled around. Their dancing master, frustrated by the failure of some of Henry's friends to keep time as he taught them, said 'they would not prove good soldiers, unless they kept always true order and measure'. Dancing connected Henry to the martial arts.

'What then must they do,' asked Henry, 'when they pass through a swift-running water?' and then have to find their own feet, and keep their own 'measure', not merely march in time.

Still, the old man kept telling them off for carelessness.

'Remember, I pray you,' Henry appealed to him, 'that your self was once a boy.'

The prince's preference for a life of action over learning and contemplation irritated James. On occasions, the king 'admonished and set down' Henry for his lacklustre academic performance and resorted to 'other demonstrations of fatherly severity' as well. Maybe he smacked him. James threatened that if Henry did not do better, as a Christian prince must, he would leave the throne to Charles, 'who was far quicker at learning and studied more earnestly'. When Newton berated his precious charge, Henry responded that he had had enough improving for one day. '*I* know what becomes a Prince!' he said. 'It is not necessary for me to be a Professor,' like you, 'but a soldier and a man of the world. If my brother is as learned as they say, then we'll make him Archbishop of Canterbury.'

Sibling rivalry never seemed to enter his relationship with Elizabeth. When she stayed nearby, they rode together for hours every

other day. After they parted again, she could not resist trying to maintain the intimacy. 'My letters follow you everywhere. I hope you find them as agreeable as they are frequent,' she sighed wryly. 'I know they don't contain any important subject matter that could make them recommended.' Henry reassured his sister: 'Your kind love and earnest desire that we may be together. I ... assure you that, as my affection is most tender unto you, so there is nothing I wish more than that we may be in one company ... But I fear there be other considerations which make the King's majesty to think otherwise, to whose well seeming we must submit ourselves.' Security, duty and ritual placed strict constraints on his freedom.

If the scope and intensity of his academic education fell short of his father's expectations and an illustrious Tudor past, Henry's piety seemed of a piece with some of his forebears. His household listened to sermons several times a week. All members of the royal family attended sermons, arguing afterwards about how it lighted them on the road to salvation, the meaning of life. But the prince was thought to need his own chaplains, to encourage him to work for the salvation of his soul.

The king asked James Montagu, dean of the chapel royal, for the names of men who might be suitable to serve Henry. An active, evangelical Calvinist, Montagu was first cousin to John Harington and Lucy Bedford and former first master of the Puritan seminary at Sidney Sussex College, Cambridge. Montagu's personal beliefs and family connections made the godly hope he would place more 'evangelical' than moderate 'preachers around Prince Henry' at St James's.

Cambridge-educated Puritan, Henry Burton, petitioned to serve the prince and was given a position of the highest importance, as Clerk of the Closet, the prince's principal chaplain and keeper of his conscience. Burton sought royal service in the belief that God had chosen the Stuarts to continue the great work of perfecting the true Calvinist faith on earth in England. He wrote a tract for Henry on the Antichrist, naturally identifying it as the pope. Henry kept the work on his shelf. Essex's tutor, Dr Gurrey, persuaded Joseph Hall, a

renowned Puritan 'neo-Stoic' – a philosophy which attempted to combine Christianity and Stoicism – to preach to Henry's circle. Henry liked him and asked him to preach again.

Hugh Broughton joined the household as tutor to young Rowland Cotton. Renowned for his immense Hebrew scholarship, Broughton devoted three works of divinity to Henry. Yet, in spite of his scholarly brilliance, James had not invited him to help create the new version of the Bible the king had commissioned, since Broughton was known to be a cleric of pronounced Puritan sympathies. Broughton preached an exposition of the Lord's Prayer before Henry. It earned him a place as another of his preachers.

As at Stirling, Henry's Calvinist clergy encouraged him to review his conscience daily in private acts of self-examination, comparing how his thoughts and actions lived up to the model of simplicity, plainness and purity Christ offered in the Bible. Not easy for a royal Stuart, it was the kind of intense self-examination Shakespeare had put Hamlet through.

The moderate clergy of the Church of England also recommended the private measuring up of one's behaviour against Christ's teaching; but they advocated a ceremony- and ritual-based religious practice as well. Bishops in ornate vestments presided over the regular ritual consumption of the body and blood of Christ in host and wine. Sublime religious music accompanied the great mythic drama of this holy communion. The whole royal family joined with the established church to celebrate feast days such as the Accession Day of the monarch, Armada Day, the Epiphany, Christmas and Easter. Nothing galled the Puritans more than the official church's contented drift towards replacing the veneration of Catholic symbols with royalist and nationalist ones.

A jingle began to circulate. If:

Henry the 8 pulled down abbeys and cells,
Henry the 9 will pull down Bishops and bells.

Treasonous in its inference of the death of King James, this piece of Puritan doggerel anticipated the rule of Henry IX to be very different to that envisioned by his parents – closer perhaps to the brutal icon- oclast phase of Henry VIII's reign. How far this reflected who Henry really was, was impossible to see at his young age. He absorbed input from all sides.

For now, the daily life of Henry's household established it as an extension of the king's court, illustrating its policies, exploring its possibilities. But beyond that, Nonsuch already contained the poten- tial to be what a Prince of Wales's household so often is – an alterna- tive source of power.

To give Henry some experience in the business of war and foreign affairs – and after his small ship proved such a hit – James assigned apartments at Nonsuch to the Earl of Nottingham. Lord High Admiral from 1585 to 1619, including the whole period of the Spanish Armada war, Nottingham possessed a breadth of court, government and mili- tary experience few others could boast. In 1604 he had just returned from leading a huge delegation to Madrid to negotiate a peace treaty to end the war. Nottingham was available to mentor Henry, infor- mally, about diplomacy, his future navy, or anything else that came up touching on the business of being a king.

The navy was a private fleet, maintained by the monarch out of his own income. After taking ownership of the *Disdain*, Henry ques- tioned Nottingham exhaustively on the building and equipping of ships; the comparison of the royal navy with the great fleets of the privateers; how he would fight and win sea battles like the Cádiz raid and the Armada; how he would avoid defeat; how the navy could be used to defend merchant shipping against attack; how he might mount expeditions to discover new lands and claim them for England and himself, and enrich his people.

Nottingham wrote that the prince and his friends went 'a fishing at my house in Carshalton', near Nonsuch, and also 'hunted afterwards in Beddington Park'. But the Lord High Admiral soon begged for release from his service, 'weary with waiting on the Prince'.

He had run his long race at court, and perhaps wanted to step back a bit.

Henry soon wanted his own shipwright, and swore Phineas Pett, builder of the *Disdain*, into his service. Corrupt in his handling of naval supplies, like so many royal naval personnel, few thought that Pett would stop his extensive appropriation of building materials for his private use now he entered royal service, especially now he had far greater scope to abuse his privileges.

In the summer of 1604, Henry sailed downriver from Nonsuch for the most important European event of the year: the signing of the Treaty of London. On 28 August, England and Spain finally agreed peace terms after nearly two decades of warfare. The Spanish had tried to make it a condition of the peace that James withdrew his support from the rebel Dutch. James refused. England still saw itself as a mainstay in European Protestantism.

The Spanish delegation and the royal family attended a special service in the royal chapel at Whitehall. 'The altar was covered in silver gilt and on it stood the Gospels in English' – not Latin, the vernacular Bible being the bedrock of Protestantism. 'After some hymns in praise of peace had been chanted' – again in English – 'Secretary Cecil handed a copy of the treaty to the Constable and read aloud the oath by which both the King and Prince bound themselves to the observation of the terms … the King and Prince meanwhile laying their hands on the Gospels.'

Death so often mocked the best intentions in a second of haemorrhage, clot, or bacterial invasion. Spain needed to look beyond James and know the future Henry IX bound himself to honour this peace. The Constable of Castile, chief Spanish negotiator, asked for an audience with the prince. Henry consented.

First the prince danced for him, then he took the constable down into the gardens of St James's Palace. There he practised at push of pike and rode for him, giving the constable a first feel for what problems or possibilities England might breed up in the years to come. Henry was precociously poised, 'with a most gracious smile' but 'a

terrible frown'. His staff thought their prince never 'tossed his pike better than in presence of his Majesty and great Ambassadors'. The constable gave Henry a beautifully caparisoned pony, and advised Madrid to keep open nascent negotiations for a marriage contract between Prince Henry and the Spanish infanta. If nothing else, it would make Anglo-French and Anglo-Dutch relations less cordial. Both of those countries were already irritated by the peace agreement.

At the feast to celebrate the treaty, Spain and England proposed toasts and exchanged gifts so excessive the Venetian ambassador felt ill at the scale of it all. 'Taxis [a Spanish minister] is making presents every day and one hears of nothing else just now,' Niccolo Molino complained. 'It is said that he has spent upwards of two hundred thousand crowns in jewels, and that money has been given as well. The Spaniards are lauded to the skies; for in fact this is a country where only those that are lavish are held in account,' he said. 'Since my arrival in this court ten months ago, I have heard of nothing so often as presents.' The bribe and bonus culture thrived in a glut of sweeteners. 'Great nobles and members of the Privy Council make [no] ... scruple about accepting them, and scoff at those who hold a different view.' Only fools entered politics without believing it would make their fortune. Public service and self-service walked hand in hand. James returned the extravagant gift-giving. Power had to be seen to be power.

Union and Disunion

'BLOW YOU SCOTCH BEGGARS BACK TO YOUR NATIVE MOUNTAINS'

By the beginning of November 1605, the whole royal family, bar Elizabeth, came together in London for the state opening of the next session of Parliament. Taken as a family the Stuarts had proved to be an act more than able to step into Elizabeth I's shoes – which partly accounted for Catesby, Throckmorton, Fawkes and their discontented Catholic friends' decision to kill them all, except the girl. The rest dead, they could forcibly convert Princess Elizabeth to Catholicism, set her up as a puppet, and offer her to a Catholic prince. With most MPs and Lords also dead, they could establish a Catholic-dominated Parliament.

The opening of Parliament was scheduled for 6 November 1605. The day before, acting on a tip-off, a search party revealed Guy Fawkes in a cellar under the great hall at Westminster nursing thirty-six barrels of gunpowder.

Prince Henry and his parents were 'a dangerous disease', Fawkes said. It required 'a desperate remedy' to 'blow you Scotch beggars back to your native mountains'. King James had betrayed them. In Scotland he let them believe he would ease the penal laws against Catholicism when he succeeded to the throne of England. He had not done it. Racist anti-Unionism overlapped with religious loathing.

The scale of this terror plot was unprecedented. It aimed to destroy the whole political nation. Henri IV of France congratulated James

and Henry on their escape. 'No Prince is safe against traitors,' he said. The French king was well placed to comment, having suffered over twenty attempts to assassinate him so far.

Shaken, Henry and his father rode to Parliament four days later. How nerve-racking for the boy. Who, behind the smiling faces and sugary words, hated him enough to want to kill him?

The discovery on 5 November showed Henry a darker portrait of his family, their subjects and the countries he was being trained up to rule. Yet, the sense of fellowship, loyalty, and relief among all of them on the 9th, when Parliament eventually opened, was palpable. It was one of those rare occasions when everyone knew they were all in it together. James and Henry, showing courage by coming, calmed the agitated spirits. The king insisted the plot was the work of a fanatic minority. Most Catholics were loyal to the established state religion. They all praised God for protecting them, to do His work.

'I don't doubt that you have given thanks to the good Lord, for the deliverance he gave us, as I have also done,' Princess Elizabeth wrote to Henry; 'But I want to join my wishes with yours and say with you: if God is for us, who will be against us; under His guard I fear nothing man can do.'

Fighting talk, but her guardian, Lord Harington, reported how disturbed the girl was. Her imagination worked round and round the thing. What sort of queen should I have been, she asked, dragged up to greatness over the bodies of all those she loved?

James ordered a nationwide service of thanksgiving to God for their escape. In November 1606, on the first anniversary of the plot, the royal family gathered to hear a sermon by Bishop Lancelot Andrewes praising their deliverance as 'our Passover'. Andrewes recalled the Jews, the chosen race, were also saved by God's intervention, parting the Red Sea to let them pass into safety. The Stuarts owed God a 'yearly acknowledgment to be made of it through all generations': 5 November became another holy day of observation in the church calendar. For the rest of his life, Henry 'would never after suffer himself to be prevented by any business from being present at the sermon appointed to be preached every Tuesday, that day of the

week, on which the plot was intended to have been executed' – except for one equally black day to come.

Henry had seen the shadow his world threw. It was a dark old age of suspicion, plots and revenge. So many plays and pamphlets and sermons spoke of conspiracies and dangers. Everyone – Protestants, Catholics, the contract monarchy men and the absolutists – suspected each other of wishing to bring down the state. Many held up Henry, the attractive male heir, as the image of the new age of light, order, civility. It gave his people pleasure to repeat to him and to themselves, how young, fresh, bright, and 'hopeful' he was – and they were. Yet, the Main and Bye plots of 1603 and the Powder Treason of 1605 showed Henry how fast disappointed men turned to violence to compensate their thwarted dreams.

Dr Lionel Sharpe, Puritan chaplain to the late Earl of Essex, wrote to alert Henry to the dangers of popery – in case it did not occur to the prince that thirty-six barrels of gunpowder illustrated that not everyone loved him. 'Beware of the Vipers, or, to speak freely, of the Jesuits,' Sharpe said. There could be no negotiating with these fanatics – it must be victory, or death. Henry 'attended himself prayers and sermons at set times', daily, which 'tied his servants thereunto'. He also despatched a message to Sharpe offering him a place in his household as a chaplain.

To help prepare Henry for his role as defender of the faith, Robert Cecil sent his nephew, Sir Edward Cecil, to attend the prince. A soldier, Cecil was currently serving with Maurice of Nassau. Sir Edward began to stay with Henry's household during the winter months, when poor weather forced a cessation of hostilities, and added his experience of fighting for international Calvinism against the forces of popery to Henry's military education.

After the Powder Plot, letters poured in to Henry from Protestant princes and sympathisers across the Continent, expressing their horror and offering support. Young Frederick, heir to the Elector Palatine – the senior Protestant elector of the Holy Roman Emperor – congratulated Henry on 'the miraculous delivery God sent from Heaven, at the same time that hell and its instruments were plotting

your ruin'. Two years Henry's junior, Frederick assured Henry of his service, when 'you are called, if it please God, to defend the Truth against these assaults of the father of lies'. Perhaps we should be grateful, Frederick said: this 'has made us' boys 'recognise early the spirit that possesses them, and the falsehood they wish to establish, in the end to hate and detest all our lives that which we have known from our infancy'.

Henry's maternal uncles and cousins – Christian IV of Denmark, the Landgrave of Hesse, the dukes of Holstein and of Brunswick – sent letters. This vast extended family of European cousins wrote to each other continually. Attacks on one, attacked them all.

The impact of the Powder Plot could be seen in the tone of Henry's written school work. Newton asked Henry to analyse an account by the Latin historian, Justin, of young Cyrus the Great of Persia's rise to power. Henry summarised each section, and attempted a translation. He was full of praise for the war-like Semiramis, legendary Queen of Babylon: you would have thought she was a man, she so 'feigned her sex by great deeds', Henry wrote. But he criticised Semiramis's pacific son, who 'grew old in the company of women', degraded by his corrupt counsellor, Sardanapalus, and lost his country. This counsellor had shamed his own manhood, he wrote, by becoming 'another example of a womanly soul in a man'. Rising twelve when he made this analysis, the son of the self-proclaimed *Rex Pacificus* concluded that 'often one may see women take upon themselves manly spirits, while womanly men bear effeminate souls'.

By effeminacy, Henry and his circle meant weakness in general. Perhaps Henry had the martial virtue and 'manly spirits' of the legendary defender of Protestant Europe, the late Queen Elizabeth, in mind. Perhaps he had picked up court gossip about 'effeminacy' among the king's coterie and then connected it with his father's pacifism. Effeminate counsellors weakened the prince's 'virtue'. Virtue – the Renaissance quality Henry would strive to cultivate in every aspect of his life – conferred vigour and power to act with force and effectiveness, and even some cunning. Virtue gave you a critical,

enquiring spirit, and led to developing a passion for scientific enquiry and accuracy. Virtue could also lead you to acts of glory, honour, fortitude, and good fortune. Effeminate weakness was, to most Jacobeans, including Prince Henry and his circle, a form of tyranny and misgovernment.

In his studies, Henry said he saw how his own role was 'born by another person' from the past: Cyrus the Great. He concluded God rescued the infant Cyrus from the threat of death as 'our sign and example, of how wonderful the power of the fates is, and how great the goodness of God, in preserving those he has destined for greatness in public affairs'. Cyrus rose to unite Persia and Media.

Henry knew of Cyrus from the Old Testament as well. Isaiah prophesied Cyrus was the child born to rebuild the New Jerusalem and free the Chosen People from captivity. This was the Puritan image of England and the English under a godly king. They could build the New Jerusalem here, and complete the renewal of the faith that had been held captive by a partial reformation. Henry sensed Providence at work, hovering over his life. It gave meaning to the trauma of 5 November 1605.

As Christmas 1606 approached, nerves jangled beneath the jollity. Whitehall teemed with over a thousand souls, eyes shifting to see whose hand in his doublet fingered an assassin's blade, and who visited the court Catholics. 'Every day something new about the plot comes to light and produces great wrath and suspicion,' said the Venetian ambassador, Molino. 'Both Court and City are more than ever in a bubbub, nor can they quiet down, and everyone is armed and ready for any event.'

The authorities claimed to have found a paper among the imprisoned plotters' effects. Chillingly, it listed all Scots' houses in England. 'The prisoners said that it was intended, after the explosion of the mine, to massacre all the Scottish in this country.' The conspirators hated to see 'the share which their natural enemies now had in government. The publication of this news has increased the hatred between the two nations, and rendered them quite irreconcilable.'

Molino heard that 'many Scots are thinking of returning home, for they fear ... a general massacre may take place'.

The Earl of Mar, whom James had named to the English Privy Council in 1603, and who was now the only Scottish member of the seven-man commission to investigate the Powder Plot, met the king in private. All the adulation, the fairyland of magnificence and power that had dropped into their laps in 1603 contained this racial and religious hatred in its viscera. Prince Henry must be sent 'to reside in Scotland', the old friends decided; 'in this way [the king] ... hopes to secure his family. For it is clear that there are many who hate not only his person, but his whole race.'

At Stirling, the Mars prepared to revert to the original scheme. Henry would have to leave Nonsuch, his family and new friends, and live out the remainder of his minority isolated behind the fortress walls of Stirling, hundreds of miles from danger.

When in August 1606, Shakespeare staged his new play, *Macbeth*, before the court, it suggested neither Henry, nor the future of the united kingdoms, would be any more secure moved to Scotland. The play contrasted – chauvinistically – a superstitious, faction-blighted Scottish world, with peace promised to the heirs of the murdered Banquo's line *after* they left Scotland. Shakespeare was alluding to the legend of Banquo's son, Fleance, who was said to have fled to Wales in the wake of his father's assassination, and married a daughter of the Prince of Wales. Their son founded the House of Stuart. The Stuarts' mythic destiny descended from Banquo through Fleance to James and Henry, rightful kings of the empire of Britain, in London.

If James and Mar reassembled the Scottish home of Henry's early years, they would reassemble the circumstances that had let factions of discontented Catholic earls plotting to seize or murder the king, and kidnap the prince. This might threaten Henry. It could also turn the wunderkind male heir into a threat to the fragile new union.

Should the English wish to imagine how bad it could get if this spirited and stubbornly wilful boy returned to Scotland, Shakespeare

showed them that too. Towards the end of 1606 he premiered *King Lear* and sounded a warning note about divided kingdoms.

At the beginning of the play King Lear is dividing up his realm between his daughters. Lear wants to retire and spend his time hunting (as King James did, absenting himself from Whitehall for half of the year) and visiting his children, who now have to take on the authority and duties of the Crown. A brutal civil war erupts, as two of his daughters fight for domination.

The logic of the play endorsed a unified British empire under one politically attentive king. Not a Britain where, for example, an ambitious Prince of Wales in Scotland might formulate foreign and religious policies at odds with England. Henry IX, it was hoped, would lead Protestant Europe, but not if he destroyed himself or his own country in civil war first.

James's solution to this threat, presented as early as 1604, was complete union of the crowns in his person – incorporating the legislatures and churches under one settlement. With Henry at his side in Parliament, the king had outlined his vision for the complete union of legal systems, parliaments and religions. This union would create a single multi-race nation: Britons.

Henry listened as his father proposed fundamental change, clothed in the conventional metaphors of natural order. James presented his well lived-in, middle-aged body as 'the Union of two ancient and famous kingdoms': 'What God hath conjoined, let no man separate ... I am the husband and the whole isle is my lawful wife.' He had brought a new nation into being: Great Britain. Henry was the first offspring of this union after the birth of Britain. James ordered the Earl of Nottingham to design a new flag for the royal navy to reflect the new nation – a Union Jack (Jack being a diminutive of James).

Many attentive MPs heard in the king's utterances the tectonic plates of the four diverse kingdoms grind against each other. Some members' reactions told James the revolutionary scale of his proposals – if he had ears to hear it. England *was* her laws, they said. Merging

the legal systems of the multiple realms of Britain would abolish English laws, and so, in effect, abolish England. As for racial integration, if their national borders came down to permit free movement of peoples between the several nations, and if the most important immigrant family are suddenly your divinely appointed rulers, then what did it now mean to be English, or Scottish, Welsh, Irish, or British? What about the thousands of Huguenot migrants, or the Dutch refugees of religious conflict? It would not be enough to say Britain was their home. They must *be* British. By which they meant, English.

James's proposals made them fear for the public realm. What would it be and what was it that everyone would agree to defend? What were the tests of citizenship of this new realm – the Oath of Allegiance to James? Allegiance to his Church of England? Allegiance to the international Calvinist Church? What if one territory tried to overlay and dominate the other? And what economic rights did all these countries and new subjects have – the same as the English? If Henry was too young to grasp the finer nuances of his father's speech, he was already educated enough to grasp some essentials.

Henry's response to the king's plans for union came in the form of a masque, commissioned from Ben Jonson. Called *Hymenaei* – 'Marriage' – ostensibly it celebrated the marriage of Henry's good friend, Robert Devereux, the 3rd Earl of Essex, to Frances Howard, daughter of one of James's chief ministers, the Earl of Suffolk. Devereuxs and Howards viciously opposed each other during Elizabeth's reign. The union of a scion of the Puritan cause, Essex, with a scion of the crypto-Catholic faction, Frances Howard, reflected the mindset of a pacific, union king.

Jonson said the voices of his masque 'sound to present occasions', but 'their sense … does or should lay hold on more removed mysteries'. Serious messages gave substance to entertainments, without which they were just magnificent froth. Masques were performed by the court, to the court, for one night only. Good quality ones explored the bonds between the sovereign and political elites, offering the court and Crown some perspective on itself, and on contemporary politics.

Within the conceit of talking about the wedding, Jonson addressed issues dominating national debate: union, legitimacy, peace, harmony. The goddess Hymen stood. She nodded to the married children, and then dived in to laud the 'union more than ours'. Hymen hailed 'the King, and priest of peace!' and his 'empress', and the 'prosp'rous issue' of their union: Henry.

Hymen played on a startling image of James and his multiple realms:

> May all those bodies [the four countries] still remain
> Whom he [James], with so much sacred pain
> No less hath bound within his realms
> Than they are with the Ocean's streams.

The sea bound them within James's sacred body politic.

Jonson called on James's self-image as Union and elaborated on it until he conjured a vision of James's kingship as a painful reconceiving of independent subjects and separate countries within him. By a kind of alchemy, James's period of gestation transforms them, till the king gives birth to them, reborn as one people (in 1603), the outline of whose body is the coast, bound by the 'Ocean's streams'.

The masque trafficked some very ambitious images of sovereignty – where the king impregnates himself and then births his people, the people of the Union: Britons. Its logic had travelled far beyond the teenage newlyweds at the centre of it, to praise a union that some had tried to kill the king and prince in order to break.

Europe Assesses Henry

'A PRINCE WHO PROMISES VERY MUCH'

In March 1606, courtiers barged into St James's Palace. The assassins had struck again, this time killed the king as he hunted near Royston, twenty-five miles north of London. Getting a grip on 'his excessive sorrow and grief', Henry 'called for the Duke his brother in great haste, that he might once see him in safety with himself'. Typical older brother, Henry parented his younger sibling in an emergency. Guards barred the gates of St James's against a death squad. The boys waited, listening as soldiers and servants searched the palace.

'The news spread to the city and the uproar was amazing,' the Venetian ambassador said. Molino peeped from his window. 'Everyone flew to arms, the shops were shut.' Bubbling fear flipped over to anger. It must have an outlet. 'Cries began to be heard against Papists, foreigners and Spaniards.'

In a heartbeat, rage turned to triumph – the king lived! Jonson composed a poem for James's salvation. Fireworks exploded for joy over London. A tumult of bells rang out.

Yet, nothing had happened. Londoners leapt at the mere threat and the relieving of it. How tightly wound up their emotions were, keyed to catastrophe. The royal children learned to live with this tension, to show resilience in the face of the insecurity that coexisted with their ritual-bound, protected lives. It surely nuanced their interpretation of gifts and sweet compliments – maybe a good lesson for someone in

Henry's position. Flattery not only weakened a prince's virtue, it might lay him open to attack.

News from Europe confirmed the heightened anti-papist sentiment being felt in London. The Republic of Venice, one of the *stati liberi* (Catholic, but free of Spanish-dominated, papal control) was in dispute with the papacy. The Venetians had just imprisoned two Catholic clergymen for impropriety. Next, judging it was no longer in the interests of the Republic to have foreigners acquire ownership of Venetian assets, they outlawed the practice. The Vatican owned extensive property in Venice. The pope reacted by placing Venice under a papal interdict and excommunicating the whole state, damning them all to eternal hell.

The Venetians answered by expelling the Society of Jesus. The Venetian monk and brilliant theologian, Friar Paolo Sarpi, laid out the Republic's case in a series of pamphlets, among them the *Apologia, Considerazioni sulle censure* and the *Trattato dell' interdetto*. A liberal Catholic, he communicated freely with Catholic and Protestant princes throughout Christendom. Sarpi blamed current levels of unrest in Christendom on Catholic and Protestant extremists alike.

Henry's household received a copy of Sarpi's analysis. 'The State and the Church are two powers,' Sarpi said, 'one for heavenly matters, the other for earthly ones; each with its own sovereignty.' It could have been a manifesto for the Church of England. The new pope, Paul V, head of 'heavenly matters', was interfering in the 'earthly' bricks and mortar of the Venetian state. Sarpi said the acquisition of properties and worldly goods had, and still, corrupted the Mother Church. A papacy so invested in foreign assets threatened international security. It interfered in the foreign states in which it held these assets, to look after its possessions.

In Sarpi's analysis, the pope, Spain and the Jesuits were now in league to destroy the liberty of Europe. Their goal was a mighty papal-backed Spain. In exchange, Spain would support the church's reclamation of all lands across Europe lost to it since the Protestant Reformation. Logically, that must include church lands lost in Britain,

as well as Venetian property. Sarpi believed this was a serious sin and a real crisis for Christendom.

Henry's household welcomed Sarpi's report, and Adam Newton translated some of the friar's works into English. Robert Cecil (now Earl of Salisbury) and Lord Chancellor Ellesmere also praised Sarpi's analyses. The prince's circle did not see the Venetian crisis as an intra-Catholic fight. For them, it was the struggle of a free Catholic republic against international popery – by which they meant a militant Catholicism with expansionist and absolutist ambitions. Venice deserved their support as much as a Protestant state facing the same threat. Henry's Calvinist monarchical household offered its support to Catholic republican Venice against the papal–Spanish alliance threatening it. They asked themselves if the Powder Treason and the Venetian interdict were part of a wider popish plan now coming to light across Europe.

It is hard to imagine the full impact of the geopolitical nightmare that stalked the hinterland of these Protestant minds. In their worst dreams, the papacy went to war to reconquer Protestant lands and convert people back to Catholicism. The Habsburgs might then recombine the thrones of the Holy Roman Emperor and the empire of Spain under one ruler, as they had been until 1556, to create a Habsburg hard-line Catholic superstate. In 1556, Charles V of Spain had abdicated and divided his bloated legacy. Philip II inherited Spain and her South American empire, and headed the Spanish Habsburg line. Ferdinand inherited the mantle of the Holy Roman Emperor. In theory an elected title, in effect the position of emperor was now hereditary in the Austrian house of Habsburg.

The Holy Roman Empire was a vast, loose community of independent European countries and principalities (centred on modern-day Germany, Austria, and Hungary). It worked communally to address common issues, such as law and order, defence and trade. But the economies across its regions varied hugely, causing resentment between richer and poorer states when it came to issues such as defence. Moreover, the imperial territories were religiously at odds with one another. Once Roman Catholic from end to end, the

Reformation had left the empire and other European territories divided between loyal Catholic states and reforming Protestant states. In 1555, to try to end the religious wars, the empire's member states signed up to the Peace of Augsburg, which gave a measure of toleration to Protestants. The imperial governing institutions accepted Lutheran Protestantism, to a point, but refused to recognise Calvinism, despite several important imperial territories being Calvinist. Despite the treaty's limitations, five decades on the peace still held.

By 1606 the Holy Roman Emperor and most of the administrative hierarchy of his empire remained Catholic, though the Protestant states found they could work within the empire's administrative and governmental structures for their common benefit. Around the empire ranged independent nations and principalities – Spain, France, England, Scotland, Denmark, Sweden, Poland, the Dutch Republic, and free Italian states (such as Venice and Savoy, among others) – professing a variety of faiths.

Henry had a blood and faith bond with many Protestant rulers. With Elizabeth's thrones, his father had inherited the presumption that English foreign policy was in part conducted to defend the international community of Protestants throughout Christendom. If 'the fundamental function of monarchy was the making of war: this was the bottom line'. Pro-European Protestants and military men attending Henry were initiating the prince in this aspect of his kingship.

By mid-summer, Spain was preparing to invade Venice and return her forcibly to obedience to Rome. Catholic but pro-Protestant and violently anti-Habsburg, Henri IV of France replied by mustering troops to help the Venetians defend themselves. Writing to the English ambassador in Venice, Sir Henry Wotton, twelve-year-old Henry declared, if 'he were of age he would come in person to serve the Republic', to fight for the liberties of those threatened by Spain and the pope.

Wotton read Henry's letter to the Senate. It was what they wanted to hear from England. Wotton hung Prince Henry's portrait in his palazzo. Even the sight of him, looking down as they passed, should give the senators confidence in their ally.

Senior diplomats such as Wotton recognised that the Protestants could not stem the Habsburg and Catholic militant resurgence in Europe, as they saw it, alone; they must ally with certain Catholic states and independent princes, such as France, and maybe some of the Swiss cantons and German principalities. Mainstream domestic political reaction aligned with Henry and his household on this matter: England should prepare to intervene in the Venetian crisis, alongside Henri IV of France.

One of the most important and influential 'independent princes' chose this moment to visit London. Henry's uncle, Christian IV of Denmark, landed at Tilbury on 17 July 1606. James, Henry and a train of nobles rode to meet him. The King of Denmark greeted his brother-in-law, then made for Henry, embracing him 'most lovingly in his arms, expressing a most tender and royal affection'. All the way to Greenwich Palace, Christian, 'with many loving favours, showed his heart's joy in ... Henry'. If he was looking he might well have seen something of himself in his nephew.

The Stuarts and Danes plunged into a month of hunting, feasting, plays, displays and political discussion. Christian congratulated his sister and his brother-in-law on their enlarged monarchy; they exchanged intelligence and discussed the implications of the Powder Treason and Venetian interdict. Some Protestant German princes had 'proposed to' James 'to declare himself head of the reformed religion ... and to pledge himself to an alliance offensive and defensive', against Spain or the Vatican. But James had refused – 'a thing that a prince of greater spirit would probably not have done', Ambassador Molino thought. While disagreeing with the resort to arms, James did think though it was essential to maintain 'the Sovereign rights of independent Princes against the violence of those who, under the cloak of religion, sought to overthrow them'.

The day before their guests left England, the Stuarts accompanied the Danish king back downriver to his flotilla anchored at Chatham. Christian feasted them. The light shimmered on the water, reflecting off the walls in roomy cabins hung with 'cloth of gold', scented 'with sweet and pleasant perfume', to cover less sweet odours.

King of a major seagoing power, Christian had asked to inspect the navy, after dinner. 'They had sight of all the ships; which were rich in ancients, pendants, flags and streamers.' Shipwright Phineas Pett had smartened up the fleet as best he could, bringing two of the better ships, the *Ark Royal* and the *Victory*, into dry dock for refurbishment. Pett stood close to Henry as they made their tour. James had just given the *Victory* to the prince. An important ship, having seen service against the Spanish during the Armada, she was a lady of a certain age, and it showed.

If magnificence was a tool of power, this tool was clearly rusty and rotten. Through his uncle Christian's eyes, the prince saw a depressing vision of a future royal navy made up of run-down ships, slack discipline and corruption in the naval dockyards. Henry had inherited his Danish family's affinity with the sea, loving it in a way his father never did, yet this fleet would be clearly incapable of defence or attack. At the very least, it needed the boost of a new warship and a properly thought-out programme of refit and repair.

On 11 August the royal families said their farewells on board the Danish flagship, the *Admiral*. Christian's parting gift to Henry was his best fighting vessel, the *Vice-Admiral*, with all her modern weaponry and equipment. Henry began to research and plan how to renovate the whole royal navy up to the same standard as his new ship.

James waited to see his brother-in-law set sail, then left to hunt and make another progress, beyond the capital.

Unable to 'follow the King because he made so little stay in any place', the French ambassador, Monsieur de la Boderie, found himself 'a frequent attendant' in Prince Henry's household. Henri IV hoped to enlist English support for French diplomacy in the Venetian crisis. The ambassador had been told to encourage Prince Henry's friendship 'by all possible means'. It would 'be a great fault to neglect' the youth. 'He is a Prince who promises very much.'

De la Boderie invited Henry to dine at his London residence. Henry's entourage hinted to the ambassador that the prince 'would soon show he had power' to act on behalf of his future countries,

whatever that might mean. He was only thirteen. De la Boderie reported that some of Prince Henry's people were offering to supply information about the prince to France, and to air French policy in the conversation at his tables. If de la Boderie could offer 'something to sharpen their tools, they would do better', he said. He could approach Monsieur de St Antoine, the riding master the French king had sent for Henry, or some of the Huguenot refugees attending on the prince. Or pehaps Chaloner, who fought under a Huguenot Henri IV in the early 1590s.

'I think it highly proper to cultivate' Prince Henry's friendship 'and to manage it early by all means suitable to his age and condition', de la Boderie advised. The management obviously included spying on him, as the ambassador sketched out his impressions of Henry for his royal master. 'None of his pleasures … savour the least of a child.' Yet, typical teenage boy, blessed with boundless youthful energy 'he is never idle'. He loves all sports, including tennis and golf, ships and the navy, exploration, anything to do with the military and *manège* (the art of horsemanship, fundamental to cavalry training).

Henri IV wanted his son, the dauphin, to send Henry a present, and asked for ideas. Easy – send 'a suit of armour, well gilt and enamelled', said de la Boderie, 'together with pistols and a sword of the same kind: and if he add to these a couple of horses, one of which goes well, and the other a barb [an Arab], it will be a singular favour done to the Prince'. These were suitable gifts for a king-in-waiting 'whose friendship', the envoy continued, 'cannot but one day be of advantage' to France.

Henry wrote to the French king. 'Sire and Treasured Uncle', he addressed him, and thanked him repeatedly for 'showing me your truly paternal affections'. The prince would often describe himself as Henri IV's 'child'. He welcomed paternal advices from him, as much as he did from his actual father.

In early summer 1607, Henry received more approaches from the French. The Prince de Joinville visited Henry, in order 'to cultivate that young plant … since it promised, to produce fruits much more favourable to France, than that stock from which it was raised'.

Joinville stressed the paternal aspect of the relationship, assuring Henry that the French king spoke '[ever] with great show of passionate affection towards [him] …; and at this time he accounted of him as of his own son'.

James's treaty with Spain ending the Armada war had changed the balance of power in Europe. Henri IV wanted to rebuild France as a great European power under his new dynasty, the Bourbons, and the Habsburgs posed the most serious threat to his ambitions. It was vital that Spain did not now ally with England by using marital diplomacy. The French proposed a marriage between Henry or Princess Elizabeth and one of the French royal children. Henry's parents accepted that a French match was prestigious enough, however James still meant Henry to wed the Spanish infanta. The queen too 'endeavoured to prejudice' her son 'in favour of Spain, and against France', which, she added unhelpfully, 'she hoped he would one day conquer, like Henry V'.

Henry asked Joinville if he might send an envoy to his 'Treasured Uncle', so that they could communicate without having their letters filtered through Whitehall first. Both knew James and the Earl of Salisbury would not welcome the minor court casting a speculative, independent line in foreign policy.

Joinville accepted, and immediately regretted it. The French caught Prince Henry's envoy spying. He was making drawings, 'examining all the fortifications' of Calais. The man confessed 'he was employed by Prince Henry, who had long waited for such an opportunity'. Spied on by informers in his own household, some of them in the pay of his 'Treasured Uncle' Henri, Prince Henry obviously felt old enough to set off by himself down the murkier byways of international relations – only to be caught stealing military secrets at the first attempt.

Henri IV hesitated. Had it been James, France would have delivered a stinging rebuke. But the spymaster here was only thirteen years old. The French brushed it off, dismissing Henry as 'not of an age nor in a condition to think of such things; nor was England in a situation to undertake any design of that kind'.

Correct about England's defences, they were self-evidently wrong about Henry. Joinville sent the young prince Henri's gift of horses and

a suit of armour. Henry thanked him: 'I perceive, my cousin, that, during your stay in England, you discovered my humour; since you have sent me a present of the two things which I most delight in, arms and horses.'

From the time of his birth, people and countries had created 'their' Henry. 'The eye of the world is on [you]' one songster told him. 'Brave Britain's beauty and fair England's joy/... Whole Europe's comet and Saint Georges Knight'.

Lord Fyvie, now the Earl of Dunfermline and Scottish chancellor, wrote to Henry from north of the border to say Scotland had 'sunk and almost expired under the want of the presence' of king and prince since 1603. If only Henry had come back home as planned, after the Powder Plot – 'You would have seen there not long ago, how great their joy, how sincere their regard and veneration of you was ... Go on most serene Prince, as you have begun ... By this means you will procure and establish an everlasting fame and glory to yourself, and perpetual peace and tranquillity to your people.' 'Peace' through strength was the watchword at Henry's household: 'tranquillity' was the reward for glorious deeds that won 'everlasting fame'.

You flatter me, Henry replied. Yet, 'the commendations of persons, who, like yourself, preside in Senates and Courts of Justice, are to be considered as exhortations, to excite us to attempt everything great and excellent. That I may some time or other do this ... I shall sincerely pray the all-merciful God.' Henry cherished the young man's dream for a heroic, extraordinary life.

He was eighteen months from turning fifteen, the age when he must officially be acknowledged as an adult. The French noticed James, 'often shrewd ... was not pleased to see [him] ... advance so fast'. Perhaps the king was right.

The very first line of *King Lear* has the Earl of Kent saying: 'I thought the king had more affected the Duke of Albany than Cornwall'. Prince Charles was Duke of York and Albany. The title Duke of Cornwall always belonged to the eldest son, the Prince of Wales. How could Henry not be precocious and assertive? He was highly

stimulated and intensively educated all day every day of his life. 'His discourse … now raised to all the most important subjects, and he grew inquisitive about the state of foreign countries as well as his own.'

The Collegiate Court of St James's

In response to his son's advance, in 1607 the king ordered Henry's household change from schoolroom to collegiate court, another decisive step towards a fully fledged royal court. Chaloner knew what the king had in mind; his own upbringing with Cecil offered a precedent for this kind of think-tank – educating young aristocrats, gentlemen and wards of court in a tradition of service to the Crown, church and commonwealth. John Dee had presided over something similar at Mortlake.

James Cleland, John Harington's tutor, eulogised the new collegiate court: 'Here they may obtain his Highness favour, as Hylas won the love of Hercules; Patroclus of Achilles, and Esphestion of Alexander the Great.' Great leaders needed high-calibre intimates. 'I recommend … the Academy of our Noble Prince,' Cleland said, because here they 'learn the first elements to be a Privy Councillor, a General of an Army, to rule in peace, and to command in war.' Cleland foresaw counsellors who ruled and commanded, as well as the king.

As king, Henry would take his young brother and his 'Patroclus' and 'Ephestion' – youths such as John Harington and Essex – with him to be his counsellors and generals. By following the 'precepts of the most rare persons in Virtue and Learning', living and dead, Henry could advance a reformation in 'government civil' as well as 'military', and perfect the reformation in religion, stuck halfway to heaven. Henry and his court would make the kingdom admired for its progressive politics, religion, and culture, and maybe even feared for its virtue.

What his father wanted, on the other hand, was to create an esteemed Renaissance centre of learning around the student prince, fit heir to the philosopher king. James, Europe's Solomon, saw the Stuarts as the ombudsmen of Europe. He wanted Henry's courtly college to reflect his own image. James was not the only parent to try and appropriate his child's life to enhance his own agenda – or the last to be disappointed when the child proved to have a mind of its own.

The growing number of military 'rare persons in Virtue and learning' at St James's did not reflect the king's mind. Still they came. Though not greatly appreciated by the King of Peace at Whitehall, Henry welcomed the vigorous, martial-souled men who spent much of their lives honing their virtue in defence of the Protestant cause. War veterans, politicians, soldiers from the front line of current conflicts in Christendom, skilled at 'command in war', stood with the prince and his friends in the long galleries of St James's and Richmond, poring over tables covered with maps of countries, sieges and battles from all over Europe. They debated the evolving European scene as new intelligence came in. The prince could not lead the conversations, but followed his father's early instructions to 'be homely with your soldiers as your companions, for winning their heart ... Be curious in devising stratagems.'

Sir Edward Cecil told them how Maurice of Nassau, the future Prince of Orange, got to the extraordinary position where a group of tiny Dutch states stood poised to defeat the might of Spain. Prince Maurice's successes were due to one simple rule: avoid errors as much as possible and observe those of your enemy. Maurice believed he learned far more from defeats than victories. 'The profiting by other men's errors and examples was a secret the ... Prince of Orange did so much study,' said Sir Edward, seeing Maurice as a role model who might make him a great military leader. 'Yea he ... professed the art of war by it ... which made us, that had the honour to bear him company, to be glad when we could get him to discourse of it.'

Sir Edward revered Maurice as 'a great Master' of the theory and practice of war and disseminated Maurice's wisdom among Henry's circle. The Dutch leader trained his commanders to go over what

happened every day, to write it down nightly and learn from their mistakes, said Cecil. Maurice called it 'his Experience' – the material he needed to formulate strategy and better tactics.

Maurice laid out his methods in his most famous work on the military arts, *The Exercise of Arms for Calivers, Muskets and Pikes* (1607). In it he detailed how he had recreated the Dutch army to suit modern warfare. The book swiftly appeared in French, German, Danish and English editions. Richly illustrated by Jacob de Gheyn, his handbook on infantry training and troop formations became the gold standard on teaching infantry drill for fifty years. Henry introduced it at home. He built a military training yard a mile from St James's Palace on which to practise and perfect Maurice's innovations. Nassau complimented Henry by dedicating the English edition to him. De Gheyn eulogised the prince in inimitable English as a youth 'who doth yet give such a lustre to this arms, by the continual familiaritie he hath with them in his often practise'. Henry wrote thanking Maurice, following his father's advice to 'use all other Princes, as your brethren, honestly and kindely'.

Maurice encouraged the study of ancient and modern texts on battles and the art of war. Henry was amassing a collection of such books and manuscripts. Some he bought, many more came as gifts. Ex-soldier Barnaby Riche sent him a copy of his military theory, the *Fruits of Long Experience*. Like Maurice, Riche emphasised the need for continual training, good discipline, good quality men and officers, decent pay, good education in modern military theory, developing leadership skills in your officers, looking after your main asset – soldiers and ex-soldiers – and ensuring the nobility adopted a professional approach to soldiering. Chivalry must serve the cavalry's needs.

As cavalrymen, Henry and his friends spent hours on horseback, perfecting control of the animal, until horse, shield and weapon were extensions of their wills. Sir Edward Cecil and M. de St Antoine, the riding master sent by Henri IV, trained Prince Henry in the latest cavalry manoeuvres. They practised equestrian ballet, the skills and discipline of dance and war overlapping, turning on a penny at speed, perfectly balanced.

Prince Charles shared their practice sessions, apparently as keen to obtain martial prowess as his brother, whom he shadowed. In 'your absence I visit sometimes your stable and ride your great horses', he told Henry, 'that at your return I may wait on you in that noble exercise'. Charles worked to make himself as brilliant a horseman as Henry.

It was soon obvious that, illustrating the law of unintended consequences, the new courtly college had led to the formation of a military salon at St James's, giving Henry and his circle a first-class martial education. The king had told Henry to make himself familiar with 'the art military' by letting it 'appear in your daily conversation, and in all the actions of your life'; so Henry did.

The French ambassador observed the tight-knit character of the collegiate court. Prince Henry 'shows himself ... very good natured to his dependents, and supports their interests against any persons whatever; and pushes what he undertakes for them or others, with such zeal, as gives success to it'. Like his father, Henry was loyal and tenacious to the point of obstinacy. 'Besides exerting his whole strength to compass what he desires, he is already feared by those who have the management of his affairs,' observed de la Boderie. If he did not become a strong character, he would be crushed.

More and more men petitioned to serve him. As the king continued his habit of removing himself from the capital for over half the year – much of the time amusing himself with a new favourite, young Robert Carr – Whitehall struggled to regain its character as that uniquely intense, claustrophobic core of power and patronage it had been under Elizabeth I, with its daily analysis of fresh news at home and abroad magnetising diplomatic activity. Inevitably, restless entrepreneurs, fringe politicians – as well as soldiers, sailors, courtiers, neglected Puritan preachers and frustrated foreign delegates – drifted to St James's. These men pulled Henry out of the schoolroom, into the mainstream of national and international affairs from a young age. He seemed willing to fulfil a role his father had semi-abandoned.

Given the king's detached stance, the collegiate court became an increasingly active arena of political activity. Salisbury sent Henry

confidential papers on European and domestic issues continually, asking Adam Newton to return them when he had copied them, in case the king wanted them back. In 1608, Spain and the Dutch Republic entered negotiations for a ceasefire, after over thirty years of war. As a matter of course Salisbury outlined the government's position to Henry. The free Dutch would never acknowledge Spain as their ruler and never accept religion on the agenda at all, he said, both of which Spain required as a condition of full peace talks. Henri IV proposed a compromise – a long truce. James supported the truce, 'with the protestation that religion shall be no part of the bargain', Salisbury told Henry. St James's should support this line. It would mean universal peace in Europe for the first time in decades. 'They that were so far off, and are come so near, will not easily sever', he added, hopefully.

However, Sir Edward Cecil, returning from campaigning in Holland for the winter break, informed them that Maurice of Nassau was against the truce and wanted England to come out against it. After fighting for so long, Maurice believed the Republic was close to outright defeat of Spain. A peace treaty would offer permanent liberty for the Dutch Protestants, whereas a truce acknowledged both sides had grievances and kept open the door to renewed hostilities. Salisbury asked that Henry at least endorse the Dutch–Spanish truce whenever he received foreign diplomats, despite any misgivings.

Henry's collegiate court now fulfilled some of the functions of the king's court. Canny, James believed he knew the way the wind blew, allowing the hotter heads to let off steam with their excitable talk at St James's, where they had no real power, while he governed by despatch from wherever he happened to be.

However, if the prince was going to take on some of his father's public duties, he must have a suitably magnificent setting, or it insulted the foreign delegates and the countries they represented. They must be received with all the pomp due to the person of the ruler himself. The problem, as ever for the Stuarts, was how to pay for it.

Money and Empire

'O BRAVE NEW WORLD'

Henry's courtly college at St James's was costing a fortune. The reconfigured household had 'become so great a court', said Chaloner, 'that it was ready to be overwhelmed with the burden and charge of itself'. Still, hundreds flocked to offer service to the crown prince.

The speed and scale of the court's expansion forced Chaloner to request more funds from the Chancellor of the Exchequer, Sir Julius Caesar. Henry himself wrote to Lord Treasurer Dorset, bluntly indicating the shortfall in his budget. Dorset disappointed him. The royal coffers were as bare as ever, he explained. 'Money is the *nervus belli*', the nerves and sinews of war, James had advised Henry. Mountains of colonial plunder had powered Spanish domination of Europe in the sixteenth century. But where would the prince find his *nervus belli*? Salisbury described the Stuarts' finances as raging like an *ignis edax*, a consuming fire. If he was to stay solvent, Henry, as king-in-waiting, must acquire a better understanding of finances than either his profligate father or mother possessed. Where better to go to learn about money than the City of London?

It was arranged for Henry to be inducted into the Merchant Taylors' Company, one of the Great Twelve livery companies of London. On arriving at the guild's hall on Threadneedle Street, he was presented 'with a purse of gold, and the Clerk of the Company delivered his Highness' another. Music floated down from twelve lutenists

positioned in high window arches. 'Hanging aloft in a ship', sat three musicians dressed as sailors. Trade and navy sailed together. Weighing the purses in his hand, Henry 'graciously accepted' them. He 'commanded one of his gentlemen … to go to all the Lords there present, and require … them that loved him', who were not committed elsewhere, 'to be free of his company'. These men, from the worlds of trade and commerce, were invited to come to his courtly college to see what it might offer them in terms of books, experts, soldiers and sailors, laboratories, scientists and inventors. In return, the City men would tell him how to fill his empty royal coffers.

The opening of the Earl of Salisbury's New Exchange in the spring of 1609 showed Henry just what trade and enterprise could offer. Located on the Strand, the ground floor was an arcade. Under the arches, merchants and estate agents conducted their business. Inside, on the ground and first floors were retail outlets for luxury goods that had been imported into London. Salisbury had created the first high-end shopping mall, which James christened 'Britain's Burse'.*

As Henry and the royal family walked into two great galleries they were plunged into a sea of jewel-coloured light. Windows glazed with armorial stained glass splashed vivid hues across interiors aglow from gilding and red, green, blue, yellow paintwork. The Cecil coat of arms dominated. The royal party passed 'Haberdashers of hats, Haberdashers of small wares, stocking sellers, linen drapers, Seamsters, Goldsmiths or Jewellers … such as sell china wares, Milliners'. They stopped to admire 'Perfumers, Silk mercers, Tyremakers or Hoodmakers, Stationers, Booksellers, Confectioners, such as sell pictures, maps or prints, Girdlers, etc'.

Salisbury had commissioned a Ben Jonson masque to celebrate the Exchange's opening and 'fitted up one of the shops very beautifully' for its setting, over which 'ran the words: "All other places give for money, here all is given for love". Three characters walked out to meet the court:

* It differed from Thomas Gresham's sixteenth-century Royal Exchange, on the corner by Threadneedle Street, in its emphasis on luxury items for the leisured classes.

a Merchant, the Merchant's Boy, and the Porter of the Burse. They welcomed the royal family and spread before them a stunning selection of opulent wares imported from China: fine silks, bracelets, scarves, fans, knives, umbrellas, sundials, silk flowers and, above all, the prettiest porcelain. These goods were meant to educate as well as amuse.

Truly, 'there is not that trifle in this whole shop that is not mysterious', boasted the Merchant, reaching for automata displaying what appeared to be moving stars and planets. He was planning bird-collecting trips to America and China, he told them. He pretended to haggle with Queen Anne over a jewel-embossed silver plaque of the Annunciation, before handing it to her. The Merchant picked out an expensive inlaid cabinet for the king. He then rummaged about and staggered forward under the weight of silver-inlaid horse tack – worthy only of Alexander the Great's steed, Bucephalus, he announced, before giving it to Henry. The prince accepted the tribute, fit for great conquerors.

Luxury and scientific progress welded together in many of the products on sale. The royal party examined an innovative 'perspective' glass – a spyglass to let you pick out the detail of a man's clothes and even the breed of his horse from miles away. The Merchant hinted he might be able to get one for young Henry, if he wanted one?

Henry definitely wanted one. Aside from the irresistible spying opportunities, owning a large telescope would put Henry's court at the cutting edge of science. One of the prince's tutors, scientist Thomas Harriot, had already made groundbreaking discoveries in optics, engineering, astronomy, mathematics, and cartography. He applied his discoveries in the field of spherical geometry to navigation, and developed advanced navigational instruments. Given the courtly college's military bent, Henry had encouraged Harriot to apply his mathematical genius to ballistics: he calculated the rise and fall of an object along a trajectory – like a cannon ball – to enable gunners to take aim accurately. Together with Henry's cosmographer, Thomas Lydiat, Harriot could use the telescope to discover how God ordered the workings of the universe – allowing the prince to peer deeper into the heavens than almost anyone before him, as if seeing into the mind

of God Himself. A spyglass showed Henry how science and beauty served imperial ends. Mapping the heavens, the globe could be navigated more confidently.

Almost every day in the courtly college, men such as Chaloner, Murray and Newton asked Henry to receive 'projectors' and 'mechanicians' in order to pitch a commercial idea or scientific invention to the prince. The times were obsessed with 'projects', everyone on the lookout for new schemes to make their fortunes. One man wanted Henry to invest in making farthing coins out of copper. Another, Sir William Slingsby, asked the prince and his circle to come in on a proposal to make a new kind of fuel-efficient furnace. Monsieur Gouget, meanwhile, gave a presentation on new techniques to improve lead, silver and tin mining in the Duchy of Cornwall.

Closer to hand lay more conventional ways for a prince to amass a fortune. When the royal family attended the opening of Salisbury House, Robert Cecil's palatial new residence on the Strand the previous April, Henry had seen for himself just how vast a wealth might be derived from exploiting the British political system's offerings of patronage, positions, and perks.

The Earl of Dorset's death in April 1608 allowed Salisbury to add the Lord Treasurer's position to his portfolio of assets and responsibilities. According to Ambassador de la Boderie, Salisbury now had 'the whole administration of affairs in his hands'. A fraction of the income that 'administration of affairs' offered would allow Henry to 'attempt everything great and excellent'.

In Salisbury's library, Henry perused the Cecils' beautiful collection of books arrayed along the walls on twelve tables, each inlaid with the name of a different country. A book on fortifications lay open on one. Another displayed hand-painted maps of the known world, together with works on genealogies, heroic men, voyages of discovery, trade and conquest. High above him, the heads of Moors, Indians and Mercury looked down, carved deeply into the library's plasterwork ceiling, all to magnify Salisbury's 'virtue'. A huge map of America dominated one wall.

* * *

The idea of America transfixed Henry. He wanted to discover the Northwest Passage sea route, to open up the wealth of the East to English trading companies, and make Sir Walter Ralegh's ambition of colonising America for England a reality.

Henry heard Ralegh's ideas through his maths tutor, Thomas Harriot. Harriot and his friend John White had voyaged to Virginia under Ralegh in the late 1580s. There Harriot observed the Algonquin people, learned the Algonquin language and made a phonetic alphabet to represent it. His friend White drew sketches of the native population. Between them they documented the life of the Algonquin, their society and religious practices, their knowledge of local plants and animals, and their produce. Despite describing them as 'military inferior', theirs was a sympathetic portrait compared to later colonial depictions of the Algonquin as 'savages'.

In 1608 Sir Walter was still locked up in the Tower under sentence of death, but Harriot visited him regularly. The king loathed Ralegh and showed no sign of releasing him, leaving Sir Walter's best hope of regaining his liberty with the two other courts. Queen Anne liked Ralegh. He was also expert in many of the Prince of Wales's interests, such as the navy, the New World, scientific experiments and an aversion to Spain. Men such as Harriot were able to slip Ralegh's world views into conversations with the prince, while, say, setting mathematical puzzles for his student to solve. When Ralegh started communicating directly with Henry, he already knew what he wanted to hear about. The prince began to receive letters containing ideas on all sorts of things – from ship-building and navigation, to how to conduct diplomatic relations with foreign neighbours, to marriage.

In April 1606, James had agreed to the formation of the Virginia Company to trade with the New World. Key investors included men from Henry's inner circle, including Sir Thomas Chaloner, John Dodderidge (MP, lawyer, and Henry's sergeant-at-law), the Earl of Southampton, who frequented St James's, George More (MP and Henry's Receiver General) and Sir Oliver Cromwell (uncle of the future Lord Protector).

The king commanded the colonists to set up a ruling council in Virginia, allowing the company council in London to retain overall control. (How this would work when decisions had to be made months before London even knew what the problem was, did not seem to cross James's mind.) Some of the colonists packing to go assumed that when they arrived in America they would have the liberty to govern their lives, without continual reference back to London.

That December, 1606, the newly chartered company had sent three ships, 105 settlers and over fifty crew on an exploratory expedition to establish a trading bridgehead in Virginia. Henry sent along his gunner, Robert Tindall, to be his eyes and ears, with a brief to record anything of interest.

Months later, the prince had received Tindall's first reports from the newly established township of 'James town'. 'We are safely arrived and planted in this country by the providence and mercy of God, which we find to be in itself most fruitful,' he wrote, 'of the which we have taken a real and public possession in the name and to the use of your royal father.'

The crossing had been unusually long and hard, lasting 144 days. The colonists made first landfall on 26 April 1607, on a broad sandy beach at what looked like the mouth of a major river. They assembled a small boat and went exploring. George Percy, younger son of the Duke of Northumberland, recorded that 'on the nine and twentieth day we returned to the mouth of the Chesiopic, set up a cross and called the place Cape Henry', in recognition of Prince Henry's commitment to the enterprise. The waters were named the River James in honour of the king. Thirteen years before the *Mayflower* landing, settlers from the *Susan*, *Constant*, and *Godspeed* arrived, claimed the New World for the Stuarts, and planted the British race permanently in American soil. They called it Nova Britannia.

On Henry's instructions, over the following months, Tindall created the first map of the Chesapeake Bay. He marked the James River and Jamestown on it, added a handful of Indian towns, and kept a journal of his impressions. Though nothing like the sumptuous

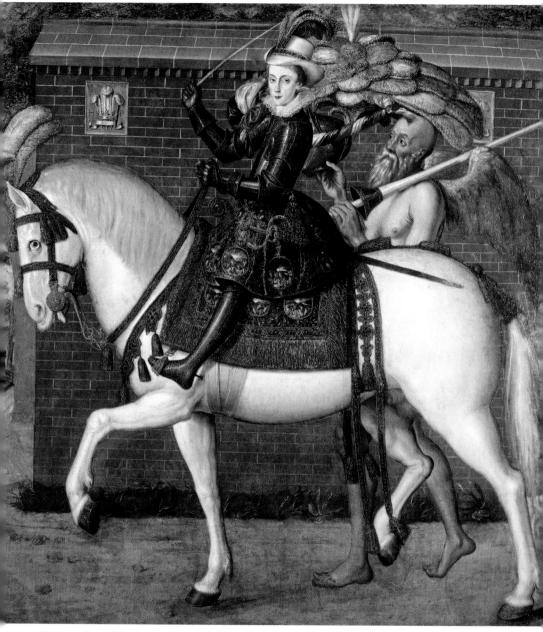

Henry leading Time, in an allegory-laden image

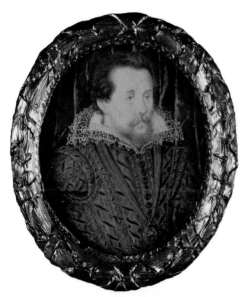

James VI and I: a clever, experienced monarch, and complicated man

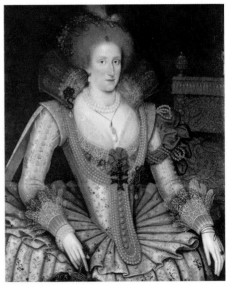

Queen Anne showed her children how to wield soft power, through art and performance

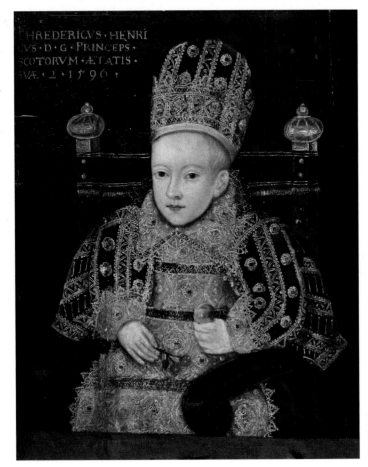

Infant Henry: as king in a high chair, rattle as sceptre

Prince Charles adored Henry, inherited his collections and love of horses, but not his religion

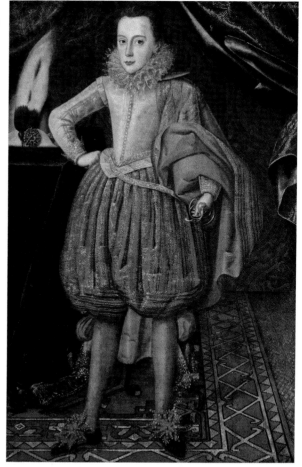

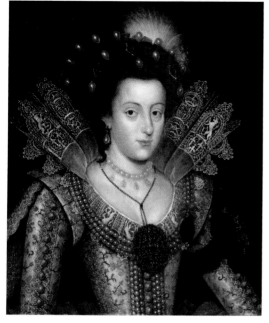

Princess Elizabeth: real heir to Henry's legacy. His last words were to ask for her

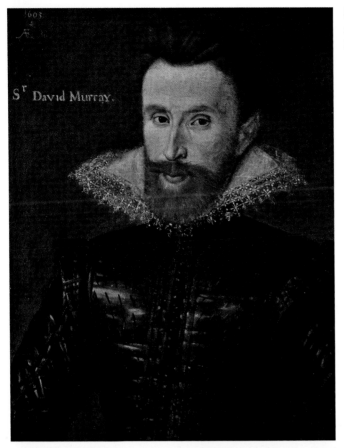

Sir David Murray: the man who lived closest to Henry all his life

Stirling Castle: Henry's birthplace, important in the formation of his mentality

eeee e e en ecce

e e e e e e

tanta est

t t tamen satis

Henricus M M M N M M

temporibus Henricus

temporibus

mea quidem sententia

Maxima cunctarum victoria vieta Voluptas

Henry practises his
signature, as children do

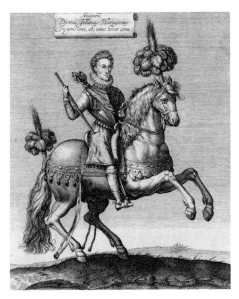

John Harington of Exton:
Henry's best friend

Robert Devereux, earl of Essex: a close friend and future civil war general, on Parliament's side

Robert Cecil, earl of Salisbury: genius statesman and mentor to the future Henry IX

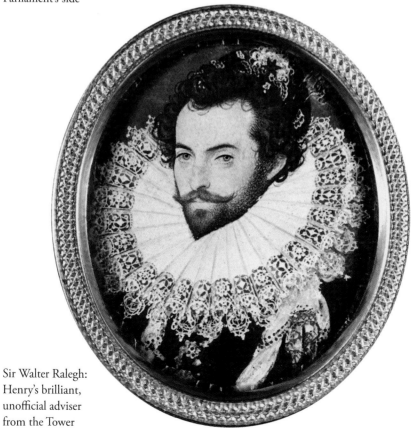

Sir Walter Ralegh: Henry's brilliant, unofficial adviser from the Tower

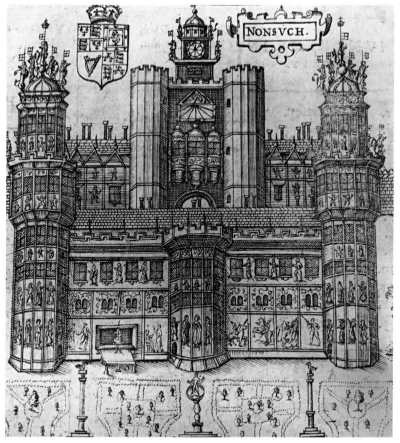

Nonsuch Palace: 'the single greatest work of artistic propaganda ever created in England'

Sir Thomas Chaloner: Henry's Lord Chamberlain, scientist, projector, Renaissance man

Henry's astrolabe: his court magnetised scientists, scholars, inventors

Ben Jonson, poet and
dramatist: his masque
texts show who Henry
was, and thought he was

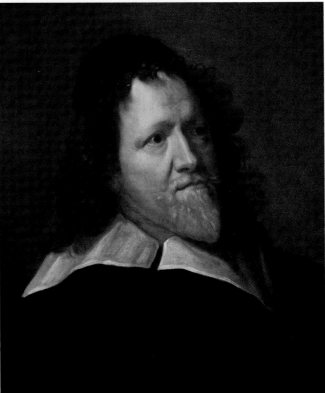

Inigo Jones, architect
and designer of masques
for Henry

maps in Salisbury's grand library, Tindall's ink and vellum map, its colours still jewel bright, tantalised the prince, giving him the first glimpse of the Chesapeake Bay area and the newly christened 'Cape Henry' and 'Prince Henrie, his river'.* The map is big for something so seemingly empty, with its mere handful of landmarks and features. Laid on thick parchment, it is thirty-three inches long and just over eighteen inches deep. It feels like a highly personal sketch – a secret map to hidden treasure. But, here the treasure is the region itself. It is waiting for Henry to come and fill it in, as the colonial ruler.

Soon after, Henry procured some money and made himself a shareholder in the company. His backing of the enterprise led men to refer to him as 'the Patron of the Virginia Plantation'. 'Actions profitable or honourable for the kingdom were fomented by him,' wrote one of his officers, 'witness the North West passage, Virginia, Guiana, the newfoundland, etc., to all which he gave his money as well as his good word.' Henry's greatest dream was to visit his American territories himself, to sail there at the head of an English fleet, modernised and powerful enough to dominate global trade on the high seas.

Such behaviour infuriated the Spanish, who claimed ownership of the whole New World.

In May 1608, Henry returned to dine at Salisbury House. After supper, he was invited to take a turn through the earl's long art gallery.

The prince stopped to admire a painting, one of the earliest works to arrive from Venice, described by the English ambassador, Sir Henry Wotton, who sent it, as 'the figure (I take it) of Prometheus, devoured by the eagle, done by Giacoba Palma'. Wotton said he hoped the image of Prometheus's suffering would prove worthy of a space in his lordship's new galleries.

Everything Henry saw at Salisbury's home showed him what power looked like from the top of the heap – tasteful, beautiful, innovative, competitive and cosmopolitan. It was a place available to Henry, as heir, if he seized it. He saw how Salisbury sat at the centre of a web of

* Today called the York River.

cultural, artistic, economic and intellectual patronage. 'Short, crook-backed, but with a noble countenance and features,' the earl had a rather beautiful face, like an owl. An intelligent, watchful humour flitted over it in response to the antics of men he saw pass before his large, calm eyes. His whole image mesmerised. Henry understood from men like Salisbury how magnificence could enhance the virtue of a Renaissance Jacobean prince, and took the lesson back to the collegiate court. The royal palaces looked decidedly old-fashioned he thought. His father had preserved Hampton Court largely unchanged since the age of Henry VIII for precisely the old-world virtues of continuity – and by extension legitimacy – this inferred. Hampton Court gave out the message the king repeated endlessly: Scottish James's natural right to the English throne. Henry never had this anxiety.

Not long after the Salisbury House dinner, the earl sent *Prometheus, devoured by the eagle* to St James's, as a gift for the prince.

Prometheus was a Titan (half god, half human) who challenged the Olympians. A trickster, he deceived the gods and destroyed the golden age of mankind by stealing fire for human beings. Fire enabled man to break through the limits that held them in a primitive condition, and opened the door to scientific and cultural advances which transformed society. As punishment for his vaulting ambition and deceit, Zeus shackled Prometheus to a rock and cursed him to have his liver devoured by an eagle every day, only for it to regenerate every night to be devoured again the next day. Was Salisbury's gift a hint to Henry – a warning, perhaps – about the risks of making transformative changes to his kingdom?

Friends as Tourists and Spies

'TRAVELLER FOR THE ENGLISH WITS'

The affairs of continental Europe demanded Henry attend to the protean political situation there, as much as domestic projects and plans to found a British empire in America. The era of the grand tour began now, not in the eighteenth century. A more peaceful Europe let men fulfil their desire to see the cradle of the Renaissance and experience the most cultured royal courts in Christendom. For an ambitious prince, touring friends offered the perfect opportunity, or cover, to gather information.

The Continent buzzed with 'intelligencers' of all kinds. Although Henry's first attempt at spying had been a dismal failure, another opportunity arose as his close band of courtly followers disappeared one by one on their European tours. The Earl of Essex, away since 1607, had not yet returned. Thomas Coryate, Henry's favoured wit, busied himself for his tour – on foot. Salisbury's son, Viscount Cranborne, was just about to go. And now, Henry's closest friend, sixteen-year-old Sir John Harington, was preparing to leave.

The two rode through St James's Park to Whitehall to obtain Harington's passport from the king. He would be gone for up to three years. As Henry spoke to his father, he felt tears welling up. 'What hast thou done, John,' said the king, turning to Harington, 'that thou art so master of the Prince's favour – tell me what art thou hast used? Not flattery – that belongeth not to thy age.' Harington said that he had

won his highness's love, not with flattery 'which I know not how to use', 'but by truth, of which, as your Majesty's true son, his Highness is the lover'. For devout Calvinists like Henry and Harington, truth meant the truth of God's word, in the Bible.

Harington and the prince experienced this truth immediately, in their hearts and minds, when they reviewed their words and deeds in its light. Each evening Harington recorded his deeds in 'a day book', in which he asked himself 'how he had offended, or what good he had done ... surveying his failings'. He recorded his sins and virtues 'in a private character'. No one except Harington, and God, understood the code. A mass of thick hair swept up from Harington's long, slim head. He managed as yet only a downy fuzz of beard round his chin and a pencil line over his mouth. His eyes were steady, though the bags under them told of hours reading, staring at a candle, Bible on his knee, in prayerful examination of his conscience; or lying awake reviewing his behaviour after a powerful sermon he and Henry had heard and discussed. He never slept above five or six hours a night.

Passport obtained, the youths planned Harington's itinerary through the most geopolitically significant areas of Europe. In May, Harington, accompanied by his tutor John Tovey and an entourage of ten other gentlemen and masses of servants, left for Europe. Bearing endorsements from his prince, Harington looked every inch Henry's ambassador from the collegiate court of St James's.

Heading first for the Netherlands, then up the Rhine, Harington described to Henry how he had passed through 'a great part of the Low Countries, and seen three courts of Princes, and as many univer-sities, together with several large cities, fortified towns, castles, forts'. He recorded as much as he could about 'politics, men eminent for authority, prudence or learning, war, the present state of affairs, the situation of cities, and the manners of people'. Everything he thought of interest to Henry and the future of Christendom went into private journals for future discussion at home. Then headed down into Italy.

He arrived in Florence, the heart of the Renaissance, on the wedding day of Cosimo de' Medici and Maria Magdalena von Habsburg of Austria, and sent home an account of the event,

including illustrations of the great court spectacles. But it never reached Henry. Harington believed it had been intercepted by 'some of the English Papists at Florence'. Most travellers were paranoid about the security of their lines of communication – tacitly admitting they had something to hide and were spying on their hosts. He had written from three German cities, he said, but had not a word yet from his parents in Kew or from Henry. He asked the prince if he had received any of his letters? Had he written back?

Harington had matters 'of great importance' to the state and what Jacobeans called the whole 'nation of Europe', which included Britain, to relate. But given the loss of his letters he felt serious matters 'could not be written without danger, paper being too weak a security for carrying, such a length of way, secrets, which might prove hazardous to the writer'. These he would share face to face on his return. He told Henry he would certainly travel home via France, and there seek an audience with Henri IV, not only to convey the prince's warmest regards but to sound him out on more sensitive shared interests. Harington knew this was the only way Henry could obtain an honest picture of the situation abroad. When foreign delegates came to see the prince they always put a spin on things, and told him what they wanted him to hear.

Letters of Harington's that did reach Henry arrived by a circuitous route, having been circulated between St James's and Whitehall. Salisbury sent copies to his son, William Cranborne, also on the Continent, as examples of how a future leading man should address the future king, with the right mix of intelligent observation, affection and respect. Still Cranborne did not get it. Writing to Henry from Bordeaux, he announced that the prince's reputation did 'most glori-ously shine' in France. Hardly news, it was the sort of flowery guff princes heard daily. Good friend of Henry as he was, the words just did not spring off the page for the Cecil heir. Homesick and depressed, Cranborne seemed to realise it. 'Although I know your Highness expects not much from me,' he wrote gloomily, 'yet having placed the eye and hope of my youth upon your person and fortune, I would be loathe by silence to fall out of your memory.'

'During this your absence, there is no cause to fear that my affection should be wanting unto you,' Henry reassured him. His father, Salisbury, was so vital to Henry and the state, that he 'draws love from me unto him and all his'. From you, said Henry, 'I do expect, if not as much sufficiency in serving princes' as his father and grandfather, 'yet as great abundance of love and loyalty as the example of so worthy patterns'. It was slightly comic, Henry telling Cranborne: just do your best.

Essex's reports from France also lacked political bite. I hope, said Essex, to 'attain to trusty knowledge and to better my experience ... that I shall return an acceptable servant to your Highness'. Essex was always going to be a better soldier than diplomat.

Patently, Harington was Henry's best and most trustworthy foreign intelligencer. He arrived in Venice just before Christmas 1608, and was welcomed by Sir Henry Wotton, delighted to be handed the diplomatic coup of receiving the intimate friend of the Prince of Wales. 'An ambassador is an honest man sent to lie abroad for the good of his country,' Wotton had said of his job, which led to James almost sacking him. During his Venice posting, he had established himself as a sophisticated connoisseur of – in addition to classical paintings – house design, sculpture, gardens, decor and antiquities. Artists' studios, recently occupied by Titian, Veronese, Tintoretto, Sansovino still hummed with their followers' activity. Architects such as Palladio had transformed the face of the old Byzantine Venice. Rich foreigners went away with shipments of glass, paintings, sculptures, drawings and mental pictures about transforming their medieval piles into Palladian palazzi fit for late Renaissance nobles. Wotton loved to share the treasures of this artistic explosion with visiting countrymen. He had already begun to advise Henry on collecting 'civilised' possessions to display the prince's virtue and sophistication.

If young Harington was a first-class contact for Wotton, the ambassador found the other travelling denizen from Henry's household – Thomas Coryate – a liability.

* * *

Often moving alone, his goods in a pack, and funded only by a very light purse, thirty-year-old Thomas Coryate had to walk through much of Europe. His journey had not started well. Forced to spend the crossing to Calais head hanging overboard, 'I varnished the exterior parts of the ship with the excremental ebullitions of my tumultuous stomach, as [if] desiring to satiate the gourmandizing paunches of the hungry haddocks', he wrote in the record of the journey he later dedicated to Henry. Coryate was not a natural sailor, then, unlike his prince.

When the young men of Henry's courtly college were not engaged in serious debate, their tone seemed to draw more on this new verbal acrobatics of the burgeoning English language than the classics and the Puritans. They digested their Latin, Greek and French and gushed it out in highfalutin' neologisms, almost Rabelaisian, to describe the most basic and earthy processes. They revelled in the comic grotesque – the same mad word-play used by Shakespeare's clowns and jesters. Henry's courtly college enjoyed such banter.

Coryate had first entered Henry's life under the protection of Coryate's old Somerset friends, Sir Edward Phelips of Montacute House, and his son, Sir Robert. Both Phelipses became MPs. Knighted by James in 1603, Sir Edward was Speaker of the House of Commons and later chancellor of Henry's court. His son, Robert, served Henry as a Gentleman of the Privy Chamber Extraordinary. Their friend Coryate – bumptious, loquacious, a man in love with the thread of his own crazy ideas – irritated the life out of the king and Salisbury. Yet he was always to be found at Henry's supper tables. 'He carried folly (which some call merriment) in his very face.'

Staggering off the boat in Calais, Coryate was aghast to see women totally veiled in black from head to foot. Moving on to Henri IV's court at Fontainebleau he blagged his way in. He admired the king's horses, but thought Henry's were better. He visited the menagerie and was amazed by birds with long pink necks, rudely devoid of feathers – sharp, black eyes regarding him at his own height as their heads swivelled round over big feathered bellies. Coryate had never seen a nun or an ostrich.

Wherever he went, he recorded historical facts, architectural descriptions of avant-garde buildings, notes on local customs largely unknown in England, such as a pronged stick for eating (a fork); or a shade on a thin pole, strapped to the thigh to protect your head when riding (an umbrella – a word Coryate introduced into the English language). He gave an idea of prices and warned against being defrauded in currency exchanges.

Moving down into Italy, Coryate reached the Spanish-dominated dukedom of Milan. Here the Italian city and the Spanish military citadel of Castello Sforzesco existed side by side. The citadel – equipped, Coryate reckoned, to withstand a three-year siege – supported a fully functioning community, cut off from the Milanese outside their walls. Coryate strode up and down measuring the castle walls and counting weapons, asking about their range and power, until an infuriated Spanish officer yelled down that he would throw him into a dungeon if he did not clear off. Coryate observed that the Italians and their Spanish protector-occupiers coexisted with 'an extreme hatred' of each other.

Eventually, Coryate closed to his main destination: 'La Serenissima' – Venice – where he was to meet Wotton. He floated down the Brenta on the current, watching horses tow returning boats back to Padua, entranced by the pleasure palaces of great Venetian merchants that lined each bank. A local proverb had it that no vessel containing a monk, student or courtesan making the crossing would ever sink (they were the most frequent passengers). The best things in life here were meant to be: *Vin Vincentin, pan Paduan, tripe Trevizan, putana Venezian* – Vincenzan wine, Paduan bread, Treviso tripes and Venetian whores.

Coryate stood in his boat to gaze across at Venice and was bowled over by 'the most glorious and heavenly show upon water that ever any mortal eye beheld'.

Wotton was scrupulously polite to Coryate, as one coming from Henry's circle, but calibrated his status exactly: a maverick, perhaps Henry's unofficial gentleman jester, a low-life intelligencer, not someone the ambassador need take seriously.

To 'research' why the name of Venetian whores was 'famous all over Christendom', Coryate visited one of the best known at her palazzo. The lack of children puzzled him, though he mused 'the best carpenters make the fewest ships'. After a tantalising delay, the courtesan appeared, 'decked like the Queen and Goddess of love' with many chains of 'gold and orient pearl … gold rings beautified with diamonds and other costly stones' and 'jewels in both her ears'. A gown of 'damask with a deep gold fringe' opened to reveal 'stockings of carnation silk', he noted, gazing at her lovely red legs. 'Her breath and her whole body, the more to enamour thee, [is] most fragrantly perfumed.' Coryate sounded like Enobarbus describing Cleopatra. She will 'enchant thee' with her singing and lute play. Better still, 'thou wilt find her … a most elegant discourser, so that if she cannot move thee with' song, 'she will assay thy constancy with her Rhetorical tongue'.

When he got home and recounted all this at St James's, his listeners roared, well able to picture the state of Coryate's 'constancy' under the onslaught of her 'rhetorical tongue'.

'And to the end she may minister unto thee the stronger temptations, to come to her lure, she may show thee her chambers of recreation, where thou shalt see all manner of pleasing objects,' Coryate continued, his words beckoning those who listened to look closer into the bedroom, even as he warned them off. Having completed his observations, Coryate left, his virtue apparently intact. You can only salute the power of his constancy.

Coryate's journey home took a line through Switzerland and down the Rhine, the imperial highway, then southwest through Speyer. He captured the culture, learning and glory of these great imperial towns and cities at their zenith. Many would be totally devastated in the Thirty Years' War from 1618. That summer, the land yielded grain, cabbages, flax, turnips, radishes, fruit trees, and vines. The cities hummed with activity. In Frankfurt he met the Earl of Essex at the biggest book fair in Europe. So many rulers were committed to learning, religion, and all the arts, wrote Coryate, in a state of bliss.

He went back along the Rhine to enter the Dutch-Spanish conflict zone. Maurice of Nassau's United Provinces resembled a huge,

reinforced fortress of independence, cocking a snook at the mighty Habsburgs. At Nijmegen, Coryate passed under the walls of Schenkenschanz, one of the most formidable strongholds in Europe, designed and built by Martin Schenk. A brutal and efficient mercenary, Schenk and his men – the hyenas and wolves of Europe, Coryate called them – fought for the highest bidder, swapping sides. Schenkenschanz was a marvel of modern military engineering. Henry would expect his traveller-intelligencer to make a rough plan of it.

As he sailed down the Waal River towards the coast, still in the guise of a tourist, Coryate passed along the front line between two huge armies, noting their defences. Dutch vessels patrolled all the time, weapons turned towards him. Coryate's journal was clearly a travel guide for a specific kind of traveller – perhaps a prince at the head of an army.

Coryate travelled mostly on foot and alone, but by the time Harington's entourage reached Venice it was so large that a palazzo had to be hired to accommodate them all.

Wotton had been asked by the Doge to introduce Harington to the Senate. The ambassador went in first, leaving Harington in an ante room. Whetting their appetites, he announced that the young man outside was 'the right eye of the Prince of Wales'. 'This world holds that he [Harington] will one day govern the kingdom.' Wotton stood in for King James; Harington stood in for the future Henry IX. Not permitted to embark on his own grand tour, the prince's closest friend spoke for him on the political stages of Christendom.

Mid-speech Harington pulled from his breast pocket a precious miniature of Henry which he carried next to his heart. Faces lit up around him. The members passed it from one to the other, examining it, matching up Harington's words with the picture of this clear-eyed young man staring at them from a little gold frame embossed with cabochon gems.

Harington told Henry he would stay in Venice 'to study the form of this government', republicanism. The prince was encouraging of '*Mon petit Chevalier*', but added that he missed him sorely.

Henry's Political Philosophy

'MOST POWERFUL IS HE WHO HAS HIMSELF IN HIS OWN POWER'

They wrote to each other often. Typical of their era, Henry and Harington believed in examining the political structures of the present through the lens of history – both classical and contemporary. They became interested in Tacitus's assessment of Roman government. It gave them a perspective on the workings of modern 'government civil'. Tacitus compared Republican Rome with the imperial Rome of the Caesars.

Harington had his Tacitus with him in Venice. The visit was the perfect chance to study and report back on a real, modern-day republic, thriving in an age where many European states increasingly resembled the Roman Empire: supreme rule under a divinely ordained monarch, ultimately unaccountable to his people, answerable only to God. Harington asked Henry to help him with his researches, wishing nothing more than to admire the prince's genius, 'to be instructed and corrected by his judgement, and to acquiesce in his determination'. You might 'give [me] the solution of a difficult passage which had occurred', Harington said, 'in reading Tacitus's *Life of Agricola*'.

Henry demurred. They both hated flattery, yet, Henry teased, Harington 'highly extolled him, the Prince, partly on account of wit, and partly for acuteness of judgement; and then proposed … a hard and perplexed passage of a writer' that was bound to show, by Henry's

failed translation of it, that Henry lacked both wit and judgement! 'Do you believe me to be a person capable of untying knots, explaining riddles, and illustrating the obscurities of difficult authors?' Henry asked. 'I, who am, in all kinds of polite learning, a mere novice, and who have made scarce any advances from the depths of ignorance … never dared look into Tacitus, whom I have heard represented by everyone, as a writer of admirable sagacity … However, since you challenge me into the field, I am determined to follow you, though with a slow pace.'

By 'everyone' Henry could only mean everyone in his courtly college, certainly not his father, a king who was vocal about divine right monarchy and his imperium. In *Agricola*, Tacitus recounted his father-in-law's service under a tyrannical Caesar who has been weakened by the influence of corrupt favourites. In 1608, it still offered a trenchant rationale for active resistance to such abuses.

Henry said he would try to work his way up to the passage his friend had highlighted – on corn prices, price fixing and other abuses of power – and then attempt to unpick its meaning. Whilst doing so, 'I thought it not improper to offer to your consideration one or two much less difficult passages, in the sense of which I could not satisfy myself.'

Henry chose passages on how to resist corruption and flattery, especially when you were not yet ruler. He alighted on Tacitus's analysis of Agricola's precocious self-discipline and how the general conditioned and grew his virtue in his youth. Agricola did so by cultivating 'Stoicism'. Stoicism, as formulated by Seneca and Tacitus, encouraged the development of self-control and fortitude in the face of adversity as a means of overcoming destructive emotions in yourself. Stoical rectitude had allowed Agricola to carry out his public duties with lofty impartiality, even amid a decadent court. Henry projected himself into Agricola's character and philosophy; just as he emulated his political heroes, Henri IV and Maurice of Nassau, through the study of martial arts, battle plans and fortifications.

Henry and Harington saw how Agricola combined classical Stoicism with Renaissance virtue. In doing so they looked towards a

contemporary version of Stoicism – distinguished from its classical roots as 'neo-Stoicism'.

Absolute monarchs, such as James, suspected Tacitus's admirers of sedition. The Roman historian asked difficult questions of senators and emperors, such as how did the conduct of their private lives affect their ability to wield power? Corrupt councillors and favourites, and the concomitant decadence, greed and tyrannical acts by absolute Caesars, was ruinous to the common good, said Tacitus. He concluded that men in positions of power must exercise Stoical self-control, cultivate their virtue, and watch and serve until they could reform abuses and call powerful, greedy men to account for behaviour that threatened the 'common weal'.

To outsiders and to the philosophy's critics, neo-Stoic rectitude was little more than hubris: an excessive pride in one's ability to control oneself. Tacitus himself suspected that, taken to extremes, Stoicism might breed a desire in men to overthrow a corrupt or tyrannous state. What Stoics thought of as their own moral constancy might lead to a high-minded fanaticism and an even worse tyranny. The risk was, 'if they overthrow it, they will attack freedom itself'.

In Henry's emerging political philosophy, Tacitean theory would connect with the other rich seam of moral education in Protestant England: religious ethics – perhaps Calvin's theory of rightful resistance to a monarch, even.

In *Coriolanus*, Shakespeare's most radical play, which premiered at the Globe theatre in 1608, Stoical Coriolanus almost destroys the state because he is incapable of being 'other than the one thing, not moving'. Adaptability is key to a ruler – 'our virtues/Lie in the interpretation of the times' – not a rigid adherence to principle.

Unlike Coriolanus, Henry did not see Tacitus's ideas leading to civil unrest. Power resided in the king at court. There, power and authority would stay until Henry IX came to the throne. The critique of Tacitus and the neo-Stoics was more a recognition of the truism that power corrupts. Jacobeans, including the collegiate court of the crown prince, were obsessed about how to counter corruption among men in positions of power.

It seemed ineradicable. Tacitus gave them no sure solution, but suggested harnessing the virtues of the Republic to a strong leader. Being Roman, he left out the option of Christian humility, of course. He promoted the ideal of a conciliar government, where elected representatives of the commonwealth, accountable to the people who elect them, ally with the stabilising benefits of a stoical, vigorous and absolute Caesar. In Henry's monarchy it might come to mean rule under a supreme sovereign advised by a confident and vocal Privy Council, and a Parliament peopled by men of virtue and honour.

If Henry and his household could have looked over the horizon and seen the constitutional crises and civil wars to come at home, and the violent destructiveness of the Thirty Years' War in Europe, it might have tempered the element of intolerant high-mindedness in these youthful letters. James always enjoined Henry not to indulge himself in 'Stoicke insensible stupidity'. He repelled all analytic comment on what he saw as the mystique of his monarchical power. But Henry was young and every lofty ideal seemed achievable.

From the start, at Stirling, James had allowed the introduction into Henry's life of neo-Stoics, supporters of champions of the previous reign: the heirs of Sir Philip Sidney, Leicester and Essex. In James's mind, in 1603 he had merely rewarded those who had supported his claim to Elizabeth's thrones. Yet, the 3rd Earl of Essex was tutored by known neo-Stoics, such as Henry Savile. Called the Tacitus of his age, Savile analysed the psychology of leaders as a major determining factor in the course of history. Similarly, before John Harington left on his grand tour, he had spent several months at Sidney Sussex College, Cambridge, a centre of neo-Stoic and Puritan ideology.

In the older generation, the devout Calvinism of Newton, Chaloner and Murray drew on neo-Stoicism to describe an ideal godly kingship, for which they might educate Henry and his circle. By now, whether the king intended it or not – and it is most likely he did not – Henry's courtly college had become the centre of neo-Stoic thinking in England, with a pronounced godly ethos and pro-European outlook.

* * *

Early in 1609, a new political crisis drew Harington out of Venice and back to the Holy Roman Empire. He made for Heidelberg, capital city of the Palatinate and renowned centre of Calvinist learning.

On arrival, Harington found 'the present state of affairs' dominated all conversation. The year 1608 had proved pivotal for the Protestant states of the Holy Roman Empire. Halfway through, the Protestant princes, led by Frederick IV of the Palatinate, walked out of the imperial diet, the Holy Roman Empire's supreme governing body.

The crisis originated in the prosperous German city of Donauwörth, just outside the western border of Bavaria. Since the Augsburg settlement of 1555, Lutheran Protestants and Catholics had shared equal rights to worship in the city. But by the early 1600s, the former Catholic majority in Donauwörth had shrunk to sixteen households in a population of over four thousand. For two years in a row sectarian violence had erupted around the city's Catholic parade to honour St Mark's Day. The marchers tried to hoist saints' relics and banners on their shoulders, sing hymns, and swing incense-filled thurifers under the noses of their Protestant neighbours. The Protestant majority, enraged by the idolatry, seized the icons and attacked the marchers.

Towards the end of 1607, the militant Catholic leader, Maximilian of Bavaria, successfully persuaded the Holy Roman Emperor, Rudolph II, to issue an imperial edict against Donauwörth denying its Protestant citizens their property rights. Rudolph permitted Maximilian to send in 6,000 of his own troops in a clampdown that would lead to the re-Catholicisation of the city. Maximilian suppressed Protestant worship, confirming Protestant suspicions of imperial skulduggery. He removed the Protestant magistrates, dismantled Donauwörth's infrastructure and returned the principal churches to the old faith.

The invasion angered Protestant princes throughout Christendom. Donauwörth lay within the legal jurisdiction (the *Kreise*, 'circle') of the Protestant Duke of Württemberg (a close English ally) not hardline Catholic Bavaria. Protestants united across Germany to demand that the Holy Roman Emperor address their grievances and confirm the Treaty of Augsburg's formal recognition of their rights.

Instead the diet passed a pro-Catholic edict effectively revoking Augsburg, placing thousands of Protestants, their homes, lands and beliefs under immediate threat. Protestant leaders feared the radicalism that might come next: Jesuit-backed religious warriors and bureaucrats sweeping through their territories, repossessing Catholic property, depriving Protestants of land, property, religious rights. The diet also considered actively imposing the clause in the Augsburg treaty that excluded Calvinism from the limited toleration granted to Protestants, thus wiping out the modest changes and gains for Calvinist states over the last half century.

Concluding they could not work within the current institutional framework of the empire, Calvinist rulers, including Frederick of the Palatinate, walked out of the imperial diet. It was a moment of profound fracture for Europe.

Protestant rulers now turned to each other to form a confessional alliance, the Evangelical Union, for their mutual security. Under the leadership of the Elector Palatine, aided by the Prince of Anhalt, the union created an institutional platform from which to renegotiate the terms of their membership of the empire. They demanded the right to defend the distinct identity of their persons, religious rights, properties and territories, in a way denied to the Protestants of Donauwörth.

Representatives were despatched across Europe to encourage key, but independent sympathisers, such as Henri IV of France, to join the union and strengthen its negotiating position. The ripples travelled across the Continent and reached London. The Duke of Württemberg sent his brother and chief minister to sound out the English and ascertain whether James would get involved, or keep standing off.

Prince Louis Frederick, his secretary Wurmsser, and a wily German diplomat called Benjamin Buwinckhausen announced their arrival in England in August 1608. Requesting an audience with the king, they presented Salisbury with a letter of introduction from the Duke of Württemberg and Frederick IV. In their letter they thanked James for his favourable disposition in the matter of the Evangelical Union (James had refused to join it) and for his kind reception of the duke's

brother and emissary (James had refused to receive them, preferring to hunt with a small group of close friends).

The king knew very well that the envoys wanted him to give written approval to the Evangelical Union, or perhaps even to lead it, reprising Elizabeth I's role as figurehead of European Protestantism. But James recognised the alliance for what it was: a formal opposition group to the imperial diet which could be used as a mechanism to ratchet up tension among disaffected Protestants in Christendom. Europe was enjoying more peace than it had for a century. Would it last much further into the new century, if these sort of crises proliferated?

Snubbed by the king, Louis Frederick wrote directly to Henry from Oxford. Henry and the heir to the Palatine had been enthusiastic correspondents since the time of the Powder Treason. The prince agreed to receive Württemberg, but there was a protocol issue. The Germans could not approach him without the king's permission. James withheld it. By November, three months after their arrival, the disappointed party left for Dieppe without having seen king or prince.

Even if Henry had been able to receive the Palatine delegation in James's place, not everyone was happy to see the future king quite so eager to stand in for his father on matters of such diplomatic sensitivity. Since the age of four, Henry had been schooled by his father to be ready 'to play the wise King's part', and bear the Crown by proxy. He showed he was now ready to do so.

SEVENTEEN

Favourites

'THE MOTHS AND MICE OF COURT'

Far from playing 'the wise King's part', James's infatuation with the Scotsman, Robert Carr* – a man whom his eldest son, wife and closest advisers regarded as a scheming parasite – threatened to damage the Crown's reputation.

James knighted Carr in December 1607 and showered more money and gifts on him than the Crown could spare. The favourite was raised to Gentleman of the Bedchamber, making him one of the few to take turns to sleep on a pallet at the end of the king's bed each night. Carr helped dress his master every day and attended to his intimate needs. Soon, no door closed to Carr that opened to the king. Carr reached him when others could not – not even Prince Henry, the queen, or the king's chief minister.

In public, James pinched Carr's cheek and patted his clothes. Unconsciously, James gazed on Carr as he addressed others, even when he spoke to the queen and Henry. Many found it intolerable. Henry and his mother were used to James's male favourites, but this one was different. The king seemed oblivious or indifferent to anyone around him. No one could be sure if they were lovers, but Carr was James's type: handsome in an androgynous way, with 'a fair complexion, equally sharing the beauty of both sexes'.

* Anglicised from the Scottish spelling, Ker.

The English ambassador in Madrid, Sir Charles Cornwallis, warned Prince Henry against such court gallants and favourites: 'the moths and mice of court'. The mice overran the stores, gnawing and fouling them. The moths laid their eggs in the cloth of state. Their grubs hatched and ate their way out through it. They were 'the maligners of true virtue and only friends to their own ambitions and desires'.

Among the great, 'how many are there, that knowing themselves to be palpably flattered, do yet love him that flatterest fastest, and hate him that speaks but the truth?' administrator, writer and veteran soldier, Barnaby Riche, asked Henry. The prince could spot a flatterer, he said, 'by their salutations. With the kiss on the hand, the body shall be bowed down to the ground; then the arms shall be cast out, like one that were dancing the old Antic, not a word but – at your service, at your command, at your pleasure.' Riche regretted that the 'old protestation, "yours, in the way of honestie", is little cared for'. Both Cornwallis and Riche flattered Henry's youthful high-mindedness and his Stoic rectitude. Were they aware that dedicating these tracts to Henry was its own act of flattery?

In *Basilikon Doron*, James had famously advised his son: 'Be at war with your own inward flatterer ... be careful to prefer none ... but only for their worthiness: But specially choose honest, diligent, mean, but responsible men.' Be 'specially free' the king told him 'of that filthy vice of Flattery, the pest of all Princes, and wrack of' Republics.

'Eschew to be effeminate in your clothes, in perfuming, preening, or such like,' he told Henry, 'and make not a fool of yourself in disguising or wearing long hair or nails.' Such accoutrements were 'excrements of nature', said James. Yet, here was Carr, long hair curled and scented, lipping compliments. Even in public, Carr never tired of James pawing him. Carr knew 'his taste and what pleased', harrumphed Anthony Weldon, a less successful competitor for favour.

The sort of nuisance Carr might be to Henry became clearer when, in the New Year 1609, the king agreed to assign Sir Walter Ralegh's sequestered Dorset estates to the favourite. James compensated Ralegh's distraught wife and children for the loss of their home with

borrowed money – a lump sum of £8,000, and an annual pension of £400. From the Tower, Ralegh wrote to invite Carr to act with honour, seek another estate, and not ruin his family. But Carr refused his invitation.

'Sure, no King but my father,' Henry snorted, 'would keep such a bird' as Ralegh 'in a cage.' Henry took up the cudgels for his caged informal mentor and tried to get Sherborne back. Ralegh meanwhile wrote tracts and pamphlets with Henry in mind. He could not be of his circle while in prison, but he could court his patronage.

Noticing, at last, that his wife was no better pleased with his conduct than his son, the king summoned Henry. Anne was avoiding her husband. James asked Henry to talk to her. An invidious request, but Henry agreed to act as go-between.

'According to your commandment, I made your excuse unto the Queen for not sending her a token by me,' Henry reported back, apologising to his mother for the king's ill manners. I explained 'your Majesty had a quarrel unto her for not writing an answer to your second letter', he said, 'written from Royston when your foot was sore'. Also, that you resented her still not 'making mention of it in her next letter, written some ten days after. Whereas, in your Majesty's former tourney to Royston, when you took first the pain in your foot, she sent [some]one on purpose to visit you.'

'Her answer was,' said Henry, 'that either she had written, or dreamed it!' Queen Anne checked with two men attending her. They confirmed that yes, she had written the first time. Perhaps someone in the king's bedchamber had let her note go astray?

No one mentioned Carr by name, although by 1609 the favourite was directly assisting the king, reading much of his master's post and writing some of his letters. The queen hated to think of her private correspondence being fingered by this churl, or feel his hand in any reply.

According to Henry's account, there was further provocative content in the king's message to the queen. 'I dared not reply that your Majesty was afraid lest she should return to her old bias,' Henry wrote

to his father, 'for fear that such a word might have set her on the way, and made me a peace breaker' not a peace maker.

'Her old bias', and talk of bringing disorder to the royal courts, recalled the years of the queen's factional politicking in Scotland. Henry's account of his parents' bickering, unleavened by wit or affection, shows how depressingly distasteful he found the whole business. Loving both, he was fair to both. The royal couple's spats spilled over into public life, showing an 'effeminacy' which Henry's neo-Stoic household despised for diminishing the authority of the monarchy.

The prince and his household carried their animus against 'supple-mouthed parasites' to Whitehall. During the Christmas season 1608, the prince had desired to have an apartment in Whitehall, to keep a closer eye on Carr and the bedchamber. Noting the lodgings of two powerful earls, Southampton and Pembroke, Henry had requested they make way for him. When they refused to move, the prince, unfazed, 'had them removed by his people, to the indignation of these gentlemen', and the amusement of the court, who saw it as 'proof of spirit on the part of the Prince, who ... gives the highest promise in all he does'. Henry's faction now asserted their presence in the main forum of power, in the same building as the king and the bedchamber coterie.

But, whether Carr was part of Henry's decision or not, in the spring of 1609, Henry decided formally to assert his courtly college's independence from his father's court and bedchamber coterie. At St James's, Henry was determined to let no one charm their way to preferment. They would earn it by doing some service first.

Henry reached 'adulthood' – fifteen – on 19 February 1609. Immediately he sought to increase his political and financial independence. He asked that control of his territories and sources of income be handed over to him and petitioned the king and government to acknowledge his change from child to adult, by mounting a state ceremony to create him Prince of Wales. Anticipating his inherited income would be insufficient for his many plans, he additionally

requested 'various emoluments' – positions offering patronage poten-
tial – 'at present enjoyed by some of these great Lords'.

The Privy Council 'pointed out to the King that it would be greatly
to his service that the Prince should leave him the revenues [of the
Prince of Wales's estates] for another two years in order to facilitate the
payment of Crown debts'. Henry recognised this as a ruse: Crown
debts were never paid down, and everyone knew that the king
preferred to use his money to indulge men like Carr. Salisbury, the
holder of many lucrative 'emoluments', visited Henry with the gift of 'a
jewel worth six thousand crowns', to try to persuade him to desist. But
the flattering trinket merely showed Henry the value of his request.

Henry's collegiate court supplied him with a copy of a report orig-
inally compiled in 1603, as the government adjusted to the require-
ments of a male heir. The heir's estates had been mixed in with the
Crown estates for half a century under Mary and Elizabeth. No one
knew the details of the territories, properties, extractive industries
and rights belonging to the prince, or their condition. Judge John
Dodderidge MP, an eminent antiquarian, was author of the original
report. Henry now asked Dodderidge to ascertain the heir's assets and
rights, and appointed him as his sergeant-at-law. Dodderidge was to
be assisted by fellow MP, Cornish businessman Richard Connock.
Connock had served both Ralegh and Cecil under Queen Elizabeth
and was a mine of information about the Duchy of Cornwall.
Dodderidge combined Connock's knowledge with records in the
Tower of London and 'diverse ancient authorities', those great sources
of legitimacy for Englishmen, to compile his report.

Back in 1603, they found that the prince's estates had declined
through poor management. Dodderidge and Connock recommended
a survey and the development of strategies to restore the estates to
their earlier efficient management and yields. Henry claimed his men
could show that neglect and abuses persisted, despite a few haphazard
reforms over the last six years. He announced that he was going to
undertake the wholesale reform of his inheritance.

Turning to the issue of 'emoluments', Henry pressed to be given one
in particular: the 'guardianship of wards', which he described as, 'at

present held by Lord Salisbury to his incredible benefit and influence'. Rich orphans and their assets – 'wards of the Crown' – were worth a fortune to the guardian. The Guardian of the Wards was not 'bound … to render account of income, but, after supplying the necessary and suitable aliment [to the wards], all the rest of the income is at his disposal; he also has the right to give both males and females in marriage to whomsoever he pleases'. The guardian could sell any of the wards' assets, if he deemed it necessary, to meet the wards' maintenance costs. The guardian retained as much of the proceeds as he could square with his conscience, for his trouble. It was an office with Dickensian-scale potential for corrupt exploitation. Parliament tried continually to have the office abolished. Henry's intention was to reform its use.

His request made sense. Henry's courtly college was created to breed up the next generation of generals and councillors. The wards, if they lived with Henry and his circle, would be nurtured under this same ethos. Henry intended to be a just and efficient guardian, but saw a chance here to increase his income, and at the same time, to grow his circle. The newcomers would be imbued with his values from youth and grow up to serve and obey him when he became king. Henry would bind the wards to him in childhood, if he managed their assets with honour. In return for protecting the wards from court predators, they would feel gratitude and affection for Henry. He would arrange marriages from within his circle. The ties would strengthen his royal 'affinity' between future king and future counsellors and courtiers. 'For these reasons, the Prince urges that an office of such weight should not lie outside the Royal House.'

The negative fiscal impact of all this mattered to the king. And a nebulous, elusive issue nagged at him as well. The changes Henry sought could provoke a shift of power and influence between the royal households. Knowing Henry, might king and Privy Council be financing a rival power base in Whitehall? On the other hand, James was enthusiastic for anything that underlined the legitimacy of his and Henry's title to the thrones. For this reason, the king warmed to one

particular scheme: the idea of a great state occasion to invest Henry as Prince of Wales in Parliament. He ordered Salisbury to examine the case for it.

Henry's Supper Tables

LUMLEY'S LIBRARY AND TAVERN WITS

As if the gods conspired to advance Henry's ambitions, his host at Nonsuch Palace, Lord Lumley, died in April 1609. Lumley's exceptional library, a resource for the prince and his tutors since they arrived at Nonsuch, passed to Henry. Should Henry succeed in his push to have full control of his princely inheritance, then he would be more than able to look after Lumley's beautiful books and manuscripts. Henry paid one of Lumley's librarians Anthony Alcock £8 13s 4d to catalogue the items, to ensure nothing went missing when he moved them. By July the bulk of the collection had been transferred to his principal palaces, St James's and Richmond.

James shared his son's excitement, offering to pay to improve the fabric of the library at St James's. Father and son added shelves and tables to display maps and manuscripts, and ordered new desks and chairs. They had the walls brightly painted and sent the books they thought especially significant away to be bound in red leather and tooled in gold leaf with Henry's arms, and 'HP' – *Henricus Princeps* – cipher. Adding Lumley's collection to the old royal library of Elizabeth I, Henry re-founded the Royal Library as the country's major archive of learned texts.

The library's science section included the standard authors on subjects as diverse as mineralogy, zoology, botany, ichthyology, mathematics, alchemy, and astrology. Of all the sciences, Lumley, like

Henry, loved geography most and had books showing routes that could expand the prince's reach across the globe. Contemporary accounts of voyages by Purchas, Hakluyt, and Ralegh, sat with records of the great modern historical voyages of Christopher Columbus and Amerigo Vespucci. Space was made for ancient accounts of journeys to Malacca, Ethiopia, Egypt, Persia and India, Tartary, Asia and Sumatra. Edward Wright, Henry's genius navigator and tutor, became the Science Librarian. He added to Lumley's core collection, gradually putting together a large, practical body of work on mathematics, cosmography, and navigation.

Lord Lumley's love of astrology and astronomy showed in his extensive collection of almanacs and treatises on the spheres. Henry's collegiate court had the classical astronomers, Ptolemy and Strabo, with their maps of the heavens and the earth. On cosmology, Aristotle, Philo, Pomponius Mela, and Cicero were all available for consulting. Under Henry's patronage, the contemporary cosmographers Thomas Lydiat and Johannes Kepler came to gather evidence to refute the Ptolemaic system of a static, earth-centred universe. Lydiat enjoyed the salaried post of his royal Cosmographer and Chronographer – the prince's mapper of the heavens and theorist of the nature of time. Henry added in his own books on religious themes and all aspects of the military arts. Books on these subjects, dedicated to him, arrived at court continually.

Henry's exceptional possessions formed the bank of materials. His prestige gave the possibility of funding for research, available pretty much nowhere else in England. Long-term inmates of the Tower, Sir Walter Ralegh and Henry Percy, Earl of Northumberland, had their own library and laboratory men came to use. But Prince Henry's collections would be the major centre of information in the future. Like the great library at Heidelberg in the Palatinate, and Tycho Brahe's island laboratory in Denmark, Henry's courtly college exerted a magnetic pull on some of the best minds in Britain and Europe. The library at St James's drew in scientists, explorers and 'projectors'.

Henry loved history. History analysed kingship, statecraft, national security, territorial expansion, prosperity, legitimacy and

the roots of the laws of England, and leadership in peace and in the wars – subjects of compelling relevance for a future ruler. The library's history section contained over 600 volumes on Greek, Roman, French, Italian, Spanish, German, Hungarian, Hebrew and world history. (Chaucer's *The Canterbury Tales* was catalogued under history.) Controversial authors, favourites of Henry's, like Tacitus, sat with approved (by James) writers such as Caesar and Xenophon; all of them mixed in with various ancient chronicles, and histories of England by living historians such as Sir John Hayward, who had written his history of *The First Part of the Life and Raigne of King Henrie IV* for the late Earl of Essex and soon began a history of the first three Norman kings for Prince Henry. This section of the library also housed the contemporary political tracts of men such as William Camden.

The influence of Cranmer, architect of the Reformation under Henry VIII, showed in the theology section. Its volumes were busily annotated with Cranmer's comments. Many books had both Cranmer and Lumley's names on the front page. Some were rebound in Prince Henry's bindings, drawing all three men together. The oldest book was Cranmer's eighth-century copy of Augustine, looted from Canterbury Cathedral.

Lighter material in the philosophy and belles-lettres section included Jodocus Willich's cookbook, a volume on *The Art of Magic* (1583) and a book of jokes. There was plenty of poetry, though nothing too lowbrow: no broadsheets, ballads or plays. So, no Shakespeare or Jonson dramas.

Masses of music books and manuscripts of works by Tallis, Byrd, chansons and motets by various hands; the scores of Ruffo and Gabrielli, waited for Prince Henry's musicians to pick them up. One manuscript was 'a song of forty parts made by Mr Tallis', *Spem in alium nunquam habui*. These were the sounds of Henry's world. He heard music every day. The twelve musicians who ended up on his payroll needed a huge repertoire of French, English and Italian romantic songs, new and old, madrigals, vocal pieces for differing numbers of voices. Henry added to them constantly. His household

processed one invoice after another for the 'pricking of books' for musical notation.

Once the Nonsuch library was settled in, the royal librarians pointed out gaps, decided what to sell – mostly legal and medical volumes and duplicates – and guided Henry to buy editions they lacked. Henry would acquire more books in the next three years than James did in his whole lifetime.

Men applied, implored even, for a place in Henry's household, adding to the hundreds here, who were causing Sir Thomas Chaloner such logistical and budgetary nightmares to accommodate. Sir Francis Bacon, philosopher and champion of modern science, wrote little advices to himself on how to get a toehold close to Henry. He was an ambitious politician, and yet another follower of the late Earl of Essex who was now drawn to Henry's court. One of the notes to self read: I am 'making much of Russell that depends upon Sir David Murray, and by that means drawing Sir David, and Sir Thomas Chaloner, [and] in time, the Prince. Getting from Russell a collection of phenomena, of surgery, distillations, mineral trials.' Thomas Russell was 'a mineral projector', an associate of David Murray and Thomas Chaloner.

Henry persuaded Chaloner to commandeer part of the Savoy hospital, on the Strand, in order to modify it for chemical experiments by those who were using his scientific books and instruments. Despite Bacon's well thought-out networking, his personal brilliance and connections to the old Essexians in Henry's household, his plotting did not manage to get him in.

Although a genius like Bacon failed, plenty of professional men, on lower rungs of the social ladder, were given a seat at Henry's supper tables. Especially if they amused him. Some of these newcomers were part of an expanding tavern society in London. Several attended a formal drinking club called the 'Fraternity of Sireniacal Gentlemen', or Sireniacs, which met in the dining rooms of the Mitre tavern in Fleet Street, or the Mermaid tavern in Bread Street. Thomas Coryate, 'traveller for the English wits', was their resident master of ceremonies. Their activities threw light on the tone of Henry's supper tables.

A tavern wit might be a member of the Inns of Court, an MP, one of Prince Henry's followers, or, say, an investor in the Virginia Company – and often several of these. Lawyer-orator wits, the bane of King James, and later Charles I, gathered round Henry. Ambitious overachievers of the middling sort, they competed for preferment. From Henry's circle, the Sireniacs included: Sir Robert Phelips, Richard Connock, Inigo Jones, Ben Jonson, Sir Henry Goodyer, Coryate, George Chapman and Sir Robert Dallington.

The tavern wits met to banter, dine and drink, and debate affairs of God and state, in an environment neither private nor public, court nor common, but halfway between the two. Beaumont's epistle to Ben Jonson captured the heady pleasure of those nights:

> … what things we have seen,
> Done at the Mermaid? Hard words that have been
> So nimble, and so full of subtle flame,
> As if that every one …
> Had meant to put his whole wit in a Jest …

They spoke with daring and freedom about the liberties they enjoyed as Englishmen, and those they lacked. Jonson contributed, by 'Inviting a Friend to Supper', promising:

> No simple word
> That shall be utter'd at our mirthfull board
> Shall make us sad next morning: or affright
> The libertie, that wee'll enjoy to-night.

They indulged in wide-ranging political discourse on the state of the nation, away from the ruling aristocratic elites. 'Libertie' was the watchword.

At one Mitre tavern meeting they held a *convivium philosophicum*. A classical Roman convivium was a satiric feast. Back from his travels, Coryate's role at the meeting, and at Henry's home, was to relax the guests and heighten the atmosphere. Sireniacs were expected to stay

poised between sobriety and drunkenness all night, as they explored an edgy mix of pleasures and poetic libels and the social and political tensions of the times. One thing was essential: the right to speak 'hard words' came with the use of 'wit' or 'jest', but not invective.

At this particular convivium, the Sireniacs discussed Henry and his growing frustration with the limits on his political role and power. One of them wrote a long anonymous poem afterwards, recalling all they said, and about whom. 'Prince Henry cannot idly liven,/Desiring matter to be given,/To prove his valour good.'

They added to the chorus criticising court decadence, sympathising when 'Suffolk seeking in severe sort,/The King his household to coerce,/Is still defatigated' in his efforts to restrain the king from his incontinent engorging of 'court Cormorants', such as Carr – flapping their 'silken scarves and their spangles' to attract his attention.

'Sweet-meats and Coryate' made up the last course at all court entertainments at St James's, as they did in the Mermaid and Mitre taverns. Coryate 'was the Courtier's anvil to try their wits upon, and sometimes the anvil returned the hammer as hard knocks as it received'. No one called Coryate a fool with impunity, except 'those who had as much learning as himself'. As a group, their preferred tone of competitive tavern banter would have bubbled up to enliven the aristocratic world of Henry's court. Hardly anyone lived at court full-time. When not on the rota to serve the prince, members of Henry's household moved back into these other worlds.

Such individuals, engaged in an exciting spirit of discussion, freedom of expression and movement, were nurturing the tentative shoots of a civic political nation, as an alternative to the aristocratic one. Returning to St James's, they connected Henry to the discourses of the wider Jacobean world, beyond palaces and courts. They could imagine working under King Henry IX, to reform the establishment along the progressive, Tacitus-inspired political lines they discussed in the taverns and at St James's. But if the circle around Henry thought and talked for change and political progress on these contractual, Tacitean lines, could the genie be put back in the bottle under a more conservative ruler?

Henry's Foreign Policy

'TALK FOR PEACE, PREPARE FOR WAR'

As Henry pushed ahead to enlarge his influence in the domestic sphere, on the Continent the Dutch and Spanish signed what appeared to be a significant truce. The Treaty of Antwerp of April 1609 proposed the unthinkable – universal peace in Europe. Yet less than twelve weeks later, James's Privy Council observed: 'it looks like there will be a dangerous war'.

The trouble arose over a messy inheritance in the Catholic German state of Jülich-Cleves in the Holy Roman Empire. The state lay on the empire's main artery, the Rhine, and close to the border with France and the Netherlands. It connected outlying northern Catholic territories with the heart of the empire. It also separated German Protestant territories, such as the Palatinate, from both the Dutch Republic and from the centre of the empire. It could disrupt communications between the Protestant states, while it protected Spanish supply lines up the Rhine to the Spanish Netherlands. All the benefits to the Catholic states reversed if Jülich-Cleves ever went out of Catholic hands. The whole northern Rhineland area of the Holy Roman Empire was so successful economically, and so divided into these small, very rich independent territories, that it was always vulnerable to attack. It was one of the most fought over regions of Europe.

Duke John William of Cleves was Catholic, but he ruled a mixed religious population. Feeling himself going mad, the duke invited the

Italian priest, Francesco Maria Guazzo, to treat him. An authority on witchcraft and demonic possession, Guazzo diagnosed 'possession' and administered the appropriate cures. The treatments failed. Guazzo said he got the initial diagnosis wrong and that the duke was in fact bewitched. In April, the duke died, more or less insane, without having named an heir. Seven claimants stepped forward: some Lutheran, some Calvinist and some Catholic. In July, the Holy Roman Emperor's pugnacious brother, Archduke Leopold, rode in secret to the fortified city of Jülich and occupied it, insisting he only acted to guarantee stability until the inheritance dispute was settled.

European Protestant leaders were outraged, convinced this was a covert move by the Habsburgs and emperor to annex Jülich-Cleves, in the same way Maximilian of Bavaria had taken possession of Donauwörth eighteen months ago. It was thought doubly suspicious since the only claimants 'whose pretensions were not absolutely ridiculous were Protestants'. The first of these was Duke John William's nephew, and future elector, the Margrave of Brandenburg. Behind him in line stood the husband of the late duke's younger sister, the Count Palatine of Pfalz-Neuburg.

As if to confirm Protestant suspicions, the Holy Roman Emperor, Rudolph II, chose this moment to gift Donauwörth permanently to Maximilian of Bavaria, as a fief, to offset the expense to Maximilian of guaranteeing peace in Donauwörth. Encouraged, Maximilian formed the militant Catholic League to help prevent further unrest in the empire. A tremor of unease threatened the nascent peace. Neither Catholic nor Protestant leaders in Germany wanted the menace of foreign troops on their soil. Yet each side needed and sought diplomatic endorsement. The Catholic League looked to Spain, of course. The Evangelical Union courted France, Britain and Denmark.

The great shaping force of Henry's European identity, as the likely leader of Protestant Christendom, affected the prince's everyday life. 'From all sides one hears about the great *Virtu* of the Prince, son to the King of England. But the world must wait a great while to reap benefit therefrom,' the Venetian monk, Paolo Sarpi said. 'For the King of England, however accomplished in the reformed religion, appears

for the rest not to be worth much: he would like to do everything with words.' That one of Henry's favourite mottoes was *Fas est aliorum quaerere regna* ('It is right to ask for the kingdoms of others') illustrated his attitude not only to taking possession of the New World, but also perhaps to Europe. It inferred he might see it as morally 'right' to overrun Catholic territories for the greater good of Protestant Christendom. However, in any war for the soul of Europe, the prince's power would depend on the strength of his position at home.

Henry waited impatiently for foreign intelligence to arrive from his travelling 'right eye', John Harington. 'I find every week,' observed Salisbury, 'in the Prince's hand, a letter from Sir John Harington, full of news of the place where he is, and the countries as he passes' through. Salisbury hoped Henry would in turn pass them all on to him. Harington told the prince he was in Austria, from where he reported on an imperial conference 'to settle the affairs' of the Protestant Germans. The Protestants wanted to negotiate 'greater liberty in religion', he said, but the meetings had stalled. There would be no treaty change. The imperial edict held, suiting the most powerful members of the empire.

Harington sent news from Frankfurt on 29 September. He was ill, unable to get out and pick up intelligence. 'The confused state of affairs here, affords but little subject and little leisure to write; except that the approaching war threatens both upper and lower Germany,' is all he could tell Henry. His old tutor, Tovey, was also sick, said Harington. At St James's they thought someone in papist Italy had administered 'a slow-working poison to' Harington and Tovey. 'Seeing they had no hopes of corrupting their minds' to idolatry, 'they might destroy their bodies.'

Henry wrote to 'My Good Fellow', hoping to amuse the invalid. 'I have sent certain matters of ancient sort,' he said, 'which I gained by search in a musty velum book in my father's closet.' It was a book on Harington's ancestry. 'It gave me some pains to read and some to write also but I have pleasure in over-reaching difficult matters,' he joked, whether it was delving into the roots of the Haringtons of Northamptonshire, or translating Tacitus at his friend's request. It

gave Henry pleasure to read about Harington's forebears and he copied out extracts to send him. 'When I see you, and let that be shortly,' Henry finished, 'you will find me your better at tennis and pike. Good Fellow, I rest your Friend, Henry.'

Health recovered, Harington resumed his homeward journey, crossing into France in the autumn of 1609. There he found Henri IV and Maurice of Nassau mobilising troops to go to the aid of the Protestants in Jülich-Cleves – a show of strength to warn the Habsburgs that any attempt to increase their power and influence in central Europe would meet resistance.

In October, with international pressure building, James stated gloomily to his Privy Council that England would have to send troops to join the French and Dutch. Yet, military activity was 'like to draw no less after it than a general War in Christendom', he concluded.

A cold war situation developed as Europe's key players lined up behind the two sides. Spain agreed to send troops to aid Leopold, on condition they would take command of the combined Spanish and imperial Habsburg forces. In December, having refused direct involvement with the Evangelical Union until now, Henri IV formalised a military pact with the Protestant princes.

Protestant Christendom now fixed on Prince Henry in England. 'Your Grace's name begins already to be spread through the whole world. I hope in God you shall follow the footsteps of … King Edward the third's son,' Edward, Prince of Wales, the Black Prince, wrote Sir Clement Edmondes, a Scots officer serving under Maurice of Nassau. Henry, the 'hope of the Christian world', would lead an English force to combine with the armies of Maurice and Henri IV. All the theory Henry had read and heard and debated in his military salon; all the exercises he practised with such vigour, would soon submit themselves to trial by sword.

From his pulpit in the Inns of Court, where he regularly invoked king and prince, William Crashaw urged: 'God hath appointed and anointed our Gracious Sovereign, and his royal issue, to hold up his religion in these declining days, and to give the Whore of Babylon that foil and fall,' from which she shall never rise. 'Hate the Whore,' he

shrieked, 'and make her desolate, and eat her flesh and burn her with fire.' Puritan clerics beseeched Henry to 'undertake [all that shall] be profitable to all Christendom ... to tame these damnable Monsters of wicked factions and pernicious sects'.

'[I] heard [Prince Henry],' said the godly MP Sir John Holles, 'confidently assever that there were now as many men and able, worthy spirits in England as were then [in Elizabeth's reign], who wanted but good occasions to put them to work to make them thereby as glorious as their forefathers.' This was the military salon of St James's courtly college in full voice. 'Neither closed he his eyes from what concerned us abroad, but entertained by his purse in sundry places as good intelligence as any we had, a rare vigilancy' in such a young man to be a spymaster.

Henry's friends were covering events in central Europe, but the prince needed an informant in Spain. In April, as the Spanish and Dutch concluded their truce, England's ambassador in Madrid, Sir Charles Cornwallis, wrote to Henry, full of news. Henri IV's forces had conducted a raid into the Spanish Netherlands and taken a few thousand cattle: 'Although it waked us a little out of sleep, yet it has not raised us out of our beds of rest.' Rather the opposite. Cornwallis stated that since signing the treaty, the Spanish were 'inclined rather to stand at mark and observe into what figures and forms ... other Princes and estates will cast themselves'. Spain wanted to keep the peace, said Cornwallis. Yet their involvement in the Catholic League was intensifying the crisis in Jülich-Cleves.

In the face of James's refusal to commission a regiment to march with Henri IV and Maurice, Henry received an anonymous tract, titled 'Propositions for War', outlining the virtues of military preparedness. 'By arms was laid the foundation of this state,' it reminded him. The politics and well-being of the country 'are best preserved from the same grounds they were first founded on'. Henry must consider entering just wars for the following reasons:

- 'Preservation of our own peace';
- 'a Venting of factious spirits': when a people cease to be fit for battle they rush 'headlong from arms to pleasures, and from employment to idleness'. This was the argument for militarised active citizenship, so popular at St James's. 'When people have no enemies abroad they'll find some at home';
- 'Instructing in arms our people': in case they are attacked and defend the state;
- 'Spoil of the enemy': these enrich the nation, and makes war self-financing in a way;
- Additional revenues from subjected territories, if they are colonised;
- Additional honour and title for our king;
- Increased dominion.

James always disapproved of such calls to arm. But he particularly disliked this one, coming at a delicate time in European relations. He asked the scholarly Sir Robert Cotton to rebuff it on behalf of the Crown. Cotton's argument against war was ten times as long as the propositions tract, crammed full of quotations drawn from the MP's extensive antiquarian researches. It was an anti-war jeremiad. A densely argued piece of overkill, Cotton's response was unlikely to shift Henry off course.

Henry's military salon at St James's saw that they, not Whitehall, formed a virtuous defensive front line, linking Prince Henry to Henri IV and Maurice of Nassau. Henry asked Ralegh to answer the anonymous pamphlet, to counter the king and Cotton. The result was *An Answer made by Command of Prince Henry to Certain Propositions of Warre and Peace, Delivered to his Highness by some military servants*. Unsurprisingly Ralegh seconded the 'Propositions for War', stating that Henry, if called, must never duck a war against the old enemy, Spain. Ralegh said that foreign war 'tended to remove the seat of blood from our own doors, and prove the cheapest school to train up in arms and better dispositions, [those] whose military skill may after serve to defend the state'.

In 1609 the playwright George Chapman, 'sewer-in-ordinary' in the prince's household, dedicated to Henry his translation of the twelve books of the *Iliad* – the epic tale of how Achilles saved the Greeks in their hour of need against an entrenched Troy. Although the king and Privy Council dominated government, Henry now focused a political counter culture and alternative policy.

Heir of Virginia

'THERE IS A WORLD ELSEWHERE'

For all his shrewdness and moral high-mindedness, Henry could be as obstinate and blinkered as his father when it came to enquiries into the probity of men *he* favoured. Although the prince initiated enquiries into abuses in the naval dockyards, he was obtuse when it came to Phineas Pett, his own shipwright, who was put on trial for corruption in May 1609.

Pett had built himself, and fitted out, a fine gentleman's house using supplies bought to refit navy ships. He estimated that to construct the *Prince Royal*, the first great warship commissioned by Henry and James, would require 775 tons of timber – and then ordered over double that amount. The scale of the fraud was colossal, though not unusual in the royal navy yards; private yards kept tighter accounts. From his stolen desk in his stolen room, Pett loudly defended himself to his young master.

The prince agreed to hear Pett plead his case before the trial. They met 'in the public view and hearing of many people' in a park at Whitehall. Henry took Pett by the hand as they walked and talked. James had decided he would come and sit in person to judge the hearing; so Henry decided that he too would attend, and defend Pett himself.

On the day of the trial, king and prince arrived at Woolwich. The examiners groaned. Royal interest made successful prosecution a nightmare. Pett entered and knelt before the king. James did not invite

him to stand. Henry intervened and proceeded to amaze the court with a torrent of technical information on the subject of ship-building, while insisting on Pett's innocence. He was fired by his own passion for the subject, and briefed by men like Ralegh and Ralegh's cousin, Sir Arthur Gorges, who had written *Excellent Observations and Notes Concerning the Royall Navy and Sea-Service* for Henry the previous year.

Half admiring his son's precocity, half overwhelmed by the detail, James dismissed the case. The prosecutors had gone for the wrong man. Challenging Pett challenged the royal judge of character. The king also employed Pett. Had they attacked Pett's superiors – the navy treasurer, Sir Robert Maunsell, or Sir John Trevor, navy surveyor, who presided over the corrupt naval administration – they might have had better success. In a rackety, buccaneering age, ritual, honour and formality often took the place of statutory regulation.

As Henry led Pett out of court, he crowed: 'Where be now these perjured fellows that dare thus abuse his Majesty with these false informations, do they not worthily deserve hanging?' He could be bumptious and immature at times.

Princess Elizabeth felt the changes in her elder brother, as he grew in confidence. She complained that he was not as readily forthcoming with her as he used to be.

'Though I do not respond to all the letters it pleases you to write me,' it is not a reason to quarrel, Henry told her. 'Being one day at a party consecrated to Bacchus and oblivion,' he could not reply, or meet to ride. 'Although my pen does not work at all, my affection will accompany you always, as much as my blood, which … wastes itself,' on distractions, 'being far from you.' She was as close as his own blood. Blood trumped any other connection.

The king and queen sensed Henry pulling away. 'Not at all ignorant of the disposition of their son, they would probably', ambassador de la Boderie believed, want to 'keep him … low, and so surrounded with persons dependent upon themselves, that it would not be easy for him to emancipate himself.'

Could they, though? Because, what was plain to all was that his courtly college had grown arms and legs and moved away in a direction not anticipated by the king and Privy Council. James could have influenced matters, but he did not give himself the opportunity to do so. He expected his royal wishes to be followed, but had grown lazy in middle age about making sure they were. Rising sixteen, Henry was a mix of contrary impulses. On the one hand was his idiotic and embarrassing shielding of Pett. On the other, he was profoundly committed to reforming and renovating the navy, and ridding it of the type of abuses Pett embodied. Henry understood a modern navy to be essential for the defence of the realm and Britain's commercial expansion across the high seas. At home, Henry wanted to spend time with his family and concentrate on reforming his domestic estates. Looking out to the greater world, he wanted to pour money he did not have into overseas exploration and embark on heroic maritime expeditions to build a New Jerusalem.

In the spring of 1609 the king reissued the Virginia Company's charter in the hope of reinvigorating interest in the project. The little palisaded settlement of Jamestown on the edge of the depthless Virginia forests needed to attract more support from the homeland if this latest attempt to found British America was not to go the way of Ralegh's Roanoke. (In 1590, when resupply ships returned to the island, they found the colony deserted, and no one ever saw the settlers again.) The new charter transferred more control from the Crown to a group of private investors ('adventurers'), who paid £12 10s per share. James retained ownership of all the land. The company could more or less do as it liked with it. They would pay an agreed percentage of any gold, silver and copper they found to the king and his heirs. James assigned the Council of Virginia a high degree of independence regarding the day-to-day governing of the colony. Active interest in the growth and ethos of the colony soon centred on Henry and his court.

Throughout the early months of 1609, publicity material streamed off the presses, boasting that the new Virginia project offered the

satisfaction of God and gold combined. Robert Johnson's sermon, 'Nova Britannia', presented the settlement as necessary to the Protestant mission to 'advance and spread the kingdom of God, and the knowledge of His Truth, among so many millions of men and women, savage and blind'. Permanent settlement promoted 'the honour of our King … enlarging his kingdoms'. Evoking America as an extension of England and the English Church, Johnson described it as an 'earthly paradise', a Garden of Eden for the elect nation to claim and possess. Virginia was lying there, 'offering most excellent fruits by planting'. His excitement was palpable.

'Divine testimonies show' that 'the honour of a King consists in the multitude of subjects, and certainly the state of the Jews was far more glorious by the conquests of David, and under ample reign of Solomon, than ever before or after'. James had taken on the image of Solomon. That left Henry to be their David, whose 'just conquest by sword' of America, would be 'honourable' not only 'in the sight of men and ages to come, but much more glorious in the sight of God'. If it came to it, they must be ready to fight for the soul of America.

Henry eagerly 'put some money in [the Plantation] so that he may, when he comes to the Crown, have a claim over the Colony'. He wrote to Maurice of Nassau to ask if Sir Thomas Gates, a patentee of the Virginia Company, might obtain a one-year leave of absence from his service and go to Virginia. The financial commitment of high-profile men such as Prince Henry, Salisbury, Pembroke and Southampton helped attract would-be migrants and investment capital. From Henry's circle, Ferdinando Wenham and Ralegh's distant cousin, Ferdinando Gorges, signed to go. Both had relatives serving Henry. Edward Fleetwood, related by marriage to Chaloner and Foulis, also prepared to sail with Gates.

James, meanwhile, trod carefully; the whole enterprise directly challenged Spain's claim to own all of the Americas and King James's cherished hope for a Spanish infanta for Henry. Don Pedro de Zuniga, Spain's ambassador in London, was horrified by the project. 'There has been gotten together in 20 days a sum of money for this voyage,

which amazes one,' he said. 'Among fourteen Counts and Barons, they have given 40,000 ducats; the merchants give much more; and there is not poor little man, nor woman, who is not willing to subscribe something for this enterprise ... They are negotiating with the Prince that he shall make himself Protector of Virginia, and in this manner, they will go deeper and deeper into the business.'

Salisbury, himself an investor, asked Queen Anne to persuade the king to give Henry his head over the colonial enterprise, 'there being diverse knights and esquires of the best sort and great livings, who desire this society and to be adventurers under the Prince, at their own charge'.

At the beginning of June 1609, nine ships set sail with 500 emigrants. For some, the voyage was catastrophic. Two of the ships, including Gates's *Sea Venture*, wrecked off the coast of Bermuda. It took months to rebuild them.

Rounding Cape Henry at last, in the spring of 1610, Gates's new ships set a course up the James River. At Jamestown a 'strange and unexpected condition' silenced them. The rest of the flotilla had offloaded their settlers months earlier and returned to England for supplies. 'Never was there more need of all the powers of judgement, and ... knowing, and long exercised virtue, than now to be awake.' The township resembled the 'ruins of some ancient fortification ... the palisades ... torn down, the ports open, the gates from the hinges, the church ruined and unfrequented, empty houses ... rent up and burned' for fire wood. It looked like Roanoke all over again, except shapes moved in the corners.

Spectral human shadows drifted towards them, across ground gnawed bare by human desperation in the worst winter they had ever known. Out there, somewhere, 'the watching, subtle and offended Indian' sat it out, letting starvation, despair, and pestilence do their work. Yet again, England's mission to Virginia, to build a New Jerusalem in the Garden of Eden, had ended in failure. 'Nothing presented the wrath and curse of the eternal offended Majesty [of God] in a greater measure' than what had gone on here.

For these settlers, living Henry's fantasy, the experience of cutting free of the restrictions of their everyday life in England had clearly brought other problems. So completely had they cut loose that no social coordinates remained by which to set a path when the catastrophe of famine hit the fledgling colony. Gates and the others looked at the bones of body parts and wondered: did the Indians do it? Was it animal attacks? Or – and this was the thought that silenced them – had the settlers made abattoirs of each other's little wooden homes and eaten each other? All they knew was something terrible had happened. The usual mortality rate among settlers was a shocking fifty per cent. The winter of 1609/10 took this number up to around eighty per cent. Gates had to think how to redeem this situation.

At home, ignorant of all this – first, due to poor communication, and then in case the news spread and panicked investors – Henry's court continued to receive copies of the fantasy literature of the New World. The English translation of Lescarbot's *Nova Francia*, addressing Henry as the 'Bright Star of the North', avowed: 'your poor Virginians do seem to implore your Princely aid, to help them shake off the yoke of the devil, who hath hitherto made them live worse than beasts, that henceforth they may be brought into the fold of Christ'.

The 'poor Virginians', the indigenous American population, looked fine. The new Virginians struggled. Virginia now haunted Protestant dreams. In that psychodrama, the founding of British America played out as an apocalyptic event in the history of the Reformation. At his baptism in Stirling, Henry had been hailed as the instrument to perfect that religious reformation, in part by establishing the New Jerusalem. He now felt ready to fulfil this destiny.

PART THREE

Prince of Wales

1610–12

TWENTY-ONE

Epiphany

'TO FIGHT THEIR SAVIOUR'S BATTLES'

Whitehall Palace, 6 January 1610. The Feast of the Epiphany. Against the king's wishes, Prince Henry appropriated the court's Twelfth Night show. He invited the court for 'barriers' – a competitive display of martial arts – to discover 'where true Virtue triumphed most'. Two opposing groups of knights, one led by Henry, would test their virtue by fighting with swords and push of pike across a wooden partition (the 'barrier'). One of the most important days in the church and court calendar, the Feast of the Epiphany celebrated the revelation of the Christ child's divinity to his human parents.

Around nine o'clock that night, over 500 people – courtiers, servants, armed guards, clergy and foreign dignitaries – poured into the banqueting hall. The audience skirted the wooden barrier bisecting the room and elbowed their way up the scaffolds towards the best vantage points. Court ladies – draped in gold chains, up to fifteen feet long, and embellished with cabochon gems and gold enamelled flowers and animals – settled in their seats. Heavy brooches swayed in the ladies' wigs. Men fingered their rings, ropes of pearls, earrings and hat jewels. Magnificence made statements that could be swiftly lost to cutpurses, operating even here.

Inigo Jones had created backcloths, painted with wild hills and rocks, and mock fortifications, to reach to the beams at each end of the chamber. A little apart from the raised platform, with its canopies

of state hanging over the empty chairs awaiting the royal party, Jones had constructed a 'sumptuous pavilion'. Here the 'Prince and his associates', all 'strangely attired', sat talking – among them, the English earls of Southampton and Arundel, and Sir Thomas Somerset; the Scottish Duke of Lennox, Lord Hay, and Sir Richard Preston. Eyes flicked back and forth, wondering if Henry's dais vied for prestige with the royal stage.

Drums and flageolets announced the king, queen, Princess Elizabeth and Prince Charles. They headed to the raised platform at the end of the room, an entourage of intimates buzzing behind each royal person. Courtiers observed Carr lean in close to James as he settled on his chair, then they looked to the other two leading royals for their reaction. The queen and Henry snubbed Carr when they could. So many dramas to enjoy, all good copy for the playwrights and gossips.

A nimbus of ostrich feathers billowed out a yard from the carved eagle on Henry's headdress. Jones had fitted him out with leather doublet, short, tight-fitting hose and 'a livery of crimson velvet and broad gold lace' in a costume that referenced a 'fantastical' mix of Roman centurion, godly knight, Italian Renaissance and Jacobean prince. Tonight, Henry was 'Moeliades'. The prince had commissioned Ben Jonson to write the introductory speeches for the 'barriers' and the dramatist had found the name in an old Arthurian chronicle. Moeliades was an anagram of *Miles a Deo* – God's soldier and Christian crusader. Henry liked it. He would adopt the character again.

It was Henry's desire to showcase the martial face of monarchy that had led the king to try and refuse his eldest son's request to fight this evening. With Europe divided by religious tensions and James positioned as Europe's peacekeeper, Henry's spectacle broadcast the wrong message. But James always struggled to refuse anything to those he loved.

The Lady of the Lake walked out to start the entertainment and greeted all the glories, riches, beauties, 'ornaments of council, as of court', back after years of neglect in the twilight of the Elizabethan era.

Her gaze fell on a beautiful young woman, playing Chivalry, sprawled dead on the floor. The 'house of Chivalry' is 'decayed,/Or rather ruined seems', said the Lady.

On the walls, the martial ornaments of kingship, 'shields and swords', hung 'cobwebbed and rusty'. Unbelievable in England, 'not a helm affords/A spark of lustre' which used 'to give/Light to the world, and made the nation live' in the hearts and minds of all Christendom, in Elizabeth I's heyday. Who would restore England's virtue, she wondered?

From a seat in the heavens, King Arthur interrupted. The first ruler to create England from separate warring little kingdoms, Arthur assured the Lady that England's virtue was secured by the one 'that doth fill that throne': King James. As an exemplar, Arthur recommended 'men should him take,/As it is nobler to restore than make'. James fulfilled Merlin's prophecy that England's greatness returned with Union. In the king's imagination he had restored the four kingdoms, to create the legendary Britain. Therefore, King James's virtue outshone Arthur's, or Henry's.

That said, Arthur thought any future 'great work', in this tense political and religious climate, called for a 'knight', not a peacemaker. Let a soldier 'tempt fate', said Arthur, 'and when a world is won,/Submit it duly to this state and throne,/Till time and utmost stay make that his own.'

Ben Jonson had to avoid assigning all of James's gifts to the past, while assigning all of Henry's gifts to the present and the future. That would be a fatal lapse of masque etiquette. Yet when Merlin, wizard prophet of Old England, came on, he too identified Henry as the virtuous hero of Protestant Europe. The very Earth reacted to Henry. For such men 'she shakes', said Merlin. 'Mankind lives in a few.'

Signalling the king's priorities, Merlin advised Henry that his 'arts must be to govern and give laws/To peace, no less than arms'. Follow the example of Edward III, father of the Black Prince, said Merlin. From the wool trade, he earned 'millions' for just wars, and to relieve 'so many poor'. As long as 'industry at home do not decline' they will

'need no foreign mine'. So much for Henry's ambition, to go aggressively into colonisation and Atlantic trade.

Henry could argue that the wool industry, as everyone knew, had stagnated. Therefore, England did need a 'foreign mine'. Besides, they came today for a display of 'the martial' arts, not a lecture on the economy.

Merlin admitted that if Henry had 'to fight their Saviour's battles' for the soul of Protestant Europe, then an exemplary line of heroic royal commanders preceded him. Richard the Lionheart let 'rivers of blood'. Edward I made 'the field a flood' of blood, then marched 'through it with St George's cross', badge of chivalry, and Garter Knights before him. Jonson compared Henry to Henry V, the prince's namesake. The two Henrys were also physically alike, said Jonson. 'War knew not how to give him enough to do.' Our Henry 'shall succeed him both in deeds and name'.

Citing precedent, using metaphor and allusion, Jonson's artistry clothed Henry's contemporary ambition in historic and mythic arguments. There was nothing antique and quaint about this. Talking about the present in the language of a mythic past was a tool of the sort of hard-nosed rhetoric of persuasion that Henry was educated to deploy. Jonson's vision foresaw a monstrously heroic Prince Henry, wading a whole field of blood behind the flag of St George – soon perhaps, if the crisis in Jülich-Cleves in Germany turned into full-blown war.

Merlin called now on God's knight 'Moeliades!' to prove his mettle.

Henry and his companions descended. Attendants clattered out with burnished weapons, shields and banners into the centre of the hall. The combatants set to, and continued the whole long night. Henry never once left the floor of the chamber, fighting with sword and a pike sixteen feet long. His skill, vigour and aggression insisted, blow on blow, shove on shove: he had come of age.

Next evening, washed and rested, Henry rode to his father, accompanied by his fighting companions. With flaring torches and music, they escorted the king through the dark streets of Westminster to Henry's palace at St James's. The Prince's Men performed a play. Then

servants bustled about to lay up a table for over a hundred guests. Henry awarded prizes to the most skilled fighters and feasted until gone three in the morning.

All this activity followed on from Henry's '*Oratio Serenissimi Principis ad Regem*' – the prince's address to the king. It was Henry's valediction to formal education. A student's oration was his rite of passage from theory to practice, from schoolroom to the adult world. Henry composed his along lines laid out by the epitome of public speaking, Cicero. Described by others continually, a few months ago he had described himself to the court in his own words.

Henry started by praising his father as his role model, in the hundreds of private conversations between them 'concerning the pre-eminence of letters'. You, 'supplied [me] with the central planks of reasoning, on which [I] constructed the building' of his vision of himself, said Henry. 'The golden books' of *Basilikon Doron* and *The True Lawe of Free Monarchies* showed Henry that, 'the fame of Kings' in learning, is essential for 'the health of the common weal'.

This 'fame' earned a prince his 'absolute rule over free and willing subjects'. Erasmus had said 'absolute rule' was only possible and did not become tyranny if it was exercised over 'free and willing subjects'. You must rule superbly to rule supremely. Henry and James differed on how to win their kingly 'fame'. Henry said that monarchs should not be 'bound fast by the chains of laws and decrees'. That part of him sat uneasily with those among his circle who imagined a more constitutional monarchy for the future Henry IX secured, but bound, by laws.

To rule well, Henry said he must master four subjects: philosophy, eloquence, politics and history. As his father's son, he had clearly absorbed the philosophy of a divine right monarchy. As a product of his more immediate educational context, he had taken on Tacitus and neo-Stoicism. This broad philosophical training gave self-mastery over the passions when wielding power, a quality 'required more in a prince since he exercises … [power] for the greater good of the public'. Rule for the benefit of the commonwealth gave a context for a monarch's exercise of absolute power. Henry's view was stronger than

his father's in recommending constancy, rectitude, and the wearing of an unreadable mask.

As for eloquence, he said rhetorical skill helped rulers to direct judges, preside over councils and intervene effectively in Parliament – to 'restrain all sedition, factions and those passionate impulses … for internal dispute' in peacetime. As Henry IX, he believed he would dominate his legislature, bending it to his will through his virtue and powers of persuasion, not by issuing edicts from on high. In times of war, eloquence let the king rouse the people, to 'impress courage and military strength on the nation'. Henry was stepping out with self-assurance from under the king's shadow.

'Does the Prince wish to preserve the laws?' Henry asked next, addressing the subject of politics, 'to assign rights and to rule the people with supreme power [imperium]. Politics will give this.' James talked of kingcraft more than the political process as such, especially as conducted in parliaments.

Henry's courtly college wanted to hear the heir declare that he valued politics. Senior statesmen such as Salisbury encouraged Henry's active political involvement. He invited Henry to sit in on the adjudication of a dispute between the Merchant Taylors' Company, of which Henry remained a member, and the Mint. Salisbury said it would be full of 'so many things of Civil Policy' vital to 'that Excellent Mind, moulded (in his own due time) for the Government of Kingdoms'.

Salisbury believed a princely education must include consistent participation in the political process, so Henry could feel it in his heart and guts, not just his head. The earl anticipated seeing Henry IX in the Privy Council daily, unlike his father. This might lead to the next king accepting the need for contractualism in the relationship of ruler and ruled, to nuance his absolute monarchy.

James, clever as he was, never 'got' England and the English style of governing, in the way he mastered Scottish kingcraft. When the English Parliament frustrated him, he withdrew, and left with his coterie of intimates, to hunt, feast and hawk in country houses and royal hunting lodges across the south of England. They were gone for months on end. Living half the year away from the capital, governing

by despatch, delegating to chief ministers, meant certain chronic problems that required the monarch's continual presence and immediate response were not addressed. Salisbury wanted to correct that in the next generation. James thought the business of kingcraft centred on study, reading wide and deep; he was essentially Platonic, believing rulers should be philosophers. Henry of course inclined to a more robust, empirical method.

Sir Charles Cornwallis, now seeking a position in the prince's household after returning from Madrid, also contributed to the debate. He proposed to Henry that, to protect their interests, 'princes may' even 'touch upon the verge of vice' in their political dealings. Henry thanked Cornwallis for his 'observations' and asked him to keep him abreast of any more 'in that kind, as occasions shall be offered'.

Robert Dallington, friend of Cornwallis and one of Henry's unofficial tutors, added his view, explaining the kind of 'vice' necessary to the virtuous exercise of power. Cicero's maxim, that the only profitable path was the honest one, was 'too strait-laced', he told Henry. In the book he dedicated to the prince, Dallington urged 'a middle way between ... [honesty and utility] which a right statesman must take'. Drawing on an infamous passage from Tacitus, Dallington observed that 'actors must of necessity wear vizards, and change them in every scene'. By extension, it was the same for rulers, also obliged to live on national and international stages. The 'good and safety of a state' being the goal of everything they do, it was a goal 'to which men cannot always arrive by plain paths and beaten ways'.

Dallington called this prudential politics, by which he meant, use a moderate, principled deceit that does not injure your virtue. Serving Henry for no reward to date, this book earned Dallington a pension for life from the prince. Henry and his political circle envisaged a government model which made use of judicious dissimulation, and small calculated amounts of artifice: core skills for a prudent monarch. You just had to know when you should tell lies.

In his childhood, Henry's 'outward shows' had reflected his father's ideas. Since then he had been introduced to quite different models

and ideas. These steps towards independence need not mean Henry would pose a challenge to his father. He could 'dissimulate', or 'wear a vizard', if he needed to.

Yet, they were all secretive, these Stuarts. James was known for it in his youth, and so were his sons. Henry learned how and when to best use concealment and bluff from statesmen such as Dallington and Cornwallis, his study of Tacitus and Stoicism, as well as from the king. Living on a public stage, he surely developed an instinct to guard his privacy. Charles, who was with Henry as much as six months of the year, also took in these lessons and discussions. Dallington eventually moved to serve Charles. Thirty years from now, Charles I perverted their ideas of mixed prudence, secrecy, principled deceit and aloof neo-Stoic constancy, to appalling ends.

Henry ended his 'Oratio' with a discussion of history. 'Any member of the public will take great delight in' history, said Henry. But a prince sees himself in it, 'his affairs born by another person'. The prince 'reads about the beginnings of wars between the most powerful rulers and bellicose nations, he observes arts and strategies of excellent leadership', and sees how he might act in that role. Everything in the education of a prince was a grounding for the art of ruling. The aim was not to turn him into the embodiment of chivalric virtue, almost his own statuesque work of art, but a dynamic modern king, learning from the recent and distant past about how to act in the present.

Having made some headway on the estates due to him, Henry returned to the question of his investiture as Prince of Wales. He summoned Richard Connock and ordered him to revise Dodderidge's survey on the Prince of Wales's assets. Connock produced a knockout report. It demonstrated how all previous princes of Wales had received their lands by the age of fourteen. It listed his possessions, along with, as Connock stated, 'reasons which moved the kings in former times ... to create their sons Princes of Wales ...'. which collections may serve as an inducement for the more speedy creating of Prince Henry'.

Connock added a personal comment on Henry's assets: the Crown had permitted a degradation of Henry's inheritance which 'must need

within a few years fall into such an irrecoverable corruption, as …
yields no hope of help'. Broadening his view, Connock stated that
when 'a state is brought to' 'irrecoverable corruption', so that 'in rest-
ing or adventuring the peril is the same, much better it must needs be
to enter into action' to reform it. He wrote with passion, in a bit of a
sweat. He dreaded the anger of the king as he argued him out of lands,
income and influence; criticised corruption in Henry's estates as well
as in the 'state'; and recommended radical reforms in the prince's
territories, while inferring a need for greater reforms to address the
corruption of the body politic. In his preface, Connock sensibly
begged Henry to protect him.

Henry thanked and rewarded his man. He assured Connock he
would 'imitate and follow the steps, worthy virtues and renowned acts
of his predecessors, Princes of this kingdom'. He sent the report to his
father, and to Salisbury. Henry said he 'will rather trust your Lordship
with the care of his creation than any other'. Salisbury decided to
make a virtue of necessity. The status quo needed a shake-up. The
present structure of Crown finances was collapsing under the weight
of expenditure and mismanagement from both sides: Crown and
legislature. A change at the top could trigger a major renovation of
royal financial affairs.

Although Henry was the driving force in the debate about his crea-
tion as Prince of Wales, his father soon agreed with him. The scholar
in James appreciated and used Connock's researches to help draw up
another list of a Prince of Wales's assets. Henry came to Whitehall
more often. Lobbying on behalf of his own favourites, exerting what
influence he could in naval and military matters, canvassing support
for his investiture, 'he makes himself already very much respected and
even by our greatest men in authority'.

'The Prince now begins to take a great authority upon him,' one
experienced diplomat told his secretary, 'many men out of the preg-
nancy of his spirit do make many descants of many things that may
hereafter ensue.'

<p style="text-align:center">*　*　*</p>

King and prince needed Parliament's consent to the parliamentary setting of Henry's installation as Prince of Wales. The king assumed he only had to state his wishes. For this reason, he reconvened Parliament in February 1610, arriving with Henry, Salisbury and other senior councillors. The king told MPs he required them to vote for Henry's parliamentary investiture, but also to vote a subsidy (to cover his current financial embarrassment). Salisbury, meanwhile, planned to use the goodwill Parliament felt towards Henry to smooth the passage of some unpopular fiscal reforms.

Salisbury needed Parliament to acknowledge financial reality. The monarchy could no longer live 'of its own': income derived from its dwindling assets and one-off taxes that tax payers tried to avoid. Parliament must guarantee the Crown annual support. However, Salisbury knew that if the king expected regular funding, then Salisbury needed James to admit he owed his parliamentary paymasters a degree of accountability for his spending. It would involve a real change of relationship between Crown and legislature. It would inevitably draw monarchy and Parliament closer together through the need to call frequent, regular parliaments to assess Crown needs, discuss how to fund them, and find out what Parliament expected in exchange for its support. The framing of the words for a bill to reform royal finances 'infinitely troubled' Salisbury. He 'toiled' to exhaustion to think how 'to induce the Parliament to yield some large contributions for the maintaining of future charges'.

Henry listened as his father addressed both houses. 'The time of creation of my Son doth now draw near, which I choose for the greater honour to be done in this time of Parliament,' he said. He knew how popular Henry was throughout the country. Radical MPs waited for the right moment to object that the king could not 'choose' the conclusion of what Parliament must first debate. James waved a hand at Henry. 'The sight of himself here speaks for him.' The king waited for them to agree to make Henry's creation a parliamentary state occasion.

The house did not mean to answer until they aired their grievances about royal finances. If Salisbury hoped Henry's popularity would

ease the passing of his bill on annual grants for the Crown, he was alarmed, but unsurprised, when Sir Thomas Wentworth MP demanded to 'what purpose is it for us to draw a silver stream out of the country into the royal cistern, if it shall daily run out thence by private cocks?' The house roared approval and disapproval of a subversive, very Jacobean, jibe at the king's bedchamber coterie.

The king must tighten the lacing on his purse, not leave it gaping at his belt, for favourites to dig in and grope about for gold. Before they came here today, Salisbury had alerted the king to the discontent caused by 'the harsh effects and ill order of your Majesty's gifts'.

As if to prove the MPs' point, James had just taken back Sherborne from Carr and gifted it to Henry, as the prince wanted. James then compensated Carr for his loss with a hefty £20,000 – 250 per cent more than he had already given Lady Ralegh to compensate her for its loss. Technically, almost none of that money was his to give. The Crown had borrowed it, and the king's creditors expected him to be prudent and use it for the commonwealth, not the wealth of 'private cocks'.

'Our gift I wish liberal,' said Sir John Holles, and 'the King's expense moderate, for unless the drain or outlet be stopped, be the inlet never so large, we may pour in but never fill ... The court is the cause of all.' Holles supported Henry and sat as a Puritan MP. A growing number of this kind of court parliamentarian looked to Henry, hoping he could reform court corruption. Like and approve Henry as many did, members queried the necessity for their involvement in Henry's installation as Prince of Wales. It would cost (another) small fortune. But James found their cavils impertinent.

The Commons presented the terms James must agree to before they could strike a deal. Most turned on the Crown giving up revenue streams raised by royal command, the king's prerogative, not via parliamentary process. James withdrew in anger. As a man, he loved jokes and debates as well as the next person. But to him the rude banter he had been subjected to trespassed on the sacred mystery of the absolute monarch.

*　*　*

In the bedchamber, Carr's whispering campaign stoked James's wrath. He said the Commons wanted to make voting supply dependent on the king sending home his Scottish intimates. Carr hinted Salisbury knew and condoned the MPs' terms. The king exploded with rage. So did Salisbury – as he noted a new, overt political intrusion from the bedchamber.

Henry and his mother loathed some of the pretty and amoral young men around the king, bleeding the state of money and exposing the monarchy to this mockery. With an adult prince to shield them from a Whitehall backlash, some of Henry's servants went into print with their dim assessments of the king's 'private cocks'.

Ralegh's cousin, Sir Arthur Gorges, urged Henry that when he ruled he must cut the number of parasitical gallants at court 'on whom the king your father hath bestowed great and bountiful gifts'. Since princes 'have more means, and opportunities to express their worthiness and virtue', said Gorges, Henry was morally bound to intervene and halt this 'decay' in the body politic. If Henry attacked the court favourites head on now, he would move his household into active opposition to the king's court, and likely alienate himself from Whitehall power. The time was not right. Besides, it was not in his nature.

Salisbury shelved the question of the royal budget for the moment. Parliament assented to a parliamentary setting for Henry's investiture, eventually, which would take place on Monday, 4 June 1610, the Feast of the Holy Trinity. Salisbury secured a loan of £100,000 from the City of London for Henry's big day. From the moment of its agreement, European rulers and their representatives started communicating their plans to mark it.

Prince of Wales

'EVERY MAN REJOICING AND PRAISING GOD'

In March 1610, Henry welcomed his cousin, Frederick Ulrich, Prince of Brunswick. There had already been 'familiar discourse between one another, with an equal affection' by letter. Now they expanded on it at their leisure, face to face. Court gossip was that Brunswick wanted 'marriage with the Lady Elizabeth'. Queen Anne liked her nephew well enough, but dismissed his pretension to marry a princess of England.

Another of the prince's friends, Frederick, heir of the Elector Palatine, wrote from Heidelberg to announce that his cousin Duke Louis Frederick of Württemberg was coming back to England, ostensibly to celebrate Henry's investiture. Young Frederick sent Henry his salutations in his own hand, but little else. It was too risky to expose his innermost thoughts on the religious and territorial tensions building up in Europe, and what action Henry and Frederick thought the countries they stood to inherit should take. Frederick trusted Württemberg to speak for him, as Henry trusted John Harington.

Henry was determined not to be prevented from meeting the duke this time. With the Jülich-Cleves crisis ongoing, Frederick's father the Elector Palatine and Duke John Frederick, ruler of Württemberg, leading lights in the Evangelical Union, wanted to press England for some written commitment to the alliance. The

foreign visitors also came to ask for Princess Elizabeth's hand for the young Palatine heir.

As news of the Brunswick and Palatine marital diplomacy spread, more offers came in for Elizabeth, including from the heir to Charles Emmanuel of Savoy, the wealthy Catholic Prince of Piedmont. Savoy was moving into closer alliance with anti-Habsburg Catholic France, to counter the Spanish presence in the Italian peninsula. Fearing the ambition of the Habsburgs (with Habsburg-dominated Milan on her eastern border), Savoy sought marital alliances to strengthen its ability to resist Spain and the papacy.

Württemberg's party arrived in April and took rooms at the Black Eagle inn on the Strand. It suited James to grant them their audience. As the Palatine delegation entered the Palace of Whitehall, they were greeted by the full spectacle of Stuart majesty – the king 'seated under a canopy of cloth of gold, together with the Queen, the Prince [Henry], the Duke of York, the Princess [Elizabeth], Madame Arbella [Stuart], and the Prince of Brunswick'. Around them stood 'a great number of earls and lords of England – all Knights of the Garter'. Nobles and ladies speaking, servants coming and going and the sound of music filled the rest of the room.

The French ambassador, de la Boderie, hurried over to Württemberg to discuss the German crisis; the Prince of Brunswick followed him, and the ambassadors of the States of the United Provinces (Messrs Berck, Verius, Oldenbarneveldt, Joachimi and Carron) presented themselves after him. A few days later, Queen Anne sent two coaches to bring Württemberg for an evening audience, and to pick up gossip on her European extended family. At the end of the week they were joined by Württemberg's cousin, the young Landgrave of Hesse.

In the run-up to Henry's investiture, the young men rode and ran at the ring. They hunted and joined the king at Royston to course for hares, a sport 'in which his Majesty takes extreme pleasure'. 'Though the beast be but little, yet are the members worth enjoyment; as the flesh, which is good for all manner of fluxes; the brains good to make children breed their teeth with ease,' and myriad other health benefits.

Henry suggested a visit to Eltham Palace to see the laboratory of Cornelius Drebbel, the scientist and inventor Chaloner had persuaded to come and work for Henry. Around the workshops stood prototype machines, each having the potential to become the invention to secure Drebbel's immortal fame. Drebbel displayed his beautiful 'perpetuum mobile' clock to the youths, showing how it revealed secrets of astronomy. But he evaded direct questions on its mechanism, enjoying the aura of hidden knowledge that the apparently inexplicable spectacle lent him. Across Europe, engineers and experimenters, 'mechanicians' as they were called, tested the theory that an ordered universe implied someone imposing order on it (the argument for the existence of God from intelligent design). If Drebbel could prove it, his reputation was made, and he would be the gatekeeper who let men see the workings of the deity's mind.

In more prosaic activities, he was already a master of the engineering of lens-grinding to make spyglasses and techniques to pump water under pressure. A natural showman, Drebbel cultivated anything that added to his mystique as a type of scientist-magus. It was that combination of science and mysticism that men like John Dee combined in the previous reign. Drebbel asked Henry for permission to hold a lottery to raise money to fund his work. Already supporting Drebbel, Henry gave him another £20 for his expenses.

Hosting his princely European cousins, Henry was 'exceedingly magnifique and stately in all his doings, and principally in feasting of great persons', observed his Groom of the Bedchamber, 'giving them all manner of contentment, that they could have desired of him'.

At the end of the St George's Day Garter feast, the king stood, head uncovered, and 'drank to his Excellency' the Duke of Württemberg, 'and the health of the Princes of the Union' gathered here. The princes took every chance to talk freely, thinking how to make progress in the negotiations to bring England into the Evangelical Union and how the union and its allies should react to Jülich-Cleves.

* * *

On mainland Europe, events sped ahead of James's intentionally glacial diplomatic pace. By April 1610, Maurice of Nassau and Henri IV of France had mustered thousands of troops to march on Jülich-Cleves. With or without the Stuarts, they must force Archduke Leopold out of Jülich and deter the Spanish Habsburgs from interfering.

English soldiers and diplomats in Holland queried James's reluctance to let them join the Franco-Dutch force. The consensus in Holland was that delays gave Leopold 'a great deal too much time' to secure himself in Jülich. Lack of instruction from London 'may protract the Cleves business while our King is amused by' his favourites, the lively young German princes, and marriage proposals for his two older children. 'It is now time for action not deliberation,' they snapped.

Dutch deputies 'bound for France passed Brussels in great lustre, but those sent for England make little show'. Henry badly wanted command of a British force. He 'was athirst for glory if ever any Prince was. He lent fire to the king in the affairs of Germany, and aspired to be head of the confederate Princes', of the union, 'who include fourteen of the Hanseatic towns'. Since Henri IV signed his military pact with the Evangelical Union the previous winter, Henry had been even more impatient to go. His 'barriers' at the beginning of the year, were, in part, Henry communicating his readiness, both at home and abroad.

At last, at the end of April, James agreed to commit English troops to the campaign. Henry waited for his call to arms from his father. The king gave the command to ... Sir Edward Cecil. Henry was not to re-enact the bloody heroics of the Black Prince and Henry V, cited in his 'barriers', after all. Not yet.

Sir Edward now mustered 4,000 English and Scots troops to join Maurice and Henri IV, and promised to write to Henry continually.

Salisbury sent a man 'to take order to furnish [William] the Lord Cranborne with all necessaries to follow the French King in this journey'. He hoped it would endear his son to Henry. In England, 'more of our court gallants talk of taking the same course if the voyage hold',

said Salisbury. It must have galled Henry no end. Salisbury wished them God speed. Better, he muttered that 'they had some place abroad to vent their superfluous valour, than to brabble so much as they do at home; for in one week we had three or four great quarrels'. Salisbury did not explain what the problem was, but Southampton, a Henry man, and Montgomery, an old favourite of James's, came to blows on the tennis court, 'where the rackets flew about their ears'.

By the beginning of May, Protestant Europe and France were ready to march, '[which] I fear will draw all Christendom into the quarrel', the English ambassador in Paris concluded grimly. Sir Ralph Winwood wondered, in all honesty, 'what should move the French King to engage himself so far in a business that no more concerns him, and', at his age, 'as [if] it were *de gaieté du coeur*, to thrust himself into so difficult a war'. Henri, a womaniser famed for a pronounced *gaieté de coeur*, had established peace in France. Was this the French king indulging his pipe dream of displacing the Habsburgs and dominating Europe himself? Perhaps, Winwood joked to a friend, he was only sabre-rattling, and when 'he hath made a great noise in the world, he will be content to put water in his wine' and calm down.

Henri IV followed up by suggesting his own match for Prince Henry: his eldest daughter Christine. If James and Anne wanted a prestigious Catholic princess, surely better to have one whose father was committed to protecting Protestantism, than a Spanish infanta, who would always see their son as a damned heretic and bring her Jesuit spies with her? Two days later, 14 May, catastrophe struck. Prince Henry was inconsolable.

Henri IV of France had survived twenty-three assassination attempts. The twenty-fourth got him. In a frenzied knife attack, Jesuit cleric François Ravaillac killed the founder of the Bourbon dynasty. It had incensed Ravaillac to watch Henri ally Catholic France with heretics, forcing Frenchmen to march on their religious brothers in Jülich-Cleves.

King James blanched 'whiter than his shirt' when he was told, said Württemberg.

Henry spun round, walked into his bedchamber alone, muttering 'my second father is dead', over and over to himself. He kept everyone away. A scheme 'which he never communicated to anyone, was now destroyed; for he had resolved' to defy his father and go to 'fight under his Most Christian Majesty whenever he marched on Cleves'.

In the Dutch cautionary town of Flushing, the English garrison, fearing Spain might now launch an attack, halted the departure of their troops to meet with Maurice.* 'I think it was never more needful to make a League of those of the Religion' than now, said the town's governor. James would have to take Henri IV's place in the Evangelical Union. There was no one else of sufficient stature. Salisbury passed the continental communications to Henry, asking them to be returned to him after copying.

Protestant momentum stalled. 'All former resolutions, projects and counsels are either utterly reversed, or to be changed and transformed,' said Winwood. Archduke Leopold 'will now grow more confident,' in his ability to keep hold of Jülich-Cleves, 'and unless His Majesty and these Provinces will undertake the cause of the Protestant Princes and supply the defects of France, I fear this year he will not be routed from [Jülich]'. If they did not act, the crisis would drag on.

Maurice's combined forces should have reached Düsseldorf by the end of May. Instead, 'we are all at a stand, until we understand what his Majesty will counsel', the English reported from Holland. The Spanish were delirious with joy at developments in France. Henri IV's widow, Marie de' Medici, was a devout Catholic. She took power as queen regent for the eight-year-old Louis XIII and at once entertained a double marriage proposal for the son and daughter of France with the infanta and infante of Spain. Marie looked as favourably on Spain as her late husband had viewed it with loathing.

* Cautionary towns were those ceded to England in return for Elizabeth I's military and financial support of the rebel Dutch in their war of independence from Spain. Hostile locals, insanitary conditions, the chaotic traffic of men and materials going to and from the war zones, made them wild places in which to live.

Henry now lived 'every day five or six hours in armour', though he had no war to fight. His 'whole talk was of arms and war. His authority was great, and he was obeyed and lauded by the military party.' He received and corresponded continually with his German cousins and allies, with Maurice, and the English officers in his service. But he could not act.

Though forced to watch others recalibrate the European power balance, at home, at least, Henry gained financial independence, as James agreed to sign over all the lands and revenues due to him. Reacting positively, Henry concentrated on the thing sure to raise his profile internationally: his parliamentary installation as Prince of Wales. By 17 May money came onto the ordinances to pay for fireworks and spectacles. Chaloner planned firecrackers and rockets to dazzle Christendom as far as Rome and Madrid.

Henry requested permission to enter London on horseback for his big day. James and Salisbury refused. After the French king's assassination, no royal dared move freely. Soldiers closely guarded James's carriage and prevented anyone approaching. Henry's investiture was to be the biggest state occasion of James's reign. It might well attract an assassin's attack.

The Privy Council ordered that Henry should make his entry along the river instead, setting off by barge from Richmond Palace. The mayor and aldermen of the City, bankrolling the day, would greet him midway. The mayor instructed the livery companies to prepare themselves. Sir William Browne, in charge of security, liked the idea of a water progress. 'All riding by land or entries by land are taken away. The world is so full of villainy.'

Salisbury took the opportunity to remind MPs that 'the new doctrine of the Jesuits' advocated the assassination of heretic rulers. Now 'no Christian king can be secure'. Had not all of them nearly been blown sky-high in 1605? They were all in this together. James ordered all Catholic recusants to be removed from the city, exiled beyond a ten-mile radius of the capital and court.

Sir Henry Montagu, Recorder of London, mused that 'amongst all

the cares of a kingdom, the sovereign care is the chiefest', and so oner-
ous it might be the death of him. The 'disaster that fell in France in this
late time ... hath made us enter into the consideration of this'. Just
what Salisbury wanted to hear. Bearing this weight, the Crown must
then have the means to fund soldiers and warships to protect them all.
Salisbury hoped the cloud of assassination might have a silver lining,
and make MPs reach a generous decision on financing the royal
family.

Taking advantage of the MPs' momentary sympathy for the perils
of monarchy, Salisbury moved Henry's investiture from the House of
Lords, the usual venue for parliamentary state occasions. In the Lords,
the Commons had to stand for hours, crushed behind a wooden bar,
while senior clergy and peers sat at ease along the benches. Salisbury
looked for a larger venue and settled on the Court of Requests, in the
Palace of Westminster, where he could seat them all.

Salisbury now set about designing a ceremony for Henry that
combined the continuity of the growing liturgy of monarchy, while
nudging Crown and Parliament towards a new era.

The day before the investiture, Sunday 3 June, James was to create new
Knights of the Bath in his son's honour. Henry was allowed to choose
from a list of fifty candidates drawn up by the king. Henry took a pen
to it, scored through most of the names, added others he wished to
promote, and reduced the total number by nearly half.

Monday dawned and guests from all corners of the political nation
approached the Palace of Westminster. The king's chair of state had
been placed at the far end of the hall, on a dais. All made obeisance to
this sacred symbol of the king's presence as they entered. To the right
was a seat for the Lord Chancellor, Ellesmere. Lord Treasurer
Salisbury's chair stood empty to the throne's left.

First to enter was the Archbishop of Canterbury, followed by the
Marquis of Winchester, followed by the earls, seventeen bishops, and
barons. The greatest nobles shuffled along benches on each side of
the throne, gathering round them their 'red velvet garments with
ornaments of white precious furs upon their shoulders. Their hats

also were of red velvet, made after the manner of coronets, with shining gold bands, and they did wear athwart their shoulders, as it were girdles, beset with precious pearls, as soldiers use to wear their belts.'

Sons followed their noble sires, like a flock of excited, highly coloured birds. In 'doublets and hose of changeable silks', their heads bobbed as they chattered and joked, shaking the multicoloured feathers on their silk hats. These youths would comprise Henry's House of Lords in due course. Fathers and sons, their blood had oiled the machinery of government for centuries; whereas James and Henry had set foot in England a mere seven years ago. Then again, the presence of Irish peers and favoured Scots at a very English ceremony to celebrate a Scottish-born Prince of Wales, created a spectacle of closer union James had failed to enact in law.

The lord mayor and thirty aldermen crowded in, gold chains of office heavy on their scarlet robes. They lined out on the observers' benches.

A wooden bar crossed the Court of Requests from side to side, notionally separating the two houses. However, the bench seating ran continuously under it, the length of the room. Below the bar sat the Commons, 'very easy and handsome'. The Speaker of the Commons walked to a raised chair in the centre of the hall, with the clerk at a table by him. He was 'face to face right over against the King's majesty', noted the Earl of Huntingdon. The arms of England hung above the Speaker's chair, a signal honour and sign of the Commons' growing stature. Many members had splashed out on 'apparel worth an hundred pounds' for the day. 'For some of them the very panes of their breeches were nothing else but laces embroidered with gold,' harrumphed John Noies, Puritan MP for Calne, Wiltshire. Most Cheapside jewellers had lent, rented or sold out their entire stock-in-trades.

Noies – making his show in top-to-toe black wool – plonked himself right in the middle of his fellow MPs. 'More boldly, than wisely, I confess,' he later said to his wife. He looked around and saw how he and a few other Puritans stuck out. 'I thought myself to be like a crow in the midst of a great many golden-feathered doves.' He found

the 'whole house being thus furnished with sumptuous and shining apparel' most unpleasant.

Spotting the court ladies in their viewing boxes, he immediately felt worse. 'If I should take in hand to write of the apparel and fashions of the ladies and maids of honour I should be as foolish as they were vain.' So much flesh on display, heavy make-up, jewellery stitched in from hair to toes. 'I say no more than this, that they were unspeakably brave and intolerable curious,' he wrote.

Noies and his brother dissenters from such luxuries were also Prince Henry's most ardent supporters. They sat here, solid, like a seam of good English mud in a wall of glistening diamonds and pearls. Henry was marching to glory. He would have to pass among the lotus-eaters and escape the clutches of court Circes, before he could emerge to strike down the enemy for God.

In a box specially constructed for them, Elizabeth and Charles, Arbella Stuart, and about twenty of their closest companions waited for their brother and father. Arbella was on the verge of taking a step that would prove fatal: marrying William Seymour without obtaining royal consent. Given the strength of her claim to the thrones – and that Seymour also had a claim and so was one of the men James would never, ever permit her to marry – she immediately condemned herself.

The ambassadors of Spain and Venice and the Archduke Albert of Austria, governor of the Spanish Netherlands, took their places beside Henry's friends and Protestant European relations from Brunswick, Württemberg, Hesse, and diplomats from the Dutch United Free Provinces. Suddenly, voices, trumpets and drums deafened all talk, as the royal barge arrived at the watergate to the Palace of Westminster.

All stood. The king entered, flanked by heralds. Two Cecils – the lords Cranborne and Burghley – carried James's train, his whole outfit 'gloriously garnished with precious stones and pearls'.

Last, Henry appeared. Stepping into place to hold Henry's train, the Earl of Huntingdon took the chance to check it over. The prince's robes had cost over £1,300.* Dressed in royal purple satin and velvet,

* About £165,000 in today's values.

his train was 'lined clean through very thick with powdered ermine' Huntingdon was pleased to note. The Earl of Sussex walked at Henry's side. The earls of Suffolk and Worcester, two of Salisbury's allies, fell in behind. An exquisitely ornamented patent detailing Henry's creation followed, carried by the Garter King of Arms. Drafted by Henry Hobart and Francis Bacon, as Attorney and Solicitor General, Salisbury had obsessively corrected and amended the Latin original, and the English translation, until it captured the right tone.

A sword, a ring, a golden vierge – wand; a gold 'crown richly set with diamonds, sapphires and emeralds', each borne on its own cushion by four earls, came next. Flanked by his new Knights of the Bath, Henry moved slowly through a waterfall of voices and instruments cascading down from the galleries. The mettle of Henry's majesty even struck Noies to sparks of delight. 'All the trumpeters and drum players did sound out their instruments, with others, which played upon cornets and flutes with such an acclamation and exultation as if the heavens and the earth would have come together,' he told his wife, sounding like a prose Caliban.

Henry turned to stand before the throne, clothed head to toe in purple, for all the world like a richly dressed bishop reverencing the high altar at a papist mass. He bowed three times to the king and then stepped up and knelt before him. Henry remained on his knees for over a quarter of an hour, while Salisbury read out the patent creating him Prince of Wales, Duke of Cornwall, Earl of Chester, Duke of Rothesay, and Baron Renfrew – first in Latin and then in English.

Another layer of purple velvet descended round the young man's shoulders. James fastened it under his son's chin. The king then crowned the Prince of Wales, put the sacred ring marrying him to his country on his finger, and the long, fine, gold wand of judgment into his hands.

Henry remained solemn, his father relaxed, jovial even. For Henry, this day marked a decisive break with the past. He acted out his arrival as adult ruler of the secondary court of the new Britain. James would see the ceremony as increasing the prestige of his own majesty, not crowning Henry as ruler of a separate court, in any meaningful way.

The king 'displayed great affection … saying that the Prince must not mind humbling himself to his father, now playfully patting his cheek and giving him other tokens of love'. James understood his son's ambition, even if at times it vexed him.

As King of Scotland, James VI had jumped to grasp the reins of government from over-mighty magnates at a young age. The ancient Stuart dynasty had come far. Crowning his son Prince of Wales, James took Henry up, kissed him and placed him on the seat to his left – Henry's 'Parliament seat'.

The ritual enacted, a fanfare blared and the choir burst into Tallis's towering anthem, his motet for forty voices, *Spem in Alium Nunquam Habui* – 'Hope in any other, I have never had'. For this day, they substituted an English text for Tallis's Latin, inserting Henry's name as the one in whom they placed their hope. The glorious music carried his name high into Westminster's rafters, over everyone's heads:

Sing and glorify Heaven's high Majesty …
Sound divine praises …
This is the day, holy day, happy day …
Live Henry, princely and mighty,
Harry, live in thy creation happy.

For nine out of ten here, it was the greatest parliamentary occasion they had seen, or would ever see. Their heads might temper the patriotic sentiment evoked by this ceremony, but they came, the elements of power in the land, because of what Henry represented. Rituals such as this encouraged a focus on the Crown as the divine symbol of the nation. They were establishing the identity and mantra many Britons went on to venerate in themselves, the essence of a magical spell: for God, King and Country.

Realistically, it was hard for King James to embody this role. He was a Scottish monarch and middle-aged import. Henry was different. He had first appeared as the blond boy in ivory and scarlet satin, aged ten: the obvious candidate for the divine child, as the kingdoms united, and a prince of Protestant Europe. People had talked, written

and manoeuvred him into this role all his life. He wanted to live up to their expectations.

Granting Salisbury's input, this was very much Henry's day. It had happened at his insistence and it won what he sought – a substantial amount of real financial and political independence for what now became the court, no longer the courtly college, of the king-in-waiting. This extraordinary, quasi-sacramental event somehow performed an informal coronation as well as an investiture.

As prince and king walked out together the whole hall broke into 'a very joyful and solemn applause, every man rejoicing and praising God, and the king and the young Prince, whose lives God long continue in all happiness and honour! Amen! Amen.' Overcome, the Puritan John Noies cried and clapped.

Coming back to earth, Lord Chancellor Ellesmere adjourned the next sitting of Parliament, commanding the members to convene the following Thursday – when the overriding concern would be to agree a political settlement to secure Crown finances.

That night, the court feasted. The great aristocrats of England – Pembroke, Southampton, Montgomery – served their friend, the Prince of Wales, at table. With the prince sat Salisbury, Worcester, Northampton, Nottingham, Shrewsbury, Derby, Cumberland, Huntingdon and Sussex, the grandees of the British state, as they would remain when Henry became king. 'During the whole dinner time the hall resounded with all kinds of most exquisite music,' sounds and sweet airs.

The next night belonged to entertainments arranged by the queen. Anne of Denmark took centre stage as Tethys, goddess of the sea. She addressed a prince who sought global expansion by mastery of the oceans. She celebrated Henry's maternal inheritance, as the daughter of a great seagoing power and progenitrix of a new Eurocentric dynasty. Inigo Jones once again designed and created the sets. Anne chose the dancers and attended closely to the content.

His mother's masque told Henry that the glorious Empire of Britain 'will be enough' for him. He should not 'think to pass the circle of that

field'. Within the 'large extent of these my waves' around Britain, will 'more treasure and more certain riches [be] got/Than all the Indies to Iberus brought'. Pro-Spanish, like James, neither parent wanted the Protestant warrior 'Moeliades' to pursue an aggressive policy towards Iberia's overseas empire. Her son would have riches enough anyway, by way of scientific discoveries: 'Nereus will by industry unfold/A chemic secret, and change fish to gold'! Henry and his court doubted it would be enough.

On the final night of celebrations, the court made its way to the banks of the Thames to join tens of thousands of Londoners. They watched as two gunships besieged a vast, floating wooden castle in the middle of the river. The boats fired at the castle and from within its flaming walls fireworks were launched, exploding into the sky. 'Some of them were so cunning that they could ... mount and ... flee up into the air twice so high as St Paul's Tower, and when it was at its highest it would stream down again as long as bell ropes, and the fires did seem to fight and to skirmish one with another in the skies, which was very pleasant to behold in the dark evening, and at length they would descend again as it were buckling and striving together until they were extinguished in the water.' Even the fireworks symbolised something about Henry and monarchy: the 'power to destroy and to illuminate', to defy gravity.

Henry's Men Go to War

JÜLICH-CLEVES

The celebrations over, most of Henry's foreign visitors left. Some went straight to join the Protestant forces of Maurice of Nassau and Sir Edward Cecil. Henry ordered a fine suit of Greenwich armour for Frederick Ulrich and commissioned Isaac Oliver to paint a portrait of his Brunswick cousins, to be hung at St James's. Sir David Murray, Keeper of the Privy Purse, petitioned the Privy Council for £1,000 for the extraordinary expenses the prince incurred entertaining his guests. Already, the newly independent court lacked funds to cover its outgoings.

Regrouping after the death of Henri IV, a combined European force finally marched on Jülich. Henry ordered Captain George Waymouth to keep a journal of the campaign. Waymouth had previously sailed with Robert Tindall to Virginia. Henry always needed to 'be informed' to help him 'apprehend and judge of matters of so great consequence', when he could not see for himself. He was bitterly disappointed not to be riding through the heart of Europe that summer, to the places his friends described in their travellers' tales, announcing his arrival on the European stage.

The allied force reached the walls of Jülich by the middle of July 1610. Maurice and Cecil split the army to approach from two sides, and concentrated on taking the castle. 'Being master of that, the town of necessity must render,' wrote Waymouth. 'This town and Castle is

reputed to be one of the best fortified by art that is in Christendom.' Busy with plans to renovate England's coastal forts, Henry wanted to know the strengths and vulnerabilities of these massive structures. Waymouth noted it all down and made drawings.

Waymouth also observed Maurice of Nassau. Prince Maurice's 'approaches and batteries were made with great art, for the safety of his men, and the offense of the castle', he reported to his prince. His Excellency 'has gotten great advantage of other soldiers in Christendom, ever applying himself to the knowledge of the mathematics, which General Cecil … has in his approaches, [also] made proof of his time spent therein'. All Henry could do was ensure he did the same at home, and wait for his day to come.

'Riding beyond the trenches, to view the ground for the next night's approach', Sir Edward Cecil came 'within 100 paces of the town'. Something exploded nearby, killing his horse under him, but missing Cecil. As skilled as Prince Henry in *manège*, Sir Edward leapt balletically from the falling beast and continued on foot until he had 'viewed the ground, the castle and the town'. The enemy was 'all this while, continually playing upon him with great and small shot'. Stoical, valiant, courageous, 'unmoved from his usual pace, he returned to the trenches, and ever after, till the castle and town was taken in, General Cecil was in the trenches and batteries at the making of them up, directing in such manner everything should be done'. This was 'a great encouragement to all others, seeing their General participate the common hazard'. Not only what you did, but how you did it, strengthened your virtue. A proper fear might flood you, but you did not let yourself drown in it.

Edward Cecil sent Henry a series of letters describing the progress of the siege. 'We press him [the enemy] so nighly with our approaches, that if his expected relief from the Archduke and Emperor fail him (as without doubt it will), the town in three weeks' time will … [be] in our hands.' Cecil had a problem with one officer, Sir Thomas Dutton, 'whom your Highness was pleased to favour beyond his merit', Cecil chided politely. Dutton was repeatedly challenging Cecil's authority and questioning his judgement. He wanted Henry's permission to dismiss him, before Dutton attacked him physically.

Henry wrote back to thank Cecil for his service and analysis. 'That great and high favour which your Highness has vouchsafed to cast upon me by [writing in] your own princely hand ... has given me a new life and encouragement in all my endeavours,' Cecil replied. A letter in Henry's own hand was an enormous compliment.

By 30 July the Protestant allies had battered a hole in Jülich castle's outer walls. Maurice ordered Colonel Cheke to charge the breach, but look out for minefields. Cecil and Maurice watched Cheke's party go. Archduke Leopold's soldiers also spied them, and exploded all their mines at once. The generals looked on as the ensign was 'blown a pike's length from the ground and almost smothered with the earth ... [he] was carried off and is now well. Only one soldier was blown quite away' into pieces.

Maurice and Sir Edward sapped under the moat, laying mines beneath it, while all the time the enemy shot 'wild fire and grenades out most of the night' over their heads. They fired their mines to drain the moat, dropped down into the empty ditch and furiously threw up a wall of faggots to scale the last defences, the castle inner walls. At their feet, engineers started to mine under them. That night was black as hell and the enemy launched 'a boat full of artificial fireworks' over the walls, lowering it on the allies, to set fire to the scaffold. Allied musketeers played continually upon the enemy's parapet, so that 'they durst not peep over to see what effect their artificial boat took'. Several times the flaming boat set fire to the wooden 'galerie' they climbed, but the old soldiers pushed it away.

By the third week of August, Cecil was able to report to Henry that Leopold had admitted defeat. He 'has called to parlay, demanded conditions [for surrender], and within a day or two we look to have troops in the town'. Not a moment too soon. Cecil's forces, having breached the outworks and negotiated the castle ditch, with its four levels, were now lodged in the ramparts. His engineers had dug into them, placing 'two great mines' and were ready to set them off the next morning. Besides, his cannon 'had already played with ... fury upon the foot of the bulwark, that a great breach was made'. The game was up. Cecil rather regretted the lost opportunity to set off the mines,

'which we much desired', he confessed, to 'have had a true experience how powder works in so high and so thick a wall'.

Henry's military exercises and ceremonial duties lacked bite compared with this sort of news; they honed skills, but offered no mounting heartbeat.

By 24 August, the princes and lords sat in council to agree terms of surrender. Jülich must return to religious toleration; the imperial forces would be allowed to leave with their colours, as long as Leopold did not blow up the munition stores and supplies; if he did, Maurice and Cecil would show him no mercy. It was a triumph for the old, mixed order of Europe, fragile and abused as it was, that everyone shared a desire not to escalate this to all-out war.

Henry pored over Waymouth's detailed record of the campaign. The king and prince could not agree on the part of war in foreign policy. The king 'is naturally very gentle, an enemy to cruelty, a lover of justice, and full of good will', observed the Italian ambassador. He loves his 'tranquillity, peace and repose; he has no inclination for war, and … it is this that displeases many of his subjects'. James's preference was to 'live privately, among eight or ten of his own set', rather than 'magnificently and in public, as is the custom of the country and the wish of the people' flattering and showing himself to them, to assure them of their importance.

When the military wing of the establishment returned to London, it continued to convene at Prince Henry's court. Like his father, Henry adhered to the few men he really trusted. Yet his repeated requests to participate in public tournaments and to stage displays showed an Elizabethan sense of spectacle. He knew instinctively something of the need to earn his people's love and respect. Although the king had prevented Henry from participating in the wars in Europe so far, for how long could he contain his son? This had been Moeliades, God's holy knight's, moment to shine. His father had denied him. He must grit his teeth and wait.

* * *

At the end of September 1610, Henry announced the completion of a long-cherished project. His flagship, the *Prince Royal*, built by Phineas Pett, and backed by the king, was ready to launch.

The whole royal family turned out for the ceremony at Woolwich, accompanied by hundreds of servants and followers from the three courts. The crowds began climbing up onto the towering ship. Pett worried that the weight of them milling about on the top deck might unbalance and capsize the vessel. Up on the poop, Lord High Admiral Nottingham waited as 'the great standing gilt cup was ready filled with wine, to name the ship, so soon as she had been on float, according to ancient custom, by drinking part of the wine, giving the ship her name, and heaving the standing cup overboard'.

A cry went up to cut the ropes. The ship groaned, slid forward, reached the dock gates, then shuddered to a halt. Everyone tipped this way and that. The tide was too low. The ship had wedged herself between the gates. People smiled nervously, glancing towards the king for their cue. Tables were consulted. High tide was at 2 a.m. Then they could launch.

Too long for most of them to wait, Henry's family returned to Westminster, the court flowing in their wake. But Henry had come to launch his flagship and that was what he intended to do.

The prince and his friends waited on board all day and into the night.

Around midnight, a vicious wind sprang up out of nowhere and the vessel stirred as if being jostled by unseen spirits. Pett watched the sudden squall churn and lash the waters, threatening to smash the *Prince Royal* against the dock. 'Indirect work' was to blame, Pett concluded, sending his men to scour the quays for signs of witches or other dark forces. Perhaps weird women stood close by, swirling a cauldron of water, crashing a ship in miniature against its sides.

Then, as high tide came in through the first hours of the morning, they felt the river shift the ship under them. High enough in the dock to squeeze through the gates, the *Prince Royal* teetered out into the Thames. As Nottingham had gone, Henry christened her himself. He, and his followers, drank off the bumper before throwing the chalice

far out into the middle of the river. Then they repaired back to the prince's cabin, to drink long toasts and plan the great voyages they and his ship would soon make together.

Hours later, the young men emerged back into the early sunlight. Henry ordered a salute from the ship's sixty-four cannon to announce his presence to the waking city.

Henry Plays the King's Part

KING OF THE UNDERWORLD

Twelfth Night, 1611. The curtain drew back on darkness, 'obscure, and nothing'. In the shadow loomed a rock face, 'trees, and all wildness that could be presented' on a stage. The moon rose off the shoulder of the rock, casting a small light. A satyr peeped over a boulder, giggled and called his friends to wake up. 'Times be short, are made for play.' Another popped up, and more and more, leaping from behind rocks, to dance, frolic, and chatter, 'Are there any Nymphs to woo?'

'If there be, let me have two!' one called, stretching his body to display himself.

Old Silenus, companion and tutor to Dionysus, came in and clapped his hands. 'Chaster language! These are nights/Solemn to the Shining rites/of the fairy Prince, and Knights,' he commanded. 'We await Oberon, King of the Underworld', and 'the height of all our race'.

The satyrs sprang about shouting: 'What will he do for us? Will he give us pretty toys,/To beguile the girls withal?'

'And,' one sniggered, 'to make them quickly fall' onto their backs.

Interrupting their bawdy banter – a sound from the cliff face as it split open to show the translucent walls of a gloriously lit palace.

Silenus barked at the satyrs to shut up and bow their heads.

Concealed beneath the surface world, it was a magical kingdom, created by Inigo Jones. Fairies stepped forward playing musical

instruments, carrying torches, singing, in the same way musicians preceded King James and Queen Anne in the outer kingdom. Within the fairy palace sat Henry's friends, his masquing knights. The court spotted the earls of Southampton, Arundel, Essex, Lords Dingwall, Hay and Cranborne among them – the usual suspects.

At the deepest point – right opposite the king, his father – Oberon (Henry) stood in a chariot, with two polar bears harnessed to it. The fairy world mirrored the personnel but also the visual grammar presented to the audience in the hall: everything drew the eye in, from servants on the edges, to the grandees, to the ruler at the centre.

Henry returned the court's gaze. He really was not a boy any more, but 'tall, … strong and well proportioned … his eyes quick and pleasant, his forehead broad … his chin broad and cloven', his whole 'face and visage comely and beautiful … with a sweet, smiling, and amiable countenance … full of gravity'. He resembled his Danish uncle, King Christian IV: his mother's side. His skin weathered from a life spent outdoors, Francis Bacon thought the prince's emerging adult face showed a new leanness, 'his look grave … the motion of his eyes composed', above a big nose, and mouth tightly closed. This countenance, focused, stubborn, wilful and stern, gazed out at them.

'To a loud triumphant music', the King of the Underworld's carriage moved forward. Ben Jonson announced a 'night of homage to the British court,/And ceremony due to Arthur's chair'. The fairy kingdom came to swear the 'annual vows' of obedience, the fairies said, and 'all their glories lay' before the king. King James 'keeps the age up in a head of gold:/That in his own true circle still doth run/And holds his course as certain as the sun'. Jonson's verbal footwork ran round to honour masque protocols, locating the ruler above everything. Crown and sun were stock symbols of the king. Jonson evoked James as another great unifier, the classical 'all', by imagining him as the universal god Pan.

If Henry was Oberon – King of the Fairy World and King of the Night – then Henry was also an earthly king tonight. If both were rulers, they were of equal status. Two kings ruled the same kingdom, one on the surface, one beneath it. At Henry's investiture and his

Epiphany 'barriers', he confirmed himself in his privileged, though subordinate, role as the most important British subject. Six months later here he was, already a king, ruling his own kingdom. His territory occupied the same horizontal footprint. The different narrative threads threatened a serious lapse of manners, inferring a potential usurper.

Adding to the tension, and holding the masque world and the ordinary world together, this Oberon had become a figure of English mythology since Shakespeare made him Titania's consort in *A Midsummer Night's Dream*. Pan was the foreigner – a Roman, classical god. Was Henry/Oberon, the first prince born to rule the united kingdoms, the native ruler, and King James (Pan), ruler of Scotland for half his life, the alien here?

The popular, often revived *A Midsummer Night's Dream* meant that the character of Oberon was well known to audiences. Subtitling this masque 'The Faerie Prince' recalled the court's memory of Edmund Spenser's great poem, *The Faerie Queene* – an allegory of Elizabeth I and her glorious reign. The late poet was back in many people's minds this year, as Spenser's works had been brought out in a special commemorative volume.

Jonson then turned the drama to restore convention. All know 'the moon ... borrows from a greater light', he said. Henry/the Moon only shines because of his proximity to the Sun/James. Phosphorus, the Morning Star, rose now to reassert the natural order. 'The moon is pale and spent ... Give way', Phosphorus ordered, 'as night hath done, and so must you, to day.' Except, as Jonson focused the action back on the king, the masque narrative twisted back again.

The Sylvans' parting song trilled:

What haste the jealous sun doth make
His fiery horses up to take,
And show once more his head!
Lest, taken with the brightness of this night,
The world should wish it last, and never miss his light.

They all heard it: the Sun – the king – was 'jealous' of the Moon, and bolted up to light the world, in case the world preferred moonlight.

With some relief, the masque opened out into the 'common measures' – the dancing. Henry's masquers invited the ladies of the court to join them, dissolving permanently the boundaries separating the two worlds. 'The Prince ... took the Queen to dance, the Earl of Southampton the Princess [Elizabeth], and each of the rest his lady.' Henry placed his mother at the centre of the masque stage.

Robert Johnson, Shakespeare's lutenist, gave his royal patron dance tunes harmonious and complex, yet orderly. Henry and the queen in the centre, mirrored the king and Carr on the royal dais.

The musicians increased the tempo, announcing corrantoes and galliards for which the younger court ladies and gentlemen usually came up. Vigorous and sensual steps made the dancers move with animal vitality, rushing towards each other, stamping, twirling, pushing against each other.

Anne turned to leave the floor, but Henry seized her hand 'for a corranto which was continued by others, and then the galliards began, which was something to see and admire'. Mother and son held the court's gaze – royalty, fully alive on their stage. Abandoned to the dance, to the mastery of steps, individuality was given up in the perfection of movement as a group. To keep time as the dance speeded up signified a lofty spirit. Rhythm amidst the hurly burly of life was a quality Jacobeans cultivated and valued.

In *Richard II*, Shakespeare had Richard account for losing the throne by his failure to keep time, good 'measure'. His sad reflections on music are a metaphor for power and his loss – the opposite of Prince Henry's dance. 'How sour sweet music is,/When time is broke and no proportion kept!/So is it in the music of men's lives,' Richard muses. 'I wasted time, and now doth time waste me.' Henry, his mother, sister, and friends, kept 'time' in these 'common measures', showing fitness to rule.

When Henry finally let his mother go, his followers, including Southampton and Essex, came and took her up, keeping the queen in the centre of the stage. This part of the masque had no allotted

timescale. They could dance all night if they had enough vigour. Carr did not join in with Henry's set, denying James the pleasure of watching him as he danced. Around midnight – early for a masque – the king sent word they 'should make an end'.

Oberon, the Faerie Prince was great entertainment and a neat political device. It endorsed and exposed the king and Henry's relationship. No one would think otherwise than that Henry, in his masques, made statements about power and his relationship to it. The following day, the prince asked Jonson to annotate a copy of the text for him, so he could trace the sources of the ideas.

Art was political, but Henry and the new Stuart court, in common with their Renaissance contemporaries, also held the reverse to be true. The state should be a work of art. It must be harmonious in all its parts: a well-sharpened, beautifully made tool of power, in the hands of an expert. 'The players,' said Samuel Calvert to diplomat William Trumbull, 'do not forbear to represent upon their stage the whole course of this present time, not sparing either King, State or Religion, in so great absurdity and with such liberty, that any would be afraid to hear them.'

The queen's analysis of the state of the court played on 3 February 1611, Candlemas, or the Feast of the Purification of the Mother of God. Jonson called the piece: *Love Freed from Ignorance and Folly*. 'The queen and the Prince [worked hard] preparing ... the masques,' moving in harmony to counterpoint the king and favourite with a power bloc to rival that of the bedchamber.

Onto the stage danced a sphinx with a woman's head and body, a lion's legs and eagle's wings: a symbol of transgressive femininity. It/ she was 'leading Love', pulling Cupid on the end of a rope. The Sphinx held Cupid's bow firmly in her hand, having tied Cupid's hands together using his own blindfold, which she had ripped from his eyes. Blindfold gone, Cupid was distraught. Love is not blind. He saw. He knew.

Love blind and bound implied the repression of sinful desire. Blindness in this sense was part of the ordering principle of sacred

love, almost in the biblical sense, of 'not letting thine eye offend thee'. Unbound, letting yourself look, chaos followed. For Henry's society, Cupid contained the potential of both loves. Here, the Sphinx and Cupid unbound embodied a disordering force. The court knew the instant they took all this in: tonight was about the disordering effect of misguided love.

Cupid's 'bow' was now a 'sceptre' in the Sphinx's hands – disordered Love ruled with it. It was only a step to imagine who might have taken the king's sceptre in his hand to try and rule with it.

Cupid pleaded with the Sphinx. 'Without me/All again would chaos be'. He stood for, even fought for, 'cosmic and divine love, whose arrows pierce the world to hold it together'. As a positive force, Cupid's arrows of desire pinned diverse things together, and held them, safely contained.

The Sphinx dragged on other prisoners – the Queen of the Orient and her eleven 'daughters of the Morn' – played by Queen Anne and her ladies, including the Princess Elizabeth, Lucy Bedford, Penelope Rich, and Frances Howard, Countess of Essex.

Frances was regarded as the most beautiful woman at court. Court gossip questioned her conduct: she had begun an intensive flirtation with James's beloved, Carr, and also with Prince Henry, friend of her husband. 'Notwithstanding the inestimable Prince Henry's martial desires, and initiation into the ways of godliness,' wrote one court observer, Lady Essex had 'first taught his eye and heart, and afterwards prostituted herself to him, who reaped the first fruits.'

Others agreed. Henry was 'captivated by her eyes, which then found no match but themselves'. Might Frances become a royal mistress and initiate the prince into the erotic side of love, which most agreed had bypassed him till now? 'The most beautiful and specious ladies of the Court and City' thronged round him. Should a young man of sixteen not look and fantasise a little? Cornwallis noted Henry was stirred by 'unbridled appetites', but added that if he was not very 'chaste in his inward thoughts, yet did he … cover them'.

Tonight, the court ladies paraded their sexual allure. Dresses cut to their navels exposed their breasts through translucent gauze, their

limbs outlined against layers of diaphanous silks. Frances mesmer-ised. Essex was rapidly becoming angered, seeing his wife's head turned by the attention received from every direction except her husband's.

If he had desired her, most agreed Henry's attraction to Lady Essex was short-lived. His 'more heroic innate qualities … soon raised him out of the slumber of *that* distemper'. More likely, he saw Frances and Carr's flirting – perhaps heard that Carr's confidant, Thomas Overbury, was involving himself by writing Carr's love letters for him – and saw the dangers. Knowing how his father loved Carr, the whole emotional mess may well have sickened the teenager.

Henry slighted Frances. 'Dancing one time among the ladies, and her glove falling down, it was taken up, and presented to him, by one that thought he did him acceptable service; but the Prince refused to receive it … He would not have it,' stating: 'it is stretched by another' – meaning Carr.

Whatever the truth beneath the coquetry, unless Cupid answered the riddle of the Sphinx, all the masque ladies would stay imprisoned by Disordered Love. Cupid eventually came up with the answer to the riddle: 'Albion' (meaning James). This word freed all of the prisoners.

The masque ended by uniting the Queen of the Orient (Anne) with her proper spouse, Albion (James), and cutting the Sphinx/Disordered Love out of the sacred circle of royal love. If only.

Out on the city streets, on the public stage, without the need to please a royal patron, Ben Jonson addressed a myriad of problems – favour-ites, the evil of flatterers, sexual and political corruption, right rule, and financial excess – in a different form. Neither Henry nor his father came out of it well. In August 1611, Jonson premiered *Catiline, His Conspiracy* at the Globe, acted by Shakespeare's company, the King's Men. Based on Roman imperial history, *Catiline* explored corruption under a weak absolute ruler.

The state is an 'iron yoke', says Catiline. 'Liberties' curtailed, citi-zens are forced to witness:

> The Commonwealth engrossed by so few,
> The giants of the state, that do, by turns,
> Enjoy and defile her.

They watch as the commonwealth, the common weal of the people, is gang-raped repeatedly.

Catiline is a dark revenge drama. The word 'engrossed' captured perfectly the image of the 'giants of the state' slaking their appetites on the commonwealth. Still not sated, they asset-strip the whole earth for their personal gain, and engross the commonwealth with it, almost impregnating her with their spoils.

> All the earth ...
> Peoples and nations pay them hourly stipends;
> The riches of the world flows to their coffers,
> And not to Rome's.

The powerful grasp 'all places, honours, offices'. James offered honours for cash, lavished gifts on his favourites, while Salisbury sat at the top of a patronage pile that revolted many to behold; although, he was too powerful for anyone to risk challenging, except perhaps James or Henry. The 'giants of the state' only leave us:

> The dangers, the repulses, judgements, wants,
> Which how long will you bear, most valiant spirits?

It infuriated Catiline to witness the elite 'swell with treasure which they pour':

> Out i' their riots, eating, drinking, building,
> Ay, i' the sea; planing of hills with valleys,
> And raising valleys above the hills, whilst we
> Have not to give our bodies necessaries.

This was the voice of the other world that Jonson and Henry's tavern wits frequented. So far, Henry could not be charged with corruption, but he was extravagant and indulged his desire to accumulate possessions that reflected his status and virtue.

How could the people enjoy their liberties when they were left too poor to act? Henry, his mother, Salisbury, Suffolk, Southampton, Pembroke, Arundel, the great ones of the land, poured fortunes into building, landscaping, collecting. By their actions, the rich might believe they enacted the popular neo-Platonic idea, in which all cultural expressions possessed the potential to transform those they touched. Their gestures did not reach most of the commonwealth.

From Courtly College to Royal Court

Henry's household records show the prince was as extravagant as any of Jonson's 'great ones of the state'. But much of the expenditure could not be avoided. His creation as Prince of Wales meant that from now on his adult court had to act with magnificence and virtue, at home and abroad; otherwise he would not command the esteem of fellow princes and their diplomatic representatives. Neither would he and his mother – working closely with Salisbury – be able to possess enough political weight to counter the king's bedchamber coterie.

Henry supervised the composition of his court from the bottom up. His account books detail 'the Allowance of diet, wages, board wages, rewards and liveries that were belonging unto his chamber, household and stables'. He signed off decisions about how many gallons of beer should be served at breakfast ('three gallons') and the number of loaves for each meal; whether to serve lapwings for dinner or supper; how many larks, capons, conies, mutton, beef, veal, chickens, tongues, sweet chewits, custards and dulcets, and so on could be produced.

Henry and his court officers decided who was entitled to eat and drink what, and when; what they were allowed in faggots of wood to heat their rooms, candles to light them (the quality – wax or tallow – and the number), the torches to be burned, and for which seasons all this was all allowable. Then Henry named 'the Prince his Highness, servants', setting the wages and board wages (maintenance allowance) for all the departments of his household. It ran to hundreds of people and positions.

In consultation with his close advisers, his father and Salisbury, as Henry's household changed from college to full court, he promoted old friends. Sir Adam Newton went from tutor to Henry's private secretary. Sir David Murray stayed as Keeper of the Privy Purse and Groom of the Stool: he remained the man most intimate with Henry domestically, the abiding, discreet, father figure, sleeping in Henry's chamber, as he always had. Sir Thomas Chaloner moved from governorship of Henry's household to being Lord Chamberlain of his court, charged with managing Henry's accounts and expenditure. Puritan preacher Henry Burton remained as Henry's sole Clerk of the Closet, keeper of the prince's conscience.

Among the new appointees, Salisbury's client, Sir Charles Cornwallis, became Treasurer. Having pursued court office for some time, the Puritan MP and ex-soldier Sir John Holles was thrilled to get the post of Comptroller of the Household. A follower of the late Earl of Essex, who had fought in the Netherlands and Ireland, Holles was very much in tune with the ethos at St James's.

The Venetian ambassador observed that Henry 'is delighted to rule, and as he desires the world should think him prudent and spirited, he pays attention to the regulations of his household'. He 'is studying an order to the cut and quality of the dresses of the gentlemen of his household ... he attends to the disposition of his houses, having already ordered many gardens and fountains and some new buildings'. 'Some new buildings', included starting on the largest royal renovation project of James I's reign – the redesigning of the house and grounds of one of Henry's principal homes, Richmond Palace.

Many men serving Henry were eminent in their fields and had successful careers in the world beyond the confines of court. John Florio, friend of Shakespeare and translator of Montaigne, was Henry and Elizabeth's Italian tutor. As the prince's 'sewer-in-ordinary', George Chapman – poet and masque-maker – tended to the household's dining arrangements. Joseph Hall, Stoic cleric and satirist, remained as another of Henry's chaplains. Thomas Coryate, the era's most entertaining travel writer, attended as the prince's unofficial

gentleman jester. Scores of others kept up their spirit of enquiry, excellence and wit at Henry's new court – Thomas Harriot, mathematician and scientist; Thomas Lydiat, cosmographer and clockmaker; Edward Wright, navigator, mathematician, and cartographer, author of a groundbreaking book on navigation, 'and a very poor man', curated Henry's collection of science books; Michael Drayton and Samuel Daniel served as playwrights; Inigo Jones, architect and designer; Robert Johnson, musician and composer; Salomon de Caus, polymath, Huguenot engineer; Constantine de Servi, an Italian architect and engineer.

All thronged around Henry. Many served in quarter yearly phases, then moved back out into the city, or to their own country homes. It was partly why Henry needed so many experts in each sphere of activity. In addition, it was not enough that a man be a specialist in one field. They had to be able to combine artistry, craft, engineering skill, court and political awareness, and experience of the wider world, to be able to serve the prince. At St James's, a court animal was an impressive beast.

The military salon continued to thrive in the new order, as did the sermons and religious atmosphere created by Henry's twenty-four chaplains, two to be in continuous service per month, to preach daily in the prince's chapel, where attendance was compulsory; and to help Henry and his friends in examinations of conscience. Henry told a favourite chaplain, Richard Milburne, that he respected preachers who challenged him from the pulpit, 'with a look that said: "Sir, you must hear me diligently: You must have a care to observe what I say"'.

In addition to the servants and court office-holders, Henry's informal aristocratic circle was consistently high calibre – Northampton, Salisbury, Southampton, Arundel, Pembroke. None of them received a pension from Henry. Some were wealthier than the prince himself. But, they were clever, worldly men who continued to develop his understanding of monarchy and government. Under their influence, he spent freely on art, sculpture, coins, architectural projects, masques, and plans to modernise the

navy and military – raising his household to one of the leading courts in Europe.

Henry received explorers such Thomas Roe and bought exotica from him for Richmond and St James's, paying for eight 'tons of Indian coloured wood transported from beyond the seas'. It cost between £30 and £45 a ton, a stupendous amount.* Roe had recently returned from a voyage up the Amazon. Having a piece of a New World in your home was intensely desirable. To furnish his homes, English agents abroad had an open commission to find him rare works of art, antiques, artefacts.

But, as Jonson made Catiline complain of the imperial court, which must include Henry, 'They ha' their change of houses, manors, lordships,/We scarce a fire, or household lar.' The few could buy anything they wanted. The many struggled to keep a roof truss, a 'lar', over their heads, and one chair to sit on, while 'they buy rare Attic statues, Tyrian hangings':

Ephesian pictures and Corinthian plate,
Attalic garments, and now new-found gems
Since Pompey went for Asia, which they purchase
At price of provinces.

Jonson's satire showed how the elite held power, by one close enough to see its naked and refined greed. At court, he celebrated, probably sincerely, the culture and glory of majesty. This was all in Henry – engaged, but at risk of becoming out of touch. The esteemed men of his circle, apart from the aristocracy, must keep him alert to the general sentiment of the political nation.

Henry soon raced through his income, forcing his officers to think of new ways to increase it. Sir Arthur Gorges proposed a bill to improve the prince's finances through the harsh imposition of the fines on recusants. It would, Gorges reckoned, 'bring unto your coffers …

* Add two noughts to this number to get an idea of the cost.

twenty thousand pounds a year at least, and to be effected with ease, without wrong to the public'. At least, the Puritan element of 'the public' might not feel wronged.

Gorges set out to present the bill in Parliament. Salisbury told Henry to withdraw it and soften it. If it 'be not tempered, it will be of ill sound in the subjects' minds in this island', said Salisbury. 'I fear me that this will be very inconvenient to his Majesty, and be found directly repugnant.' The Countess of Shrewsbury, the Earl of Northampton and his niece, Lady Suffolk, confidante of the queen, as well as Queen Anne herself, and the Earl of Arundel, were all court Catholics.

Sir Arthur encouraged Henry to answer anyone who went 'about to disgrace your bill in Parliament' by saying the bill 'favours more of a well-policed Christian state, and of the government of a wise and godly Prince, rather, with mild and provident remedies to prevent growing mischiefs, than afterwards to seek to weed them out with rigorous and bloody means when they are already planted'. The tone at Henry's court, in the shadow of Jülich-Cleves and the assassination of Henri IV, sounded aggressively anti-Catholic. Gorges's bill failed even to get a reading.

Alternative solutions to his indebtedness led Henry to ask Salisbury to help him raise his first substantial capital debt. The prince wanted to take on a debt the Crown held over Sir Henry Carey. Carey had 'bargained with the King my father for his land', said Henry, and had borrowed to finance it. Carey could not make his mortgage repayments on his country house in Hertfordshire. 'I mean to give him a composition for Berkhampstead [Place],' Henry told Salisbury. (He meant to lease back it to Carey for less than the amount of the debt. He would take on responsibility for paying the balance to the Crown, in order to gain control of the property.) He was sure he could overhaul the asset, improve it, and make a big enough return to show a profit for himself. 'I would be content absolutely to take upon me his debt, and pay it to the King my father, if you durst adventure to trust me,' Henry said. 'For though I am like enough to prove an unthrift, yet I will be loathe to lose my credit in my first undertaking, if you will give me reasonable' terms.

He knew – from that slightly forlorn admittance: 'I am like to prove an unthrift' – that he spent without hesitation to realise his interests and ambitions. Yet, he wanted to craft a reputation as a good business-man, 'a projector', a man you could rely on to honour his debts.

Court Cormorants

HENRY AND THE KING'S COTERIE

At Whitehall, his father's court, the masques *Oberon* and *Love Freed from Ignorance and Folly* seemed to hit a raw nerve. 'The King now means to play the good husband,' to queen and country, 'to reject all importunate and impertinent suitors, to reform excess of apparel both in Court and elsewhere, by his own example and by proclamation,' John Sanford informed the diplomat William Trumbull, the English resident in Brussels who needed informers. 'And of the £40,000 given to six of the Court cormorants, I do not hear that they have yet received anything … All the world wishes they may not' get a penny, said Sanford, a Latin poet, absentee chaplain of Magdalene College, and one of Trumbull's team.

The candidates for the title of 'cormorant' had to start with Carr; then James's old school friend, Sir Thomas Erskine, now Viscount Fenton, and John Murray: another old friend from Scotland, and brother of Henry's mentor, David Murray. James's travelling secretary, Sir Thomas Lake could be included; and James Hay, Earl of Carlisle; and George Hume, Earl of Dunbar; and an English courtier and favourite, Sir Roger Aston; among others of James's close coterie.

Carr knew better. He encouraged the king not to engage in dialogue with Parliament over regular financial support for the Crown. The Privy Council divided. Northampton and Suffolk came up with schemes for raising money, but bypassing the need for parliamentary

consent. Salisbury, seconded by nobles such as Southampton and Pembroke, advocated the Privy Council, Lords, Commons and king *in* Parliament, governing together.

To Salisbury's dismay, on 9 February 1611, the king dissolved Parliament, resenting their impertinent demands that he must discipline himself and account for monies spent. A few weeks later, James showed what absolute power meant. He handed over substantial money gifts which he had promised not to give six 'Court cormorants'. On 25 March, Accession Day, he followed it up by creating Carr 'Viscount Rochester' in the English peerage. It was the first time a Scotsman had been allowed to sit in the House of Lords. Eight weeks later, James made Carr 'Keeper of the Palace of Westminster'.

Henry received an anonymous tract, 'An Instruction to Princes, to know how to Govern state well': another missive warning him off favourites and flatterers. They caused 'the prince to be deemed a weak and unwise man', it said. It argued a Machiavellian line on why rulers failed – weakness, more than vice; both were tyrannies. The pamphlet verged on treason. Favourites 'disorder the whole government', it declared. A courtier hoping for patronage would never send something like this to the king. But Henry welcomed it, and kept it, perhaps to remind him to maintain his virtue and to avoid misguiding his affections.

The king and Rochester announced their own schemes to increase royal revenues. Under the pretext of raising money for the garrisoning of Ireland, James increasingly began to sell titles – cash for honours. The going rate for a baronetcy was set at £1,095. It attracted ambitious commoners. Scores bought the title in the next few years, establishing their families on the outer thread of the web of the titled, and entitled, with the royal family at its centre.

Two months later, James made Rochester a Knight of the Garter, alongside the Earl of Arundel. Henry carried the banner and helmet of the late Garter Knight, Henri IV, to the altar and laid them down – his face stiff with pain, disgust and self-control.

By mid-summer 1611, all could see that Rochester was 'further in the King's graces than any other subject' – including his wife, heir, and

chief minister. 'All this is displeasure to the English,' the Venetian ambassador noted. 'All the same, everybody is endeavouring to secure his favour and good will.' The favourite 'had more suitors following him than my Lord Treasurer', said Viscount Fenton. If true, this was a serious, unpropitious turn of fortune for Lord Treasurer Salisbury and Henry. Salisbury found his responsibilities exhausting him beyond his capacity to carry them out. He was depressed by the failure of his scheme to modernise and stabilise royal finances. He was wearied by Rochester's crude attempts to outmanoeuvre him. He now felt unwell all the time.

Henry reacted to Rochester's swift advancement by stepping up his own political activities. He wooed courtiers and looked 'graciously on everyone', except the new Viscount Rochester and his followers. 'So, everyone is his most devoted servant, and he can manage the King's most intimate, and make them speak to the King just as he thinks best.' An overstatement of the facts but not of Henry's ambition: to weaken the disordering force of the bedchamber, as advised in the tracts Henry received, in Jonson's masques and plays, and as discussed at his court.

The developments at Whitehall frustrated that brilliant group of ministers who had done so much to ensure the success of King James I's accession. Rochester embodied the problem. The Earl of Suffolk, as the tavern wits had noted, was 'still defatigated' by his attempts to impose some restraint on the royal purse. The bedchamber – weakened as a political entity for decades in Elizabeth's reign, since women could not hold office, as Rochester could – now felt like a secret, unofficial governing body that carried out whispering campaigns against any group trying to stand between it and the king. It undermined Salisbury and his colleagues on the Privy Council. Rochester was soon asking James to appoint him to that body as well. Henry was determined to get his place on it before him.

Rochester's slighting of the queen increased Henry's determination. Rochester and his confidant, Overbury, told themselves Anne was of little account – by no means the first or last of James's intimates to

make that error. The French ambassador thought Rochester treated the queen with 'insupportable contempt', while Overbury 'always carried himself insolently' towards her. It was astounding behaviour towards an anointed queen. In the bear pit of court, if their star ever fell, jaws stood open and ready to tear them to bits.

They overstepped the mark as they walked in the garden of the queen's palace at Greenwich. Anne stood at an upper window, chatting with her ladies and watching the courtiers walking and talking. As they passed her, they turned and made an obeisance. Rochester and Overbury did not give her a second glance, but shared a joke and laughed.

No one missed it. Certainly not Anne. She flew to her husband, expecting James, with his sense of monarchy, to punish such a serious insult to the queen's majesty. Rochester said he did not see her, and James ignored his wife. The queen returned to him and burst into tears. She 'cast herself on her knees and besought him not to suffer her to be so scorned and despised of his grooms, though', she lashed out at the flaunting of his love for his cormorants, 'she were content to suffer it [scorn] from him'. In private, Rochester sneered that she was jealous of him.

James sat unmoved. Inwardly, he shook. In the face of the king's impassivity, the queen lost her head. If this was how it was, she would return to Scotland or Denmark. He made her position here untenable.

Henry agreed to tackle the king on his mother's behalf. James was terrified of losing his queen, or Rochester. The prince watched as, 'much afflicted', his father, 'walked up and down his chamber. "Ah, woe is me, my queen will go from me, my Carr, my Carr"'. James's passions seemed to incapacitate him. No wonder Henry made a mental note to rein in his own carnal appetites. To appease his wife and son, the king resigned himself to summon Rochester and Overbury before the Privy Council to account for their behaviour.

Henry and his mother knew the king would not give up Rochester, but Overbury was within their reach. Salisbury approved their plan to humble him. When the Lord Treasurer received a letter from the

queen saying she expected 'that fellow' – not deigning to name him – to be punished in council, Salisbury willingly obliged. Overbury was widely believed to be the brains behind Rochester's increased political activities, as well as the love letters to Lady Essex. 'I recommend to your care how public the matter is now,' said Anne.

The council banished Overbury from court and the king swore Henry onto the Privy Council. From now on, the prince would play an official role in government. It was rumoured, wrongly, he 'is President of the Council'. 'He will, no doubt attend regularly, for he takes great pleasure in the conduct of important affairs,' concluded the Venetian ambassador-elect Foscarini. Henry could counterbalance Rochester, if and when he attended council, as few others could, perhaps including Salisbury.

Rochester was seen 'grappling often with the Prince in his own sphere, in diverse' arguments. For Henry, 'being a high-born spirit, and meeting a young competitor in his father's affections that was a mushroom of yesterday, thought the venom would grow too near him, and therefore he gave no countenance but opposition to' the poisonous growth. These days, Henry was 'almost always with the Earl of Salisbury', although the Lord Treasurer opposed Henry becoming President of the Council, reasoning that it was 'dangerous to divide the government, and to invest the son with the authority of the father'.

Henry once again found himself caught between two warring parents, as the court witnessed the nasty 'contestation between their Majesties about Sir Thomas Overbury's offense, and though her Majesty's displeasure be not yet much mitigated, Sir Thomas begins to approach the court again, his great friend Carr much labouring in his behalf'. Rochester threatened to abandon James if he did not restore Overbury. James, unable to think of life without 'my Carr', gave in, but needed the queen's assent. In the end, Anne gave it. Back Overbury slid, but only on the condition he never, ever entered the queen's line of sight.

When the dust settled, Rochester changed tack. Knowing he would be vulnerable when James died, he set himself to court the future king

and his mother. Rochester worked to have the queen's patronage requests granted, rather than thwart them. He involved himself in the negotiations surrounding Henry and Elizabeth's marriages. The Viscount Rochester 'carries it handsomely and begins to have a great deal of more temper', a cousin to the Earl of Mar observed. Nevertheless, he could not 'find the right way to please either the Queen or the Prince', no matter what he did. 'They are both, in the conceit of this court, not well satisfied with him.'

The Mars knew what it was like to be the focus of the queen's hatred. Anne had learnt from years of experience in Scotland to work such factionalism to her advantage. She now headed 'a great faction against' Rochester, 'having the same spirit and animosity against [him] … that her son' and Salisbury had. Common cause bound the three of them.

The Humour of Henry's Court

CORYATE'S *CRUDITIES*

At least within his own circle, Henry could relax. It was a great pleasure to him to grant Thomas Coryate's request for an audience at St James's. Coryate had spent the last couple of years compiling a travel book from his notes, 'for the nourishment of the travelling Members of this Kingdome'. He requested Henry become its patron and the prince consented. Delighted with himself, Coryate engaged Henry's engraver, William Hole, to create the plates and asked a few friends to contribute the usual little puff pieces for the front pages of his *Crudities*.

One or two verses arrived for the book. Then people began to answer each other's poems. Soon others, unsolicited, put in their contribution. Coryate's Somerset patrons, and Henry's officers, Sir Edward Phelips and his son Sir Robert, contributed. Inigo Jones sent a poem. So did John Donne. Donne very much wanted service with the prince; yet he found himself thwarted repeatedly by his reluctant, irate father-in-law, Sir George More, who was also Henry's Receiver General, and who sent his own poem.

Ben Jonson wrote the introductory character sketch. Henry's friend John Harington (as 'Ajax Harington') and Adam Newton offered a few lines. Sir Lewis Lewkenor, the king's Master of Ceremonies, and the wealthy merchant, financier, and businessman, Lionel Cranfield, added their pieces. Richard Martin MP, lawyer-orator, and his friend, Laurence Whitaker, who was Edward Phelips's secretary, contributed.

So did Hugh Holland, Christopher Brooke MP, and John Hoskyns, another lawyer-orator. Many versifiers attended on Henry directly. About thirty per cent of them were also MPs, members of the Inns of Court, members of the Virginia Company and the Northwest Passage Company. And many were tavern wits. Thomas Campion, writer of masques contributed, as did John Owen, the epigrammatist. Michael Drayton, Henry's poet and organiser of royal spectacles, and John Davies of Hereford, Henry's writing master, had all piled in answering each other and bantering in verse. Soon Coryate was buried in over sixty of the things – far too many. The epigraphs had taken on a life of their own.

Henry commanded Coryate to read them all to him and the house-hold. When Coryate finished he told the prince he would select the choicest (most flattering) and publish the rest separately. Not a bit of it, Henry insisted all the voices from his court must be included. These were their friends and acquaintances and some were bound to mock gently, while others simply heaped praise. The travel book acquired a very long preface, the 'Banquet of the Wits'.

Coryate showed up at St James's Palace, early on Easter Monday evening, 1611, his precious tomes packed into panniers on the back of a donkey.

Henry received him in the Privy Chamber, surrounded by the contributors and mutual friends. 'Most scintillant Phosphorus of our British Trinacria [three-cornered land],' Coryate began, bowing his nose almost low enough to sweep the ground with it. Coryate straight-ened up and off he went. 'With this May-dew of my crude collections, I have now filled this new-laid egg-shell, not doubting of the like effect in your Highness.' His book was the contents of the egg, the cover its shell.

You are, Coryate told Henry, 'the radiant sun of our English Hemisphere'. You, the 'great Phoebean lamp' warms the egg 'produced by a chuckling hen', me, Coryate. By 'your Gracious irradiation', you make this egg 'conspicuous and illustrious', he hoped, fervently.

Coryate's language played with images, twisting them into wit, making up new words that sailed to the edge of nonsense. 'A great and

bold carpenter of words,' was how Ben Jonson described him. 'Yea,' continued Coryate, 'I wish that by this auspicious obumbration [shading] of your princely wings, this senseless shell may prove a lively bird … and so breed more birds of the same feather … In the meantime, receive into your indulgent hand … this tender feathered Red-breast.' With that he handed over Henry's presentation copy, bound in vibrant red velvet.

'Let his cage be your Highness's study, his perch your Princely hand.' That is, Henry should put the book in a prominent place, where all visitors could see it.

Henry's volume delivered, Coryate led his donkey to deliver the other advance copies. The king received his at Theobalds, his mansion in Hertfordshire – Coryate greeting his monarch as 'the refulgent carbuncle of Christendom'. James rolled his eyes: he never understood Henry's indulgence of 'that fool'.

The queen, 'most resplendent gem and radiant Aurora of Great Britain's spacious hemisphere', received hers at Greenwich Palace – from me, said Coryate, 'who am nothing but a foggy vapour and an obscure relic of darkness'. He hoped she would recommend it in England and in Denmark.

Princess Elizabeth was presented with her copy at Lord Harington's house at Kew, where she was staying. Coryate pressed it into 'your Grace's lily white hands … in whose name, sex and heroical disposition methinks I see our great Queen Elizabeth revived and resuscitated back unto life'.

He returned to London and found ten-year-old Prince Charles at St James's with Henry. Coryate hailed him as the 'most glittering Chrysolyte of our English diadem, in whose little, yet most lovely gracious, and elegant body do bud most pregnant hopes like fair blossoms of great fortunes and greater virtues'.

It was all very Coryate, very Henry, very Jacobean – and very easy fun, compared with the complexity and seriousness of life outside St James's, where new problems were presenting themselves.

Marital Diplomacy

'TWO RELIGIONS SHOULD NEVER LIE IN HIS BED'

Henry's parents had come to power in that brief, already passing, European moment when a multi-faith marriage might create a broad political path their multi-denominational people could walk together, between fundamentalist, intolerant poles. That situation had changed. Attitudes were hardening across Christendom. Prince Henry and Princess Elizabeth preferred to marry fellow Protestants – ideally political opponents of the papacy and the (Spanish and Austrian) Habsburgs. Henry wanted to continue Henri IV's work of suppressing any resurgence of international popery under the Habsburg banner.

However early in February 1611, Queen Anne received Ottaviano Lotti, the Tuscan representative in London, at Greenwich. He brought with him presents, including portraits of the grand duke himself, Cosimo II de' Medici, and his grand duchess, Magdalena.

Lotti and Anne strolled in the palace's gallery. The queen wanted to see where the paintings might be hung in the best light. They stopped to admire a portrait of the eldest Spanish princess, Ana Maria, still a child: 'I see that little Princess [will be] Queen of England,' said Lotti, 'if her youth does not impede it.'

The queen thought so too. She herself was a lot younger than James. The infanta was their first choice for Henry.

Lotti asked about the French representative, Marshal de Laverdin, who was expected any day with an offer of the Princess Elisabeth for Henry.

'By God, that will never be. I would rather see my son damned,' said the queen.

'Why, Madam?'

'Because it does not please me,' she replied. 'I do not wish to have children by one who has four wives' – the late Henri IV having been a womaniser of European renown.

Prince Henry, on the other hand, might contemplate a French match, to keep Catholic France connected to Protestant Christendom, although it was known that Henri IV's widow, Marie de' Medici, was already passing anti-Huguenot legislation and had begun to negotiate with Spain to marry the young Louis XIII or his sister Elisabeth into the Spanish royal family. England proposed that if Elisabeth of France married the Spanish infante, Prince Henry should marry his sister, the Infanta Ana Maria – 'the Spanish olive', as Salisbury called her.

When penning his 'golden books' of instruction for the infant Henry, James VI of Scotland had warned his son against marrying outside the faith: 'Disagreement in religion brings with it ever disagreement in manners; and the dissension between your Preachers and hers, will breed and foster a dissension among your subjects, taking their example from your family.' James had obviously changed his mind. Though Spain offered their daughters to all comers, the king noted acerbically, he and the queen very much wanted the infanta for Henry. If he could add a high-status Catholic to his ruling dynasty, the king might then be pleased to negotiate a Protestant match for Princess Elizabeth.

Lotti had not come to praise a Spanish or French or Protestant match, but to offer his own princess, eighteen-year-old Caterina de' Medici. He also brought gifts for Henry – beautiful Renaissance bronzes displaying the cultural excellence of the Medici and all that it implied. But soon he was irritated to learn of a competing Italian offer for the prince, from Savoy.

The king and Salisbury had allowed both Italian states to play their hand. Tuscany, run by arriviste bankers – the Medici – could offer an enormous dowry, but they lacked honourable dynastic roots. Isabella of Savoy's bloodline was ancient and eminent, and the dowry was close enough to the Tuscan bid. Half the blood the Princess of Savoy offered was her mother's Spanish Habsburg line.

From Henry's Europhile perspective, although this was yet another Catholic, Savoy offered some geopolitical benefit. It bordered France on the west. To the east lay the Spanish military citadel in Milan, which Coryate had reconnoitred for him, strategically important to securing the north–south movement of Spanish troops up through Italy, and over the Alps, to flood into Germany and the Low Countries. Savoy owned Mediterranean ports, including Nice and Villefranche.

However, Isabella's father, the Duke of Savoy, was regarded as a megalomaniac and mentally unstable. Nicknamed the 'Hot-Headed', at one time or another Charles Emmanuel claimed to be King of England, Provence, Cyprus, Morea, Albania, Sicily, Sardinia, and Poland; and to be the Holy Roman Emperor. A Catholic and devotee of the cult of the Blessed Virgin Mary, he also welcomed refugee Huguenots and Waldensians (a southern French Calvinist sect, who came and settled in Piedmont). A man of huge appetites, the duke had already fathered ten children by his wife, and eleven more by a string of mistresses.

Soon after the Italian bids, the leading French Huguenot prince, the Duke of Bouillon, arrived in London. Bouillon asked if an approach from his nephew, the hard-line Calvinist Frederick V (the new ruler of the Palatinate) for Princess Elizabeth's hand would be well received. James said he required a formal proposal before he could reply.

By the middle of 1611, a raft of potential matches for Henry and Elizabeth lay before the Privy Council, each with its supporters. Henry could speak for himself in council. In public, he had to be more circumspect and use mouthpieces and proxies. As ever, he did not want to throw his court into opposition to the Crown. Whitehall could cut St James's off from the heart of power quick enough, if it wished.

Henry asked one of his favourite scribal proxies, Ralegh, for his opinion of 'the Prince Palatine of the Rhine', Frederick V's suit, compared with that of Savoy. 'Certainly, he is as well born as the Duke of Savoy, and as free a Prince as he is,' Sir Walter replied. 'The Nation is faithful, he is of our Religion, and by him we shall greatly fasten unto us the Netherlands, and for the little judgement that God has given me, I do prize the alliance of the Palatines and of the House of Nassau, more than I do the alliance of ten Dukes of Savoy.' Just what Henry wanted to hear. If the Palatine bid won, Henry acquired Frederick as brother-in-law, and his uncle Maurice of Nassau, with him.

Another 'faithful' prince, Otto of Hesse, arrived in England in June 1611 with a train of thirty noblemen to secure Princess Elizabeth for himself. Astutely, his party included a prestigious supporter, Maurice of Nassau's brother, Henry.

Prince Henry welcomed Otto 'with fare, and sports, tennis, the ring, *manège*, and hunting, very royally at Richmond' for three days, and then 'presented him at his waygate with dogs, horses, bows and guns. Many liked him better for our Infanta [Princess Elizabeth] than the Savoyard in regard of religion, and of the Palsgrave [Frederick V] because his father drunk himself dead, and we fear his patrisation.' Yet, Henry's comptroller Sir John Holles concluded, 'have I good grounds to believe that the Palsgrave will get the golden fleece'.

Anne and James did not find any of these princelings magnificent enough – except, at a stretch, the Palatine electors, blood descendants of Charlemagne himself, founder of the Holy Roman Empire. William Fennor, James's gentleman fool, composed a ditty about the marriage shenanigans, and sang it before the king, queen, Henry and Elizabeth.

> Five heirs, true youths, five kinsmen and five Princes,
> Of one religion, though in five provinces,
> Each of these are their countries' joyful hope,
> Friends to the gospel, foes to th'devil and Pope.

The five were Henry and the princes of the Palatinate, Brandenburg, Brunswick and Hesse. 'We'll forebear to speak of France or Spain,' said Fennor, speaking of them by saying he would not. James disliked mockery of his foreign policy and rebuked his fool.

Meanwhile, Henry listened to the Privy Council go over the offers and seem to work towards a Spanish or Italian Catholic match for him. But in September a piece of news left the negotiations dead in the water: the French government announced the queen regent's pleasure in concluding a double marriage contract with Spain. Elisabeth of France would marry the infante, the Spanish heir, and her brother, King Louis XIII, would marry the infanta.

James was furious. Two major European powers had played him for a fool, leaving France, Spain and the Holy Roman Emperor to draw ever closer together. King James clearly did not command enough fear or respect. France and Spain murmured about the availability of younger princesses for Henry. Their deceit strengthened Henry's argument: no papist state could be trusted.

The king answered France and Spain by accepting the Palatine offer for Elizabeth. To show what that meant for Christendom, the king then formally joined the Evangelical Union, founded by Frederick V's father. In James's mind he had joined a defensive alliance. To other members, his participation moved Britain and its heir back into the top echelon of politically and militarily active European Protestant states and princes. Logically, the Evangelical Union would now be spearheaded by Henry and young Frederick. They would defend the faith.

Before his early death to drink the previous summer, Frederick IV of the Palatine had despatched his own clarion call to England – for king or prince to take the place of Henri IV. 'Our brethren' are daily being 'robbed, taken, ransomed, burnt, fought withal, besieged, exposed ... overrun, spoiled and forcibly handled', he pleaded. He called for a religious war of liberation. Their apocalypse was nearly on them. How could the Stuarts not answer the cry from their beleaguered brothers and sisters in Christ, he asked?

The *French Herald*, an anonymous pamphlet circulating in England, begged Henry to take up the banner of his 'valorous god-father ...

Henry the Great', the late Henri IV. Lead the crusade 'under the happy auspices of your glorious father, or rather he himself by you', it told him. Everyone knew James would never go.

'You need not stir out of your royal Whitehall', the *Herald* assured the king. 'We will send you the news of the ruin of your enemies. Your arms are long enough to chastise them ... most especially your right arm, the son of your thigh', Prince Henry. 'Let us but have him, let him but have himself, and he will come to us', they pleaded. 'Let him go for the public good of all Christendom ... We have none else to be the head of our croisado.'

The *Herald*'s tone grew shriller. 'To horse, to horse!' it urged Henry. 'The quarter is broken, the bloody Trumpet hath sounded; true and mortal war is open.' Enough practising 'among your tiltings and feigned combats', it urged, 'though otherwise in peace, honourable, delightful, needful', they are not enough any more. 'Do not ... mould any longer among your books.'

The pamphlet sold out, and had to be reprinted. Other voices came in behind it. 'Here is the Alexander of Great Britain. Here he is – weapons in his hand, his side and blade turned towards the enemy of God', Huguenot, George Marcelline, wrote, offering himself, 'as one of yours', to Henry. 'You shall find me readier to lay hand on my sword for you, than on my pen, and would rather spend my blood than mine ink, for your honour and service, in all, and by all, My Young Caesar, and great Alexander.'

So many marriage contracts and new alliances agreed this year, yet Prince Henry, the key player, was left unmatched. Finalising the contract for Princess Elizabeth, the king and Salisbury turned to see who still held what cards: Spain dismissed, France still in play; Tuscany and Savoy now came back to the table to win Henry for one of their princesses.

While seeing a certain logic in his parents' desire for a European, mixed-faith match, for Henry and his entourage it killed the dream. He was not yet king though; he and his followers must tread softly on this matter, although they realised Henry would have to wed soon.

Henry tried to fend off the issue by saying he 'intended to marry a subject and a beauty, to avoid keeping a mistress' – a sly dig, perhaps, at his parents' marriage and 'Mistress' Carr.

And he did not react when Sir Edward Cecil, prompted by his uncle, Salisbury, held up the portrait of Caterina de' Medici for him to admire. Of course he supported any tactic aimed at challenging Spain's presence in the Italian peninsula. If his father hardened his views on a Catholic match, he might have to marry an Italian. 'Behold our Prince turns to Tuscany for a bride,' the crypto-Catholic earls of Northampton and Suffolk cheered in the Privy Council.

In the autumn, Caterina sent her confessor to Rome to seek the pope's approval for her to marry a heretic. Ambassador Lotti assured the king and queen that a papal curia of six cardinals was working on how tacit approval could be given, without being seen to facilitate the inherent 'evil' of such a match.

If he was to be sold to Tuscany, Henry wanted to see evidence of future benefits. He asked Sir Thomas Chaloner to commission his former pupil, the exiled Sir Robert Dudley, to visit the Medici. The price of Henry's consent would be a large proportion of the dowry, paid direct to him, not the Treasury.

Henry undermined the Tuscan negotiations as best he could. He asked Sir Charles Cornwallis to publish a damning review of the match. Cornwallis's 'A Discourse Concerning the Marriage Propounded to Prince Henry with a Daughter of Florence' said Tuscany was remote, and therefore useless geopolitically. And, it was too closely tied to the pope. The dowry would not provide investment capital for the good of the country, would only pay down a bit of royal debt – and most likely leak out into favourites' pockets. Last, the Medici were nouveau riche and no honourable match for a prince of such ancient lineage and esteem.

The alternative was a Protestant princess. Cornwallis concluded happily: 'Your conjunction with your own religion will demonstrate your clear, and undoubted resolution not to decline in the cause of God' – unlike his father and council, apparently. 'This will fasten unto you, throughout all Christendom, the professors of the reformation,

and make you dear to the subjects of this kingdom; out of whose loves you may expect a permanent and continual treasure.' If Henry was thinking ahead to his own reign, he would not marry Caterina.

A Catholic queen meant 'a marriage in so high a degree distasteful to them', his subjects, Cornwallis continued, that it 'is likely to breed, and increase, those obstructions which have lately been showed upon the demands of supply in parliament, by the King your father'. Henry and Sir Charles assumed Parliament's input in policy-making.

Salisbury approved much of Henry's maturing narrative. Especially, any hints that Henry might sense something James did not – that government by Privy Council and king *in Parliament*, not despite it, was the way forward.

To stall for time and keep the king, queen, Salisbury and the Privy Council at bay required some subterfuge and strength of character in a seventeen-year-old. The playwright John Webster said it felt as if 'we stood as in some spacious theatre', to those around Henry now, 'musing what would become of him'. Henry's vision was no longer just the political culture he had inherited from the descendants of the godly, Elizabethan war party, whose heirs had always gravitated to his court. Plays, masques, poems and wild-talking pamphlets showed he now chimed with the contemporary imperial and religious aspirations of a broad spectrum of the British people.

As winter came in, Henry's court asked themselves if a large section of these Britons really wanted the prince to throw himself away on a papist in order to solve, temporarily, his parents' chaotic finances and satisfy their outmoded vision for Europe, and to accommodate his father's exalted view of divinely sanctioned rulers. For King James, monarchy was a transcendent state, which certainly included the capacity to transcend mere confessional barriers.

Supreme Protector

THE NORTHWEST PASSAGE COMPANY

On other subjects king and prince thought as one. James responded to accounts of the most recent voyage to discover the Northwest Passage with a compliment to his son's vigour and passions. 'To the ears of the Prince, who is keen for glory, come suggestions of conquests far greater than any made by the Kings of Spain,' the Venetian ambassador said, deftly checking off Henry's interests in one sentence – glory, conquest, wealth, empire, defiance of a religious and colonial enemy.

Between 1607 and 1611, English navigator Henry Hudson had undertaken four exploratory voyages, naming a cape in the Hudson Straits 'Prince Henry's Foreland' on his final voyage, from which he had failed to return. The Northwest Company projectors had high hopes the mythic passage lay within one more voyage, one 'extraordinary means to grace and honour', a final push through the ice. At the end of July 1611 the king issued a grant of incorporation to the 'Company of Discoverers of the Northwest Passage'. He announced the 'action itself will be more fortunate, and the undertakers thereof the more encouraged, if it shall be countenanced by our most dear and well beloved son, Henry, Prince of Wales', now to be titled 'Supreme Protector of the said Discovery and Company'. The motto James gave the company, *Juvat ire per altum* – 'He Delights to go upon the Deep' – celebrated his son's spirit with typical generosity, affection, some wit, and irony: Henry had actually gone nowhere.

The list of investors was a roll call of Henry's followers. The prince instructed Phineas Pett to help Hudson's replacement, Admiral Thomas Button, choose ships for the voyage. Button liked the *Resolution* and the *Discovery*. By April 1612 they were ready to set sail, Button carrying 'Certain Orders and Instructions set down by the most noble Prince, Henry'.

'Let there be a religious care running throughout your ships,' Henry instructed Button, and quick punishment of 'profane speeches'. There should be 'no swearing or blaspheming of his Holy name, no drunkenness or lewd behaviour'. Henry and Button needed to avoid the expedition collapsing into mutiny as, by most accounts, Henry Hudson's final trip had. The mutineers abandoned Hudson to his fate, setting him adrift in a small boat, and no one saw the explorer again. As usual, Henry ordered a full navigational-geographical record be kept. He expected them to be gone for up to two years.

At the same time, Henry asked his father, repeatedly, to appoint him Lord High Admiral. The prince sent 'a spy', to observe 'privily … how the royal navy was ordered'. He felt passionately he must set out 'with diligence and authority … to regulate many abuses which the present Admiral who is decrepit, can hardly do'. The prince was stubborn enough not to give up till he got his way. The king met him halfway, permitting Henry to make a general review of the navy with a view to its complete refit and modernisation. Henry's men had to 'report what defects there were'. But the prince used the opportunity to pry 'into the King's actions' regarding the navy, showing 'dislike' of his father's neglectfulness. Not content with examining the royal naval dockyards, there was 'no doubt, but he had others', spying for him, 'in the Signet Office' as well. Given an inch, Henry took a mile.

James reacted by announcing that Prince Charles would become Lord High Admiral on Nottingham's retirement. Henry was furious. Charles was only eleven. The king knew the depth of Henry's commitment to the navy. James wavered under his torrent of objections, and soon Henry had his father's agreement to allow him 'to execute [the position] during his brother's minority, with a Commission of the

greater Lords, and … of Inferiors'. That gave Henry years to launch the navy on its programme of upgrades and expansion.

In the Privy Council, Henry pressed his fellow councillors to sanction the construction of eight new galleons and produced detailed lists of cost-cutting measures. They stonewalled. Undeterred, Henry took his usual course of action, of gathering expert opinion from within his circle and circulating it. That meant experienced sailors such as Ralegh and Sir Arthur Gorges, who were both asked to contribute reports. Ralegh wrote pieces on ship design and on the royal navy, and emphasised the bond of trade, domination of the seas, and global power: 'For whosoever commands the sea commands the trade; whosoever commands the trade of the world commands the riches of the world, and consequently the world itself.'

Ralegh concluded that Dutch naval strength was already damaging British commercial activity (though they were Britain's closest allies). Henry's expedition to discover the Northwest Passage was part of his challenge to the Dutch for trade to Asia and the Far East. He also insisted that Spain must, once and for all, be prevented from enforcing its exclusive domination of American colonisation and trade. Henry vowed that the moment his father broke 'with Spain … [he himself] would, in person, become the executor of that noble attempt'.

All the prince could do for now was get experience on the water. He commissioned Pett to build him a pinnace to support the *Prince Royal*, with instructions that his cabin should be roomy, for Henry desired 'to solace himself sometimes into the Narrow Seas'.

Pretty soon, Henry was sure Charles would never be Lord High Admiral. 'The Prince has managed so cleverly with the king that he has got his [father's] word for the post for himself,' reported the Venetian ambassador. In Elizabeth's reign 'the post of Admiral was worth one hundred and fifty thousand crowns', Henry had ascertained. 'In time of war, it is undoubtedly the greatest post in this kingdom.' It would become great again, when he had finished with it. The results would surely produce for his father and himself all the money they could spend, as it had for Spain – and possibly allow him the

freedom to marry who he wished. Economic prosperity, national security, and royal prestige met in Henry's plans for the navy.

A knock-on effect of these projects was that commitment to Virginia steadied initially under Henry's patronage. Henry's poet, Michael Drayton, urged 'you brave heroic minds' to 'go and subdue' the Spanish, and save Virginia for God and King. Only womanish 'hinds' stayed at home 'with shame'. One Spaniard irritably informed his king that 'those who are interested in this colony [Virginia] show ... they wish to push this enterprise very earnestly, and the Prince of Wales lends them very warmly his support and assistance towards it'. James and Henry were 'new Constantines ... propagating' Christianity among the Virginians, 'who yet live in darkness', said William Crashaw, Preacher for the Inner Temple. There was also the promise of a dividend of twenty pence in the pound, while souls were harvested, a great return on your outlay.

In reality, the project of colonising North America had failed repeatedly since Ralegh first sailed thirty years earlier. Sir Thomas Gates had been trying to pull the fledgling colony back together since that starving winter, but after months of effort, felt it was beyond him. No attempt was ever made to think ahead, about what was needed on the ground once the colonisers had taken possession of the Native Americans' lands, and 'liberated' them from the 'darkness' of their way of life. The settlers needed detailed, well-informed plans about how to cultivate the land efficiently; how to construct strong, fortified settlements; how to establish and maintain friendly relations with the natives you were dispossessing; and ideally, how to acquire prior understanding of how their society and economy functioned, on their terms. A good start would be if colonists learned to speak the Algonquin language. John White and Thomas Harriot's researches could have helped here: Harriot could be reached through Henry.

Instead, the Virginia Company stood on the brink of another collapse. The English were preparing to abandon America again, when Admiral Lord De La Warr, accompanied by Henry's former weapons tutor, Sir Thomas Dale, landed at Jamestown on 29 May

1611. Henry had written to Maurice of Nassau to secure Dale's release for this voyage. Thomas Dale took one look and concluded that only the temporary imposition of martial law could hope to stop the rot and consolidate their foothold in the New World. Gates was appointed lieutenant-governor under De La Warr. Dale was to be high marshal. A brutal man, Dale drew up a series of severe martial laws, imposed them, and set about rebuilding the colony. Unwittingly, he created the first legal system for America. Once Dale and Gates regulated the colony so it could begin to function, Dale set off up the James River. About seventy miles upstream, he found prettier, drier, sweeter ground than the malarial pit of Jamestown.

By early 1612, Dale reported to Henry that the new township which he had named Henrico (sometimes Henricus or Henricopolis) was 'much better and of more worth than all the work ever since the colony began'. He had laid the town's foundations already, he said: three streets of timber buildings and a church, and sent his master a little present of an American 'hawk and a tassall'. The Virginia Company drew up plans for a private university in the town: the first in America, they called it Henrico College. The company minutes recorded the carving out of 'ten thousand acres of land for the University to be planted at Henrico and one thousand acres for the College for the conversion of the Infidels'.*

Along with Cape Henry at the mouth of the Chesapeake Bay, and Fort Henry on the Hampton River, bit by bit Henry's representatives filled in the map for their prince. Henry's 'royal heart was ever strongly affected to that action'. Virginia's first historian judged Dale and Gates, brutal as they were, essential to the founding of British America. Without them, the colony, said Robert Johnson, would have collapsed once more from the combined effects of famine, absence of the rule of law, the ravages of disease and attack from indigenous tribes. Yet, Johnson's recommended actions to ensure the future well-being of the colony explained why James came to dislike the Virginia Company. 'Let them,' the colonists, 'live as free Englishmen under the

* Today, Henrico is a suburb of Richmond, Virginia.

government of just and equal laws, and not as slaves after the will and lust of any superior … discourage them not in growing religious nor in gathering riches,' he said.

'Any superior' could so easily evolve to include that most superior of 'free Englishmen' – the sovereign. Many English settlers hoped they came to create a brave new world of opportunity. In 1612, most survivors found themselves to be almost indentured labourers, living under martial law, for the benefit of vested City interests and the shareholders of the Virginia Company, Prince Henry prominent among them.

In all this, Henry was a man of his time, embracing his era's fascination with voyages of discovery, imaginary and actual. Henry dreamed of travelling through 'unpathed waters, undreamed shores', to bring back never-before-seen wonders. The desire for odysseys, to make the world bigger and fresher, was such an ancient impulse, and the desire surged hard in Henry now. But he could not go where he wished. He was not a Thomas Coryate, nor an Edward Cecil, nor Ralegh, Dale or Gorges.

Henry had badly wanted to lead English troops to Jülich-Cleves, yet had not even been allowed to cross the English Channel in his own ships. He desired direct experience of Christendom, where preachers said the apocalyptic struggle for Europe's salvation was brewing – a battle in which, from six months old, his role had been prophesied. When Coryate and Henry's boyhood friends came back, their tales let him travel freely – in his mind. When King Henri IV was alive, Henry fantasised about visiting him dressed in disguise. Now he enabled some of his followers to go to America, to do what he yearned to do: establish a godly brave new world, freed from the rituals and constraints that held even an absolute monarch-in-waiting in his place. When he was king though …

Henry planned to sail his ships, including the *Prince Royal*, out across the high seas, rather than up and down the Thames estuary. It was a question of time. He was seventeen. He had all the time in the world. To be trapped in the southern half of England for ever, within

the boundaries marked by hunting tracks and royal progresses, was unimaginable.

He would travel for friendship's sake, to visit princely cousins in Europe – as his uncle Christian IV had visited the Stuarts, and his father had sailed on impulse to Denmark to fetch home his mother. He would travel for diplomatic reasons, visiting the capitals of his allies. He would travel as a pilgrim, the holy knight of his 'barriers' tourney, to ally with the rest of Protestant Christendom and complete the Reformation. He would travel for wealth, to prosper the common weal, and secure his borders. He would travel to war to daunt enemies. He would travel to escape the gilded cage of court. The siren song of the still-to-be-discovered was irresistible to him.

The danger was that he would become like Icarus. His image shone so bright at home and abroad. Would he throw a correspondingly dark shadow? Yearning to soar above the grey compromises necessary to everyday life, he was a glory-hunting young man. He risked developing the affliction of visionaries and heroes, who can become inhuman in the pursuit of their vision.

Henry asked Robert Sidney, Viscount Lisle and governor of Flushing, to find him a company of soldiers in Holland. 'I had purposed the Company to your young knight,' Lisle told his wife. Their son was a friend of Henry's, and one of those the prince had chosen to make a Knight of the Bath in June the previous year. Lisle's son also longed to command a company of soldiers under Maurice. Of course he did. He was one of Henry's people. Lisle told his wife he could only let their son have it, 'if I can get free of the Prince [Henry], to whom you know of old I did make a promise of the next Company [to fall vacant in the Flushing garrison]'. It is impossible to think Henry would let such a chance slip through his fingers.

Selling Henry to the Highest Bidder

'THE GOD OF MONEY HAS STOLEN LOVE'S ENSIGNS'

In the cold light of day Henry sat in council to review the offer of marriage from Savoy. The Savoyards had asked the king if the Privy Council would consider making a double match: Isabella for Henry, the Prince of Piedmont for Elizabeth.

Meanwhile, the Tuscans pressed on, certain they were closing their deal for Henry. A cannonade retorted from St James's. We only entertain the Savoy match for our prince for one reason, said Holles, Henry's comptroller and proxy: 'the clearing of the King's debts … But, why should the heir of England be sold?' In any case, Savoy offered a price not 'above the reach of three subsidies of 2*s* in the pound', the detail underlining the grubbiness in all this. Our princes used to marry for 'greatness or affection', said Holles. If his highness had to speak of his marriage in the language of profit and loss, then what gain should he seek? Princes' profit was 'to be understood in augmentation of empire, either present or future; in reason of state, by intelligences; commerce for commodities; conjunction of arms, or diversion for the recovering of withheld rights', not a one-off lump sum that failed to address the underlying causes of the financial woes at the Treasury. The king and his advisers were throwing away a powerful tool of foreign policy.

Henry could fulfil none of these expectations if he married into Savoy (or Tuscany). He would gain no increase of dominion as

Charles Emmanuel had many sons. There was no reason of state: Savoy might spill some intelligence about France, but never about Spain, to whom Savoy was economically beholden and related by blood and faith. Commerce? Not a chance, said Holles, as Savoy's 'strait countries afford none'. Help in arms? Perhaps. Again, although Savoy was wary of Habsburg ambition, the Savoyard default alliance was with Spain.

Charles Emmanuel answered the critical commentary in England by doubling the huge dowry offered by Tuscany. But the view at St James's was that Savoy could not afford to put up this amount: Spain and Rome would have to cover Savoy's bet to 'make the stake good'. When that happened, to whom did the Duke of Savoy owe loyalty? His own creditor cousins, neighbours and co-religionists, or a heretic, foreign son-in-law? By a Catholic match, Holles continued, 'Rome shall reap thereby great honour, great profit, namely she shall recover her ancient supremacy and jurisdiction … Spain will have us abandon our sympathisers, the United Provinces of the Netherlands, and … cast off our well willers for religion's cause, or other common interest'. As for her faith, even if a prospective Catholic queen only practised her faith in private, 'one mass in the court … begets 1,000 in the country'. That summed up the hotter Protestants' assessment of Anne and the other court Catholics.

James disapproved of this maturing tone from Henry's circle. But Henry's people could rely on their master to protect them. His close-knit court knew him to be ferociously loyal.

Having secured Elizabeth for Frederick V of the Palatinate, the Duke of Bouillon came from France in May 1612 to offer Christine, the second daughter of the late Henri IV, for Henry. Only nine years old, the princess's marriage to a Calvinist of Henry's calibre would strengthen the battered Huguenot faction in France. Bouillon half hoped Spain might find the prospect so distasteful they would step back from committing both senior Spanish political pawns to France as a result.

Henry once more spoke through the scribal publications he commissioned, endorsed or sponsored, from which he could distance

himself, just enough, if challenged. James disliked his son broadcasting through the back door, via the voices of 'common men', but he needed Henry's cooperation on a matter of such national importance as his marriage. On the surface, Henry drew on his neo-Stoic pride, adopting a pose of aloof demurral. He 'does not show many signs of stirring himself, and seems to defer to the judgement of his father'. He would choose how and when to compete openly for powers. For now, he resorted to the guile he learned from Dallington, Northampton, Cornwallis, and from Tacitus.

However, had James been left in any doubt of his son's views, the entertainment he arranged for the Feast of Epiphany told him, again.

Love Restored could not have differed more from the usual princely spectacle. The subject was topical enough in a year when marital chess enthralled the leaders of Christendom. Yet 'Robin Goodfellow' just shambled on. He moaned and groaned about offering them an apologetic, impoverished little show – no good music, singing, enchanting sets, costumes, poetry. They had little money to honour the company tonight.

The court, arrayed to magnify the splendour of the evening, stiffened. Henry always played his part. Had he taken a false step?

Interrupting Robin's whinging, Cupid entered. They knew it was Cupid – bow and arrows in his hand, blindfolded, talking of Love. Yet, it did not sound like Love. Who then?

''Tis that imposter, Plutus,' said Robin, enlightening them, 'the god of money, who has stolen Love's ensigns.'

Masquerading as Love, Plutus/Money 'reigns in the world, making friendships, contracts, marriages and, almost, religion; begetting, breeding and holding the nearest respects of mankind and usurping all those offices in this age of gold, which Love himself performed in the Golden Age'.

Henry's masque denounced his era as a grasping, gold-coin obsessed age, not the real Golden Age. Plutus sets himself up 'to tie Kingdoms'. Every sacred thing is reduced to a commodity to be traded. There was real anger and resentment here.

Taken with the other commentaries from Henry's circle, it formed a coherent narrative. If England did not act to address economic problems, and to stand up for what it understood love to comprehend – 'friendships, contracts, marriages and, almost, religion' – then it ended up selling the heir to the throne. *Love Restored* showed the ignominy of being treated as the star lot, touted about to attract the highest bidders to the auction. Was Henry's marriage not to be a sacrament, a sharing of your dearest values – pleasing to God, as well as the state? A song lamented the change in Cupid:

> O how came Love, that is himself a fire,
> To be so cold!
> Yes, tyran money quenches all desire,
> Or, makes it old …

Jonson and Henry had Love/Cupid enter at this point, and go onto the attack. 'Away with this cold cloud that dims/My light!' He turned on the god of money:

> Imposter Mammon, come, resign
> This bow and quiver, they are mine.
> Thou hast too long usurped my rites.

The masquers – Henry, very unusually, not dancing tonight – stepped up to reset the world's moral compass:

> Till all become one harmony
> Of honour and courtesy,
> True valour and urbanity,
> Of confidence, alacrity,
> Of promptness and industry,
> Hability, reality.

Henry was under pressure. He had to think seriously and fast about the matter of who he should marry, or it would be done for him. He knew he *could* marry a Catholic. His mother was a papist. Certain men of his set, such as Arundel, were known to be papists. It did not make them Counter Reformation zealots. It might indeed make Henry into the sort of holding figure in Europe that his father hoped the new British kings could be – between the Scylla and Charybdis of aggressive, expansionist Catholicism and militant international Protestantism.

'I would advise the Prince to keep his own ground for a while,' counselled Ralegh, 'and no way to engage or entangle himself' in a marriage he might later regret. Ralegh's (prophetic) reading of the times was that 'the world is yet aslumber'. Henry should wait for the inevitable, he told him, when 'this long calm will shortly break out in some terrible tempest'.

Delaying tactics might work for a Prince of Wales who wielded great influence but did not, yet, make policy for his kingdoms. It would leave him free to claim both traditionalist and progressive laurels. It was a shrewd position to take up, almost resolving the conflicting desires and beliefs of the various circles in which he moved, from Whitehall to St James's.

At least his sister Elizabeth was beyond barter. Bouillon, together with the Elector Palatine's servant, Count Schomberg, had come to discuss Henry's possible bride, but primarily to finalise articles for Elizabeth's marriage to Frederick. The couple had not yet met but had been communicating directly. The count carried letters for Elizabeth and Henry from Frederick – and muddled them, nervously present-ing a love letter to Henry and a clarion call to his future brother-in-arms to Elizabeth.

Henry was more than happy to take Ralegh's advice and stall. He was attracted to Henri IV's second daughter, Christine, as a prestig-ious and politically interesting prospect, and dragged his heels on an Italian match. Some describe the prince as being reticent to the point of taciturnity, but Henry knew very well how a person of his signifi-cance had to guard his thoughts, to manage how and where he

broadcast them to greatest effect. 'While he is yet free, all have hope,' said Ralegh, 'but a great deal of malice will follow us afterwards, from those that have been refused.'

Quietly, Henry gathered intelligence from France, using a spy called Lorkin. Mr Lorkin had tutored Henry's school friend, Thomas Puckering, during his grand tour. He reported that the French queen regent was attacking the Huguenots' governing body, and the Huguenot strongholds of Languedoc and Provence had sent deputies to Paris to protest. The queen replied that if they did not submit, she would 'hold them as traitors and rebels, and accordingly … proceed against them'. Lorkin also described a dispute at the Sorbonne raging between the Huguenots and Jesuits. The Jesuits wanted to beatify their founder, Ignatius of Loyola – the first step to sainthood. The Huguenots thought it a 'damnable and detestable' idea to make a saint of a man whose followers had slaughtered their king not two years ago. The Jesuits countered that 'their order has done greater miracles by the power of Ignatius … than did the Prophets and Apostles by the power of God himself'.

Such intelligence helped Henry assess the impact a French bride might have on the balance of power in Christendom. If France was drifting towards a militant Jesuitical Catholicism, it did not bode well for the chances of a mixed political and religious settlement in Europe. Part of him was 'resolved that two religions should never lie in his bed'. Another hoped he might be able to convert Christine. She was only nine, and her father had been Protestant for most of his life.

Still, Ambassador Lotti remained buoyant, convinced that he had achieved the match for Tuscany. He told his replacement Signor Cioli as much before returning to Florence. Cioli imagined this was going to be a prestigious, easy mission. So he could not understand why, throughout the spring of 1612, St James's laid one stumbling block after another in his path. Sir Edward Cecil presented him with a long list of objections to the Tuscan marriage and told Cioli he needed to address them before Henry could give his decision.

All talk from within Henry's circle consistently favoured a Protestant match. Although possessing strong Catholic sympathies

himself, the Earl of Arundel told Henry, over the supper table, that he believed this route best secured the independence and strength of the British Crown. Cornwallis echoed his view, as did Edward Sackville, nephew of the late Earl of Dorset. Lord Roos, grandson of the Earl of Exeter and someone James used for diplomatic missions, told David Murray that the Tuscans knew Murray was 'so great a Puritan, that you are not only an endeavourer against this match' of Henry and Caterina, 'but also against all other matches which are popish'. No one knew Henry's heart better than David Murray.

Thwarted and confused, Signor Cioli had had enough. He denounced King James as a 'weathercock' who swung towards several different Catholic matches. He said the queen was stuffed with 'extravagant fancies' and was unbearably vain and haughty. Henry, he admitted, was a 'generous and heroic spirit', yet he too had an unattractive sense of superiority and arrogance.

Cioli's opinion soon became irrelevant when the pope forbade any Medici princess from marrying a heretic British prince unless England changed its laws. The Tuscans demanded James's government rewrite the Oath of Allegiance to ensure it did not offend his holiness, the pope. In addition, the English must make greater concessions to Catholic worship.

Negotiations collapsed. The pope's stance confirmed everything Henry and most Britons believed about papal and Jesuit interference in sovereign states. Under the guise of facilitating a dynastic alliance between European powers, they had the temerity to demand changes in the laws of independent nations. One Savoyard negotiator, thrilled to see the Tuscan bid founder, said Savoy would not be so anxious to appease the papacy.

Cioli was suffering considerable distress. 'I am in a state of such mental confusion,' he said, and now just wanted to go home.

A Model Army

'HIS FAME SHALL STRIKE THE STARRES'

Maurice of Nassau had no daughter to offer, although his nephew, Frederick of the Palatine, was to marry Elizabeth. Maurice courted the prince in order to keep Henry firmly in the Calvinist camp. In March 1612, Maurice introduced one of his own engineers, Captain Abraham van Nyevelt, to St James's. Van Nyevelt was of that generation of brilliant military engineers to emerge from the Protestant side in the Dutch-Spanish war.

Maurice told Henry the captain was writing a book on fortifications and wanted to dedicate it to him. Henry accepted the man and his book. For Van Nyevelt to appear just now meant Sir Edward Cecil must have briefed Maurice about the prince's desire to modernise Henry VIII's garrison forts. The prince had Waymouth's recent plan of the fortress at Jülich, Coryate's account of Schenkenschanz and the drawings of the Venetian fort of Palma, 'the finest in the world as far as fortification goes', said Henry. His own theoretical knowledge was extensive. He commissioned Van Nyevelt to make 'patterns' for England's new fortifications.

As well as putting forward his thoughts on defence plans and marriage proposals, Henry was deeply embroiled in renovation schemes for his royal palaces, particularly Richmond, as he strove to create the right settings in which to display his prestigious collections of art, coins, gems, antiquities, books, maps, plans and drawings, and

scientific instruments, and showcase his court. He had already created a new gallery at St James's, where he displayed the fine collection of Renaissance bronzes given to him by the Grand Duke of Tuscany.

Sir Edward Cecil wrote from Utrecht to say he had the chance of getting a superb army in miniature for Henry. The models had been created by a soldier called Edward Helwis, who served under King Henry VIII at Boulogne. Maurice of Nassau used these 'engines' to plan and review some of his greatest battles, said Sir Edward. They were perfect for 'the very practise of everything either defensive or offensive'. However, the present owner wanted £1,000 for it, a huge sum.

The imprimatur of Henry VIII's and Maurice's connection to this army sold it to Henry. Crates and crates of models arrived. Toy army as it was, the models were quite a size, including '15 pieces of brass ordnance, each 22 inches long', 'one model of a beacon', 'one model of a bridge', 'an engine for driving piles', 'one scaling ladder', '17 boards with foot companies', '16 small boards with carriages', 'one table with a camp of horse and 3 pavillions', 'one table with 3 boats, on a cart 2 carriages for mortar pieces; one sledge'.

Henry gathered his military salon and set out 'battles of Head-men appointed both on horse and foot', on huge tables, 'whereby he might, in a manner, view the right ordering of a battle, how every troop did aid and assist another, as also the placing of the Light Horsemen, Vauntguard, main battle, with the assisting wings, and rearwards, & c'. At St James's he could practise being Maurice, until he took on his mantle, and like Henry VIII before him, be an English king leading his troops into continental Europe.

The salon then repaired to the tiltyard or the riding school to improve the skills Henry's war games showed them they needed, by 'tilting, charging on horseback with pistols, after the manner of the wars, with all other the like inventions'. Before, during and after, the men reconvened as Henry delighted to 'confer both with his own [people] and other strangers, and great captains, of all manner of wars, battles, furniture, arms by sea and land, disciplines, orders, marches, alarms, watches, stratagems, ambuscades, approaches, scalings,

fortifications, incampments' and so on. He ordered 'new pieces of ordnance to be made', and spent time 'learning to shoot, and level them right to the Whist: No less provident was he to have great horses, and those of the best, which were sent to him from all Countries.'

Michael Drayton demanded that 'Britain' look at 'Henry, thy best hope, and the world's delight':

Ordained to make thy eight great Henries nine …
Thus in soft peace, thus in tempestuous warres,
Till from his foot, his Fame shall strike the Starres.

Henry rewarded the poet with an annuity of £10 a year.

Isaac Oliver painted a miniature of Henry, in profile, dressed as a Roman general with breastplate and a scarlet toga. The profile pose in classical garment gave a timeless, dislocated feel to the image, as Henry gazes forward at his destiny, somewhere beyond the range of ordinary mortals. It created him as a being set apart, while the red toga connected him to the classical world and his fabulous collection of classical gems, coins, medals and miniatures. In another he was painted in one of his suits of armour, with an army camp in the background that seems to be peopled with both Roman and contemporary soldiers.

In reality, rising eighteen, he was a little over medium height for the day. Five foot eight inches tall, he was broad-shouldered and, while not fat, 'his habit [was] rather full'. His hair had now darkened to the auburn Stuart hair of his father and grandmother, Mary, Queen of Scots. When he spoke, he spoke slowly, deliberately – so slowly in fact he may have had some speech impediment. His father had a speech disorder and his brother Charles stammered badly. Henry used 'otftimes say of himself that he had the most unserviceable tongue of any man living'. Yet he welcomed those wits at his tables whose words tumbled from their mouths like acrobats. Though not a rapid-fire banterer, Henry spoke to the point and with certainty. His measured delivery suggested forethought, not mental incapacity; he had been educated to concentrate for hours.

Francis Bacon thought Henry's bearing and movements showed real grace, 'his countenance composed, and the motion of his eyes rather sedate than powerful'. The young man had poise. Hawkins, Henry's bedchamberer, agreed. His master had 'a close disposition, not easy to be known or pried into'.

Presenting your poker face to the world was admired as a strength in itself. The stern face gave nothing away. Too much grinning and laughing dented one's virtue. It looked ingratiating. The neo-Stoic court at St James's praised rectitude. Henry's self-mastery inferred the authority to exert mastery over others. 'His forehead bore marks of severity and his mouth had a touch of pride.' Yet, 'beyond those outworks', those catching Henry's interest with 'due attention and seasonable discourse … found him gentle and easy to deal with; so that he seemed quite another man in conversation than his aspect promised'. Guarded in public, but a good man to know in private, did not seem a bad way for the prince to strike people at this stage of his life.

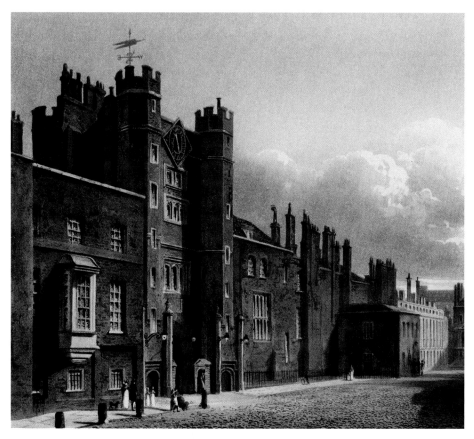

St James's Palace: Henry added a gallery, library and riding school, to increase his royal prestige

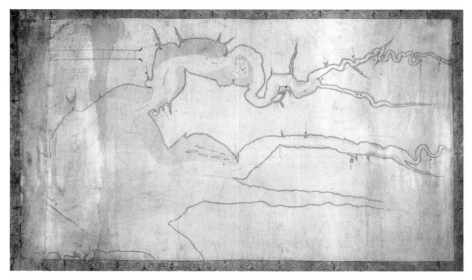

First ever map of Chesapeake Bay. Made by Robert Tindall for Henry, it's half empty, ready for Henry to name and claim

In Roman armour and opulent toga, Henry signals fitness to rule – referencing Rome, the Renaissance and all the qualities associated with these

Maurice of Nassau: Calvinist, military genius, inspirational role model for Henry

Henri IV of France: enemy of the Habsburgs, Henry saw him as a second father

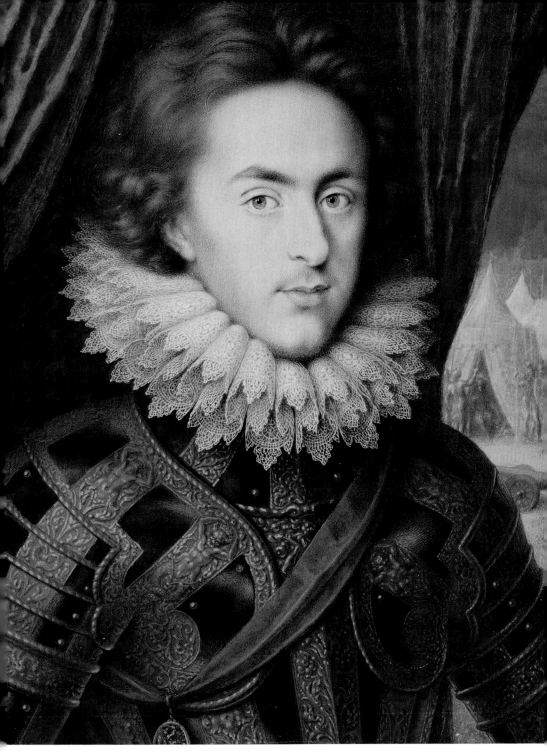

Henry illustrating the bottom line of monarchy: when and how to make war

'King of the Underworld': Henry as Oberon, by Inigo Jones

Pacing horse, after Giambologna: Renaissance gem, in Henry's hands when he died

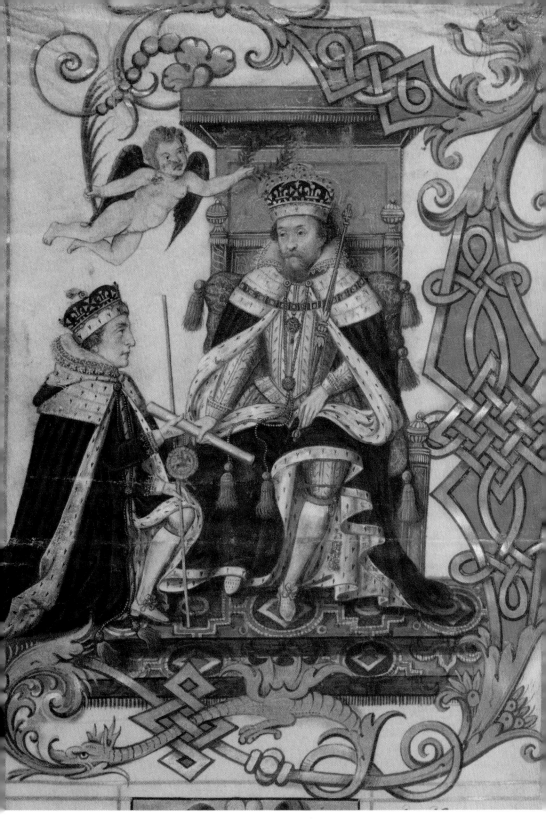

Letters Patent, jewel bright, creating Henry, Prince of Wales: James and Henry together

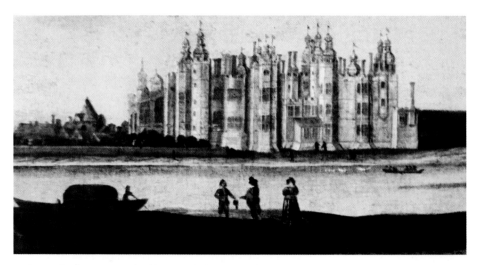

Richmond Palace: Henry had begun the biggest architectural renovations of the age at his death

The first 'rough guide' to Europe: it gives us the voice of Henry's circle

Frederick of the Palatine: he and Henry believed they would be brothers-in-arms

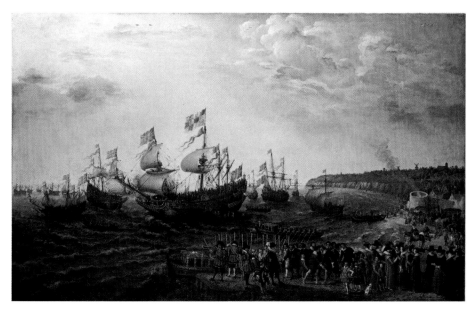

The Prince Royal, Henry's first ship: he planned a major renovation of the royal navy

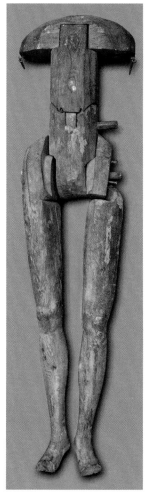

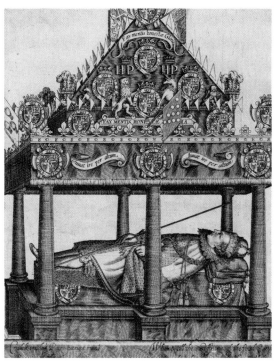

His funeral was the first state funeral for a prince, not a monarch

The remains of Henry's effigy – ravaged for relics by a grieving public in the years after his death

Stunning Prince of Wales feathers, against a gold sunburst

End of an Era

'MY AUDIT IS MADE'

If Henry stood ready to greet his glorious tomorrows, fit, poised, trained and vigorous, weapons sitting easily in his practised hand, eyes peeled for the pursuit of greatness, then by the spring of 1612 it was clear the Crown's greatest servant was not going to be there to counsel Henry IX. Though still flogging himself through a mountain of work, Lord Salisbury's physician had diagnosed the earl with stomach cancer.

He collapsed and left for Bath to take the waters, hoping to ease the pain. His chaplain accompanied him. They talked of life and death and the salvation of the soul. Salisbury comforted himself with the thought that 'my audit is made' – appropriately for a Lord Treasurer. To Salisbury's great joy, Henry gave William Cranborne permission to leave and ride to his father. The king and queen sent Salisbury presents in the hand of the king's most flamboyant favourite, Lord Hay. Salisbury began a slow journey home to London. Physical agony forced him to stop at Marlborough. He died there on 24 May 1612. With him, the era of Cecil political domination ended.

His death cut Henry's finest link into the heart of government. Salisbury had involved him, kept him informed, trained him, and joined with him and his mother in opposing the king's bedchamber coterie. Henry had to act fast if he was to establish his own power bloc in council, and at his father's court. Rochester sat with the prince on

the Privy Council now – an established rival for Henry's access to his father.

William Herbert, Earl of Pembroke, moved closer to Henry's court. Long enjoying a good relationship with Henry, the two men shared interests in commerce and colonial development. Some of Pembroke's clients built up the Herbert–Pembroke presence at St James's by attending on Henry. The prince, Pembroke and the Earl of Southampton united in being the Earl of Essex's closest supporters at court. It angered them to see the suffering caused to Essex by the intensifying affair between Rochester and Frances Howard, Essex's now estranged wife.

As Salisbury's death unleashed furious libelling of his reputation, competition for his positions and access to the rivers of patronage he had controlled, Henry determined to head off the favourite. The prince requested his own nominees be given some of the positions vacated by Salisbury's death. John Chamberlain, a close observer of the court, wrote to his friend, Dudley Carleton, who was seeking a post: 'If I might advise, I would you could rather devise how to grow in with the Prince, and not without need if all be true I have heard.'

Henry asked for the post of Secretary of State to go to his candidate, Sir Ralph Winwood. Recently returned from a mission in The Hague, Winwood called on Anne and Henry at Greenwich. He spent an afternoon 'with the Queen who used him extraordinarily well, and had long talks with him and commanded him to come to her again before his departure'. Next day, 'he took his leave of the Prince and had the same usage'. Winwood had spent years with the Dutch and Maurice. Henry could use a man like this.

Another individual ready to come home and be rewarded with high office, Sir Henry Wotton, ambassador to Venice, canvassed Henry and Anne for their support. 'The Queen and the Prince are in earnest in Sir Henry Wotton's behalf, and the Lord of Rochester is not willing, after his late reconciliation' with Anne and Henry, 'to oppose himself, or stand in the breach, against such assailants.'

As much as Rochester wanted to be seen as building bridges with the queen and prince's courts, he craved old Salisbury's offices more.

James settled the matter by announcing he would be his own Secretary of State. Then, within weeks, he appointed Rochester his private secretary. Rochester had outmanoeuvred queen and prince. The private secretary was the tongue and pen of the royal master, literally writing his letters in his name – the role Sir Adam Newton occupied for Henry. The favourite's star had truly ascended. He saw everything that came to James, and Henry was certain he did not always pass it to St James's, as Salisbury had. Someone saw the prince lash out one day, hitting Rochester on the back with a tennis racket.

Henry wrote to Sir Thomas Edmondes, out of sorts. 'As matters go here now' – meaning the dominance of Rochester – 'I shall deal in no business of importance for some respects,' he fumed. However, when he was king, he 'would not leave one of that family to piss against the wall'.

Wedding Parties

'LET BRITISH STRENGTH BE ADDED TO THE GERMAN'

When he thought about his sister Elizabeth's marriage, he was able to put Rochester out of his mind. Henry called in his servant, poet and physician, Thomas Campion. Elizabeth and Frederick's wedding was due to take place at the end of the year and Henry had to create the entertainments for their guests.

The prince had Campion hail Elizabeth as: 'The mother of kings, of emperors. Let the British strength be added to the German: can anything equal it? One mind, one faith, will join two peoples, and one religion and simple love. Both will have the same enemy, the same ally, the same prayer for those in danger, and the same strength. Peace will favour them, and the fortune of war will favour them; always God the helper will be at their side.'

George Chapman created a second show, the *Memorable Masque*. It celebrated the conversion of the indigenous Virginians to Protestantism, as Britain expanded her empire. The native Virginians sat inside a mountain of gold and worshipped the sun – looking more like Aztecs than native North Americans. The tableau showed the immense wealth Henry and his fellow colonisers assumed Virginia concealed. This show made Honour choose to raise her temple in England. And because she did so, Fortune followed her, and resided here for ever too. It was classic Henry – a Renaissance image of

Honour and Fortune together. Act with Honour, said Henry, to commit us to our destiny, and Fortune will come to us.

The final entertainment Henry planned that year was too fierce a polemical dish for some foreign powers to stomach. Informally called the *Masque of Truth*, it told how Atlas decided to relinquish the burden of holding up the world and handed it over to Alethea – Truth. In Henry's 'barriers', James had been Atlas. Henry's duty as God's knight, Moeliades, was to help Atlas carry his burden. By now, he was ready to lift the burden clean off Atlas's shoulders, and bear it on behalf of Truth. But whose truth?

Truth was shown to be a monolithic reclining statue, located in Britain. The head radiated light. Truth held the globe and read a Bible in English, the source of all truth for godly men and women. The arms of England and the Palatinate stood on each side of the set, bracketing the action.

The Muses called the nations of the world to end religious conflict. The globe in Truth's hand split open to show paradise, implying this was the reward for ending religious conflict. Stars and angels flew around Truth. Heavenly music played. Truth spoke. She invited princes and potentates to come to her here, enlightened, repent their error, and seek the truth of the love of Christ, in paradise, in England – where truth now is, the truth of the Word of God as interpreted by the reformed faith in the vernacular Bible.

> You Empires and Republics,
> Lead all your heretics
> To the feet of this TRUTH.
> Then receiving this knowledge,
> They will be touched with Repentance,
> And find again Purity.

It was an explicit Calvinist Christian parable. Puritans had 'Purity'. It was quite clear who were assigned the role of the 'heretics'. It showed the perfection of the reformation that Henry, Elizabeth and her betrothed, Frederick, sought.

Here, Henry stated that the marriage was not just one half of the religious, geopolitical balancing act; more than this, the union of the Palatinate and Britain created an unstoppable force for Protestant good. In effect, Henry's Church of England would be transformed by this union into an evangelising, international Protestant Church.

Seeing where this was leading, when the Spanish ambassador received his wedding invitation, he refused it.

Late spring turned into summer – long, hot, glorious, almost 'excessive in continuance and degree of heat, more than any now alive in England had ever seen'. Satisfied with the wedding entertainments, Henry went to Richmond to check on the progress of the renovations.

While there, fond of his food, 'having often filled himself with fish, and with oysters both raw and dressed with fire, at every meal, three or four days in the week', he went to the river to bathe and ease his stomach. He remained 'in the water for some hours together'. Fusspots tried to dissuade him. Fit as a fiddle, Henry laughed them off. He enjoyed all his physical appetites to the full. When he was not swimming in it, or dreaming of sailing on it, he found peace walking by the water in the balmy moonlit evenings. He listened to the echo of trumpets coming across it to him, and talked quietly with his most trusted friends.

Reassured that the works at Richmond were proceeding well, he dashed to meet his parents and siblings who had set out already on their summer progress among the people. Henry had agreed to join his father to hunt at Belvoir Castle in Rutland. He posted sixty miles in nine hours, stayed over at Hinchingbrooke near Huntingdon, then covered the remaining thirty-six miles to meet his father on schedule the following day. He had ridden almost a hundred miles in forty-eight hours in the middle of a heatwave.

Towards the end of the progress, Henry rode ahead of his family to the old Elizabethan hunting lodge of Woodstock, now his. He was to feast them and the court there, and wanted to oversee the creation of a great summer pavilion of fresh-cut boughs that he was building in

the park for them. It was as if Oberon entered the day world, ready to welcome the 'sun' king and queen to the greenwood bower of the Fairy King.

Courtiers arrived several days before the royal family. Henry kept them company, arranging hunting by day, music and dancing by night. The prince came down each day to his temporary banqueting house, to sit under the cool shade of branches cut in their prime, amongst the sweet-smelling sap. He checked all was in order. A good host, 'it was his great care to give contentment'.

A fanfare announced the royal family. He led them to his leafy hall. 'The King and Queen being set at a Table by themselves at the upper end of the room, his Highness with his sister accompanied with the Lords and Ladies sitting at another table of thirty yards long and more … there was to be seen one of the greatest and best ordered feasts as ever was seen.' They had so much to celebrate this year. Henry was 'like to a Princely Bridegroom cheering and welcoming his guests, there appeared an universal contentment in all'. They applauded 'his Highness['s] cheerful carriage, the Time, Order, State, Magnificence, and Greatness thereof', supervising the feasting and dancing, keeping 'good measure' in his life. A belief in the healing, synchronising power of a conjunction between man, spirit and nature ran deep in them. Henry possessed its mystique right now. No one should see anything 'ominous therein'. The king congratulated Henry with real pleasure. Everything was so well ordered, with decorum maintained in the middle of such splendour and luxury. James complimented his fine son that 'he had never seen the like before all his lifetime, and that he could never do so much in his own house'.

Henry left Woodstock very happy with life. He galloped back to Richmond to make sure all his arrangements were in place, and his houses prepared to receive Frederick. The Count Palatine was expected any day in early October. Henry planned to spend as much time as possible with Frederick, 'to grace him with all possible honour'.

* * *

As he waited for Frederick, he noticed he felt tired. He was never tired, though he had pushed himself very hard this year. His head ached. The weather was still hot; he must have a touch of sunstroke. Henry summoned his physician, Dr Hammond, who listened as his patient dredged up heavy sighs, bored by ill health. Hammond asked what made him sigh.

Henry shrugged. 'He knew not.' The sighs 'came unawares'. But he said he thought 'they were not without cause'. He was just not himself, no vitality; none of the stubborn, Henry-like teenage certainty in his voice. Despite 'his continual headache, laziness and indisposition increasing', he ignored his malaise. He was not going to fall ill now, of all times.

Most mornings he rose before five, 'to walk the fields' with a close friend – John Harington, or Essex – talking freely. Now though, he found himself unable to shrug off whatever illness had got into him and had to 'lie a-bed … until nine of the clock, complaining of his laziness, and that he knew not the cause'. His grooms of the bedchamber came to get him up and dress him. 'How do I look this morning?' he asked every day. 'To make his Highness laugh', they teased him 'with one jest or other', that he looked like a lazybones.

He soon recovered enough to move his court downriver, from Richmond to St James's, to wait for Frederick.

The king and Rochester sought him out, badgering him to express his wishes with regard to a bride. They were eager to settle with one of the offers – Christine of France or Isabella of Savoy. In mid-October, Rochester passed Henry a letter recently received from the English ambassador to France. They want to know, Henry told his friends, about 'my marriage with the second daughter of France'. The king had scribbled a line on the bottom of the letter, asking him 'to give my opinion thereon'.

Henry took his time, as always, then replied. There was 'no reason to yield' to the French straightaway, he told his father. It made England look too keen. It was in the hands of France to make the marriage 'go forward or otherwise'. Henry recommended some provisos. They should accept France only if the princess came at once, to grow up in

a Protestant milieu; then there 'will be a greater likelihood of converting her to our religion'. Also, 'your majesty's credit will be the better preserved' if 'the delivery of both the daughters shall be made at the same time' – one French princess to England and one to Spain. 'As for the exercise of her religion, your Majesty may be pleased to make your ambassador give a peremptory answer that your Majesty will never agree to give her a greater liberty in the exercise of it than that which is agreed upon with the Savoyard, which is ... in her most private and secret chamber.'

Henry admitted he demanded 'somewhat strict' conditions. Yet, if the French proceeded from 'a sincere and hearty affection, I make no doubt but they will make no rub of them'.

He compared France and Savoy: 'If your Majesty looks to the greatness of the dowry, then it is likely you will make choice of Savoy ... But if you lay aside the little piece of disgrace in being served after another,' Spain having got the choicest fruit, and we consider 'which will give the greatest contentment and satisfaction to the general body of the Protestants abroad, then I am of the opinion that you will sooner incline to France than Savoy,' because of the Huguenot element in Christine's provenance. This, for Henry, was decisive. His marriage must strengthen the European Protestant union. Henry rounded off by saying – hoping – 'your Majesty may think that my part to play, which is to be in love with any of them, is not yet at hand'. This was his real view – no hurry, the world was 'yet aslumber' – almost repeating Ralegh's recommendation.

'My master' sought to heal his drifting nation, said Sir John Holles, 'by upholding religion, bettering the policy, moderating the oligarchal greatness of court, of Council, opening the passage to virtue, with reward of merit', not favouritism. Henry could 'make us once again the nation among all nations, a terror to God's enemies, the triumph of the Church at home, and a sure haven to the distressed Church abroad'.

Henry sent his reply to Whitehall, wearily – aware Rochester would open it, peruse its contents and present it to the king with his own gloss on it.

The Palatine wedding party was almost with him, but he still did not feel completely well. 'He began to be displeased almost with everything, exceeding curious in all things, yet not regarding, but looking as it were with the eyes of a stranger upon them.' As 'for sundry things showed him', mechanical curiosities and fine collectibles, 'which before he wonted to talk of, ask questions and view curiously, he now scarce vouchsafed to look upon, turning them away with the back of his hand', and walked off, as if to say, "'I take pleasure in nothing.'"

Henry Loses Time

'I WOULD SAY SOMEWHAT, BUT I CANNOT UTTER IT!'

On 16 October 1612, Frederick V, Count Palatine of the Rhine, landed at Gravesend. Henry failed to greet him. Instead, the Duke of Lennox and a tail of courtiers took Frederick and his party to their lodgings. They rested for a couple of days and then went onto the river to be rowed upstream to Whitehall. Over a hundred boats crowded on the water, pennants blowing. The guns on the Tower roared a salute. Trumpets blared and thousands of people lined the banks to cheer their arrival.

Charles came to Whitehall Stairs to meet them, attended by the earls of Shrewsbury, Sussex, Southampton and others numerous enough to compliment Frederick. They greeted each other in a mixture of Latin, French, German and English. Charles led them to the palace's banqueting hall. The king and queen sat beneath a canopy of gold damask, with Elizabeth and Henry sitting on each side, in front of the arms of Britain.

Frederick struggled through a speech in French, in a low voice, slightly awed. The queen surveyed him coldly. 'Say no more about it,' said James, putting him at his ease. He patted him kindly. 'Suffice it that I am anxious to testify to you, by deeds, that you are welcome.'

Elizabeth held herself apart, while the king and Henry greeted the guests – though Henry remained seated. He apologised to Frederick,

explaining he had a 'cold, lazy drowsiness' in the head, no more. Frederick, 'straight and well-shaped for his growing years', with a friendly and intelligent face, made a good impression on everyone, except the queen.

Frederick came forward to kiss Anne's hand. Again she stared at him 'with a fixed countenance'. Recently, whenever the queen had talked with Elizabeth on the subject of her marriage, she signalled her contempt for what she saw as a low-status match by calling her daughter 'Goody Palsgrave'. Elizabeth shrugged her mother off. Calvinist Henry was the real influence in her life, not the Catholic queen. And Henry supported Frederick.

Now Frederick turned to Elizabeth who 'did not turn so much as a corner of an eye towards him'. He bowed low twice and made to kiss the hem of his mistress's robe. Elizabeth stopped him. She made a deep curtsey, rose, then leaned forward and offered her cheek. He kissed it. She blushed. Everyone relaxed and applauded.

Frederick lodged at Essex House but came every day to court Elizabeth. 'He seems to take delight in nothing but her company and conversation.' The alliance might even grow into a love match.

Meanwhile, Frederick's uncle, Henry of Nassau, and the other nobles sought out Prince Henry and his circle. The future young leaders of Calvinist internationalism were now gathered in one place: Henry of Nassau, representing his brother Maurice and the free Dutch; Frederick of the Palatine, representing the Evangelical Union; and Henry of England, representing the kingdoms of Britain. Henry rallied. They rode and hunted, played cards and practised military arts, and talked and talked.

On Saturday 24 October, the prince challenged Henry of Nassau to a game of tennis in the court at Whitehall. The prince seemed to have thrown off his lurgy. 'As though his body had been of brass,' he played in his shirt, both sweating hard as they fought to win.

The next day being the Sabbath, Henry went to his chapel to hear Robert Wilkinson preach. Wilkinson took Job 14:5 as his text: 'Man that is born of woman is of short continuance and full of trouble.' Although lauded for 'your matchless wisdom, your incomparable

valour, your equity, piety and princely Majesty' now, Wilkinson warned Henry that once he was dead, well then, 'every Hare ... dare dance upon [your] ... carcase, and dogs dare bark, and Poets then dare rail and rhyme with pen and tongue'. Henry thanked Wilkinson for his plain-dealing. Perhaps he liked the astringency which cut through praise endlessly sugaring over his faults. The prince, by training and temperament, was the answer to his godly preachers' prayers. He attended regularly and listened with humility.

Then he rode, as he always did when he was at St James's, to Whitehall, to hear the Sunday sermon with his father. After it, the two men went into dinner together. At around 3 p.m., Henry suffered a spasm of 'sudden sickness and faintness of the heart'. The nausea did not pass. He shivered hot and cold. His head pounded. Henry apologised to his father and called his entourage to take him 'home unto his bed; where being laid, he found himself very ill, remaining all this evening in an agony'. A huge unquenchable thirst parched his throat and mouth. His eyes burned so badly 'they were not able to endure the light of a candle'. Whatever the malady, it was back.

On Monday morning the Privy Council sat to decide whether Henry should marry a daughter of France or Savoy. Henry found he could not go, to speak for himself.

Yet, the Europeans among whom he wished to be counted were here now. He could not lay around in bed. He had work to do. He forced himself to dress and play cards with his brother and Henry of Nassau. Henry of Nassau said he should ask the Privy Council to delay choosing a wife until he could come and speak for himself. Messages came from the king and from Frederick, calling for him. Dr Hammond returned cheerful answers, saying he was preparing delicious 'cordials and antidotes', 'broths and jellies' and 'juleps' to assuage the ailing prince's dreadful thirst.

The next few days a pattern set in. Henry rose, declared himself better, only to retire to bed a few hours later. His father sent his physicians, Dr Naismith and the Huguenot, Dr Theodore Mayerne, the most famous medical man of his day, to confer with Hammond. The king also summoned seventy-six-year-old Master Butler from

Cambridge, 'one of the greatest Physicians and most capable humourists of his time', to read Henry's humours.

One night, a spectacular display of the aurora borealis filled the sky above St James's for two hours. The court looked out of the windows and trembled at the sight of gory reds, oranges and poisonous greens leaking all over the sky, as if the heavens ran with blood and putrefaction. At the end, a 'lunar rainbow ... [hung] over Saint James's House', observed one of Henry's servants. After such a sign they were not surprised when 'this night was unquiet, and he rested ill'.

On Sunday afternoon, Henry's whole family visited: James, Anne, Charles, Elizabeth, and the Elector Palatine. Some of his closest friends also called, reassured by the prince's good spirits. Charles brought his brother his favourite bronze from the Medici collection, a beautiful little pacing horse. They both loved it. Charles put it in Henry's hands and told him to recover and come back to them, so they could ride together again.

The physicians purged Henry 'to wash his bowels'. Even so, by Monday evening his mind showed 'greater alienations of the brain, ravings, and idle speeches out of purpose, calling for his clothes and his rapier, and saying, he must be gone, he would not stay, and I know not what else, to the great grief of all that heard him'. He began to sob that this was all 'chastisement ... a deserved punishment upon him, for having ever opened his ears to admit treaty of a Popish match'. That did not sound like 'idle speeches out of purpose', but feverishly churning religious and political thoughts.

His vigorous, youthful body fought, but as 'his boundings being turned into convulsions, his raving and benumbing becoming greater, the fever more violent', the physicians could see he approached crisis. They felt confident he would survive until the fever broke. All except Mayerne, who demanded action, showing nerves. They must *do* something. Mayerne wanted to bleed again. The others did not like it. Mayerne berated them.

No one said: keep Henry quiet, hydrate him, cool him, let him rest. Rather, 'for easing of the extreme pain of his head', Henry's 'hair was shaven away, and pigeons and cupping glasses applied to lessen and

draw away the humour and that superfluous blood from the head, which he endured with wonderful and admirable patience'. Yet it was 'all without any good'. He sang in his delirium, raving and tearing at his bedding.

Desperate, Princess Elizabeth slipped Charles's coachman some money to escort her to St James's in secret. Dressed in disguise, travelling by night, she hoped anyone who knew her would be in bed and she might make her way in. But of course the court officials recognised her, barred the door, and she was sent home in distress.

Next day, the eleventh since Henry fell seriously ill, the physicians sliced open a live cockerel up its backbone, and applied it to the soles of Henry's feet. But in vain. The doctors ordered everyone to stay away now. They even stopped James at the door, on his way in to see his isolated, beautiful boy. The king left in tears.

Yet, they admitted the Archbishop of Canterbury fast enough. Have any prayers been said over him, Archbishop Abbot asked the minute he saw him? The servants shook their heads. Abbot criticised their carelessness of his immortal soul.

Henry murmured that 'for all that, I have not failed to pray quietly by myself' – 'which … answer pleased them well'.

Abbot leaned over Henry and whispered. Would he like to hear prayers? Henry nodded. He wanted Dr Milburne, Dean of Rochester, a favourite of his.

Milburne came, sat in the corner and prayed for a miracle. The archbishop talked in a low voice, not to pain the prince's 'distempered ears'. Speak up, said Henry, 'repeating the Confession of his Faith word by word after' the archbishop.

Thursday, 5 November, was the day of national thanksgiving for salvation from the Powder Plot. The churches filled with prayers for the prince to be saved again, by God's mercy.

King James, 'looking more like a dead than a living man', told Mayerne 'to do what he would of himself, without advice of the rest'. Mayerne convened the doctors. He wanted to bleed Henry once more.

They refused, but agreed to insert a clyster, an enema, into his bowel and force more cordials down him.

Abbot returned. Taking one look at Henry, he had nothing to say to him of this world. Very gently, 'like a wise and skilful physician', he put the young man in 'mind of the excellency and immortality of the soul, with the unspeakable joys prepared for God's children, and the baseness and misery of the earth, with all the vain, inconstant, momentary and frail pleasure' of the earth. Henry believed it, though it had never been his experience of life in the flesh.

Abbot then told Henry he might die, the first person to say it to his face. Henry raised a feeble protest. The archbishop back-pedalled. Of course he might recover, as the whole nation 'hoped he should'. Yet he might also die, he reminded him – as if the prince needed to be told the news twice.

Then the archbishop rationalised the blow, to make it easier for a young man in the prime of his life to grasp the proximity of his anni-hilation. 'It was an inevitable and irrevocable necessity that all must die once, late or soon, death being the reward of sin.' That was what it all meant then: the healthy person must have sinned to earn the 'reward' of 'death'. Abbot asked Henry, 'if it should so fall out', that he was dying, 'whether or no[t] he was well pleased to submit himself to the Will of God' – meaning Death.

'Yea, with all my heart,' the young man said. Encouraged, the arch-bishop did not leave until he was sure the prince's soul was safe. Abbot hauled up one satisfactory answer after another about the one true reformed church, the salvation and resurrection of his soul by Jesus Christ, the everlasting joy awaiting him. Then, the archbishop left to attend to other business.

Henry drifted between delirium and lucidity. 'David! David! David!' he shouted, calling for David Murray.

Murray came to his bedside and sat by him, asking what his lad needed. Henry looked up at him 'in an extremity of pain and stupe-faction of senses confounding' his speech. 'I would say somewhat' Henry said. He stared at Murray, 'but I cannot utter it!' Where had his

thoughts gone? Murray went to bed in tears, leaving instructions that he was to be woken at any time.

As midnight turned, the prince made a monumental effort and grabbed Dr Naismith's collar. He seemed to be 'speaking to him somewhat, but so confusedly, by reason of the rattling of the throat, that he could not be understood; which his Highness perceiving, giving a most grievous sigh, as it were in anger, turned him from him'. A servant ran to fetch Murray.

Murray came and sat on Henry's bed. He asked what was eating his mind. Henry 'was not able to say anything' coherent, but gave signs. Murray understood he meant the 'burning of a number of letters in a certain cabinet in his closet'. Henry's servants said these contained his secret plans and 'showed him to have many strange and vast conceits and projects' – his determination that their contents should remain private perhaps an attempt to protect his followers.

In the early hours of Friday morning, rumours of his death swept London. 'There arose a wonderful great shouting, weeping, and crying in the Chamber, Court and adjoining streets.'

Yet he lived. The queen sent a note to Ralegh in the Tower. He must hurry and concoct something in his laboratory, a miracle cure using new wonder drugs from the New World. A tiny vial and a note came back. It was his famed 'balsam of Guiana'.

Ralegh's accompanying note worried them: it claimed universal efficacy 'except in case of poison'. The physicians tested the cordial on themselves, found it did not harm them, and gave it to Henry, who picked up.

The Archbishop of Canterbury returned and shouted at him: 'Sir, hear you me? Hear you me, hear you me? If you hear me, in certain sign of your faith and hope of the blessed resurrection, give us for our comfort a sign.' Henry lifted 'up both his hands together' in the prayer position. Abbot still did not let him be. He nagged at Henry 'to give him another sign, by lifting up his eyes; which, having done, they let him alone'. Fear for the unshriven soul meant they gave him no peace.

Henry stared round the chamber. 'Where is my dear sister?' he whispered.

All that day, Death delayed, and toyed with him. 'Many times did he [Death] from that morning until night offer to shoot and thrust in his dart a little, yet pulling it presently back again' – the onslaught recorded in quasi-sexual terms. Death teasing, penetrating, withdrawing; at times steady, at others impatient.

Evening came in. Out 'of mere pity', Death suddenly 'thrust the dart quite through; after which his Highness quietly, gently, patiently … yielded up his spirit to his immortal maker, Saviour and Restorer'.

The wreck of Henry, his body insulted by the scars left by the well-meaning, who had laboured to hold him in life, became utterly still. Death hovered in the room, over the shrunken, wounded, most naked thing you can imagine – a young man without clothing, without sense, without a breath. The corrupted, sweating flesh cooled and hardened like wax. Patience personified. Britain's lost king, Prince Henry, died a little before 8 p.m. on Friday, 6 November 1612.

THIRTY-FIVE

Unravelling

AFTER 6 NOVEMBER 1612

... Care not for issue;
The crown will find an heir.
THE WINTER'S TALE, V, SC. I

The next morning Mayerne opened Henry's body in front of privy councillors and the prince's closest court officials. He examined, emptied, stitched, embalmed, and encased Henry in lead, then sent his report to the king.

Assassination theories abounded. In Brussels, the diplomat William Trumbull heard that Mayerne's autopsy repudiated the most popular rumour: no sign 'of poison appeared, all his principal parts sound, only his liver a little discoloured towards whiteness, and his brain somewhat charged with matter. His death is imputed to an universal inflammation of the blood, occasioned through his over-violent exercise at tennis and over-eating of grapes.' In 1882, another doctor analysed the report and diagnosed typhoid fever. Another writer thought Henry displayed symptoms 'quite consistent with variegate porphyria'. That, and the cures.

In the hours after Henry died, the king fled in panic to Theobalds. Hunter and hunted, James could not outmanoeuvre his loss. 'He stayed three days only, in which time for the most part, he kept his

bed.' On Monday, he rode to 'Sir Walter Cope's house at Kennington'. Finding no peace, 'he returned to Whitehall, nor will he stay there any longer but till Monday next, but again in Theobalds'.

As the weeks passed, James recovered enough to attend to some matters of government, until inevitably someone said the wrong thing, and James cried: 'But Henry is dead! Henry is dead!'

Condolences poured in. 'The news of the death of the Prince of Wales has stunned us all. It is a very great loss to us Germans also,' read the letter from Württemberg. 'God preserve us from many such accidents and save for us, the King, Queen and the rest of the royal house, which we consider as a bridle to the Spaniard.' In Cologne, half Catholic and half Protestant, 'the well-affected here are lamenting the death of the Prince of Wales; the others rejoice at such news'.

Though many Catholic leaders expressed sorrow, in Madrid Sir John Digby observed, 'there could scarce anything have happened whereat these people would have grieved less'. As for the Habsburg archdukes of the Spanish Netherlands, 'both by their discourses and countenance ... the whole pack of that Spanish faction, upon this death of our most excellent Prince ... do already begin to cry out *vie la gaigne*' – 'life wins it' – victory to the survivor.

On the night of the prince's death, the queen disappeared into her privy chamber at Somerset House. Her ladies heard her weep alone. Months later, still no one was permitted to mention Henry's name unexpectedly, for fear the shock would throw her back into her private hell. 'Nor does she ever recall it without tears and sighs.' If she had to hear it, she needed to steel herself to take the blow. Charles stuck close to his mother, equally devastated.

Elizabeth ate nothing, drank little, day after day. She wept continually. Frederick and Henry of Nassau, dismayed to find themselves here, now, made plans to go home. But James encouraged the elector to stay, giving him 'as free access as before to the Lady Elizabeth and to eat with her', to see if he could encourage her to talk to him.

Soon, he was indispensable to her. Frederick and Elizabeth would marry the following spring, before leaving England together.

<p style="text-align:center">* * *</p>

At St James's, towards midnight on the day after Henry died, Sir John Holles 'attended my dear master's bowels to the grave'. Holles wrote letter after letter to his friends.

What was left of Henry lay a few rooms away. It was so Jacobean – Henry anatomised to a bucket of tripes and a mummified, lead-clad shell – his heart and brain to be encased in their own lead casket. To 'see the fruit and not to taste it', wrote Holles, was agony.

Silence fell on the prince's vibrant, busy household. The Privy Council came to St James's to ensure the 'whole house, Chapel, great Chamber, Presence, Lobby, Privy Chamber and Bedchamber were all hung in black'. The palace of light and colour transformed into a sepulchre.

In Henry's presence chamber, his servants hoisted a black velvet canopy over him – the canopy of the realm of death. Carpenters built a trestle beneath the canopy. They draped that too in black velvet and put his coffin on it.

Morning and evening, Henry's household clerics entered the presence chamber to offer prayers for his soul and the future of the country. During the day they delivered sermons to 'the family of Prince Henry'. By this they meant his court. They had long thought of themselves as a family, with their own family culture. For four weeks, over forty members of his household attended on him, day and night.

Nothing changed, though nothing was the same. They brought him a basin and cloth to wash his hands, and kept offering 'the same service and order of meals as when he was alive'. They offered body service to the corpse of the future Henry IX, because the monarchy could never die. The monarch suffered not death, but demise, and the next monarch raised the crown back up. This was the ritual governing the lying in state of a king or queen. Henry was not a king, though. This was the first time in history a crown prince had earned this honour.

Those closest to Henry – Murray and Newton, Chaloner and Holles, Cornwallis, Harington, Essex and Cranborne – now suffered like his blood relations. Adam Newton did not touch a pen for ten

weeks, having written daily in Henry's voice for over fifteen years. When he could pick up a piece of paper, he admitted, 'I am loathe even at this present to touch upon that string and to recall that grief.' He too dreaded being ambushed by the sudden aftershock of a memory.

Henry's death 'came so sudden and unexpected', Newton could not take it in. 'When we were preparing for nuptials and jollity ... the blow astonished the more ... what weakness and uncertainty is in the likeliest of human beings.' Losing his secretaryship, he became Prince Charles's Receiver General.

Others rushed into print. Scores of laments in prose and poems, sermons, songs and funeral music appeared. Sylvester, Henry's poet, set his elegy within a printed frame of interwoven skeletons. Thomas Campion, George Chapman, John Donne, William Drummond, Sir Arthur Gorges, George Herbert, Henry Peacham, Joseph Hall, Daniel Price, Cyril Tourneur, John Webster, all grieved publicly. It was a horrible echo of their poems for Coryate's 'Banquet of the Wits' that had made Henry, and all of them, laugh so long the previous year.

Where did it leave them? Henry's death sent a shudder of panic through the body politic. The heir was now a slightly disabled, twelve-year-old weakling. A nice boy, but not strong.

At St James's, Henry had created a dazzling and fully functioning court for the Prince of Wales. Charles had lived there half his time. He had shared many of Henry's concerns. He knew Henry's circle intimately. The new heir only had to step into Henry's shoes and fill a loss Charles's future people experienced as their own. James had arranged it so Henry's court developed a close-knit, collegiate character. It could cope with catastrophe.

But, the king did not move Charles in here. Rather, within weeks the king gave away all of Henry's beautiful horses and hounds, though he knew how much Charles loved them. Men like Rochester discouraged the king from setting Charles up in the way he had Henry. The boy must be kept passive and dependent for as long as possible. Apart from emptying the stables and kennels, Henry's great collections and possessions were seized. James unravelled his son's life.

If the king heard Daniel Price's sermon to 'that Princely family' at St James's, it would have confirmed his decision not to install Charles in Henry's place. Price told Henry's people that 'certainly the soldier however he paces the same measure of misery with the scholar, yet in all ages hath been ever in high esteem, till these days', under James VI and I. The 'soldier is the heart, and arm of the State ... and the most laudable improver of his country. For always the olive garlands of Peace be not so glorious as the Laurel wreaths of victory, seeing Peace only keeps, and often rusts, good spirits.'

Worse, some of the court cormorants crept about and whispered that Henry had harboured ambitions to challenge James for supreme power. Those accusing Henry of designs 'not compatible with the safety of the King and State' were 'worse than swine', Sir John Holles raged. As if Henry might 'snatch the sceptre out of the father's fist'! It was a contemptible fiction. 'With this opium they rock the parent to sleep to drowse out the sorrow for his lost child,' said Holles.

There were mad happenings as well as ominous ones. 'A young fellow came stark naked to St James's.' He hammered and shouted at the gates. Amazingly they opened, and in he ran. He 'marched very magnifically along until he came to the Privy Chamber, and there made a speech to all the company, saying he was the Prince's soul and was come from heaven whither he would return after two days, having in the meantime spoken with the King'. It was as if some ghastly parody of Henry's masques was among them, with a crazed, naked 'Poor Tom', instead of a heroic prince.

Should Henry's old servants not grasp the scale of their loss, the unseen household genius Henry had so frequently consulted, Sir Walter Ralegh, spelled it out. A death sentence had hung over Ralegh since 1603. He lived in a place of torture and murder. He saw it and heard other people facing it daily. He was well placed to throw a light on Henry's death. Over the last ten years Ralegh had mapped his long road to liberation, with King Henry IX as the door out of his darkness. Now that door was gone and Ralegh was walled up. It must have occurred to him that he might die in this hole. The destruction of Henry's vision began as his body lay at St James's.

Ralegh had been busy writing a *History of the World* for the prince. He kept at it now. His paean to Death hurled down his challenge to the free. "'I have considered," saith Solomon, "all the works that are under the sun, and, behold, all is vanity and vexation of spirit;" but who believes it,' Ralegh asked, 'till Death tells it us?' No one. Therefore, confrontation with 'Death alone … can suddenly make man to know himself.'

Death 'tells the proud and insolent, that they are but abjects, and humbles them at the instant, makes them cry, complain, and lament … He takes the account of the rich, and proves him a beggar, a naked beggar, which hath interest in nothing but the gravel which fills his mouth.' It was as if he saw the dance of death projected onto his cell walls, and just described it.

Ralegh conjured man as Lear's 'poor, bare, forked animal', cast into the night, cut off, a busy insect scurrying across an empty plain between birth and death. All men, including everyone at St James's. Men of ambition, who put their hopes in Henry, saw their tomorrows roll into the grave by the flame of the brief, guttered candle of light and hope Henry had been for them. Ralegh lived what Shakespeare imagined, and found himself qualified to make the beautiful brutality of his statement. He had travelled so far in his imagination in the last ten years, proposing foreign marriages, distant empires, mountains of treasure, brilliant battles on sea and land, and voyages of discovery in wonderful ships, all for Henry. At the last, Henry let Ralegh imagine death.

Death 'holds a glass before the eyes of the most beautiful and makes them see therein their deformity and rottenness, and they acknowledge it'. Human hopes and dreams looked like vanity. But oh the deadly greyness of the world, as Henry's people saw their dreams collapse to ashes.

"'Naked came I into the world, and naked shall I go out of it",' Ralegh acknowledged with a conviction few could match. 'O eloquent, just and mighty Death! Whom none could advise, thou hast persuaded; what none hath dared, thou hast done; and [those] whom all the world hath flattered,' like Henry, and himself once, 'thou only

hast cast out of the world and despised. Thou hast drawn together all the far-stretched greatness, all the pride, cruelty and ambition of man, and covered it all over with these two narrow words, *Hic jacet!*' Here it lies! – the corpse, the meaning of it. This is all. No sight of salvation here. His vision was comfortless.

Endgame

Farewell, thou child of my right hand, and joy;
My sin was too much hope of thee, loved boy.
BEN JONSON, 'ON MY FIRST SON'

As evening fell on 7 December, a creaking of floorboards and doors disturbed the calm of Henry's watching family. A spectre appeared: the prince, just 'as he went in life'. He was a waxwork over a wooden frame.

They clothed him with reverence, dressing him in his creation robes. What a day that had been! They placed his cap and gold coronet on his head, fastening his collar and the George and dragon badge of the Garter Knight about his neck. Closing his wax hand around a staff gilded with gold leaf, they laid him on top of his coffin, binding him to it and supporting his head on black cushions. Abraham van der Doort, one of Henry's servants, had made the head separate from the body. It was not a good fit. The sight of them all trying to fix it firmly as it lolled this way and that was almost funny.

The next morning, over two thousand mourners took four hours to assemble behind Henry's bier. A wooden canopy mounted on eight wooden columns rose above the coffin and effigy, 'trimmed and set thick within and without with diverse escutcheons, small flags, and pencils of his Highness's several Arms of the Union chained, Scotland, Wales, Cornwall, Chester, Rothesay, Carrick, & c'. The arms were 'mingled here and there with his Highness's motto "Glory is the torch

of the upright mind", and his motto as patron of the Northwest Passage Company: 'He Delights to go upon the Deep'. His past, present and future layered up – body below, effigy in the middle, and the honours of the future king above – for his final state occasion.

The bier highlighted Henry's status as a great military hero, though he died before facing a single enemy.

Crushed by despair, neither of his parents attended. They left the young – Charles and Frederick – to be chief mourners. Only one person joined Henry on the bier. Sir David Murray, who had been with the prince since Stirling, sat by his feet, looking ghastly. Never married, Henry was his life. Friends were lobbying the king to have Murray reappointed to the new crown prince's household. The rest of Henry's court lined up behind them.

As the cortege moved out into the street to make its way to Westminster Abbey, a horrible howling came out of the thousands of every age and class lining the roads. 'Some holding down their heads, not being able to endure so sorrowful a sight, all mourning ... Some weeping, crying ... wringing of their hands, other half dead, swooning, sighing inwardly, others holding up their hands, passionately bewailing so great a loss, with rivers, nay oceans of tears.' Nearly everyone believed the social order was divinely ordered. Henry's death was their own loss. The resemblance of the effigy to the living Henry made the loss more shocking. He was here and not here.

At the abbey, his friends pulled him inside. Archbishop Abbot preached from Psalm 82:6–7: 'I have said ye are Gods, and ye are children of the most High; But ye shall die as a Man, and ye Princes shall fall like others.' Die like a man maybe, but he went into the grave as a prince, almost a king.

Abbot set Henry in company with all of us, offering the solace Ralegh denied them. Henry was only 'one brave ship lying amongst a number of others, all tending towards one haven, whither at length they must needs all come, or ship-broken perish by the way'. Do not pity Henry, he said. Setting out like them 'fresh and strong, with a fair gale of wind. [He] arrived quickly without any danger at the haven of safety' in heaven.

When Abbot climbed down, the great officers of Henry's court – Chaloner, Cornwallis, Holles, and the prince's three gentlemen ushers – stepped up and broke their white staves of office over the coffin, leaving them on top. With this gesture, Henry's court disbanded itself.

They returned to St James's Palace, confident 'each would be readmitted to his old post' any day now. The king, well known for esteeming images of peace and continuity in his new united kingdoms, was expected to help the Crown recover from this loss. Put Charles in Henry's place. The country needed it to be business as usual for this young dynasty as soon as possible.

What a shock then, on the last day of December 1612, when James dismantled Henry's court family. The king simply turned most of them out 'to seek their fortune elsewhere'. He dismissed men such as Murray on a charge of Puritan populism. Rochester was given Murray's place, close to the new crown prince, although Charles 'interceded earnestly' for Murray. The king 'refused, alleging he was a Puritan seducing his late master to their schism'.

Charles was to have no independent court for years. The fact that the king had stripped St James's of many of its trappings so quickly in November might have alerted Henry's people that something along this line was afoot.

A few of Henry's more radical Puritan preachers joined Elizabeth and Frederick when they departed for Heidelberg, as if the Palatine couple were Henry's true heirs. Elizabeth even perfected her signature over the coming years, until it was almost indistinguishable from her great Protestant namesake, Elizabeth I of England. A little surprisingly, the king readmitted the Puritan court divine, Henry Burton, to Charles's service. Charles could not keep his loyalty. Burton would turn into one of his old patron's most virulent opponents. He and his companion Prynne went on to become two of the most celebrated Puritan 'martyrs', when King Charles and Archbishop Laud excised Calvinism out of the court clergy in the 1630s. Charles had them arrested, tortured by having their ears cropped, crushed them with

huge fines, and exiled them to remote prison houses. Puritan and non-Puritan alike would be outraged by Charles's brutality and tyranny.

Breaking his white rod of office over Henry's coffin marked the end of Sir Thomas Chaloner's time at court. The coterie of Fleetwoods, Chaloners and Foulises had served the Crown loyally for several generations. King James cast them off. They melted away from the national stage to reappear themselves, or in the next generation, as opponents of the court in the civil wars. Chaloner's sons, Thomas and James, had lived part of the year with Henry and Charles, dancing, playing, practising the military arts. But in 1649 James Chaloner sat in the Painted Chamber as a judge. His brother, Thomas, signed the death warrant of King Charles.

Of their Fleetwood cousins, by the 1620s, Sir William Fleetwood headed the country opposition in Parliament. His son Colonel George would also sign Charles I's death warrant. George's cousin, Charles Fleetwood, became a lieutenant-general in the New Model Army under Fairfax and married Cromwell's daughter, Bridget. Courtiers to absolute princes, these families ended the relationship by destroying the monarchy.

Astonishing how the world of their youth around Henry, powered by an apparently noble, unstoppable vision of a modernising monarchy, fell apart so spectacularly. Sir David Foulis was reappointed in 1613 by King James and served as cofferer to Prince Charles, as he had to Henry. But King Charles would refuse to protect his old friend, Foulis, when one of Charles's favourite statesmen, Sir Thomas Wentworth, hounded and imprisoned him. Foulis was a member of the king's Council of the North. Charles created Wentworth its despotic president. The old Essexian in Foulis accused Wentworth of abusing his president's office and Wentworth sought vengeance. Foulis's eldest son, unsurprisingly named Henry, became a lieutenant-general of the horse in the New Model Army.

Of the others, the Phelipses went home to Montacute House in Somerset. Their protégé, Thomas Coryate, died an anonymous death

in India, despised by James to the end. Sir John Danvers, gentleman of Henry's privy chamber, turned regicide. Sir Humphrey Tufton returned to Kent. He came back to public life to sit in the Puritan republic's Long Parliament. As for those other Parliament-minded royal servants, the Cottons, they continued their stewardship of Robert Cotton's magnificent library of manuscripts. Robert's immersion in it had been the purpose of his life. The library, and Cotton's public service, was dedicated, he said, to proving 'the sacred obligation of the King to put his trust in parliaments'. In 1630, King Charles had Cotton's library confiscated. Cotton's son had to petition to get it back after his father's death.

Sir John Holles stayed around court in 1613, asking for favour. Considering the Puritan radicalism of his politics and religion he should not have been surprised to be rejected by the king – though he was. He retired, consumed by bitterness. His son, Denzil, returned to Parliament to fight the Holles corner with a vengeance. He too signed Charles I's death warrant.

John Harington survived his master and companion by only fifteen months. Weighed down by grief, struggling with the £30,000 of debts his parents incurred as guardian of their beloved Princess Elizabeth, he succumbed, aged twenty-two, to a smallpox outbreak at Kew, and died there in February 1614. For his funeral sermon, Richard Stock, the godly minister of All Hallows, Bread Street, implicitly linked Harington and Prince Henry, describing Harington's model Puritan life that nevertheless blended seamlessly with aristocratic and court duties. John Donne lamented 'thou dids't intrude on death, usurps't a grave' before time.

Robert Devereux, 3rd Earl of Essex, and Essex's first cousin, Robert Rich, 2nd Earl of Warwick, stayed at court, but turned and led the nobles who revolted against Charles, drawing their swords against their childhood friend in the civil wars, accusing him of tyranny. Essex's devotion to Elizabeth of Bohemia and the parliamentarian side in the civil war can be traced to the political legacy of his father and the old Elizabethan Protestant internationalists, and his upbringing with Henry.

Historians have traced a trajectory from the Essex era of Elizabeth I's last years to Charles on the scaffold in January 1649. I think that trajectory passed through Henry and his world.

Whatever political ideology made the 2nd Earl of Essex move against Elizabeth in 1601, perhaps King James saw its spirit still moved and lived in Henry's circle in 1612, and feared it. Henry's court bred well-born future parliamentarians. Here the survivors of the first generation of Essexians nurtured the second generation, instilling into them their political philosophy, never imagining it would lead to a republic.

It was not just the Puritan ideology in Henry's court that James disliked. It was how the Puritanism of St James's mingled with the old Essex group's neo-Stoic, Tacitus-influenced politics. The implications of these views was what lay behind the unfounded rumours that Henry had been about to seize power. Just because Henry thought his father did not always act for the benefit of the 'common weal' in areas such as finances, favourites and the marriage negotiations, it did not mean Henry would rise against him. Henry's followers were blamed and ousted for whatever spirit James sought to kill off by destroying Henry's court.

Perhaps he was right to do so, for between Henry's death on 6 November 1612 and January 1649 a significant number of the families who had moved from the 2nd Earl of Essex to Prince Henry, then moved to oppose and destroy the Crown they had served with such faith and hope when Henry lived. Feeling increasingly alienated from the court as it drifted towards High Church Anglicanism – and its association, for them, with the corruption and tyranny of the eleven years of King Charles's personal rule – they opposed the Crown. The monarchy betrayed what Henry's political heirs believed both they and their prince stood for: international Protestantism, active citizen-ship (a form of 'public spiritedness'); and government by the troika of king, Privy Council and Parliament, caring for the liberties of the commonwealth. This way of ruling, they believed, would temper the steel of 'free', absolute monarchy.

Just look, said one commentator, speaking from the other side of decades of terrible bloodshed in Britain and Europe. 'The stage stands,

the actors alter. Prince Henry's funerals are followed with the Prince Palatine's nuptials, solemnised with great state, in hopes of happiness to both persons, though sad in the event thereof, occasioning great revolutions in Christendom.'

As Westminster Abbey emptied, all these other players left the prince on that December night in 1612. What remained of Henry lay centre stage in our national theatre of death.

In the days that followed, crowds came and paid their respects. On 19 December, church officers carried the prince's coffin and effigy down to the crypt. They laid him 'among the representations of the kings and queens, his famous ancestors'.

Soon, tourists began to peck holes in his effigy, tearing off bits of leather and clothing as relics – the undoing of all his display, back to anonymous, bare wood. Henry was taking part in his last great entertainment, 'the play of the dead folks', they said. What a dark, Jacobean, irony it would have been to him: the only active service Britain's lost king ever saw was centuries on duty in the group of royal effigies fondly disparaged as the 'ragged regiment'.

NOTES

Abbreviations

Account – *An Account of the Baptism, Life, Death and Funeral of the most incomparable Prince, Frederick Henry, Prince of Wales, by Sir Charles Cornwallis, Knt., his Highness's Treasurer*

ASF – Archivio di Stato di Firenze, Florence

BD – www.stoics.com/basilikon_doron.html (1603 edition)

BL – The British Library

CSPD – Calendar of State Papers, Domestic

CSPF – Calendar of State Papers, France

CSPS – Calendar of State Papers, Scotland

CSPV – Calendar of State Papers, Venice

Discourse – *A Discourse of the Most Illustrious Prince Henry, late Prince of Wales. Written Anno 1626, by Sir Charles Cornwallis, Knight, sometime Treasurer of his Highness's House*

Hatfield CP – Archive of the Cecil papers, at Hatfield House

HMC – Historical Manuscripts Commission

LPL – Lambeth Palace Library

NRS – National Archives of Scotland, now the National Records of Scotland

RCIN – The Royal Collection

RPC – Register of the Privy Council of Scotland

SPS – State Papers Scotland

TNA – The National Archives

WH – William Haydon, *The True Picture and Relation of Prince Henry* ... (1634)

Preface

xix *made to honour ... offspring.* MacLeod, 2012, p. 164.

xx *'Fas est aliorum quaerere regna ...'.* Nichols, 1828, vol. 2, p. 759.

PART ONE: SCOTLAND, 1594–1603

Chapter 1: Birth, Parents, Crisis

3 *'son of goodly hability'.* CSPS, vol. 11, p. 280.

3 *'great comfort ... daft for mirth'.* Moysie, 1830, p. 113; Calderwood, 1844, p. 293.

4 *'peach and parrot-coloured damask' ... and shuddered.* Williams, 1970, p. 14.

4 *'lack of devotion ... devil's bairns'.* Melville, 1842, p. 352.

5 *'the largest and most efficient naval force in northern Europe'.* Barroll, 2001, pp. 6–7.

7 *'venerable and noble matron'.* NRS GD 124/10/63/1.

7 *'In case God call me ... command you himself.* NRS GD 124/10/70; Akrigg, 1984, p. 141.

8 *Her son ... ate at the ladies' table.* Juhala, 2000, p. 77ff.

8 *'lewd Lords ... to the horn as traitors'.* CSPS, vol. 11, p. 287.

8 *'in no case to seek the young Prince'.* CSPS, vol. 11, p. 308.

8 *'deeply engaged ... in relation to the Catholics'.* CSPS, vol. 11, p. 337.

9 *'in my mother's belly ... fearful nature'.* His Majesties Speech, 1605; Sommerville, 1994, pp. 147–8.

10 *'one resulted in the king's near assassination'.* For a more detailed account of the Gowrie Plot, start with Stewart, 2003, p. 150ff.

Chapter 2: Launching a European Prince

13 *'extreme pleasure ... our representative'.* CSPS, vol. 11, pp. 410–11.

13 *'the Ambassadors of France ... be reached'.* CSPV, vol. 9, p. 143.

14 *'to renew the ancient friendship ... alliance against Spain'.* Birch, 1760, p. 3.

14 *'fair cupboard of plate'.* CSPS, vol. 11, pp. 403–4.

14 *'to cause provision ... to his Majesty's self.* RPC Scotland 5, 167.

14 *On the morning of 30 August 1594 ...* The following account of the baptism is drawn from Birch, 1760; Fowler, 1594; CSPS, vol. 11; Account, pp. 2–15.

15 *David Cunningham ... chapel door.* Account, p. 7.

15 *A fanfare sounded*. Birch, 1760, p. 8.

15 *as if the king replaced God as an object of worship*. John Adamson termed this evolution of court and religious culture a developing 'liturgy of the monarchy'; Adamson, 2000, pp. 101–5.

16 *'the lights and torches … commoved his tameness'*. Juhala, 2000, p. 213.

16 *'that their generations may grow into thousands'*. Account, p. 14.

17 *'sensuous and spectacle-loving lady'*. Chambers, 1923, vol. 2, p. 272.

18 *'Those who were divided … space and time?'* Buchanan, 1995, pp. 276–8.

18 *'… after the decease of her Majesty'*. Reid, 2014, p. 62.

18 *'Your foot … the Capitoline Hill'*. Buchanan, 1995, pp. 276–8.

19 *'It crossed … had no rivals'*. Scott, 2000, p. 29.

Chapter 3: The Fight for Henry

20 *'the question of the Queen … mightily'*. CSPS, vol. 11, p. 550.

20 *'dry through sickness … impute this fault to Mar'*. CSPS, vol. 11, p. 504.

21 *'Two mighty factions … departure of the King'*. CSPS, vol. 11, p. 511.

21 *'What the end will be, God knows'*. CSPS, vol. 11, p. 545.

21 *'to the coal … young Prince'*. CSPS, vol. 11, p. 550.

21 *'by all appearances … denies it'*. CSPS, vol. 11, p. 601; Croft, 2003, pp. 24–5.

21 *'sought nothing but the cutting … treason'*. CSPS, vol. 11, p. 607.

21 *'dearest bedfellow'*. CSPS, vol. 11, p. 609.

21 *'the Queen very lovingly … yield to her'*. CSPS, vol. 11, p. 617.

22 *'a King is as one set on a stage'*. BD, p. 41.

22 *'somewhat crazed … "marvellous secret"'*. CSPS, vol. 11, p. 627.

22 *'I fear it will very suddenly … for their advantage'*. CSPS, vol. 11, p. 627.

22 *'for the amendment of the present danger'*. CSPS, vol. 11, p. 683.

22 *'My Heart … me and my blood'*. CSPS, vol. 11, pp. 662–3.

22 *'obey the King in all things'*. CSPS, vol. 11, p. 682.

22 *'to see him so evidently … they best merited'*. CSPS, vol. 11, pp. 626–30.

Chapter 4: Nursery to Schoolroom

24 *'good sort to attend upon his person'*. Account, sigs A 6–A 6v.

24 *'study to know well … to rule people'*. BL, 38.

24 *'three books … rightly or wrong used'*. BD, intro.

25 *'contain your Church in their calling'*. BD, p. 39.

25 *'Beware with both the extremities … proud Papall Bishops'*. BD, p. 24.

25 *'a loving nourish-father'*. BD, p. 24; Rhodes, 2003, p. 225.

25 *'the art military ... placing of batteries'*. BD, p. 40.

26 *'little god ... sliddriest to sit upon'*. BD, p. 12.

Chapter 5: Tutors and Mentors

27 *'next his parents ... before the pleasing of his fancies'*. WH.

29 *Essex meanwhile ... Scottish king and his progeny*. Gajda, 2012, p. 183.

29 *'an ancient friend' of the Essexians*. Hammer, 1999, p. 168.

29 *Essex's codename was 'Plato' and the king 'Tacitus'*. BL Add MS 4125, f38r; Hammer, 1999, p. 168.

30 *Mar facilitated ... power base near Westminster*. LPL, MS 652, f270r.

30 *Mar boasted of his own importance*. LPL, MS 659, f368.

30 *name James as her successor in Parliament ... Mar come to London*. For the political vision of the Essex group as it played out in this crisis, see Scott, 2014, pp. 97–103; Gajda, 2012, p. 180ff, inc. fn 197, Essex to Mar, LPL, MSS 655, f218r; MS 656, f177.

31 *'sparks of piety ... chiefly to strangers'*. Account, p. 21.

31 *By the age of six ... from Maurice himself*. BL Harley MS 6986, f35.

32 *'began to apply himself ... the use of arms'*. Birch, 1760, p. 21.

32 *'"Praetorian" role'*. Wilks, 2013, p. 10.

32 *'no music being so pleasant ... any sort of Armour'*. Account, p. 20.

32 *'The one I use as a rapier ... dagger'*. WH, p. 13.

32 *'another kind of hunting better ... higher than the rest'*. WH, p. 12.

33 *Newton gave him Cicero's De Officiis ... in public life*. BL C.28.a11.

33 *'Ye have rather written ... your loving father, James R'*. BL Harley MS 6986, f40.

34 *Anne of Denmark had converted to Catholicism*. Fry, 2013, p. 2.

34 *'to the hostile times which we have to endure'*. Fraser, 2002, p. 19.

34 *'The King and Queen are in very evil ménage ... "mintit" at that he intended'*. SPS, vol. 13, p. 721.

34 *'new troubles arise ... finds in his own house'*. Chamberlain, 1939, p. 187.

PART TWO: ENGLAND, 1603–10

Chapter 6: The Stuarts Inaugurate the New Age

39 *she was seen to move her arm to her head*. Whitelock, 2013, p. 342.

39 *'the contentment of the people ... spoiled and sacked'*. HMC Salisbury, vol. 15, p. 11.

40 *'but time is so precious ... Your loving father, James R'.* BL Harley MS 6986, f39.

40 *Henry and Charles and Princess Elizabeth ... childhoods.* CSPV, vol. 9, p. 541.

40 *'your Majesty by sight may have ... all due reverence'.* BL Harley MS 7007, f16

41 *the Mar clan watched as Anne approached.* RPC, vol. 6, pp. 571–2; Calderwood, vol. 6, pp. 230–1.

41 *'prevailed not ... when they rose in revolt'.* CSPV, vol. 10, p. 40.

41 *'Her Majesty's present estate ... danger of inconvenience'.* Balfour, 1838, pp. 53–5.

41 *Lord Fyvie was given the unenviable task of persuading Anne to depart for England.* The drama of this encounter for Fyvie, Montrose and the rest, as well as Anne, is in Balfour, 1838, pp. 53–5.

43 *'God for the peaceful possession ... ascribed to the Earl of Mar'.* As well as communicating with Essex until 1601, Mar had carried many of James's letters to Cecil, and written many of them, in discussions with Cecil during the uncertain times before Elizabeth died.

43 *'she would rather never see England ... for the same'.* Spottiswoode, 1847, p. 477.

44 *'embracing the said Earl, burst forth in tears'.* WH, p. 5.

44 *'brought with her the body ... his death was only feigned'.* Sully, 1805, vol. 3, pp. 115–16.

44 *'Leave off these womanly apprehensions ... impertinent at this time'.* Akrigg, 1984, pp. 213–14.

45 *'he desired to see her always by him'.* WH, p. 4.

45 *'She was naturally bold ... tumult and intrigue'.* Sully, 1805, vol. 3, pp. 115–16.

46 *'Your father gives you here to the service of this Prince'.* Nichols, 1828, vol. 1, p. 182.

46 *'dear Lord, on whom my covetous eye, ... the Arctic star'.* Jonson, 1941, vol. 7, pp. 130–1.

47 *'when slow time hath made you fit ... better than our words'.* Nichols, 1828, vol. 1, p. 187.

Chapter 7: A Home for Henry and Elizabeth

48 *their train numbered over five thousand.* Nichols, 1828, vol. 1, p. 197.

48 *'was some squaring at first ... passed over in peace'.* HMC Report VIII, Corporation of Leicester, 428b; CSPV, vol. 9, p. 63.

48 *Henry kneeled with Lennox ... at such a young age.* Stow, 1631, 1, sig. Zzzz5.

49 *'He is ceremonious beyond his years ... meant to learn Italian'.* CSPV, vol. 10, p. 74.

50 *'I most kindly salute you ... your most loving sister, Elizabeth'.* BL MS Harley 6986, f49.

50 *'these few lines ... I rest, your loving brother, Henrie'.* BL MS Harley 6986, f21.

50 *'delightful memorials of your brotherly love ... living together'.* BL MS Harley 6986, f52.

51 *'subtle and fine wit ... fit man for the condition of these times'.* Somers, 1809, vol. 2, p. 267.

51 *Northampton typified the kind of expert ...* Peck, 1982, passim.

51 *'galliards and corantos ... like a tennis ball'.* Chambers, 1923, vol. 3, p. 280.

51 *The first dynastic marriage ... chatting amiably.* Winwood, 1725, vol. 2, p. 43.

52 *'I protest I am not thoroughly reconciled ... "No" to the Union'.* Cecil to Shrewsbury, quoted in *Illustrations of British History, Biography and Manners, in the Reigns of Henry VIII, Edward VI, Mary, Elizabeth & James I,* Edmund Lodge (London, 1838), p. 82.

52 *a conference at Hampton Court on 14 January 1604.* Account taken from the records of James's speeches to Parliament in Sommerville, 1994, passim; of the conference, in Collinson, 1983, passim.

Chapter 8: The Stuarts Enter London

55 *'We are all Players'.* Shapiro, 2006, p. 257.

55 *'mechanicians ... suck the honey dew of Peace'.* Nichols, 1828, vol. 1, p. 342.

56 *'saluted them with many a bend'.* Nichols, 1828, vol. 1, p. 416.

56 *'fair Prince ... Since Norman William's happy conquering'.* Drayton, 1931, vol. 1, p. 481.

56 *'streamers, ensigns ... into some bodies' bellies'.* Nichols, 1828, vol. 1, p. 334.

57 *'that fair shoot ... your princely offspring'.* Nichols, 1828, vol. 1, p. 128.

57 *'some enchanted castle ... the glittering poisons chew'.* Nichols, 1828, vol. 1, pp. 360–70.

57 *'Our globe is drawn ... new faces and new men'.* Nichols, 1828, vol. 1, pp. 360–70.

58 *Father Tesimond ... in the long run.* Edwards, 1973, pp. 28, 93.

Chapter 9: Henry's Anglo-Scottish Family

60 *Nonsuch Palace.* http://www.everycastle.com/Nonsuch-Palace.html.

61 *the keeper of Nonsuch.* For Lord Lumley's collections at Nonsuch, see the Sears and Johnson catalogue, 1956.

61 *marrying into the Puckerings.* The late Sir John Puckering had been Speaker for the House of Commons and Elizabeth I's Lord Keeper of the Great Seal of England.

61 *Newton prevailed on the prince ... Dean of Durham.* Pollnitz, 2007, p. 33; BL Lansdowne MS 1236, f66r.

61 *They bickered like a family too ... 'need be a wise man that would do that'.* WH, p. 15.

63 *William Fleetwood, Queen Elizabeth's Recorder of London.* Brooke, 2004, for Fleetwood.

63 *'militarised ideal of active citizenship' ... monarch and commonwealth.* Gajda, 2012, p. 256.

64 *Henry went 'often to visit ... in vain'.* WH, pp. 3–4.

65 *Anne and Henry stopped at Oxford ... spells, and dreams.* Birch, 1760, pp. 48–58.

65 *John Harington looks up at Henry.* Both Harington's father, Sir John, and his sister, Lucy Bedford, patronised Peake.

65 *In the early days of Henry's new life in England, a painting ...* The Metropolitan Museum of Art/Art Resource/Scala, Florence: *Henry, Prince of Wales and Sir John Harington*, Robert Peake the Elder, 1603.

65 *livery colours of the Tudors, not the red-and-white of the Stuarts.* I would like to thank Professor John Adamson for pointing this out.

66 *Bales taught Henry for nearly two years before he dared ...* HMC Salisbury, vol. 24, p. 107.

66 *he commissioned a model ship ... as a libation, tossing the bowl in after it.* Pett, 1918, pp. 20–2.

67 *'Mercury with Diana ... study with exercise'.* BL Harley MS 7007, f69r.

Chapter 10: Henry's Day

68 *Adam Newton and his team of tutors ...* Newton's archive of Henry's schoolbooks is Wren TC MS R.9.30, R.14.10, R.7.23*; but see also, Pollnitz, 2007, passim; MacLeod, 2012, p. 136, and Wilks, 1987, p. 167.

68 *'Terence's Hecyra ... and two books of the selected Epistles of Cicero'.* BL Harley MS 7007, f14r.

68 *'deserved to be imprinted in the minds of men'.* BL Harley MS 7007, f27r.

68 *'most powerfully written for the education of princes'.* Wren TC MS R.7.23*, VII, fol. 2r; Pollnitz. 2007, p. 32ff.

69 *never showed his father's great and deep love of learning.* Account of King James's school day is given in Willson, 1956, p. 23.

69 *'hawking, hunting, running at the ring ...'.* Account, p. 22.

69 *'chiefly under his father's spur, not of his own desire'.* CSPV, vol. 10, p. 513.

69 *'his affection to his Majesty did grow with his age'.* WH, p. 3.

70 *'We had a king, Aeneas called ... could match him one'.* WH, p. 11.

70 *'Renown is a furtherer of an honest mind'.* WH, p. 11.

70 *'Thou doest thy father's forces lead ... Bellona's hands'.* Alexander, 1604; Wilson, 1946, p. 28.

70 *The king ordered new stables and barns to be built.* CSPD, 1603–10, pp. 132, 135.

70 *'I will give anything that I have to you ... Good brother, love me'.* BL Harley MS 6986, f85.

71 *'they whistle and sing to each other for music'.* Stuart, 1778, p. xxiv; Harley MS 6987, f24.

71 *'they would not prove good soldiers ... your self was once a boy'.* WH, pp. 19, 21.

71 *the king 'admonished and set down' Henry ... 'Archbishop of Canterbury'.* CSPV, vol. 10, p. 513, my italic; WH, p. 3.

71 *Sibling rivalry never seemed to enter his relationship with Elizabeth.* WH, p. 4.

72 *'My letters follow you everywhere ... make them recommended'.* BL Harley MS 6986, f66.

72 *'Your kind love and earnest desire ... we must submit ourselves'.* Harley MS 7007, f62.

72 *'preachers around Prince Henry'.* McCullough, 1998, pp. 184–5.

72 *Burton sought royal service ... on earth in England.* TNA SP 14/139 f144.

72 *He wrote a tract for Henry on the Antichrist.* McCullough, 1998, pp. 185–7.

72 *Joseph Hall ... preach again.* Hall, 1845, p. xxix.

73 *Hugh Broughton ... exposition of the Lord's Prayer.* Broughton, 1603; Birch, 1760, pp. 44–5; Wilks, 1987, pp. 231–2.

73 *'Henry the 8 pulled down abbeys and cells ...'.* HMC Salisbury, vol. 19, p. 242, Sir John Harington to Chaloner in Salisbury.

74 *'a fishing at my house in Carshalton ... weary with waiting on the Prince'.* Kenny, 1970, pp. 274, 313.

75 *'The altar was covered in silver gilt … the King and Prince meanwhile laying their hands on the Gospels'.* CSPV, vol. 10, p. 178.

75 *'a most gracious smile' but 'a terrible frown'.* Birch, 1760, p. 375.

75 *'tossed his pike better than in presence of his Majesty and great Ambassadors'.* WH, p. 11.

76 *The constable gave Henry a beautifully caparisoned pony.* CSPV, vol. 10, p. 178.

76 *'Taxis is making presents every day … scoff at those who hold a different view'.* CSPV, vol. 10, p. 179.

Chapter 11: Union and Disunion

78 *'I don't doubt that you have given thanks … I fear nothing man can do'.* BL MS Harley 6986, f73.

78 *'yearly acknowledgment to be made …'.* Andrewes, 1606, passim.

78 *'would never after suffer himself to be prevented … been executed'.* Birch, 1760, pp. 61–2.

79 *'Beware of the Vipers … tied his servants thereunto'.* McCullough, 1998, pp. 183–4; Birch, 1760, pp. 62–4, 414–16.

79 *'the miraculous delivery God sent from Heaven … we have known from our infancy'.* BL Harley MS 7007, f76.

80 *analyse an account by … Cyrus the Great of Persia's rise.* Henry's commentary here is drawn from Wren TC MS 7.23*, VI, fols 1r–12r passim. Henry's words are from ff5r–11r, and f12r; trans. Pollnitz, 2007, p. 51ff.

81 *'Every day something new about the plot … a general massacre may take place'.* CSPV, vol. 10, pp. 303–4, passim.

82 *Prince Henry must be sent 'to reside in Scotland' …* CSPV, vol. 10, pp. 304, 309–10.

83 *'What God hath conjoined … I am the husband and the whole isle is my lawful wife'.* King James, Speech to Parliament, 19 Mar 1604.

84 Hymenaei. Quotations from *Hymenaei* are drawn from Stephen Orgel's edition of Jonson's *Works*, 1969, p. 76ff; and critical analysis uses Curran, 2009, passim.

84 *'sound to present occasions … more removed mysteries'.* Jonson, 1969, p. 76.

85 *'May all those bodies … with the Ocean's streams'.* Jonson, 1969, p. 86.

Chapter 12: Europe Assesses Henry

86 *'his excessive sorrow and grief ... in safety with himself'*. WH, p. 4.

86 *'The news spread to the city ... Papists, foreigners and Spaniards'*. CSPV, vol. 10, p. 333.

87 *'The State and the Church ... each with its own sovereignty'*. Kainulainen, 2014. See especially pp. 180–2 for an analysis of the genesis of Sarpi's thought on this distinction.

88 *The Holy Roman Empire*. For good modern histories of the empire and the Thirty Years' War, see Wilson, 2009 and 2016; Simms, 2013.

89 *'the fundamental function of monarchy was the making of war'*. Scott, 2000, p. 31.

89 *'he were of age he would come in person to serve the Republic'*. BL Harley MS 7007, f117; CSPV, vol. 10, pp. 2, 494.

90 *'most lovingly in his arms ... his heart's joy in ... Henry'*. *The King of Denmarkes Welcome*, 1606.

90 *'proposed to ... prince of greater spirit would probably not have done'*. CSPV, vol. 10, p. 519.

90 *'the Sovereign rights ... sought to overthrow them'*. Wotton, 1907, vol. 1, p. 78ff; Yates, 1944, pp. 123–43.

91 *'They had sight of all the ships ... pendants, flags and streamers'*. Nichols, 1828, vol. 2, pp. 66, 80, 83 for an account of this visit.

91 *the* Vice-Admiral, *with all her modern weaponry*. Nichols, vol. 2, p. 93.

91 *Unable to 'follow the King ...'*. Boderie, 1750, vol. 1, p. 60 passim; Birch, 1760, pp. 69–70 passim.

92 *'Sire and Treasured Uncle ... your truly paternal affections'*. BL Harley MS 7007, f143; f103.

92 *'to cultivate that young plant ... accounted of him as of his own son'*. Sir George Carew to Salisbury, 26 Aug 1607; Birch, 1760, p. 89; Williamson, 1978, p. 36.

93 *'endeavoured to prejudice ... conquer, like Henry V'*. Birch, 1760, p. 45.

93 *Henry asked Joinville*. BL Harley MS 7007, f148.

93 *'he was employed by Prince Henry ... for such an opportunity'*. Birch, 1760, pp. 86–7.

94 *'The eye of the world ... Saint Georges Knight'*. Wilson, 1946, pp. 45–6.

94 *'You would have seen there ... everlasting fame'*. Birch, 1760, pp. 79–80.

94 *'the commendations of persons ... pray the all-merciful God'*. Birch, 1760, p. 78.

95 *'His discourse ... foreign countries as well as his own'*. Birch, 1760, p. 86.

Chapter 13: The Collegiate Court of St James's

96 *'Here they may obtain his Highness favour ... to command in war'.* Birch, 1760, p. 97; Cleland, 1607, pp. 35, 36 passim.

97 *'be homely with your soldiers ... devising stratagems'.* BD, p. 29.

97 *'The profiting by other men's errors ... get him to discourse of it'.* BL Royal, 18. C. xxiii. f7r: written in the 1620s, the introduction recalled Cecil's time under Maurice in the early 1600s, when he was also a member of Henry's circle; also, quoted in Lawrence, 2009, p. 108.

98 *'who doth yet give such a lustre ... in his often practise'.* De Gheyn, 1608, introduction.

98 *'use all other Princes, as your brethren, honestly and kindely'.* BD, p. 28.

98 *Barnaby Riche.* See Maley, 2004; Riche, 1604.

99 *Prince Charles shared their practice sessions.* Lawrence, 2009, pp. 127–30 passim.

99 *'your absence I visit sometimes your stable ... that noble exercise'.* BL Harley MS 6986, f87.

99 *The king had told Henry to make himself familiar with 'the art military'.* BD, p. 40.

99 *'Besides exerting his whole strength ... management of his affairs'.* Boderie, 1750, vol. 1, pp. 400–01; Birch, 1760, pp. 75–6.

99 *Salisbury sent Henry ... 'will not easily sever'.* Birch, 1760, p. 129.

Chapter 14: Money and Empire

101 *'that it was ready to be overwhelmed with the burden and charge of itself'.* Birch, 1760, p. 97.

101 *The royal coffers were as bare as ever, he explained.* Birch, 1760, p. 83.

101 *It was arranged for Henry to be inducted into the Merchant Taylors' Company.* Account given in Stow, *Annales*, sig. Ffff1v; Wilson, 1946, p. 50.

102 *'Haberdashers of hats ... maps or prints, Girdlers, etc'.* TNA SP 14/44/5.

102 *'fitted up one of the shops very beautifully' ... "here all is given for love"'.* The account of this day is drawn from Knowles, 2002, pp. 182–9.

103 *Thomas Harriot.* For Harriot see Shirley, 1974.

104 *receive 'projectors' and 'mechanicians'.* Examples are in BL Harley MS 7009, ff12, 14.

105 *He wanted to discover the Northwest Passage sea route.* Canny, 2009, p. 54.

105 *Between them they documented the life of the Algonquin.* Petworth Harriot MSS, MS HMC, pp. 240, i–v; 241, i–x; BL Add MSS 6782–9.

105 *mathematical puzzles for his student to solve.* BL Add MS 6782–3.

106 *a ruling council in Virginia.* On the first governing bodies of Virginia, see Gardiner, 1883, vol. 2, p. 52; Armstrong, 2007, p. 129.

106 *Tindall's first reports … 'to the use of your royal father'.* BL Harley MS 7007, f139.

106 *'set up a cross and called the place Cape Henry'.* http://friendsoffirstlandingstatepark.com/History_of_First_Landing.html; https://www.virginia.org/listings/historicsites/firstlandingcross.

106 *Tindall created the first map of the Chesapeake Bay.* BL Cotton MS Augustus, I, ii, p. 46; Brown, 1890, vol. 1, pp. 108–9; Canny, 2009, pp. 45–55.

107 *'the Patron of the Virginia Plantation … as well as his good word'.* HMC Portland, vol. 9, pp. 8–11.

107 *Henry returned to dine at Salisbury House.* HMC Salisbury, vol. 24, p. 150.

107 *'Prometheus, devoured by the eagle, done by Giacoba Palma'. Prometheus chained to the Caucasus*, Giovane de Palme, RCIN 406075.

107 *Everything … showed him what power looked like from the top of the heap.* Smuts, 1991, pp. 99–112.

108 *'Short, crookbacked, but with a noble countenance and features'.* CSPV, vol. 10, p. 515.

108 *Zeus shackled Prometheus to a rock.* Bracken, 2002, p. 122. There are variations on the Prometheus myth; this is one account.

Chapter 15: Friends as Tourists and Spies

109 *The Continent buzzed with 'intelligencers' of all kinds.* A good introduction to spies and tourists in this period is Chaney and Wilks, 2014.

109 *'What hast thou done, John,' … 'his Highness is the lover'.* CSPV, vol. 10, pp. 215–16.

110 *Each evening Harington recorded his deeds … understood the code.* Birch, 1760, p. 118; Harington, 1792, vol. 3, pp. 163–4. Both make use of Stock, 1614.

110 *Then headed down into Italy.* Birch, 1760, p. 123.

111 *He asked the prince if he had received any of his letters.* For examples of this correspondence, see BL Harley MS 7007, ff215, 221, 223, 224 passim; Birch, 1760, p. 124.

111 *Salisbury sent copies to his son.* Birch, 1760, p. 168.

111 *'most gloriously shine'*. Birch, 1760, pp. 174–5.

111 *'Although I know your Highness expects not much from me'*. HMC Salisbury, vol. 20, p. 285.

112 *'During this your absence ... so worthy patterns'*. HMC Salisbury, vol. 20, p. 286.

112 *'attain to trusty knowledge ... acceptable servant to your Highness'*. BL Harley MS 7007, f189.

112 *Rich foreigners went away with shipments of glass.* Strachan, 1962, p. 41.

113 *'He carried folly (which some call merriment) in his very face'*. Fuller, 1662, p. 30ff.

114 *Wherever he went, he recorded.* Henry's copy of Coryate's account, *Coryat's Crudities* is BL G.6750.

114 *an umbrella – a word Coryate introduced into the English language.* Strachan, 1962, p. 117.

115 *'And to the end she may minister ... stronger temptations'*. Strachan, 1962, pp. 51–2.

115 *He went back along the Rhine to enter the Dutch-Spanish conflict zone.* Strachan, 1962, p. 101.

116 *Harington told Henry ... he missed him sorely.* BL Harley MS 7007, f241.

Chapter 16: Henry's Political Philosophy

117 *'Most powerful is he who has himself in his own power'*. Seneca, *Epistles*, 2:2, A.S., pp. 63–4.

117 *'to be instructed and corrected by his judgement'* ... *'in the sense of which I could not satisfy myself.* Transcriptions of these exchanges are in Birch, 1760, pp. 120–1.

118 *Henry chose passages on how to resist corruption ... amid a decadent court.* Pollnitz, 2007, p. 52; BL Harley MS 7007, f226v.

119 *'other than the one thing, not moving'*. *Coriolanus*, IV, 7, line 42.

119 *'our virtues/Lie in the interpretation of the times'*. *Coriolanus*, IV, 7, lines 49–50.

120 *'Stoicke insensible stupidity'*. BD, p. 41.

120 *Henry's courtly college had become the centre of neo-Stoic thinking.* For more on neo-Stoicism and its popularity with Henry's circle, see Brooke, 2012, p. 60ff.

121 *'the present state of affairs'*. BL Harley MS 7007, f185; Wotton, 1907, vol. 1, pp. 425–7.

121 *the prosperous German city of Donauwörth.* See Anderson, 1999, pp. 14–15, for the crisis in Donauwörth and the lead up to Jülich-Cleves.

122 *Prince Louis Frederick, his secretary Wurmsser.* Rye, 1865, p. cxiii, for an account of Württemberg's visits.

123 *'to play the wise King's part'.* BD, p. 29.

Chapter 17: Favourites

124 *'a fair complexion, equally sharing the beauty of both sexes'.* Osborne, 1811, p. 6.

125 *'the maligners of true virtue'.* Discourse, p. 218.

125 *'how many are there … "yours, in the way of honestie", is little cared for'.* Riche, 1606, p. 6.

125 *'Eschew to be effeminate in your clothes'.* BD, p. 46.

125 *Carr knew 'his taste and what pleased'.* Weldon, 1650.

126 *'Sure, no King but my father … would keep such a bird'.* Coke, 1694, p. 37.

126 *'According to your commandment, I made your excuse unto the Queen'.* From here to the end of this exchange is taken from BL Harley MS 7007, f. 316.

127 *'had them removed by his people' … the bedchamber coterie.* CSPV, vol. 11, para 393.

128 *The Privy Council 'pointed out to the King … an office of such weight should not lie outside the Royal House'.* CSPV, vol. 11, pp. 227, 430.

Chapter 18: Henry's Supper Tables

131 *Lumley's exceptional library … passed to Henry.* E.403.2728; CSPD, 1603–10, vol. 58, No. 87.

131 *Father and son added shelves … ordering new desks and chairs.* CSPD, 1603–10, vol. 58, No. 55. For the contents of Lumley's library see Jayne and Johnson, 1956.

132 *practical body of work on mathematics, cosmography, and navigation.* MacLeod, 2012, p. 137.

134 *Sir Francis Bacon … wrote little advices to himself on how to get a toehold close to Henry.* Wilks, 1987, p. 40; Bacon, vol. 4 (ii), p. 63; for Russell's projects see CSPD, 1611–18, pp. 111, 250, 468.

134 *commandeer part of the Savoy hospital.* Chamberlain, 1939, vol. 1, p. 251.

135 *A tavern wit … and Sir Robert Dallington.* O'Callaghan, 2007, p. 4ff.

136 *One of them wrote a long … 'silken scarves and their spangles'.* BL Harley MS 4931, ff22–5.

136 *'Sweet-meats and Coryate … as hard knocks as it received'.* Fuller, 1662, p. 31.

Chapter 19: Henry's Foreign Policy

138 *the only claimants 'whose pretensions were not absolutely ridiculous'.* Gardiner, 1883, vol. 2, p. 94.

138 *A tremor of unease threatened the nascent peace.* For the background to the Thirty Years' War, see Anderson 1999, Simms 2013; and Wilson 2009 and 2016.

138 *'For the King of England … would like to do everything with words'.* Livesey, 1965, pp. 109–17.

139 *'I find every week … the countries as he passes' through.* BL Lansdowne MS 108, f94.

139 *'a slow-working poison … they might destroy their bodies'.* Harington, 1792, vol. 3, p. 158.

139 *Henry wrote to 'My Good Fellow … your Friend, Henry'.* Harington, 1792, vol. 3, p. 305.

140 *'like to draw no less after it than a general War in Christendom'.* Winwood, 1725, vol. 3, p. 76.

140 *'Your Grace's name … King Edward the third's son'.* Birch, 1760, pp. 42–3.

140 *'Hate the Whore … and pernicious sects'.* Crashaw, 1609.

141 *'there were now as many men and able … a rare vigilancy'.* HMC Portland, vol. 9, p. 9.

141 *Sir Charles Cornwallis, wrote to Henry.* Birch, 1760, pp. 172–73; BL Harley MS 7007, f 266.

141 *'Propositions for War'.* Williamson, 1978, p. 61.

142 *Cotton's argument against war was ten times as long.* Birch, 1760, pp. 186–7; Cotton, 1657.

142 An Answer made by Command of Prince Henry. Ralegh, 1655, p. 2.

Chapter 20: Heir of Virginia

144 'There is a world elsewhere'. *Coriolanus*, III, 3, line 145.

145 Excellent Observations and Notes Concerning the Royall Navy and Sea-Service. This essay used to be included in Ralegh's *Works*. Both Ralegh and Gorges had a low opinion of Pett as a naval engineer.

145 *'Where be now these perjured fellows'.* Pett, 1918, pp. 50, 62;
Williamson, 1978, pp. 54–5.

145 *'Though I do not respond to all … being far from you'.* BL Harley MS
7007, f284.

145 *'Not at all ignorant of the disposition of their son'.* Birch, 1760,
pp. 109–10.

147 *Robert Johnson's sermon,* 'Nova Britannia'. Johnson, 1609, and for the
discussion of it in the context of establishing the New Jerusalem, see
Zakai, 1992.

147 *put some money in … have a claim over the Colony.* CSPV, vol. 11,
para 449.

147 *'There has been gotten together … deeper and deeper into the business'.*
Brown, 1890, vol. 1, pp. 245–6.

148 *'there being diverse knights … at their own charge'.* HMC Salisbury,
vol. 21, p. 276.

148 *'Never was there more need' … than what had gone on here.* BL Harley
MS 7009, f58ff; Strachey, 2010, pp. xxv–xxvi. For more on the
starving winter see historicjamestowne.org/history/history-of-
jamestown/the-starving-time.

PART THREE: PRINCE OF WALES, 1610–12

Chapter 21: Epiphany

153 *'barriers'.* Jonson's text is in Jonson, 1969, p. 142ff.

153 *'where true Virtue triumphed most'.* Account, p. 23.

154 *'a livery of crimson velvet and broad gold lace',* HMC Downshire,
vol. 2, p. 216.

154 *Moeliades was an anagram.* Drummond, 1913, vol. 1, p. 75.

156 *Next evening, washed and rested … three in the morning.* Chambers,
1923, vol. 4, p. 124n; CSPD, King James I, vol. 1, p. 587.

157 *Henry's* 'Oratio Serenissimi Principis ad Regem'. The fullest
discussion, with translations, is in Pollnitz, 2007, pp. 49–53, and I
draw on that for my analysis of it. The original is BL Harley MS 7007,
ff229r–231v.

157 *'required more in a prince … greater good of the public'.* Pollnitz, 2007,
p. 50.

158 *'so many things of Civil Policy … Government of Kingdoms'.* BL Harley
MS 7002, f87r. Other letters on this theme between Salisbury and

Newton/Henry are in BL Harley MS 7002, fol. 95r; BL Lansdowne MS 90, ff61r and 59r.

159 *Sir Charles Cornwallis … 'touch upon the verge of vice'.* BL Egerton MS 3876, ff1r–3v.

159 *Henry thanked Cornwallis for his 'observations'.* BL Harley MS 7007, f266r.

159 *Robert Dallington … a pension for life from the prince.* Dallington, 1613.

160 *He summoned Richard Connock … begged Henry to protect him.* Trinity College Cambridge MS 720; and Connock, 1747, pp. 69–71.

161 *Henry said he 'will rather trust your Lordship with the care of his creation than any other'.* Hatfield CP 128/13.

161 *'he makes himself already very much respected …'.* HMC Downshire, vol. 2, p. 211.

161 *'The Prince now begins … many things that may hereafter ensue'.* HMC Downshire, vol. 2, p. 199.

162 *'toiled … yield some large contributions for the maintaining of future charges'.* Croft, 1992, p. 186; HMC Downshire, vol. 2, p. 199; *CSPV*, vol. 11, p. 401.

162 *'The time of creation of my Son … himself here speaks for him'.* *The Kings Majesties Speech to the Lords and Commons*, xxj, March 1609, ns 1610.

163 *'Our gift I wish liberal … The court is the cause of all'.* HMC Portland, vol. 9, p. 113.

164 *'on whom the king your father hath bestowed great and bountiful gifts'.* Gorges, 1610.

Chapter 22: Prince of Wales

165 *Henry was determined … written commitment to the alliance.* BL Harley MS 7007, f338; *CSPV*, vol. 12, pp. 31, 51, 234, 239.

166 *Württemberg's party arrived in April … the young Landgrave of Hesse.* BL Add MS 20,001; Rye, 1865, p. 58ff.

166 *'Though the beast be but little, yet are the members worth enjoyment'.* *Countrye Contentments*, 1615, p. 31.

167 *Henry gave him another £20 for his expenses.* Henry's Privy Purse expenses are in *CSPD*, vol. 57–8; for Drebbel, see Rye, 1865, pp. 234–420.

168 *He 'was athirst for glory if ever any Prince was'.* *CSPV*, vol. 12, pp. 449–50.

169 *'what should move the French King … be content to put water in his wine'.* Winwood, 1725, vol. 3, pp. 154–5ff.

170 *'my second father is dead … marched on Cleves'.* Birch, 1760, pp. 189–90; *CSPV*, vol. 11, p. 506.

170 *'I think it was never more needful to make a League of those of the Religion'.* HMC Downshire, vol. 2, p. 290.

170 *'we are all at a stand, until we understand what his Majesty will counsel'.* HMC Downshire, vol. 2, 291.

170 *Henry now lived 'every day five or six hours in armour'.* Chamberlain, 1939, vol. 1, p. 330.

171 *His 'whole talk was of arms and war'.* CSPV, vol. 12, p. 450.

171 *After the French king's assassination … an assassin's attack. CSPV*, vol. 11, p. 496; Boderie, 1750, vol. 5, p. 268; *CSPD*, 1603–10, p. 611; BL Stowe MS 171, f23.

172 *James was to create new Knights of the Bath …* Daniel, 1610, p. 15ff.

172 *Monday dawned and guests … the Palace of Westminster.* I have recreated this day from John Noies's account in HMC *Reports*, vol. 3, pp. 259–63; *CSPV*, vol. 11, para 945; Daniel, 1610, and Croft, 1992, pp. 177–93; BL Cotton MS Vesp. F III, No. 20; and HMC Downshire, vol. 2, 296ff.

175 *An exquisitely ornamented patent … the right tone.* TNA SP14/53/71, 73, 75; SP 14/55/10; BL Add MS 36932.

175 *A sword, a ring, a golden vierge.* TNA SP 14/55/12; Bray, 1806, pp. 18–20; and BL Cotton MS Vesp. CXIV f135, which is the list for 'Things to be provided for creation of the Prince of Wales for his principality, Dukedom and Earldom'.

176 Spem in Alium Nunquam Habui – *'Hope in any other, I have never had'.* The earliest extant MS version of *Spem in Alium* is BL Egerton MS 3512, almost certainly made for this day, with English words beneath the Latin text; Willetts, 1968, pp. 38–41.

176 *Sing and glorify Heaven's high Majesty …* BL Egerton MS 3512.

177 *'During the whole dinner time … most exquisite music'.* HMC Downshire, vol. 2, p. 316.

177 *Tethys, goddess of the sea.* Daniel, 1610, p. 29ff.

177 *His mother's masque told Henry … 'A chemic secret, and change fish to gold'.* Barroll, 1991, p. 123ff; Butler, 2008, chapter 6.

Chapter 23: Henry's Men Go to War

179 *Henry ordered Captain George Waymouth to keep a journal ...* BL Royal MS 17 B XXXII. All quotations by Waymouth in the following account of the siege are from this manuscript.

180 *'We press him [the enemy] so nighly ... in all my endeavours'.* Birch, 1760, 198ff; BL Harley MS 7007, f398; Chamberlain, 1939, vol. 1, p. 369.

181 *'blown a pike's length ... Only one soldier was blown quite away'.* BL Royal MS 17B XXXII, f15.

181 *'a boat full of artificial fireworks' ... old soldiers pushed it away.* BL Royal MS 17B XXXII, f19v.

181 *'has called to parlay ... in so high and so thick a wall'.* Birch, 1760, p. 202.

182 *'tranquillity, peace and repose' ... to assure them of their importance.* CSPV, vol. 10, p. 513.

183 *His flagship, the* Prince Royal *... was ready to launch.* Pett, 1918, pp. 76–86.

Chapter 24: Henry Plays the King's Part

185 *'obscure, and nothing ... Are there any Nymphs to woo?'* Oberon quotations: Jonson, 1969, p. 159ff; analysis draws on Butler, 2008, pp. 188–94; Butler, 1998, p. 24ff; Barroll, 1991, p. 129ff; HMC Downshire, vol. 3, p. 1ff.

186 *'tall, ... strong and well proportioned ... the motion of his eyes composed'.* Bacon, 1861, p. 327ff.

188 *'The Prince ... took the Queen to dance ... each of the rest his lady'.* Downshire, vol. 3, pp. 1–2.

188 *'for a corranto ... which was something to see and admire'.* HMC Downshire, vol. 3, pp. 1–2.

188 *'How sour sweet music is ... now doth time waste me'. Richard II,* V, 5, lines 42–4, 49.

189 *'The players do not forbear ... any would be afraid to hear them'.* Nichols, 1828, vol. 1, p. 500; Butler, 1998, pp. 20–1.

189 Love Freed from Ignorance and Folly. Quotations are drawn from Jonson, 1969, p. 174ff; analysis benefits from Craig, 2010, pp. 400–11.

190 *'Notwithstanding the inestimable ... who reaped the first fruits'.* Halliwell (ed.), 1845, vol. 1, pp. 90–1.

190 *Henry was 'captivated by her eyes, which then found no match but themselves'.* BL Add MS 25348, f4v. This rumour has persisted, although this observation is from a play written after Henry's death.

190 *'The most beautiful and specious ladies ... yet did he ... cover them'.*
 Discourse, p. 262.

191 *His 'more heroic innate qualities ... soon raised him out of the slumber*
 of that distemper'. Wilson, 1653: p. 56, my italic.

192 *'The Commonwealth engrossed by so few ... Enjoy and defile her'.*
 Catiline I. 1. 346–9. All quotations from *Catiline*, from here to the end
 of the chapter, are from Act I, Scene 1.

Chapter 25: From Courtly College to Royal Court

195 *Henry 'is delighted to rule ... and some new buildings'.* CSPV, vol. 12,
 p. 106.

196 *Edward Wright ... 'a very poor man'.* TNA SP 14/71/17.

196 *'with a look that said: "Sir, you must hear me diligently"'.* Birch, 1760,
 p. 377.

197 *eight 'tons of Indian coloured wood transported from beyond the seas'.*
 TNA E.351/2793.

197 *'They ha' their change of houses, manors, lordships ... At price of*
 provinces'. Catiline, I, 1, lines 381–7.

197 *'bring unto your coffers ... without wrong to the public'.* BL Harley MS
 7007, f357.

198 *'be not tempered, it will be of ill sound ... directly repugnant'.* Birch,
 1760, p. 134.

198 *'I mean to give him a composition ... if you will give me reasonable'*
 terms. Hatfield CP 134/163.

Chapter 26: Court Cormorants

201 *He handed over substantial money gifts.* TNA SP Warrant Book, ii,
 191.

201 *'An Instruction to Princes, to know how to Govern state well'.* Wren TC
 MS R.7.23*, II, f16v.

201 *The going rate for a baronetcy was set at £2,000.* Many of the oldest
 extant baronetcies began here, in this way.

201 *Henry carried the banner ... disgust and self-control.* CSPV, vol. 12,
 pp. 153–4.

201 *Rochester was 'further in the King's graces ... secure his favour and good*
 will'. CSPV, vol. 12, pp. 142, 135.

202 *'more suitors following him than my Lord Treasurer'.* HMC Buccleuch,
 vol. 1, pp. 101–2.

202 *'graciously on everyone ... just as he thinks best'.* CSPV, vol. 12, p. 265.

202 *Rochester's slighting of the queen increased Henry's determination.* The details of this incident come from Wilson, 1653, p. 79; *CSPV*, vol. 12, p. 142; Tillières, 1863, p. 4; Huntington Library: Ellesmere MS 5979, f6.

203 *his father, 'walked up and down ... how public the matter is now,' said Anne.* Goodman, 1839, vol. 1, p. 216, and vol. 2, p. 145; HMC Downshire, vol. 3, p. 83.

204 *It was rumoured, wrongly, he 'is President' ... 'in the conduct of important affairs'.* HMC Downshire, vol. 3, p. 155; *CSPV*, vol. 11, para 364.

204 *Rochester was seen 'grappling ... opposition to' the poisonous growth.* Wilson, 1653, p. 56.

204 *Henry was 'almost always with the Earl of Salisbury'.* CSPV, vol. 12, p. 227.

204 *'dangerous to ... invest the son with the authority of the father'.* Birch, 1760, p. 254.

204 *Henry once again found himself caught ... never, ever entered the queen's line of sight.* See Goodman, 1839, vol. 2, pp. 143–4; HMC De L'Isle, vol. 5, p. 65, wrongly dated; HMC Downshire, vol. 3, pp. 138–9, 180; Chamberlain, 1939, vol. 1, p. 314, for further comment on this friction.

205 *Rochester 'carries it handsomely ... not well satisfied with him'.* HMC Mar and Kellie, 1930, p. 41.

Chapter 27: The Humour of Henry's Court

206 *Thomas Coryate's request for an audience at St James's.* Coryate 1611, contains the poetic sketches by friends, and Coryate's addresses to the royal family, that I quote from here. Other commentary benefits from Strachan 1962 and Pritchard 2004.

Chapter 28: Marital Diplomacy

210 *'the Spanish olive', as Salisbury called her.* Williamson, 1978, p. 133.

210 *'Disagreement in religion ... taking their example from your family'.* BD, p. 35.

211 *the leading French Huguenot prince, the Duke of Bouillon ... formal proposal before he could reply.* CSPF, Privy Council to Edmondes, Feb 1611; Edmondes to Salisbury, Jan 1611.

212 *Henry asked ... Ralegh, for his opinion ... Just what Henry wanted to hear.* Ralegh, 1829, vol. 8, pp. 223–36; TNA SP 14/70 ff163–6.

212 *Another 'faithful' prince ... secure Princess Elizabeth for himself.* These
 1611 marital goings on, also cite Nichols, 1828, vol. 2, p. 424; *CSPV*,
 vol. 12, p. 196; Rye, 1865, p. 143ff; BL Harley MS 7008, ff81–2, 89, 138.

212 *'good grounds to believe that the Palsgrave will get the golden fleece'.*
 HMC Portland, vol. 9, p. 26.

212 *'Five heirs, true youths, five kinsmen and five Princes ...'* Fennor, 1616.

213 *'Our brethren ... overrun, spoiled and forcibly handled'.* Publicke
 Declaration, 1610, p. 8.

213 *The* French Herald, 1611 passim; Werner, 1996, p. 124.

213 *'Here is the Alexander of Great Britain ... My Young Caesar, and great
 Alexander'.* Marcelline, 1610, sig. A2r.

215 *'intended to marry a subject and a beauty, to avoid keeping a mistress'.*
 Strong, 1986, p. 67; ASF 4189.

216 *John Webster said ... 'we stood as in some spacious theatre'.* Webster,
 1612, sig. B.

Chapter 29: Supreme Protector

217 For investors and general comment on the Northwest Passage
 Company, see Brown, 1890, passim; Birch, 1760, p. 264; *CSPD*, James
 I, p. 139; BL Harley MS 7009, f168; *CSPV*, vol. 12, pp. 233, 265,
 299–300, 333, 361; Chamberlain, 1939, vol. 1, pp. 321–32.

218 *'Let there be a religious care' ... He expected them to be gone for up to
 two years.* Button, 1849, pp. 81–94.

218 *The prince sent 'a spy ... the royal navy was ordered'.* Goodman, 1839,
 vol. 1, p. 250.

218 *'with diligence and authority ... Admiral who is decrepit, can hardly
 do'.* CSPV, vol. 12, p. 227.

218 *a general review of the navy with a view to its complete refit and
 modernisation.* CSPD, James I, pp. 85–6, 99.

218 *'no doubt, but he had others' ... Henry took a mile.* Goodman, 1839,
 vol. 1, p. 250.

218 *'to execute [the position] during his brother's minority ... of Inferiors'.*
 HMC Downshire, vol. 3, p. 147.

219 *Henry pressed his fellow councillors ... They stonewalled.* CSPV, vol. 12,
 pp. 240, 264–5; BL Harley MS 7009, ff30–47.

219 *'For whosoever commands the sea commands the trade'.* Ralegh, 1829,
 vol. 8, p. 325; though this is now thought to be Gorges's work.

219 *'with Spain ... become the executor of that noble attempt'.* Discourse,
 p. 261.

219 '*The Prince has managed so cleverly ... the greatest post in this kingdom*'. CSPV, vol. 12, pp. 226–7.

220 '*those who are interested in this colony ... his support and assistance towards it*'. Brown, 1890, vol. 2, p. 554.

221 *Henrico ... 'much better and of more worth than all the work ever since the colony began*'. Wilson, 1946, p. 119.

221 *Henry's 'royal heart was ever strongly affected to that action*'. Hamor, 1615, sig. E3; Land, 1938, pp. 453–98, for a discussion of the college more generally.

222 '*discourage them not in growing religious nor in gathering riches*'. Johnson, 1612.

222 '*unpathed waters, undreamed shores*'. *The Winter's Tale*, IV, 4, line 572.

223 *Henry asked Robert Sidney, Viscount Lisle ... slip through his fingers*. HMC De L'Isle, vol. 4, p. 239.

Chapter 30: Selling Henry to the Highest Bidder

224 '*The god of money ... has stolen Love's ensigns*'. Ben Jonson, *Love Restored*, 1612. Quotations from Jonson, 1969, p. 193ff, and comment on it draws on Parry, 1993, pp. 87–117.

224 '*why should the heir of England be sold?*' ... *a powerful tool of foreign policy*. HMC Portland, vol. 9, pp. 41–5.

225 *doubling the huge dowry offered by Tuscany*. ASF Misc. 293, inserto 28, n21.

225 '*Rome shall reap thereby great honour*' ... *Anne and the other court Catholics*. HMC Portland, vol. 9, pp. 41–5.

226 '*does not show many signs of stirring himself ... defer to the judgement of his father*'. TNA PRO 31/3/45; BL Harley MS 6986, f103.

228 '*I would advise the Prince to keep his own ground ... some terrible tempest*'. Ralegh, 1829, vol. 8, p. 250.

229 '*resolved that two religions should never lie in his bed*' ... *Protestant for most of his life*. BL Stowe MS 172, f284; BL Harley MS 7002, ff149–51.

229 *Ambassador Lotti remained buoyant ... before Henry could give his decision*. ASF Misc. 293, inserto 29, n10; Strong, 1986, p. 72.

230 *Lord Roos ... No one knew Henry's heart better than David Murray*. Birch, 1760, p. 321.

230 *Signor Cioli had had enough ... 'I am in a state of such mental confusion*'. Strong, 1986, pp. 72–3; ASF Misc. 293, inserto 28, n20 and 38, my translation.

Chapter 31: A Model Army

231 *Maurice introduced one of his own engineers, Captain Abraham van Nyevelt.* BL Harley MS 7008, f112; pension in Harley MS 7009, f1–2.

231 *Palma, 'the finest in the world as far as fortification goes'.* CSPV, vol. 12, p. 194.

231 *He commissioned Van Nyevelt to make 'patterns' for England's new fortifications.* TNA E 351/2794: AO 1/2021, No. 2.

232 *'the very practise of everything either defensive or offensive' ... a huge sum.* CSPD, 1611–12, p. 53; Dalton, 1885, pp. 234–6; Edward Helwis to Henry, BL Harley MS 7009, f10.

232 *Crates and crates of models arrived ... '2 carriages for mortar pieces; one sledge'.* After Charles I's execution, the sale of the contents of St James's included this model army: Millar, 1972, pp. 153–4.

232 *'battles of Head-men ... sent to him from all Countries'.* Account, p. 26.

233 *'Ordained to make thy eight great Henries nine ... his Fame shall strike the Starres'.* Drayton, 1612.

233 *Henry, in profile, dressed as a Roman general.* Williamson, 1978: p. 67; *Henry, Prince of Wales, in Profile*, Isaac Oliver (1611–12) in MacLeod, 2012, p. 117.

233 *he was painted ... with an army camp in the background.* RCIN 420058, Isaac Oliver, *Henry, Prince of Wales* in MacLeod, 2012, p. 102.

233 *'he had the most unserviceable tongue of any man living' ... to concentrate for hours.* Discourse, p. 263; Bacon, 1868, vol. 6, pp. 328–9.

234 *His master had 'a close disposition, not easy to be known or pried into'.* Account, 1751, p. 51.

234 *'His forehead bore marks of severity' ... at this stage of his life.* Bacon, 1868, vol. 6, p. 327.

Chapter 32: End of an Era

235 *'my audit is made' – appropriately for a Lord Treasurer.* Croft, 1991b, p. 794.

236 *Some of Pembroke's clients built up the Herbert–Pembroke.* Petyt MS 538, vol. 36, fol. 81v.

236 *'If I might advise, I would you could rather devise how to grow in with the Prince'.* Chamberlain, 1939, vol. 1, pp. 352, 357, 359.

236 *Rochester wanted to be seen as building bridges ... he craved old Salisbury's offices more.* Barroll, 2001, p. 134; Chamberlain, 1939, vol. 1, pp. 359–60.

237 *'As matters go here now ... not leave one of that family to piss against the wall'.* Birch, 1760, p. 256; Osborne, 1811.

Chapter 33: Wedding Parties

238 *Henry called in his servant ... Thomas Campion.* Parry, 1993, pp. 101–2.

238 *'Let the British strength ... God the helper will be at their side'.* Strong, 2000, p. 137; Winwood, 1725, vol. 3, pp. 403–4. Ironically, Elizabeth's German descendants made her this 'mother of kings' by ousting her own brother's Stuart heirs to establish the Hanoverian dynasty.

238 *George Chapman created a second show, the* Memorable Masque. Chapman, 1613, passim; Strong, 2000, pp. 132–3; Marshall, 1998, ch. 3.

239 *Informally called the* Masque of Truth *... when the Spanish ambassador received his wedding invitation, he refused it.* Jocquet, 1613, passim; Norbrook, 1986, pp. 81–109; Parry, 1993, pp. 103, 105–6; Strong, 2000, pp. 135–7. In 1613, Elizabeth and Frederick carried the text of the *Masque of Truth* back to Heidelberg and there published it in French.

240 *'excessive in continuance ... in the water for some hours together'.* WH, p. 33.

240 *He posted sixty miles in nine hours ... in the middle of a heatwave.* BL Add MSS 30075, B6v–B7v; Wilson, 1946, pp. 122–3.

241 *'like to a Princely Bridegroom ... and Greatness thereof.* BL Add MSS 30075, sigs B7v–B8v.

241 *James complimented ... 'he could never do so much in his own house'.* WH, p. 9.

242 *Henry shrugged ... they teased him 'with one jest or other'.* Birch, 1760, pp. 471–2.

242 *They want to know ... 'my marriage with the second daughter of France'.* BL Stowe MS 172, f284v.

242 *Henry took his time, as always, then replied.* Henry's words all from BL Harley MS 6986, f103.

243 *'My master' sought to heal ... 'a sure haven to the distressed Church abroad'.* HMC Portland, vol. 9, pp. 8–11.

244 *The Palatine wedding party ... '"I take pleasure in nothing"'.* Birch, 1760, p. 472ff. Birch's narrative draws on WH, and Cornwallis's *Account* and *Discourse*.

Chapter 34: Henry Loses Time

245 *Charles came to Whitehall Stairs ... Henry sitting ... in front of the arms of Britain.* HMC Downshire, vol. 3, pp. 391–2.

245 *Henry remained seated ... a good impression on everyone, except the queen.* Winwood, 1725, vol. 3, pp. 403–4; Birch, 1760, p. 466.

246 *'He seems to take delight in nothing but her company and conversation'.* Chamberlain, 1939, vol. 1, pp. 383–4.

246 *'As though his body had been of brass,' he played ... as they fought to win.* Birch, 1760, p. 473; *Account*, p. 30.

246 *Wilkinson took Job 14:5 as his text.* Wilkinson, 1614, p. 21.

247 *At around 3 p.m. ... a spasm of 'sudden sickness and faintness of the heart'.* From here to the end of Henry's life, the narrative draws on Birch, 1760, p. 475ff, and *Account*, p. 30ff; *Discourse*, except where cited below.

248 *'a deserved punishment ... for having ever opened his ears to admit treaty of a Popish match'.* HMC Buccleuch, 1899, vol. 1, p. 118.

249 *Desperate, Princess Elizabeth ... she was sent home in distress.* Chamberlain, 1939, vol. 1, p. 390; Oman, 2000, p. 66.

251 *Henry 'was not able to say anything' ... perhaps an attempt to protect his followers.* Chamberlain, 1939, vol. 1, p. 391.

251 *'Where is my dear sister?' he whispered.* Chamberlain, 1939, vol. 1, p. 390.

252 *Out 'of mere pity', Death suddenly 'thrust the dart quite through ... and Restorer'.* Account, pp. 43–4.

Chapter 35: Unravelling

253 *no sign 'of poison appeared ... over-violent exercise at tennis and over-eating of grapes'.* HMC Downshire, vol. 3, p. 419.

253 *'quite consistent with variegate porphyria',* which famously afflicted his family, including, very likely, his father James, and certainly his sister Elizabeth's great-great grandson, George III, see Rushton, 2008, p. 63.

254 *On Monday, he rode to 'Sir Walter Cope's ... but again in Theobalds'.* HMC Downshire, vol. 3, pp. 419–20.

254 *'But Henry is dead! Henry is dead!'* CSPV, vol. 12, pp. 449, 469, 521, and passim.

254 *'The news of the death of the Prince of Wales has stunned us all ... others rejoice at such news'.* Buwinckhausen to Trumbull, HMC Downshire, vol. 3, pp. 415–17.

254 *'there could scarce anything have happened whereat these people would have grieved less'.* HMC Downshire, vol. 3, p. 432.

254 *James encouraged the elector to stay ... could encourage her to talk to him.* HMC Downshire, vol. 3, p. 420.

255 *Sir John Holles 'attended my dear master's bowels to the grave' ... was agony.* HMC Portland, vol. 9, pp. 35–6.

255 *Silence fell on the prince's vibrant, busy household ... the first time in history a crown prince had earned this honour.* Woodward, 1997, p. 149.

256 *Henry's death 'came so sudden ... in the likeliest of human beings'.* BL Harley MS 7004, f68.

257 *Daniel Price's sermon to 'that Princely family ... rusts, good spirits'.* Price, 1613, pp. 3, 24–5; McCullough, 1998, p. 193.

257 *'not compatible with the safety of the King and State ... drowse out the sorrow for his lost child'.* HMC Portland, vol. 9, p. 11.

257 *'A young fellow came stark naked to St James's ... spoken with the King'.* HMC Downshire, vol. 3, p. 414.

258 *Ralegh had been busy writing a* History of the World *for the prince.* Quotations from Ralegh are in Ralegh, 1829, vol. 7, chapters 4–6.

Chapter 36: Endgame

260 *the prince, just 'as he went in life'. He was a waxwork over a wooden frame.* Details of the funeral are drawn from Birch, 1760, p. 475ff; *Account*, p. 30ff; *Discourse*, passim, except where cited.

262 *confident 'each would be readmitted to his old post'.* CSPV, vol. 12, p. 453.

262 *The king simply turned most of them out 'to seek their fortune elsewhere'.* Chamberlain, 1939, vol. 1, p. 405.

262 *Charles 'interceded earnestly' for Murray ... 'seducing his late master to their schism'.* BL Add MS 32464f.

262 *the king readmitted the Puritan court divine, Henry Burton.* NA SP 14/139 f144. Burton might have got back in because Charles's guardian, Carey, patronised Burton. I would like to thank Professor John Adamson for bringing this letter to my attention. For the destiny of Burton and Prynne, see Adamson, 2007, p. 115.

264 *Richard Stock, the godly minister of All Hallows ... linked Harington and Prince Henry.* Stock, 1614, passim.

264 *John Donne lamented 'thou dids't intrude on death, usurps't a grave' before time.* Donne, 'Obsequies on the Lord Harington' (London, 1614).

265 *The monarchy betrayed what Henry's political heirs believed both they and their prince stood for.* Scott, 2014, pp. 102–3; Adamson, 2007, more generally, for his account of the English noblemen, who challenged Charles I's movement towards absolute, authoritarian monarchy.

265 '*The stage stands, the actors alter ... revolutions in Christendom*'. Fuller, 1655, quoted in Werner, 1996, p. 132.

BIBLIOGRAPHY

Manuscript Sources

Archivio di Stato, Florence
ASF Misc. 293, 4189 – letters to marriage negotiations for Henry and
Caterina de' Medici.

Bodleian – Bodleian Library, Oxford
Bodleian MS Carte 74: Misc. Jacobean correspondence; Bodleian Tanner
MS 94 for plans to expand and make the courtly college more
permanent.

British Library, London
BL Add MS 25348; BL Add MS 34324: Papers of Sir Julius Caesar; BL Add
MS 39853: Papers of Sir Charles Cornwallis, including orders for
Henry's household; BL Add MSS 5750: Royal Warrants, C16–17; BL
Add MS 34218: 'An account of the lord treasurer's last sickness', Bowle,
J., fols 125–7; BL Add MSS 11406, 36767; BL, MSS, Add MSS 5664,
6177, 5503; BL Cotton MSS, map of Virginia and correspondence; BL
Egerton MS 3512 *Spem in Allium numquam Habui*; BL Egerton MS
3876: Cornwallis, 'Short Remembrance to Prince Henry'; BL Harley
MSS 6986, 7002, 7004, 7007, 7008, 7009, correspondence between
Henry and others; BL Lansdowne MSS 90, 91; BL Royal 18. C.xxiii. f7r,
'A Demonstration of divers parts of Warre, especially of the Discipline
of Cavalleria by Sir Edward Cecil'; BL Royal MS 17 B XXXII, Captain
Waymouth's account of the Jülich-Cleves campaign for Henry; BL
Sloane MSS, vols 2063, 2066 for Sir Theodore Mayerne; BL Stowe MSS,
correspondence.

Lambeth Palace Library, London
LPL MSS, various correspondence to 1603; MSS 652, 655, 656, 659 –
correspondence between the Earl of Mar and Essex up to 1601.

The National Archives, Kew
E351/3206: Paymaster of the King's Works, Accounts; E351/541–44:
Treasurer of the Chamber, Accounts, Exchequer Orders, etc., 1557–
1627; LC2/4/6: Funeral of Prince Henry, Declared Accounts; SP 14:
Domestic State Papers, James I.

Trinity College Library, Cambridge
TC MS 720 – Connock's report for Henry; Wren TC MS II; MS R.7.23*
Adam Newton's archive.

Printed and Reprinted Primary and Contemporary Sources
*Accounts of the Masters of Works for Building and Repairing Royal Palaces
and Castles*, Henry Paton, John M. Imrie, and John G. Dunbar (eds), 2
vols (Edinburgh, 1957; 1982)
A Collection of the Names of all the Princes of this Kingdom of England
(London, 1747)
*A Publicke Declaration, made by the United Protestant Princes Electors and
other Princes, States and Lords of the Holie Empire ... to Aide and Assist
the Princes Electors of Brandenburg and the Palsgrave* (London, 1610)
Alexander, Sir William, 'A Paranaesis to the Prince', *Aurora* (London, 1604)
Ashton, Robert (ed.), *James I by his Contemporaries* (London, 1969)
Bacon, Sir Francis, *The Letters and Life of Francis Bacon*, 7 vols, edited by
James Spedding (London, 1861–74), especially 'The Praise of Henry,
Prince of Wales', vol. 6 (London, 1861), p. 327ff
Balfour, Sir James, *Letters and State Papers during the Reign of James VI ...
from the MS Collections of Sir James Balfour of Denmyln*, edited by
Adam Adamson (Edinburgh, 1838)
Birch, Thomas, *The Life of Henry, Prince of Wales, Eldest Son of King James I*
(London, 1760)
—— *The Court and Times of James I*, 2 vols (London, 1848)
*Bishop Hacket's Memoirs of the Life of Archbishop Williams, Lord Keeper of
the Great Seal of England, abridg'd, With the Most Remarkable
Occurrences and Transactions in Church and State* (London, 1715)
Boderie, Antoine le Fèvre de la, *Ambassades de Monsieur de la Boderie en
Angleterre (1606–1611)* (Paris, 1750)

Broughton, Hugh, *An Exposition upon the Lord's Prayer ... in a Sermon, at Oatelands: before ... Henry Prince of Wales* (n.d., 1603?)

Brown, Rawdon (ed.), *Calendar of State Papers, Venice*, 38 vols (London, 1864–1947)

Buchanan, George, *George Buchanan: The Political Poetry*, edited and trans. by Paul J. McGinnis and Arthur Williamson (Edinburgh, 1995)

Button, Sir Thomas, 'Voyage of Sir Thomas Button', in *Narrative of Voyages Towards the Northwest in Search of a Passage to Cathay and India*, edited by Thomas Rundall (London, 1849)

Calderwood, David, *The History of the Kirk of Scotland* (Edinburgh, 1844)

Calendar of State Papers, Scotland, 13 vols, various editors (London, 1898–1969)

Camden, William, *The Annals of Mr. W. Camden, in the Reign of King James I. Viz. From the year 1603, to the year 1623, Done into English from Camden's 'Regni Regis Jacobi I. Annalium Apparatus', first published in 'V. cl. Gulielmi Camdeni ... Epistolæ'* (London, 1706)

Carier, Benjamin, *A Sermon Preached Before the Prince* (London, 1606)

Carleton, Sir Dudley, *Dudley Carleton to John Chamberlain, 1603–1624: Jacobean Letters*, edited by Maurice Lee (New Brunswick, 1972)

Cecil, Robert, *An Answere to Certaine Scandalous Papers, Scattered Abroad* (London, 1606)

Chamberlain, John, *The Letters of John Chamberlain*, 2 vols, edited by N. E. McClure (Philadelphia, 1939)

Chapman, George, *The Memorable Masque of the Two Honourable Houses, or Inns of Court, the Middle Temple and Lincoln's Inn*, 15 February 1613

—— *The Plays and Poems of George Chapman*, edited by Thomas Mark Parrott (London, vol. 1: 1910, vol. 2: 1914)

Charles I, *Letters to James I*, edited by Philip, Earl of Hardwicke (London, 1778)

Cleland, James, *The Institution of a Young Noble Man* (London, 1607; New York, 1948 facs repro, 1948)

Coke, Roger, *A Detection of the Court and State of England during The Four Last Reigns and the Inter-Regnum ...* (London, 1694)

Connock, Richard, *A Collection of the Names of all the Princes of this Kingdom of England* (London, 1747)

Cornwallis, Sir Charles, *An Account of the Baptism, Life, Death and Funeral of the most incomparable Prince, Frederick Henry, Prince of Wales ...* (London, 1751). Also BL Add MS 30075, John Hawkins, 'Know then:

that, the Kings Majesty and the Quene …'; BL Add MS 11532, copy of Add MS 30075.

—— *The Life and Death of our most incomparable and heroic Prince Henry, Prince of Wales … Written by Sir Charles Cornwallis, Treasurer of His Highness's Household* (1641). (This is a reprint of BL Add MS 30075. Roy Strong concludes there is no reason to doubt the author was in fact John Hawkins. It was reprinted again in 1751 as *An Account of the Baptism, Life, Death and Funeral of the most incomparable Prince, Frederick Henry, Prince of Wales, by Sir Charles Cornwallis, knight, his highness's treasurer …* (London 1751).

—— *A Discourse of the Most Illustrious Prince Henry, late Prince of Wales. Written Anno 1626 by Sir Charles Cornwallis, Knight, sometime Treasurer of his Highness's House* (London, 1641). (As opposed to the *Account*, internal and external evidence suggests this is Cornwallis's own version of his late master's life. There is a manuscript version in the papers of Cornwallis's son, BL Add MS 39853, ff26–29.

—— 'A Relation of the Marriages that should have been made between the Prince of England and the Infanta Major, and also after with the younger Infanta of Spain', *Harleian Miscellany*, VIII (London, 1746)

Coryate, Thomas, *Coryats crudities hastily gobled vp in five moneths trauells in France, Sauoy, Italy, Rhetia co[m]monly called the Grisons country, Heluetia aliàs Switzerland …* (London, 1611)

—— *Coryats Crambe, or his Colwort twise sodden, and now serued in with other Macaronicke dishes, as the second course to his Crudities* (London, 1611a)

—— *Odcombian Banquet Dished Foorth by Thomas the Coriat, and Served in by a number of Noble Wits* (London, 1611)

—— *Coryats Crudities 1611* (facs edn, London, 1978)

Cotton, Sir Robert, *Warrs with Forregin Princes Dangerous to our Common-Wealth: Or, Reasons for Forreign Wars Answered* (London, 1657)

Crashaw, William, *Sermon preached at the Crosse … 1607* (London, 1609)

Dallington, Sir Robert, *Aphorismes Civill and Militaire … Guicciatine* (London, 1613)

Daniel, Samuel, *The order and solemnitie of the creation of the high and mightie Prince Henrie … Whereunto is annexed the Royall Maske, presented by the Queene and her Ladies, on Wednesday at night following* (London, 1610)

Drayton, Michael, *Poly-Olbion* (1612)

—— *The Works of Michael Drayton*, edited by J. W. Hebel (Oxford, 1931)

Edmondes, Clement, *Observations upon the First Five Books of Caesar's Commentaries* (London, 1609)

Fennor, William, *Fennors Descriptions, or A True Relation of Certaine and Divers Speeches, Spoken before the King and Queenes Most Excellent Majestie, the Prince his Highnesse, and the Lady Elizabeth's Grace* (London, 1616)

Forman, Simon, *The Autobiography and Personal Diary of Dr Simon Forman, The Celebrated Astrologer*, edited by J. O. Halliwell (London, 1849)

Fowler, William, *A True Reportarie of the most triumphante ... baptisme of Frederick Henry: Prince of Scotland by William Fowler* (Edinburgh, 1594)

The French Herald Summoning All True Christian Princes to a General Croisade, for a Holy War Against the Great Enemy of Christendome, and All His Slaves (London, 1611)

Fuller, Thomas, *The Church-History of Britain* (London, 1655)

—— 'Somersetshire: Memorable Persons', in *The History of the Worthies of England* (London, 1662)

Gheyn, Jacob de, *The exercise of armes for caliures, muskettes, and pikes after the ordre of his Excellence. Maurits Prince of Orange Counte of Nassau etc., Sett forthe in figures, by Iacob de Gheyn* (Amsterdam, 1608)

Goodman, Godfrey, *The Court of King James the First*, edited by John S. Brewer, 2 vols (London, 1839)

Gorges, Sir Arthur, 'A breefer Discourse tending to the wealth and strength of this kingdome, of Great Brittayne' (London, 1610)

—— *A true transcript and Publication of his Majesties Letters Patent. For and Office to bee erected and called the Publicke Register for Generall Commerce. Wherein is annexed and Overture and explanation of the said office ... by Sir Arthur Gorges, Knight* (London 1612, 2nd edn)

Green, M. A. E. (ed.), *Calendar of State Papers, Domestic, 1547–1625*, 12 vols (London, 1856–72)

Hall, Joseph, *A Selection from the Writings of Joseph Hall, D. D. sometime chaplain to King James the First ... with his own hand*, edited by A. Huntington Clapp (Andover; New York, 1845)

Hamilton, H. C., et al. (eds), *Calendar of State Papers, Ireland*, 24 vols (London, 1860–1912)

Hamor, Ralph, *A True Discourse of the Present Estate of Virginia* (1615)

Harington, Sir John, *The Letters and Epigrams of Sir John Harington*, edited by N. E. McClure (Philadelphia, 1939)

—— *Nugae Antiquae*, 3 vols (London, 1792)

Harrison, Stephen, *The Archs of Triumph Erected in Honour of the High and Mighty Prince* (London, 1604)

Haydon, William, deduced to be W. H., *The True Picture and Relation of Prince Henry his Noble and Vertuous Disposition, Containing Certaine Observations and Proofes of his Towardly and Notable Inclination to Vertue, of the Pregnancie of his Wit, Farre above his Age, Comprehended in Sundry of his Witty and Pleasant Speeches* (Leyden, 1634)

Hayward, John, *The Lives of the III, Normans, Kings of England* (London, 1613)

Herford, C. H., Simpson, Percy, and Simpson, Evelyn (eds), *Ben Jonson*, 8 vols (Oxford, 1941)

HMC Buccleuch, *Manuscripts of the Duke of Buccleuch and Queensberry … at Montagu House, Whitehall*, 3 vols (London, 1889)

HMC De L'Isle, *Manuscripts of … Viscount De L'Isle … at Penshurt Place*, 6 vols (London, 1925–66)

HMC Downshire, *Manuscripts of the Marquess of Downshire … at Easthampstead Park*, 6 vols (London, 1924–95)

HMC Mar and Kellie, *Manuscripts of the Earl of Mar and Kellie … at Alloa House*, edited by Henry Paton (1904)

HMC Portland, *Manuscripts of his grace the Duke of Portland … at Welbeck Abbey*, 10 vols (1891–1931)

HMC Report, *Report on Manuscripts in Various Collections*, 3 vols (1903–04)

HMC Salisbury, *Manuscripts of the … Marquess of Salisbury preserved at Hatfield House*, 24 vols (1883–1976)

James, VI of Scotland, *The True Lawe of Free Monarchies: or, The Reciprock and Mutuall Dutie betweixt a free King and his Naturall Subjects* (Edinburgh, 1598)

—— *Basilikon Doron, or His Majesties Instrvctions to His Dearest Sonne, Henry the Prince* (Edinburgh, 1599; www.stoics.com/basilikon_doron.html)

James, VI of Scotland, and I of England, *The King's Maiesties Speech, as it was delivered by him in the upper house of the Parliament, to the Lords Spirituall and Temporall, and to the Kinghtes, Citizens and Burgesses there assembled, on Munday the 19 day of March 1603* (London, 1604)

—— *His Majesties Speech in this last Session of Parliament, as neere his very words as could be gathered … the examination of some of the prisoners* (London, 1605)

—— *Basilikon Doron of King James VI*, 3rd series, 2 vols, edited by J. Craigie (Edinburgh, 1944–50)

—— *Minor Prose Works of King James VI*, 4th series, edited by J. Craigie (Edinburgh, 1982)

—— *Letters of King James VI and I*, introduction and edited by G. P. V. Akrigg (London, 1984)

—— *King James VI and I: Political Writings*, edited by Johann P. Sommerville (Cambridge, 1994)

—— *King James VI and I: Selected Writings*, edited by Neil Rhodes, Jennifer Richards, and Joseph Marshall (Ashgate, 2003)

Jocquet, D., *Les Triomphes, Entrees, Cartels, Tournois, Ceremonies, et autres Magnificences, faites en Angleterres* … (Heidelberg, 1613)

Johnson, Robert, *Nova Britannia* … (London, 1609)

—— *The New Life of Virginia* (London, 1612)

Jonson, Ben, *Catiline* (London, 1611; 1972)

—— *The Complete Masques*, edited by Stephen Orgel (Yale, 1969)

The King of Denmarkes Welcome: Containing His Arrivall, Abode, and Entertainement, Both in the Citie and Other Places (London, 1606)

Lescarbot, Marc, *Nova Francia: or the Description of that Part of New France, which is One Continent with Virginia* (London, 1609)

The Life and Death of Our Late and Most Incomparable and Heroic Prince Henry, Prince of Wales, 1613 (London, 1641)

Marcelline, George, *The Triumphs of King James the First* (London, 1610)

Markham, Gervase, *Countrye Contentments of the English Huswife* (London, 1615)

Mayerne, Sir Theodore, 'The True Account of the Illness, Death and Opening of the Body of the Most High and Most Illustrious Henry, Prince of Wales, deceased, at St James's in London, the 6th of November, 1612', in J. Browne (ed.), *Opera Medica* (London, 1701)

Melville, James, *The Autobiography and Diary of Mr James Melville*, edited by Robert Pitcairn (Edinburgh, 1842)

Moysie, David, *Memoirs of the Affairs of Scotland*, edited by James Dennistoun (Edinburgh, 1830)

Nichols, John, *A Collection of Ordnances and Regulations for the Government of the Royal Household, made in divers Reigns … also, Receipts in Ancient Cookery* (London: Society of Antiquaries, 1790)

—— *The Progresses, Processions, and Magnificent Festivities, of King James the First, His Royal Consort, Family and Court*, 4 vols (London, 1828)

The Order and Solemnitie of the Creation of the High and Mightie Prince Henrie, Eldest Sonne to our Sacred Sovereigne ... Whereunto is Annexed the Royall Masque Presented by the Queene and her Ladies on Wednesday at Night Following, Printed at Britaines Bursse for John Budge (London, 1610)

Osborne, Francis, *Secret History of the Court of James the First* (Edinburgh, 1811)

Pett, Phineas, *The Autobiography of Phineas Pett*, edited by W. G. Perrin (London, 1918)

Price, Daniel, *Praelium and Praemium* (Oxford, 1608)

—— *Recusants Conversion: A Sermon ... before the Prince* (Oxford, 1608)

—— *The Spring: A Sermon Preached before the Prince* (1609)

—— *The Creation of the Prince* (London, 1610), sig. D2r

—— *The Defence of Truth* (Oxford, 1610)

—— *Lamentations for the Death of the Late Illustrious Prince Henry* (Oxford, 1613)

—— *Prince Henry His First Anniversary* (Oxford, 1613)

—— *Spiritual Odours to the Memory of Prince Henry* (Oxford, 1613)

—— *Two Sermons Preached in His Highnesse Chappell at Saint IAMES* (1613)

Ralegh, Sir Walter, *The Works of Sir Walter Ralegh, Kt., Political, Commercial and Philosophical; Together with his Letters and Poems*, edited by Thomas Birch, 2 vols (London, 1751)

—— *The Works of Sir Walter Ralegh, Kt., Now First Collected ... Oldys and Birch*, 8 vols (Oxford, 1829)

Riche, Barnaby, *The Fruites of long Experience. A pleasing view for Peace. A Looking-Glasse for Warre. Or, Call it what you list. Discoursed betweene two Captaines* (London, 1604)

—— *Faultes, Faultes, and Nothing Else But Faultes* (London, 1606)

Richer, Edmond, *A Treatise of Ecclesiasticall and Politike Power* (London, 1612)

Rhodes, Neil, Richards, Jennifer, and Marshall, Joseph (eds), *King James VI and I: Selected Writings* (Aldershot, 2003)

RPC Scotland, *The Register of the Privy Council Scotland*, 1st series, 14 vols (Edinburgh, 1877–98)

Somers, John, *A Collection of Scarce and Valuable Tracts ... Second edition, Revised, Augmented and Arranged by Walter Scott*, 13 vols (Edinburgh, 1809–15)

Sommerville, Johann P., *Political Writings* (Cambridge, 1994)

Speed, John, *The Theatre of the Empire of Great Britaine ... divided and described by John Speed* (London, 1627)

Spottiswoode, John, *History of the Church of Scotland* (Edinburgh, 1847)

Stock, Richard, *The Churches Lamentation for the Losse of the Godly* (London, 1614)

Stow, John, *Annales of England ...* (London, 1631)

Strachey, William, *The History of Travaile into Virginia Britannia*, 1609 edited by R. H. Major (London, 1849; Cambridge, 2010)

Sully, Maximilian de Bethune, duc de, *Memoirs*, 5 vols (Edinburgh, 1805)

Symonds, William, *Virginia: A Sermon Preached at White-Chappel, in the Presence of Many Honourable and Worshipfull, the Aduenturers and Planters for Virginia, 25 April 1609* (London, 1609)

Tillières, Comte Leveneur de, *Mémoires*, edited by M. C. Hippeau (Paris, 1863)

Webster, John, 'A Monumental Columne' (1612), in F. L. Lucas (ed.), *The Complete Works of John Webster* (London, 1927)

Weldon, Sir Anthony, *The Court and Character of King James Written and Taken by Sir A: W Being an Eye, and Eare Witnesse* (London, 1650)

Wilkinson, Robert, *A Pair of Sermons Successively Preached to a Pair of Peerless and Succeeding Princes ...* (London, 1614)

Wilson, Arthur, *The History of Great Britain, Being the Life and Reign of King James the First ...* (London, 1653)

Winwood, Sir Ralph, *Memorials of Affairs of State ... Collected from the Original Papers of the Right Honourable Sir Ralph Winwood*, edited by Edmund Sawyer, 3 vols (London, 1725)

Wotton, Sir Henry, *The Life and Letters of Sir Henry Wotton*, 2 vols, edited by Logan Pearsall Smith (Oxford, 1907)

Secondary Sources

Adamson, John, *The Princely Courts of Europe, 1500–1750* (London, 1999)

—— *The Noble Revolt: The Overthrow of Charles I* (London, 2007)

Akrigg, G. P. V., *The Jacobean Pageant, or, The Court of King James I* (London, 1962)

—— (intro. and ed.), *Letters of King James VI & I* (London, 1984)

Anderson, Alison Deborah, *On the Verge of War: International Relations and the Jülich-Kleve Succession Crises (1609–1614)* (Brill, 1999)

Appleby, John C., 'War, Politics and Colonization', in *The Origins of Empire ...* (Oxford, 1998), pp. 55–78

Armstrong, Catherine, *Writing North America in the Seventeenth Century: English Representations in Print and Manuscript* (Aldershot, 2007)

Badenhausen, R., 'Disarming the infant warrior: Prince Henry, King James, and the chivalric revival', *Papers on Language and Literature*, 31/1 (Spring, 1995), pp. 20–37

Barroll, J. L., 'The Court of the First Stuart Queen', in Linda Levy Peck (ed.), *The Mental World of the Jacobean Court* (Cambridge, 1991)

—— *Anna of Denmark, Queen of England: A Cultural Biography* (Philadelphia, 2001)

Beer, A. R., '"Left to the world without a maister": Sir Walter Ralegh's The history of the world as a public text', *Studies in Philology*, 91/4 (Autumn, 1994), pp. 432–63

Bellamy, Alastair, 'A Poem on the Archbishop's Hearse: Puritanism, Libel and Sedition after the Hampton Court Conference', *Journal of British Studies* 34 (April, 1995)

Bevington, David, and Holbrook, Peter (eds), *The Politics of the Stuart Court Masque* (Cambridge, 1998)

Bracken, Susan, 'Robert Cecil as art collector', in Pauline Croft (ed.), *Patronage, Culture and Power: the Early Cecils* (New Haven, 2002), pp. 121–37

Bray, W., 'An Account of the revenue, the expenses, the jewels, etc., of Prince Henry', *Archeologica*, XV (1806), pp. 18–20

Brooke, Christopher, 'Fleetwood, William (*c.*1525–1594)', http://www. oxforddnb.com/view/article/9690

—— *Philosophic Pride: Stoicism and Political Thought from Lipsius to Rousseau* (Princeton, 2012)

Brown, Alexander, *The Genesis of the United States*, 2 vols (London, 1890)

Buchtel, John A., 'Book Dedications in Early Modern England: Francis Bacon, George Chapman, and the Literary Patronage of Henry, Prince of Wales', unpublished PhD dissertation, University of Virginia, 2004

Butler, Martin, 'The Early Stuart Masque', in Malcolm Smuts (ed.), *The Stuart Court and Europe* (Cambridge, 1996), pp. 65–85

—— 'Courtly Negotiations', in Bevington and Holbrook (eds), *The Politics of the Stuart Court Masque* (Cambridge, 1998), pp. 20–40

—— *The Stuart Court Masque and Political Culture* (Cambridge, 2008)

Calendar of the Manuscripts of the Most Hon. the Marquis of Salisbury, 24 vols (London, 1883–1976)

Canny, Nicholas (ed.), *The Origins of Empire: British Overseas Enterprise to the Close of the Seventeenth Century*; Vol. 1 of William Roger Louis

(editor-in-chief), *The Oxford History of the British Empire* (Oxford, 1998)

—— 'England's New World and the Old, 1480s–1630s', in *The Oxford History of the British Empire: Volume I: Origins of Empire* (Oxford, 1998), pp. 148–69

Chambers, E. K., *The Elizabethan Stage*, 4 vols (Oxford, 1923)

Chaney, Edward, and Wilks, Timothy, *The Jacobean Grand Tour: Early Stuart Travellers in Europe* (London, 2014)

Cogswell, Thomas, Cust, Richard, and Lake, Peter (eds), *Politics, Religion and Popularity in Early Stuart Britain: Essays in Honour of Conrad Russell* (Cambridge, 2002)

Collinson, Patrick, 'The Jacobean Religious Settlement: The Hampton Court Conference', in Howard Tomlinson (ed.), *Before the Civil War: Essays on Early Stuart Politics and Government* (London, 1983)

Colvin et al. (eds), *History of the Kings Works*, vols 3 and 4 (London, 1975; 1982)

Craig, Jennifer J., 'New Riddles from the Sphinx: A Dialogue of Emblems in Ben Jonson's Masque *Love Freed from Ignorance and Folly* (1611)', in Simon McKeown (ed.), *The International Emblem: From Incunabula to the Internet* (Cambridge, 2010), pp. 400–11

Croft, Pauline, 'A Collection of several Speeches and Treatises of the later Lord Treasurer Cecil', *Camden Miscellany*, 29 (1987), pp. 273–317

—— 'The reputation of Robert Cecil: libels, political opinion and popular awareness in the early seventeenth century', *Transactions of the Royal Historical Society*, 6th ser., Vol 1 (1991a), pp. 43–69

—— 'The religion of Robert Cecil', *Historical Journal*, 34 (1991b), pp. 773–96

—— 'Robert Cecil and the Early Jacobean Court', in Linda Levy Peck (ed.), *The Mental World of the Jacobean Court* (Cambridge, 1991)

—— 'The parliamentary installation of Henry, prince of Wales', *Institute of Historical Research*, 65 (June, 1992), pp. 177–93

—— (ed.), *Patronage, Culture and Power: the Early Cecils* (New Haven, 2002)

—— *James VI* (Palgrave, 2003)

Curran, Kevin, *Marriage, Performance and Politics at the Jacobean Court* (Aldershot, 2009)

Dalton, Charles, *Life and Times of General Sir Edward Cecil, Viscount Wimbledon, Colonel of an English Regiment in the Dutch Service, 1605–1631, and One of His Majesty's Most Honourable Privy Council, 1628–1638* (London, 1885)

Darby, Graham, *The Thirty Years' War* (London, 2001)

Dobson, David, *Scottish Emigrants to Colonial America, 1607–1785* (Georgia, 1994)

Edwards, Francis, Fr., S.J., *The Gunpowder Plot: the Narrative of Oswald Tesimond, alias Greenway. Translated from the Italian of the Stonyhurst manuscript, edited and annotated by Francis Edwards* (London, 1973)

Foster, Elizabeth Read (ed.), *Proceedings in Parliament, 1610*, vol. 1: House of Lords (New Haven, 1966)

—— *Proceedings in Parliament, 1610*, vol. 2: House of Commons (New Haven, 1966)

Gajda, Alexandra, *The Earl of Essex and Late Elizabethan Political Culture* (Oxford, 2012)

Gardiner, Samuel Rawson, *Parliamentary Debates in 1610, edited, from the Notes of a Member of the House of Commons* (London, 1862)

—— *History of England from the Accession of James I to the Outbreak of Civil War, 1603–1642*, 10 vols (London, 1883)

Godfrey, Elizabeth, *Home Life Under the Stuarts, 1603–1649* (London, 1925)

Goodare, J., and Lynch, M. (eds), *The Reign of James VI* (London, 2000)

Gossett, S., 'A New History for Ralegh's Notes on the Navy', *Modern Philology*, vol. 85, no. 1 (1987), pp. 12–26

Gregg, Pauline, *King Charles I* (London, 1981)

Gristwood, Sarah, *Arbella, England's Lost Queen* (Bantam, 2004)

Guy, John, 'Tudor Monarchy and Political Culture', in John Morrill (ed.), *The Oxford Illustrated History of Tudor and Stuart Britain* (Oxford, 1996)

Halliwell, James Orchard (ed.), *The Autobiography and Correspondence of Sir Simonds D'Ewes, Bart., during the Reigns of James I and Charles I* (London, 1845)

Hammer, Paul, E. J., *The Polarisation of Elizabethan Politics: the Political Career of Robert Devereux, 2nd Earl of Essex, 1585–1597* (Cambridge, 1999)

Haynes, Alan, *Robert Cecil, Earl of Salisbury, 1563–1612: Servant of Two Sovereigns* (London, 1989)

Holloway, Edward, R., *Andrew Melville and Humanism in Renaissance Scotland, 1545–1611* (Brill, 2011)

Horn, James, 'Tobacco Colonies: The Shaping of English Society in the Seventeenth-Century Chesapeake', in *The Origins of Empire* (Oxford, 1998), pp. 170–92

Houlbrooke, Ralph (ed.), *James VI and I: Ideas, Authority, and Government* (Aldershot, 2006)

Hutton, Ronald, *The Stations of the Sun: A History of the Ritual Year in Britain* (Oxford, 1996; 2001)

James, M., 'At the Crossroads of the Political Culture: The Essex Revolt of 1601', in M. James (ed.), *Society, Politics and Culture: Studies in Early Modern England* (Cambridge, 1986)

Jayne, Sears, and Johnson, Francis R. (eds), *The Lumley Library. The Catalogue of 1609* (London, 1956)

Juhala, Amy L., 'The Household and Court of King Kames VI of Scotland, 1567–1603', unpublished DPhil. dissertation (Edinburgh, 2000)

Kainulainen, Jaska, *Paolo Sarpi: A Servant of God and State* (Brill, 2014)

Kane, Brendan, *The Politics and Culture of Honour in Britain and Ireland, 1541–1641* (Cambridge, 2010)

Kaplan, Benjamin J., *Divided by Faith: Religious Conflict and the Practice of Toleration in Early Modern Europe* (Harvard, 2007)

Kenny, R. W., *Elizabeth's Admiral: The Political Career of Charles Howard, Earl of Nottingham, 1536–1624* (Oxford, 1970)

Kevill-Davies, Sally, *Yesterday's Children: The Antiques and History of Childcare* (Woodbridge, 1991)

Kishlansky, Mark, *A Monarchy Transformed: Britain 1603–1714* (London, 1997)

Knowles, James, '"To raise a house of better frame": Jonson's Cecilian Entertainments', in Pauline Croft (ed.), *Patronage, Culture and Power: the Early Cecils* (New Haven, 2002), pp. 181–95

Land, Robert Hunt, 'Henrico and its College', in *William and Mary College Quarterly*, vol. 18, no. 4 (October, 1938), pp. 453–98

Lawrence, David R., *The Complete Soldier: Military Books and Military Culture in Early Stuart England, 1603–1640* (Brill, 2009)

Lee Jnr, Maurice, *John Maitland of Thirlstane* (Princeton, 1959)

—— *Great Britain's Solomon* (Chicago, 1990)

de Lisle, Leanda, *After Elizabeth: The Rise of James of Scotland and the Struggle for the Throne of England* (London, 2005)

Lievsay, John, 'Paolo Sarpi's Appraisal of James I', in Heinz Bluhm (ed.), *Essays in History and Literature* (Chicago, 1965), pp. 109–17

Lockyer, R., *James VI and I* (London, 1998)

Lodge, E., *Illustrations of British History ... from the MSS of the Noble Familes of Howard, Talbot and Cecil*, 2nd edn (London, 1838)

McCullough, Peter, *Sermons at Court: Politics and Religion in Elizabethan and Jacobean Preaching* (Cambridge, 1998)

McGinnis, Paul J., and Williamson, Arthur H., 'Politics, Prophecy, Poetry: The Melvillian Moment, 1589–96, and its Aftermath', in *Scottish Historical Review*, vol. 89, 1: no. 227 (2010), pp. 1–18

MacGregor, Neil, *Shakespeare's Restless World* (London, 2012)

McKeown, Simon (ed.), *The International Emblem: From Incunabula to the Internet* (Cambridge, 2010)

MacLeod, Catharine, *The Lost Prince: The Life and Death of Henry Stuart* (London, 2012)

Maley, Willy, 'Rich, Barnaby (1542–1617)', in *Oxford Dictionary of National Biography* (Oxford, 2004)

Marshall, Tristan, 'The Tempest and the British Imperium in 1611', in *The Historical Journal*, vol. 41, no. 2 (June, 1998), pp. 375–400

—— *Theatre and Empire: Great Britain on the London Stages under James VI and I* (Manchester, 2000)

Millar, Oliver, *The Inventories and Valuations of the King's Goods 1649–51*, Walpole Society, XLIII (1972), pp. 153–4

Moore, Norman, *The Illness and Death of Henry Prince of Wales in 1612* (London, 1882)

Mulryne, J. R., '"Here's unfortunate revels": war and chivalry in plays and shows at the time of Prince Henry Stuart', in J. R. Mulryne and M. Shewring (eds), *War, Literature and the Arts in Sixteenth-Century Europe* (London, 1989), pp. 165–96

Murray, Catriona, 'The Pacific King and the Militant Prince? Representation and Collaboration in the Letters Patent of James I, creating his son, Henry, Prince of Wales', in British Library Journal, 2012, Article 8 (http://www.bl.uk/eblj/2012articles/article8.html)

Nicholls, Mark, and Williams, Penry, *Sir Walter Raleigh, In Life and Legend* (London, 2011)

Norbrook, David, 'The Masque of Truth', *The Seventeenth Century*, vol. 1, no. 2 (1986), pp. 81–109

O'Callaghan, Michelle, *The English Wits: Literature and Sociability in Early Modern England* (Cambridge, 2007)

O'Farrell, Brian, *Shakespeare's Patron: William Herbert, Third Earl of Pembroke 1580–1630: Politics, Patronage and Power* (London, 2011)

Oman, Carola, *The Winter Queen: Elizabeth of Bohemia* (London, 2000)

Orgel, Stephen (ed.), *Ben Jonson: The Complete Masques* (New Haven and London, 1969)

—— *The Illusion of Power: Political Theater in the English Renaissance* (Berkeley, 1975)

Parry, Graham, 'The Politics of the Jacobean Masque', in J. R. Mulryne and M. Shewring (eds), *Theatre and Government under the Early Stuarts* (Cambridge, 1993) pp. 87–117

Patrides, C. A., '"The greatest of the kingly race": the Death of Henry Stuart', *The Historian*, 47 (1985), pp. 402–8

Peck, Linda Levy, *Northampton: Patronage and Policy at the Court of James I* (London, 1982)

—— (ed.), *The Mental World of the Jacobean Court* (Cambridge, 1991)

—— 'Monopolizing Favour: Structures of Power in Early Seventeenth-Century English Court', in J. H. Elliott and L. W. B. Brockliss (eds), *The World of the Favourite* (New Haven, 1999)

—— *Consuming Splendour: Society and Culture in Seventeenth-Century England* (Cambridge, 2005)

Pitcher, J., '"In those figures which they seem": Samuel Daniel's Tethys' festival', in D. Lindley (ed.), *The Court Masque* (Manchester, 1984), pp. 33–46

Pollnitz, Aysha, 'Humanism and the Education of Henry, Prince of Wales', *Prince Henry Revived* (Southampton, 2007)

Pritchard, R. E., *Odd Tom Coryate: The English Marco Polo* (Sutton, 2004)

Reid, Stephen J., 'Andrew Melville and the Law of Kingship', in Roger A. Mason and Stephen J. Reid (eds), *Andrew Melville (1545–1622): Writings, Reception, and Reputation* (Aldershot, 2014)

Rhodes, Neil, Richards, Jennifer, and Marshall, Joseph (eds), *King James VI and I: Selected Writings* (Aldershot, 2003)

Rowse, A. L., *Shakespeare's Southampton: Patron of Virginia* (London, 1965)

Rushton, Alan R., *Royal Maladies: Inherited Diseases in the Royal Houses of Europe* (London, 2008)

Russell, Conrad, *Unrevolutionary England 1603–1642* (London, 1990)

Rye, William Benchley, *England as Seen by Foreigners* (London, 1865)

Scott, David, *Leviathan: The Rise of Britain as a World Power* (London, 2014)

Scott, Jonathan, *England's Troubles: Seventeenth-Century English Political Instability in European Context* (Cambridge, 2000)

Seton, Walter W., 'The Early Years of Henry Frederick, Prince of Wales and Charles Duke of Albany (Charles I) 1593–1605', *Scottish Historical Review*, XIII (1915–16), p. 344ff

Shapiro, James, *1606: The Year of Lear* (London, 2015)

Sharpe, Kevin, *Politics and Ideas in Early Stuart England: Essays and Studies* (London, 1989)

—— *Image Wars: Promoting Kings and Commonwealths in England, 1603–1660* (London and New Haven, 2010)

Shirley, J. W. (ed.), *Thomas Harriot: Renaissance Scientist* (Oxford, 1974)

Simms, Brendan, *Europe: The Struggle for Supremacy, 1453 to the Present* (London, 2013)

Smith, John Thomas, *Antiquities of Westminster; The Old Palace; St Stephen's Chapel … &c* (London, 1807)

Smuts, Malcolm, 'Cultural Diversity and Cultural Change at the Court of James I', in Linda Levy Peck (ed.), *The Mental World of the Jacobean Court* (Cambridge, 1991)

—— (ed.), *The Stuart Court and Europe* (Cambridge, 1996)

—— 'Prince Henry and his World', in Catharine MacLeod, *The Lost Prince: the Life and Death of Henry Stuart* (London, 2012), pp. 19–31

—— (ed.), *The Oxford Handbook of the Age of Shakespeare, Oxford Handbooks* (Oxford, 2016)

Soellner, R., 'Chapman's Caesar and Pompey and the Fortunes of Prince Henry', *Medieval and Renaissance Drama in England*, 2 (1985), pp. 135–51

Somerset, Anne, *Unnatural Murder: Poison at the Court of James I* (London, 1997)

Sommerville, Johann. P. (ed.), *King James VI and I: Political Writings* (Cambridge, 1994)

Starkey, David (ed.), *The English Court: from the Wars of the Roses to the Civil War* (Longman, 1987)

Stewart, Alan, *The Cradle King: A Life of James VI and I* (London, 2003)

Stone, Lawrence, *Family and Fortune: Studies in Aristocratic Finance in the Sixteenth and Seventeenth Centuries* (Oxford, 1973)

Strachan, Michael, *The Life and Adventures of Thomas Coryate* (Oxford, 1962)

Strong, Roy, 'England and Italy: The Marriage of Henry Prince of Wales', in Richard Ollard and Pamela Tudor-Craig (eds), *For Veronica Wedgwood These* (London, 1986) pp. 59–87

—— *Henry, Prince of Wales and England's Lost Renaissance* (London: Pimlico, 2000)

Trevor-Roper, Hugh, *Archbishop Laud: 1573–1645* (London, 2000)

Vilim, Jan, Bryson, Anne, and Vakrman, Margaret (eds), *Bellum Tricennale, The Thirty Years' War* (Prague, 1997)

Wedgwood, C. V., *The Thirty Years' War* (London, 1938; 1981)

Wells, R. H., '"Manhood and Chevalrie": Coriolanus, Prince Henry, and the chivalric revival', *Review of English Studies*, 51 (2000), pp. 395–422

Werner, Hans, 'The Hector of Germanie, or the Palsgrave, Prime Elector, and Anglo-German relations of early Stuart England: the view from the popular stage', in Malcolm Smuts (ed.), *The Stuart Court and Europe* (Cambridge, 1996), pp. 113–32

Whitelock, Anna, *Elizabeth's Bedfellows: An Intimate History of the Queen's Court* (London, 2013)

Wilcox, Helen, *1611: Authority, Gender and the Word in Early Modern England* (Oxford, 2014)

Wilks, Timothy, 'The Court Culture of Prince Henry and his Circle 1603–1613', unpublished DPhil. dissertation (Oxford, 1987)

—— (ed.), *Prince Henry Revived: Image and Exemplarity in Early Modern England* (Southampton, 2007)

—— 'Introduction', in Catharine MacLeod, *The Lost Prince: The Life and Death of Henry Stuart* (London, 2012), pp. 11–17

—— *Of Neighing Coursers and Trumpets Shrill: A Life of Richard, 1st Lord Dingwall and Earl of Desmond* (London, 2013)

—— *The Jacobean Grand Tour: Early Stuart Travellers in Europe*, with Edward Chaney (London, 2014)

—— 'Poets, Patronage, and the Prince's Court', in R. Malcolm Smuts (ed.), *The Oxford Handbook of the Age of Shakespeare, Oxford Handbooks* (Oxford, 2016)

Willetts, Pamela, 'Musical connections of Thomas Myriell', *Music and Letters*, vol. xlix (1968), pp. 18–20

Williams, Ethel Carleton, *Anne of Denmark* (Longman, 1970)

Williams, M. C., 'Merlin and the prince: the speeches at Prince Henry's Barriers', *Renaissance Drama*, 8 (1977), pp. 221–30

Williamson, J. W., *The Myth of the Conqueror: Prince Henry Stuart, a Study in 17th Century Personation* (New York, 1978)

Willson, David Harris, *King James VI and I* (London, 1956)

Wilson, Elkin Calhoun, *Prince Henry and English Literature* (New York, 1946)

Wilson, Peter H., *Europe's Tragedy: A History of the Thirty Years' War* (London, 2009)

—— *The Holy Roman Empire: A Thousand Years of Europe's History* (London, 2016)

Winship, Michael P., *Godly Republicanism: Puritans, Pilgrims and a City on a Hill* (Cambridge, Mass., 2012)

Woodward, Jennifer, *The Theatre of Death: The Ritual Management of Royal Funerals in Renaissance England, 1570–1625* (Woodbridge, 1997)

Wormald, Jenny (ed.), *The Seventeenth Century* (Oxford, 2008)

Yates, Frances, 'Paolo Sarpi's "History of the Council of Trent"', *Journal of the Warburg and Courtauld Institutes*, vol. 7 (1944), pp. 123–43

Zakai, Avihu, *Exile and Kingdom: History and Apocalypse in the Puritan Migration to America* (Cambridge, 1992)

Online Sources

historicjamestowne.org/history/history-of-jamestown/the-starving-time/; https://www.washingtonpost.com/... cannibalism.../5af5b474-b1dc-11e2-9a98-4be168

http://friendsoffirstlandingstatepark.com/History_of_First_Landing.html)

https://www.virginia.org/listings/historicsites/firstlandingcross

www.oxforddnb.com/ (*Oxford Dictionary of National Biography*)

www.stoics.com/basilikon_doron.html

Sound Recordings

Maskes & Fantazies (E 8504 AD 100, Auvidis France, 1992)

Musicians of the Globe, Philip Pickett, *Oberon, The Faery Prince, A Masque of Prince Henry's* (catalogue: 446 217–2 DDD PY925 P H, Philips Classics Productions, 1997)

Shakespeare's Lutenist, Theatre Music by Robert Johnson (LC 7873, Virgin Classics Ltd, 1993)

ACKNOWLEDGEMENTS

My aim in writing this book was to bring Henry to life in his time and place. Any hope I had of accomplishing that ambition was helped immeasurably by the scholarship of many great historians of the period.

My debt to the scholars whose works illuminate different aspects of Henry's life is huge, as shown in the notes and bibliography. However, I must mention in particular the benefit any would-be Henry biographer gains from starting with the researches of Roy Strong and Timothy Wilks. Their knowledge of the art, culture and political activities circulating around Henry is a rich and stimulating source for those who follow in their footsteps. The rich trove of material displayed in the National Portrait Gallery exhibition devoted to Henry in 2012 was simply inspiring.

I want also to thank John Adamson, Alexandra Gajda, Jacqueline Riding, Jo Hines, Paul Murton, Eion Gibbs, Catherine Moye, Will Talbot, Lord Dalmeny, Laura Lindsay, Catharine MacLeod; Hayley Shah at St Nicholas Church, Chiswick; my excellent editor, Arabella Pike, and her team at HarperCollins: Iain Hunt and Katherine Patrick; Ruth Killick; and my wonderful agent, David Godwin. The staffs of the major libraries and archives are a godsend to writers: thank you all. Last but not least are my husband and family, who must weary of hearing the phrase (excuse for not doing something I promised them I would do), 'Soon, I'm nearly there'. Heartfelt love and thanks.

ILLUSTRATION CREDITS

Prince Henry on Horseback, by Robert Peake the Elder, *c.* 1606–8 (*Photo: Nick Hugh McCann © Parham Park Ltd*)

James VI and I, miniature by Nicholas Hilliard, *c.* 1609–15 (*Royal Collection Trust/© Her Majesty Queen Elizabeth II 2017*)

Queen Anne, in her pomp, by Marcus Gheeraerts the Younger (*Royal Collection Trust/© Her Majesty Queen Elizabeth II 2017*)

Prince Henry, aged two, artist unknown (*In a Private Collection*)

Prince Charles, the future Charles I, by Robert Peake the Elder, *c.* 1610 (*National Galleries of Scotland/Getty Images*)

Princess Elizabeth, Electress Palatine, later Queen of Bohemia, artist unknown, 1613 (*Photo by VCG Wilson/Corbis via Getty Images*)

David Murray (*Unknown. Sir David Murray of Gorthy, 1567–1629. Poet. Scottish National Gallery/David Laing bequest to the Society of Antiquaries of Scotland. Gifted in 2009*)

Stirling Castle (*By DeFacto (Own work) [CC BY-SA 4.0 (http://creativecommons.org/licenses/by-sa/4.0)], via Wikimedia Commons*)

Henry practising his signature from his schoolbook (*Wren TC MS r.7.23, v.1, the Master and Fellows of Trinity College Cambridge*)

John Harington, 2nd Baron Harington of Exton, *c.* 1613–14 (*artist unknown, © The Trustees of the British Museum*)

Robert Devereux, 3rd earl of Essex, close friend of Henry (*ART Collection/Alamy Stock Photo*)

Robert Cecil, 1st earl of Salisbury (*ART Collection/Alamy Stock Photo*)

Sir Walter Ralegh, miniature by Nicholas Hilliard (*Granger Historical Picture Archive/Alamy Stock Photo*)

Nonsuch Palace (*Author photo*)

Sir Thomas Chaloner and Elizabeth Fleetwood in St Nicholas Church, Chiswick, a full Jacobean tomb reeking of memento mori: the skull sitting between them (*Author photo*)

Henry's astrolabe (© *The Trustees of the British Museum*)

Ben Jonson, by Abraham van Blijenberch, *c.* 1617 (*Ian Dagnall/Alamy Stock Photo*)

Inigo Jones, Anthony van Dyck, 1636 (*The National Trust Photolibrary/ Alamy Stock Photo*)

St James's Palace (*Heritage Image Partnership Ltd/Alamy Stock Photo*)

O, my America, my new found land – Henry's map of the Chesapeake Bay area (*Map of James and York Rivers/British Library, London, UK/© British Library Board. All Rights Reserved/Bridgeman Images*)

Henry in Roman armour and opulent toga (*No.3903 Henry Frederick, Prince of Wales (1594–1612), eldest son of King James I of England (VI of Scotland), Oliver, Isaac (c. 1565–1617)/Fitzwilliam Museum, University of Cambridge, UK/Bridgeman Images*)

Maurice of Nassau (*Photo by Fine Art Images/Heritage Images/Getty Images*)

Henri IV of France (*DEA/G. DAGLI ORTI/Getty Images*)

Henry in armour, by Isaac Oliver, *c.* 1610–12 (*Royal Collection Trust/© Her Majesty Queen Elizabeth II 2017*)

Henry as Oberon, by Inigo Jones (*Final design for Oberon's dress, c. 1611 (pen & ink on paper), Jones, Inigo (1573–1652)/Collection of the Duke of Devonshire, Chatsworth House, UK/© Devonshire Collection, Chatsworth/Reproduced by permission of Chatsworth Settlement Trustees/Bridgeman Images*)

Henry's bronzes – the pacing horse he had in his hands when he died (*Royal Collection Trust/© Her Majesty Queen Elizabeth II 2017*)

From the ornate Letters Patent creating Henry, Prince of Wales, 4 June 1610 (*James I creating his son Henry Prince of Wales and Earl of Chester; witnessed by Charles, Duke of York, and many other peers 'in pleno Parliamento'./British Library, London, UK/© British Library Board. All Rights Reserved/Bridgeman Images*)

Richmond Palace, 'A view from the south-west by an unknown seventeenth-century hand', (detail) (*Photo: Universal History Archive/ UIG via Getty Images*)

Frontispiece/title page of Coryate's *Crudities* (*Title Page from 'Coryats Crudities Hastily gobled vp in five Moneth trauells ...' by Thomas Coryat, 1611 (coloured engraving), English School, (17th century)/British Library, London, UK/Bridgeman Images*)

Frederick of the Palatine, miniature by Isaac Oliver (*Royal Collection Trust/© Her Majesty Queen Elizabeth II 2017*)

Henry's ship – *The Prince Royal* carried his sister Elizabeth and her new husband Frederick from England in March, 1613 (The Embarkation at Margate of Elector Palatine and Princess Elizabeth, *1623 (oil on canvas), Willaerts, Adam (1577–1669)/Royal Collection Trust © Her Majesty Queen Elizabeth II, 2017/Bridgeman Images*)

Henry's effigy (*Copyright © Dean and Chapter of Westminster*)

Henry's funeral bier (*© The Trustees of the British Museum*)

Prince of Wales feathers (*Crest of Henry, Prince of Wales. Emblem with sun design./British Library, London, UK/© British Library Board. All Rights Reserved/Bridgeman Images*)

INDEX